THE LURE
OF THE EAST
BRITISH
ORIENTALIST
PAINTING

THE LURE
OF THE EAST
BRITISH
ORIENTALIST
PAINTING

EDITED BY NICHOLAS TROMANS
With essays by Rana Kabbani,
Fatema Mernissi, Christine Riding
and Emily M. Weeks

Yale University Press

Published in North America by
Yale University Press
P.O. Box 209040
New Haven, CT 06520-9040
www.yalebooks.com

First published in 2008 by order of the Tate Trustees
by Tate Publishing, a division of Tate Enterprises Ltd,
Millbank, London SW1P 4RG
www.tate.org.uk/publishing

On the occasion of the exhibition
The Lure of the East: British Orientalist Painting
Organized by Tate Britain in association with the
Yale Center for British Art

Yale Center for British Art, New Haven
7 February – 27 April 2008

Tate Britain, London
4 June – 31 August 2008

Suna and İnan Kıraç Foundation Pera Museum, Istanbul
23 September 2008 – 4 January 2009

Sharjah Art Museum
February – April 2009

© Tate 2008

Text by Fatema Mernissi © Fatema Mernissi 2008
All other texts © Tate 2008

Library of Congress Control Number: 2007940708

ISBN 978-0-300-13898-6

Designed by Atelier Works
Colour origination by DL Repro, Great Britain
Printed and bound in Singapore by CS Graphics

Front cover: Arthur Melville, *An Arab Interior* 1881 (detail
of fig.82)

Measurements of artworks are given in centimetres,
height before width

CONTENTS

FOREWORD

This is the first major museum exhibition to explore in any depth the British branch of that predominantly nineteenth-century genre, Orientalist painting – generally defined as the depiction by European artists of people and places in the Middle East including North Africa. The project seeks to explore what constituted and what characterised the output of British artists in the field, and it does so principally, though not exclusively, with reference to their immediate historical and art historical contexts rather than in relation to broader histories of East–West relations up to the present day.

But the political dimension of our subject – and indeed of each object within it – is never very far from the surface. In particular, the issues identified in Edward W. Said's seminal book *Orientalism* (1978) and since fiercely debated, are omnipresent. Although Said himself was little concerned with the visual image, his contention that Westerners' ostensibly admiring interest in Oriental culture was ultimately and harmfully imperialist in nature has raised important questions for historians of Orientalist art. Said held that Orientalism served political ends for the West, misrepresented Arab and Islamic cultures by viewing them through a European lens, and was as much about defining Europe's self-image (through the creation of contrasting 'others') as about the Orient itself. The Oriental world tended to be portrayed as luxurious, sensuous and static, implicitly in contrast to the dynamic, innovative and expanding West. Linda Nochlin was the first of a number of art historians to apply these contentions to Orientalist painting, arguing that such works were effectively active participants in an imperialist ideology, far from the straightforward, realist, 'truthful' and admiring images they seemed at first glance. Of course the strength of such an argument does not prevent the same works of art from operating coherently at other, less charged, levels too

– documentary, aesthetic, narrative – and for this reason the widespread admiration by Middle-Eastern collectors today for Orientalist painting is perhaps a less ironic phenomenon than is often claimed.

Indeed the multiplicity of meanings of, and possibilities surrounding, Orientalist painting readily nurtures a broad spectrum of interpretation, a fact reflected in the notably diverse methodologies and conclusions of the authors within this book alone. It seems to us that it is the responsibility of the museum to encourage such breadth. Indeed, there has been an inspiring openness in the curatorial dialogue that has driven this project from the outset, coinciding as it has with a moment when European and American political relations with the Middle East have been particularly difficult. With this background, we are delighted that the exhibition tour covers four countries: the United States, Britain, Turkey, and Sharjah in the United Arab Emirates, in the last two places mounted in partnership with the British Council.

This project began with a proposal by a former Yale graduate student, Emily Weeks, to curate an exhibition of the work of John Frederick Lewis at Tate Britain, London, and the Yale Center for British Art, New Haven. We put her in touch with Nicholas Tromans in London when a conversation about a related project began to gain ground, and their subsequent discussion forged the structure of the exhibition we now proudly present. Dr Tromans took on the overall curatorship of the project and editorship of the catalogue, supported by Christine Riding at Tate Britain and Julia Marciari Alexander and Eleanor Hughes at the Yale Center. We would like to express thanks to all these key participants, supported by many staff members at both institutions. In addition we would like to thank Rana Kabbani and Fatema Mernissi for contributing powerful and important essays to this book. Briony Llewellyn has generously shared with the curators her knowledge of many of the works in the show. Her important contribution is greatly appreciated, as is the good advice we have received on a variety of fronts from Rose Issa, Gilane Tawadros, Venetia Porter, Andrea Rose, Yasmin Alibhai-Brown and Hugh Kennedy. In Istanbul, we would like to extend our warmest thanks to Özalp Birol, General Director of the Suna and İnan Kıraç Foundation Pera Museum. In Sharjah, we are enormously grateful for the support of Sue Underwood, Director of the Sharjah Museums Department.

In both London and New Haven the exhibition sits at the heart of a wider, related public programme. At the Yale Center an accompanying exhibition, *Pearls to Pyramids: British Culture and the Levant, 1600–1830*, curated by post-doctoral research associate, Eleanor Hughes, draws on Yale's collections to provide a broader context for *The Lure of the East: British Orientalist Painting*. At Tate Britain, an exhibition of contemporary lens-based work is staged in parallel, along with a display related to *Nahnou-Together*, a Tate–British Council initiative linking artists, young people and educators in London, Amman and Damascus. At both institutions, a programme of films, lectures and performances has been conceived to complement the associated exhibitions. We hope thereby to play some part in the expansion and progression of the rich debate around Orientalism and its politics.

Stephen Deuchar
Director, Tate Britain

Amy Meyers
Director, Yale Center for British Art

7

ACKNOWLEDGEMENTS

There have been many people who have contributed to *The Lure of the East* to whom we owe a debt of gratitude. Our heartfelt thanks go to Emily Weeks and Briony Llewellyn, both of whom have given continual guidance, assistance and support. We would like to thank Fatema Mernissi and Rana Kabbani for their important and illuminating essays in the book accompanying the exhibition and to Heather Birchall for the artists' biographies. In addition, we have had discussions with many people who were most generous in giving time and expertise. In particular we would like to thank Tabitha Barber, Patricia L. Baker, Judith Bronkhurst, Rosemary Crill, Karen Hearn, Hugh Kennedy, Reina Lewis, Susan North, Hallie Rubenhold, Alison Smith and Peter Trippi.

The response from lenders has been impressive and we are most grateful to all the institutions and individuals who have given their support. The selection includes an unusually high proportion of works in private collections and we are extremely grateful to colleagues in auction houses, dealerships and other individuals who have acted on our behalf to secure important loans. In particular we would like to thank Martin Beisly, Jane Luke, Harriet Drummond, Jonathan Horwich, Sarah Rees, Betsy Thomas and Sarah Vowles from Christie's, Grant Ford, Mark Griffith-Jones, Aarti Chanrai and Henry Wemyss from Sotheby's, Simon Edsor from the Fine Art Society, Brian MacDermot at the Mathaf Gallery, Peter Nahum at The Leicester Galleries, Marco Frignati, Karen Reihill and Mohammed Farooq Vaid.

At Tate Britain, the project has been guided from the start by Stephen Deuchar and Judith Nesbitt. A number of our colleagues deserve special recognition. Our thanks again to Heather Birchall and also Martin Myrone who contributed to the shaping of the exhibition and who oversaw the development and

administration of the project until last year. Sofia Karamani has subsequently taken on the logistics of this complex project and has tackled the various challenges with great professionalism and humour. Gillian Buttimer, the exhibition registrar, has brought her extensive knowledge and practical experience to bear and Cathy Putz has managed the tour and contractual elements of the projects with great diligence and patience. Thanks are also due to Rachel Crome, Rica Jones and Piers Townshend in the Conservation Department and Andy Shiel, Art Installation Manager. We have worked very closely with colleagues in the Interpretation and Education Department at Tate Britain, in particular Christina Bagataviticus and Jenny Batchelor, who have created an exciting interpretation concept. Concerning the exhibition publication, the input from colleagues in Tate Publishing and the designers has been nothing short of heroic. We would therefore like to express a very special thank you to Mary Richards, Mary Scott, Emma Woodiwiss, Rebecca Fortey, Celia Gibson and Anne Low at Tate Publishing, and to Quentin Newark and Paola Faoro of Atelier Works. We would also like to acknowledge the following Tate staff for their help and advice: James Attlee, Robin Hamlyn, Hayley James, Alice Teng, Clarrie Wallis and Katy Westerman.

To the acknowledgements already set out in the Foreword, we would like to add our thanks to colleagues at the three venues in the United States, Turkey and the United Arab Emirates that are staging *The Lure of the East*: at the Yale Center for British Art, Julia Marciari Alexander, Tim Goodhue, Eleanor Hughes, Angus Trumble, Scott Wilcox; at the Pera Museum, M. Özalp Birol, M. Hakan Elbir and R. Barış Kıbrıs; at the Sharjah Art Museum, Sue Underwood, Manal Ataya, Hind bin Darwish, Zekryat Matouk and Nuria Oscoz; and a special thank you to colleagues at the British Council, Andrea Rose, Gemma Latty, Mona Lotten, Alison Moloney, Esra Oztemir, Richard Riley, Paul Sellers, Ruth Ur, Kristine von Oehsen, Elizabeth White and Louise Wright.

Finally, we would like to acknowledge the following individuals for their advice or assistance in making this exhibition possible: Annie Ablett, Patricia Allderidge, Julia Aronson, Jane Arthur, Joe Audi, Caroline Bacon, Ray Barnett, Mària van Berge-Gerbaud, John Berkeley, Peter B. Boydon, Chris Brown, Iain Gordon Brown, Anne Buddell, Rupert Burgess, Mary Busick, Felicity Cobbing, James Cowper, Tim Craven, Chris Edwards, Martin Ellis, Guillaume Faroult, Simon Fenwick, Paul Flintoff, Robert Futernick, Annelise Hone, Aisha Gibbons, Geraldine Glynn, Christopher Gordon, Michael and Christine Gorman, Antony Griffiths, Colin Harrison, Barbara Hay, Alexia Hughes, Valerie Hunter, Matthew Jarron, Christopher Jordan, Vivien Knight, Julie Lawson, Christopher C. Lee, François Leurquin, Stephen Lockwood, Rob Lynes, Alasdair Macleod, Francis Marshall, Sally McIntosh, Maggie McKernan, Rita McLean, Jennifer Melville, Julie Milne, Vanessa Mitchell, Yara Moualla, Edwina Mulvany, Charles Newton, Richard Ormond, Varshali Patel, J. Michael Phillips, Abi Pole, Rebecca Posage, Janice Reading, Eugene Rae, Maria F. Reilly, Leslie Richardson, Mary Roberts, Daniel Robins, Marie-Catherine Sahut, Andrea R. Selbig, Jennifer Scott, David Scrase, Desmond Shawe-Taylor, Tessa Sidey, Janice Slater, Helen Smailes, Gillian Smithson, Kathleen Soriano, Thyrza Smith, Ann Steed, MaryAnne Stevens, Sheena Stoddard, Keiichi Sudou, Reena Suleman, Julia Toffolo, Roger Tolson, Rebecca Wallace, Stephen Whittle, Timothy Wilson, Phillippa Wood and Liz Woods.

Nicholas Tromans and Christine Riding

INTRODUCTION: BRITISH ORIENTALIST PAINTING

NICHOLAS TROMANS

Locating the Orient

The world, so we are regularly told, is shrinking, but the places described by the paintings in this book seem to be getting further away. What is now the Middle East had, until the early twentieth century, been known to the West as the Near East, and before that, for much of the nineteenth century, it is probably true to say that the cities of Istanbul (Constantinople), Jerusalem and Cairo seemed more familiar to the British public than they do today.[1] Of course that familiarity may have been at least in part an illusion, built on a series of distorted images more reflective of the British beholder than truly descriptive of the ostensible Oriental object of the gaze. Perhaps the loss of beautifully lucid Orientalist illusions was a necessary step on the way to a more honestly impaired vision of these places and the people who live there. This book sets out to explore the history of British Orientalist imagery, which was accepted in its own day as a peculiarly truthful form of art and, inasmuch as it disavowed flagrant fantasy, differed from some of the most well-known examples of the French variety of Orientalist painting.

Where was the British painters' Orient? Essentially it was the Muslim Mediterranean, really not so very far from artists' traditional hunting grounds, and reached by degrees in the early nineteenth century (see fig.2). One line of tourist expansion lay through Spain and Morocco, a second through Greece and Asia Minor. Both converged on the Turkish capital (Constantinople), on Palestine (the Holy Land) and on Egypt in the years around 1840. David Roberts and John Frederick Lewis, both central figures in the history of British Orientalist painting, explored Spain and Morocco in the early 1830s, and then each set out again several years later, Roberts to tour Egypt and the Holy Land in 1838–9, Lewis to reside in Cairo for a full decade through the 1840s. After this, the Maghreb (Muslim north-west Africa including Morocco, Algeria and Tunisia) was by and large considered French artistic territory until much later in the century, as the French political annexation of the region fanned out from Algiers, which France had occupied in 1830. The other 'way in' to the Orient, through the Ottoman Balkans, was associated above all with Byron, whose superb portrait by Thomas Phillips (fig.59) commemorates his grand tour of 1809–11, which took him via Greece as far as Smyrna (Izmir) and Constantinople. This 'Classical' route, leading the traveller into the Ottoman heartlands via Homeric territory, was described for tourists in the guide to *The Ionian Islands, Greece, Turkey, Asia Minor, and Constantinople*, written anonymously and brought out by Byron's publisher John Murray in 1840. Indeed, around this key moment, we can observe a bifurcation in the tradition of British travel literature. On one hand there was this practical guidebook, inviting readers to send in records of their own travels to allow optimum objectivity in future editions. On the other was Alexander Kinglake's bestseller of the 1840s, *Eothen* (Greek for 'Oriental'), a deliberately cavalier account of a young Englishman's inviolate self-satisfaction even under the pressures of Oriental travel. Its clear, and evidently welcome, message was that reading about the Orient was more entertaining than going there.

David Wilkie, a pioneer among British artists in Spain in the 1820s, ended his career in the East, visiting Constantinople and Jerusalem in 1840–1 before embarking at Alexandria in Egypt for the journey home which he would never complete. J.M.W. Turner's *Peace – Burial at Sea* (fig.1) represents Wilkie's body being lowered over the side of the P&O steamer *Oriental* in June 1841. The ship had entered service less than a year beforehand, providing the first stage of the Overland Route to India, sailing from Southampton to Alexandria (passengers and

mail then continued by canal to the Nile, then overland to Suez and on to India via the Red Sea). The presence of the faithfully depicted *Oriental* in Turner's picture thus reminds us of the power of British steam to develop Mediterranean tourism, and of the importance of Egypt for communications between Britain and its foremost imperial possession, India. In these terms, what we now call the Middle East was indeed already, from a British geopolitical viewpoint, in the middle, which explains Napoleon's eagerness to occupy Egypt in 1798 in order to divide Britain from India. What the British wanted in the region during this period was above all stability, hence their interest in shoring up the faltering Ottoman Empire for fear that its implosion would allow in the Russians, ever pressing against the Ottomans' north-eastern frontiers. Despite its centrality to British identity, few professional British artists made it to India, and fewer still to Persia (Iran), Afghanistan or Mesopotamia (Iraq), let alone Arabia, all of which were, so far as British power politics was concerned, within the sphere of influence of British India.[2] Art and tourism flourished, not so much within the bounds of the British Empire, but in places relatively easy to access by boat. The hinterland well beyond the coasts (with the exception of the Nile valley) remained the province of soldiers and explorers.

The Orient of the British Orientalist painter was thus a rather narrowly defined region, but even within this limited territory there was little internal coherence. Its frontiers were defined by the realities of transportation, and the associated consideration of pressures of time for, with some exceptions (for example Lewis, and the peripatetic writer and painter Edward Lear), professional artists generally wanted to gather their pictorial material with some urgency and then head back to London to start turning it to profit. Nominally, Egypt and Palestine were both under Turkish control, and in theory the painter's Orient was Ottoman. But provincial little Jerusalem, so fundamental to the British mythology of the East, was of little strategic interest to the Ottomans, and they had never really restored Cairo to their jurisdiction after Napoleon's arrival there. For although Nelson had soon helped force the French out of Egypt, after their departure power there was seized by an Ottoman soldier of Albanian extraction, Muhammad 'Ali, who was to become ruler of the country into the 1840s (his descendants were pashas, khedives and ultimately kings of Egypt until the Free Officers' coup of 1952). From the outset, then, we are dealing with an Orient which, whatever its intricate realities on the ground, was defined, as a category, by and for the professional convenience of Europeans. And so, again from the start, we already find ourselves in the hot waters of the Orientalism debate sparked by the book of that name, published in 1978 by the late Edward Said.

Orientalism and Truth

One criticism sometimes made of Said's book is that its conception of the Orient was too narrowly defined, omitting all sorts of Islamic or Eastern places (Japan to name only the most obvious) in which the West had long shown great interest. But his

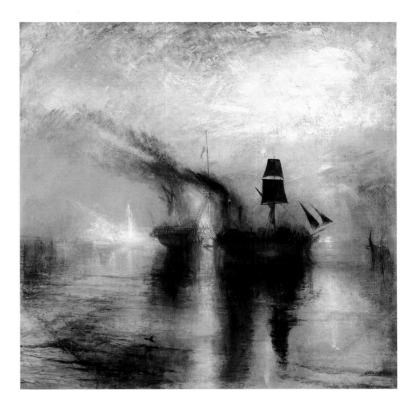

Fig.1
Peace – Burial at Sea 1842
J.M.W. Turner
Oil on canvas, 87 x 86.7
Tate

arguments turned precisely on this idea of the invention by the West of different characterisations of the Orient on the basis, not of 'pure', but of 'useful' knowledge. What was useful was in turn determined by the professional interests of those generating different kinds of representations of the East – poets, soldiers, travel writers, missionaries and so on. Said was primarily interested in the relationships between texts, but art historians have since sought to transpose some of his interpretations from literature to images, with uneven results. A besetting problem has been that some Orientalist paintings are so spectacular, and so spectacularly negative in their representations of the Orient, that it has seemed more urgent, and proved easier, to disdain the artists' bad taste or ignorance than to follow through Said's more subtle arguments about the professionalisation of knowledge (although it might fairly be said that Said himself often conflated the two approaches). Here I would like, through introducing some of the ideas prompted by the pictures in this book, to ask afresh the question of what the Orient had to offer the professional painter; or, to adapt the title of a recent book by the American critic W.J.T. Mitchell, to ask: what did the Orientalist picture itself want?[3]

Although Said, in his *Orientalism*, does not deal with painting, he does make one single reference to British images of the Middle East, and this reference, though slight, is revealing. One of the greatest nineteenth-century British Orientalists, that is European experts on the East, was Edward William Lane (fig.3), whose minutely described but sprawling work, *An Account*

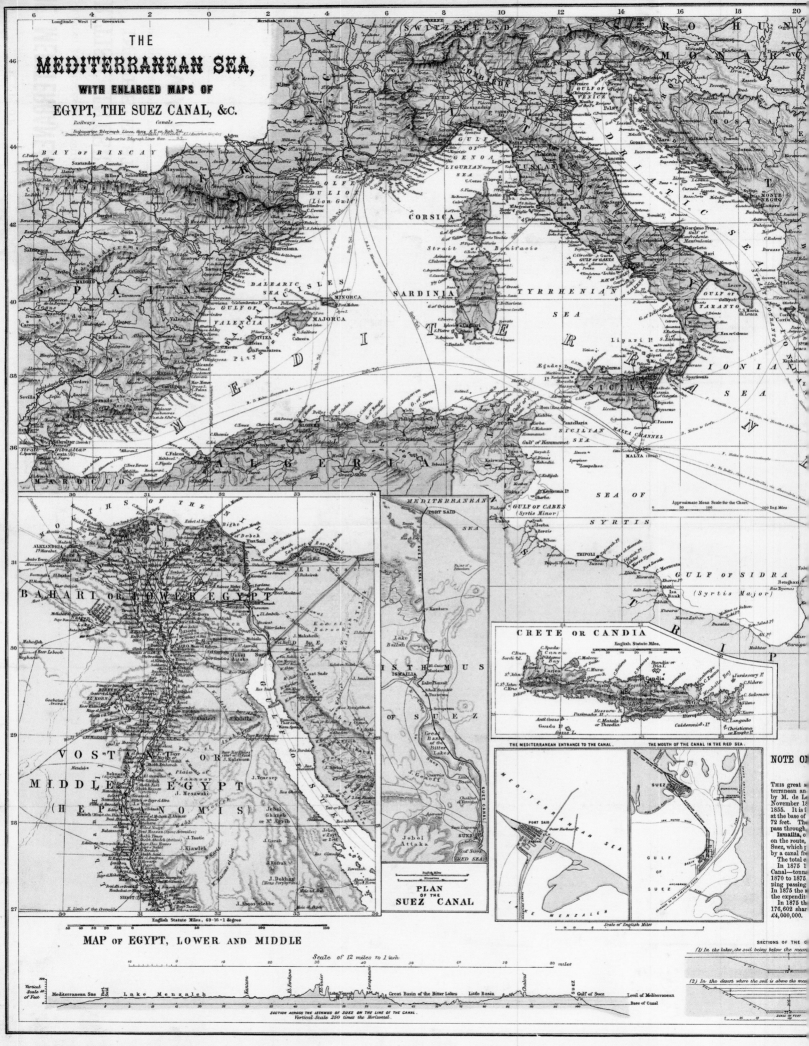

THE
MEDITERRANEAN SEA,
WITH ENLARGED MAPS OF
EGYPT, THE SUEZ CANAL, &C.

Railways ———— Canals ————

PLAN
OF THE
SUEZ CANAL

CRETE OR CANDIA

THE MEDITERRANEAN ENTRANCE TO THE CANAL. THE MOUTH OF THE CANAL IN THE RED SEA.

MAP OF EGYPT, LOWER AND MIDDLE

English Statute Miles, 69·16=1 degree

Scale of 12 miles to 1 inch

SECTION ACROSS THE ISTHMUS OF SUEZ ON THE LINE OF THE CANAL.
Vertical Scale 250 times the Horizontal.

Fig.2
The Mediterranean Sea, with enlarged maps of Egypt, the Suez Canal, etc, published by W. and A. K. Johnston, London 1876
Royal Geographical Society, London

ITERRANEAN SEA—SHOWING ALL PLACES OF IMPORTANCE TO BRITISH INTERESTS.

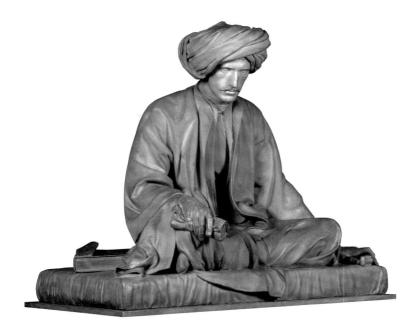

Fig.3
Edward William Lane 1829
Richard James Lane
Plaster statue, 95.3 high
National Portrait Gallery, London

of the Manners and Customs of the Modern Egyptians, was published
for the Society for the Diffusion of Useful Knowledge in 1836.
Lane's book was regularly referenced in exhibition catalogues
by British painters wishing to lend authority to their images of
Egyptian life. A trainee engraver himself before succumbing
to the archaeologically inspired Egyptomania of the 1820s, Lane
was a writer of extreme detail and precision. Facts, names and
descriptions are compounded into sometimes impenetrably dense
pages, relieved at intervals by Lane's own elegantly simple and
effective line drawings (which sometimes offer precedents for
the pictures of Lewis, whom Lane knew in Cairo in the 1840s).
For Said, Lane's writing style is characteristic of Orientalism's
inability to achieve coherence, falling back instead on a litany
of staccato bullet points. Lane's book opens with some
generalisations about the Egyptian climate but, writes Said,
the reader is 'soon bogged down in descriptions, complete with
charts and line drawings, of Cairene architecture, decoration,
fountains, and locks. When a narrative strain re-emerges, it is
clearly only as a formality.'[4] The visual is here construed as the
nadir of positivistic Orientalism, as the point indeed where the
discourse of Orientalism collapses under the weight of its own
accumulated pseudo-evidence.

For a writer as sceptical as was Said regarding
representation *per se*, we might have expected the image to
come in for a particularly rough ride.[5] If the problem with
Orientalism generally is its susceptibility to repetitious habits of
representation that end up taking on a spurious authority, then
art was always going to be especially culpable, for it generally
depends so much upon semantic conventions, on iconographic
patterns handed on from artist to artist. The painter Thomas
Seddon, for example, complained in the 1850s that he had seen

a British book about the Holy Land with 'the same woodcut
put as a representation of two several towns': the Oriental city
could not it seemed be represented with authentic individuality.[6]
But, crucially for our understanding of British Orientalist
painting, Seddon was himself in Palestine when he made this
complaint, and he had gone there as an enthusiastic Christian
artist, precisely to remedy the problem. He was in the company
of the Pre-Raphaelite painter William Holman Hunt, like
Seddon a born-again Christian and also intent on remaking
religious art for a modern Protestant audience. Hunt in turn
(even if he chose not to say so openly) was following in the
footsteps of David Wilkie, whose own doomed expedition of
1840–1 had been undertaken with the same ambition. As Wilkie
had put it, 'a Martin Luther in painting is as much called for as in
theology, to sweep away the abuses by which our divine pursuit
is encumbered', that is, to dredge out the banked silt of falsehood
represented by the traditions of Catholic religious iconography.[7]
David Roberts's religious ambitions for his Oriental work were
less explicit (if most certainly still present), and his trip of the late
1830s was above all about the present reality of the Middle East;
indeed his prints and pictures were prized as dramatically fresh
visions of real places that had for centuries been represented
only verbally or in the most conventionalised visual formats.
If, for Said, the image signalled the faltering of Orientalist
narratives, then for the leading early British painters of the
Middle East this very disruption could mean the redemption of
representation, not its final demise: pictures of the Orient could
be the antidote to the lazy and ignorant repetition of received
wisdom.[8] Here then is the paradox intriguingly played out in
British Orientalist painting of the Victorian period. Acutely
aware of the pitfalls of convention, Roberts, Wilkie, Hunt and
others headed to the Orient, a place which as we have suggested
existed primarily as an artistic category, to redeem the value of
their own art as the potential communicator of absolute truth.

Orientalism and Reform
The steam power that revolutionised transport in the 1830s
was also remapping British politics, as the industrialised regions
demanded representation in Parliament. Following the Reform
Act of 1832, some campaigners moved on to agitate for universal
male votes, which became one of the articles of the People's
Charter of 1838, drawn up at a time when other, more utopian
visions of the future of British society were also flourishing.
The following year there were Chartist shows of strength in
various parts of the country, and a full-scale uprising in the town
of Newport in south-east Wales, in which some twenty Chartists
were killed. The establishment's hero of the hour was the town's
mayor, Thomas Phillips (not to be confused with the portraitist
of the same name), who faced down the rioters and was rewarded
with a knighthood. After recovering from his wounds, and
in advance of settling in London, Phillips made a tour of the
Eastern Mediterranean, taking with him as a draughtsman
a brilliant young painter named Richard Dadd. While abroad
Dadd fell into mental illness and after his return, having

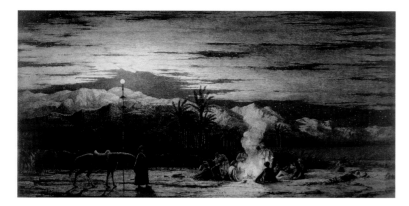

Fig.4
The Halt in the Desert *c.*1845
Richard Dadd
Watercolour, 36.8 x 70.7
The British Museum, London

murdered his father, was to spend the rest of his life in Bethlem and Broadmoor hospitals as a criminal lunatic. He continued to paint, however, and remembered visions of his Oriental tour regularly appear in his work. This tangential connection with Chartism seems strangely relevant on looking back at the general history of British Orientalist culture, for one aspect of the 'Orientalist moment' around 1840, the point at which British artists first headed to the Middle East in substantial numbers, was a mutual projection of ambitious political aspirations between Eastern and Western societies. As embryonic British socialism dreamed of its possible futures, the Orient became one source of metaphors for such utopian states. The followers of the industrial–utopian guru Robert Owen, for example, figured their future condition of Harmony as a new Israel in 1839, while the following year Wilkie, trying to make sense of the harems of Constantinople, wrote of these embodying 'the complete Utopia of our Owenites'.[9] The image of Jerusalem as the ultimate destination of the pilgrim, religious or political, was of course deeply embedded in English literary culture from John Bunyan to William Blake, and was regularly on the lips of Victorian hymn-singers, whether of Tory Anglican or Socialist Methodist persuasion.

Meanwhile, at the top levels of government in Turkey, modernisation of the Empire was continuing apace. The Ottomans had been lagging behind Europe in technological terms since at least the later seventeenth century, but it was perhaps only in this period that modernisation became unmistakably identified with Westernisation. Dress reform in the 1820s, which had replaced the turban with the fez, was followed by the onset of the *Tanzimat* (Reorganisation) era, inaugurated by the promulgation of the Noble Rescript of the Rose Chamber (or Charter of Gulhane) in 1839, which tentatively introduced secular principles into the Ottoman legal system, providing for equality of all citizens before the law regardless of race or religion. In Wilkie's portrait of the teenage Sultan Abdul Mejid, painted for Queen Victoria in 1840 (fig.45), the sitter is shown, in the words of a London newspaper critic,

'in a most anomalous costume, half-reformed Turk, half-dandy European'.[10] Among the internal reforms came other changes, such as the granting to European powers of an expansion of their consular services within the Empire. Thus by the end of the 1830s there was a British Consul at Jerusalem, just in time to help the British painters who were then regularly starting to arrive there. With these concessions came more far-reaching ones, such as those which allowed Europeans to import their own laws when involved in criminal cases in Ottoman territory. Protection of the various non-Muslim minorities within the Empire gave European powers another excuse to intervene, as did protection of European citizens and assets.[11] In 1840 the threat posed to Ottoman stability by the occupation of Palestine and Syria by Muhammad 'Ali of Egypt was enough to prompt Britain, in league with several other European powers, to intervene to eject him. The Ottoman need for this European assistance against the newly mighty Egyptian army was indeed a crucial factor in their whole reform process. This rapprochement inaugurated a period of relative pro-Turkish sentiment in Britain, signalled in Wilkie's painting of the news of the fall of Acre arriving in the Ottoman capital (fig.61), which survived until the arrival of reports of Turkish atrocities committed against the breakaway Balkan province of Bulgaria in 1876.

The Pasha of Egypt – also painted by Wilkie (fig.44) – took his country down the same path as the Ottomans of increased dependency on European technology, expertise and finance, so that when the British occupied Egypt in the 1880s they were able to take direct control over a process of Westernisation in which they had already for long been deeply involved. Egypt formally became a British Protectorate in 1914 at the outbreak of the First World War, in which Turkey sided with Germany and shared her defeat. After the war, the Ottoman territories were carved up into new states and into mandatory regimes of the victorious powers, Britain and France. The Sultanate was abolished by Ataturk's new Turkish Republic in 1922, which has been taken as the endpoint of this book.

The Themes of Orientalist Painting

What then did British painters depict once they had been, so to speak, invited into the Ottoman lands by the announcement of *Tanzimat* in 1839? This book sets out to explore this question across five thematic sections. The first three, devoted to portraiture, genre painting and landscape, follow the refractions that took place within these three traditional Western categories once they were shifted into Oriental mode. The last two sections, about the harem and religion, look at the two principal ways in which Orientalist iconography developed its own novel subject matter.

The image of the conqueror 'going native' as he developed his empire into the East is longstanding within European culture. Alexander the Great, conqueror of Persia, and Constantine, the first Christian Roman Emperor who moved his capital from Rome to Byzantium (Constantinople), both adopted Oriental costume in the hope of facilitating their rule. In later times,

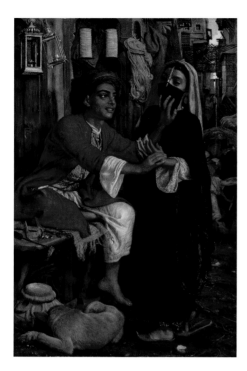

Fig.5
A Street Scene in Cairo: The Lantern-Maker's Courtship 1854–7; 1860–1
William Holman Hunt
Oil on canvas, 54.6 x 35
Birmingham Museums & Art Gallery

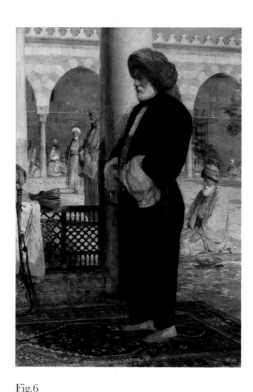

Fig.6
Interior of a Mosque, Afternoon Prayer (The 'Asr) 1857
John Frederick Lewis
Oil on wood, 31 x 21
Private Collection

such cross-cultural dressing was adopted by lesser men and women for a range of different reasons. Robert Shirley, roving European ambassador in the employ of Shah 'Abbas of Persia in a period well before Middle Eastern powers had permanent representatives at European courts, signalled his credentials by his clothing, as recorded in the portrait illustrated here (see fig.49). His wife, a Circassian (Caucasian) whom he met in Persia, is shown in the companion picture (fig.50) holding a pistol and a watch, emblems of European technology, indicating perhaps the Shirleys' aspirations to be power-brokers between East and West. Later, artists themselves adopted Oriental costume when in the East, to enable them to move around and sketch less conspicuously. A European hat in the Middle East was often the primary sign of a Christian interloper, and as such plays a significant role in William Holman Hunt's *A Streeet Scene in Cairo: The Lantern-Maker's Courtship* (figs.5, 73), where in the background a top-hatted Englishman beats his way through the narrow Cairo street. This suggests Hunt's refusal, early on during his time in the East, to accommodate local expectations. The artist himself only adopted an Oriental guise – at least to the extent of growing a beard – as a precaution against the Arab pederasty which he and fellow Pre-Raphaelite John Everett Millais affected to fear in their letters to one another of this period.[12] Crossing over to local culture in this limited way in the cause of undercover observation retained a frisson of espionage. Henry Salt, British Consul at Cairo in the 1820s and a leading early patron of Egyptian archaeology, warned British women visitors against wearing local dress 'as being a species of disguise which rendered it

impossible for him to be responsible for the safety of those that wore it'.[13] (By the time that Thomas Cook was organising Oriental tour packages in the 1870s, comparable advice was standard.) Today, the image of the blue-eyed North European in Oriental costume still resonates, if in a darker fashion. Two widely read recent novels on the theme of East–West encounters, Orhan Pamuk's *Snow* (2002) and Khaled Hosseini's *The Kite Runner* (2003), share the feature of a 'fundamentalist' Islamic leader whose blue eyes seem to mark him, on some level, as a European in disguise, an *agent provocateur* perhaps.[14]

The principal couple of figures in Hunt's *Lantern-Maker's Courtship*, teenage fiancés flirting at the young man's shop in a Cairo market, behave entirely out of the character of modern Egyptians as described by Edward William Lane. Hunt quoted from Lane's *An Account of the Manners and Customs of the Modern Egyptians* in his catalogue note for the picture in 1861:

> The wearing of the burks [i.e. burqa], or face veil is common to all the respectable classes in Cairo. 'The bridegroom can scarcely ever obtain even a surreptitious glance at the features of his bride, until he finds her in his absolute possession.'[15]

The artist has shown how the lantern-maker, 'pressing his tawny fingers on the veil, *felt* the charms of the laughing girl, her nose, her lips, her chin, that he was forbidden to see'.[16] Hunt, who witnessed such a scene in Cairo, thus rather undermines Lane's authoritative text, or at least suggests that the artist's eye might

turn up evidence of its own, not merely illustrations to the scholar's account.

Hunt's painting, an allegory of the frustrated gaze, encapsulates the problem of European genre painting when transported to the Orient. This category of picture had traditionally been about domestic life, about family life in particular, and above all about relations between the sexes. If in the Middle East the sexes lived more segregated lives, and if Europeans had themselves been accustomed to exaggerate that segregation into a defining characteristic of the Orient, then genre painting was in trouble. Wilkie, the great talent in British genre painting of the early nineteenth century, felt acutely frustrated in Constantinople at not being able to find more picturesque subjects, before alighting on the sight of a pair of female clients of a public letter-writer (fig.62). The answer to this basic problem could only be to make more of male-only genre subjects, such as those in which Lewis specialised alongside his harem pictures. There, everyday social life is represented as a male affair. In the public, commercial spaces of the city, women are pressed to the edges, as for example the veiled figures discretely making their way through Lewis's *Bezestein Bazaar* (fig.77). When women do become the centre of attention in such a place, the result is not happy. They may be rudely interfered with (as in Hunt's *Lantern-Maker's Courtship*), embarrassed by disputes over their competence to transact business (as in Lewis's *The Seraff – A Doubtful Coin*, fig.75), or even become the commodities of the market themselves, as in the scenes of slave trading by William Allan, Jean-Léon Gérôme and others (figs.74, 126). Once the artists had got over their initial disappointment in the pictorial problems posed by gender separation, they evidently soon learned to make new narrative capital out of this very challenge.

The conventions of European landscape painting were equally challenged, disciplined and expanded through translation into the Orient. David Roberts was the pioneer here. Having to dispense with the formulae for generating landscape compositions defined in the seventeenth century by Claude, Rubens and others, Roberts turned to particular architectural monuments to structure his views, taking his eye up close to – even inside – the buildings, so that their forms would frame and compose the picture, not just supply the central motif, as in *The Ruins of the Temple of the Sun at Baalbec* (fig.93). When architecture was not the main focus, and natural landscape was the interest of the painter, the problem of framing the composition often led to the elongation of the picture: by stretching the image, the need for framing devices at the sides was in effect deferred. British Orientalist landscape painting had it seems an aspiration to the panoramic, and indeed Ali Behdad, in his book *Belated Travellers*, suggests that 'The tendency to have a wide angle of vision is symptomatic of the modern orientalist's fragmentation', that is, a fear of missing the meaning of the landscape led to a hoovering up of as much of it as possible.[17] The original panoramas – vast canvases turned into a circle to engulf the viewer, invented in Britain in the 1790s – often featured Oriental cities. The naturally and architecturally spectacular cityscape of Constantinople was an obvious choice for the panoramists, and indeed this was the first foreign city to be featured at London's Leicester Square panorama, in 1801. It may be that this sublime cityscape's peculiar absence from British Orientalist painting of the gallery type is to be explained by artists feeling that only the panorama could do it justice.

The portrait, the genre subject and the landscape were thus long-established categories of painting that might be put in to an Oriental gear. The harem, and religious subjects, however, were themselves inherently Oriental categories. It has become something of a cliché in writing about Orientalism to observe that these latter two themes have an etymological relation. *Harim* derives from the same Arabic three-consonant root as *haram*, meaning sacred, forbidden or enclosed, as in the Haram al-Sharif, the Noble Enclosure atop Mount Moriah (the Temple Mount) in Jerusalem, the former site of the first and second Jewish Temples, on which were built in the seventh century CE the Muslim structures of the Dome of the Rock and the Aqsa Mosque. In the work of most British artists, the harem and the mosque are represented as places of peace and order, in contrast to the cramped bustle of the streets and the awkwardness of life on the move between picturesque venues. Partly because so much fantasy and ignorance attached to British ideas about Middle Eastern domestic life and about Islam generally, the harem and the mosque were also, paradoxically in light of what has just been said of their inherently Oriental nature, the places where British artists most obviously superimposed their own image (we have already quoted Wilkie's vision of the harem as a Radical utopia). Male artists of course had very little opportunity to access the harem, which makes Henriette Browne's *A Visit: Harem Interior, Constantinople, 1860* (fig.112) so intriguing a candidate for authenticity. An exception however was Lewis, who married a young Englishwoman, Marian Harper, during his residency in Cairo and so for several years before his return to England was able to carry on his Oriental role-playing even to the extent of having his own 'harem', in which, we can only imagine, more or less English manners obtained. Marian certainly appears in Lewis's harem scenes painted back in Britain, just as the artist himself appears to be his own model in some of his works, including the *Interior of a Mosque, Afternoon Prayer* (figs.6, 168).

The final section of this book, on the theme of sacred places, is in keeping with the other sections insofar as it is also about the present appearance of the Holy Land and of sites of devotional significance elsewhere. We have not sought to tell the story of the revival and development of New Testament illustration in the nineteenth century for, although central figures such as Wilkie and Hunt went to the Middle East with the aim of painting such Christological works, their pictorial interests were deflected and broadened once they arrived there, and this process has been emphasised here. One component of British Orientalist painting – its historical, or biblical–historical aspect – has thus been edited out of the story told here, and so it may seem a rather circular process to go on, as I would now like, to claim

Fig.7
Dune
Cover of book by Frank Herbert
First published by Chilton Books,
Pennsylvania, 1965

Fig.8
Bethlehem *c*.1842
David Roberts after David Wilkie
Watercolour, 19 x 26.5
Private Collection

that British Orientalist painting had no real historical mode to speak of. The fact is that the artists rarely entered into history except via the biblical (even Ancient Egypt tended to appear primarily as the setting for Hebrew history). They sought the locales of New Testament narratives and Old Testament events (Christian tradition had long learned to interpret the latter as prefigurations of the former), but were generally badly disappointed in these efforts, coming indeed to despise the Eastern Christian denominations who preserved – so British tourists regularly complained – false sacred geographies in the Holy Land. These traditions were set aside in favour of a Protestant instinct to rely upon the evidence of the Bible alone. The best part of two thousand years of history had, it seemed, to be eliminated in order to access the religious truth of Palestine.

With that swathe of forgotten history also of course went the Muslim past. William Brockedon, one of the compilers of the texts that accompanied the hugely popular lithographs after Roberts's Oriental sketches, felt that although it was amazing that God had allowed Islam to take over the Holy Land, nevertheless, 'to us the history of her various Caliphs has little interest'.[18] Indeed one imagines that few if any of the artists in this book could have given an account of, say, the difference between Sunni and Shi'a Islam. (This was by no means a failing necessarily shared by literary British Orientalists such as Lane, although Robert Irwin has recently claimed that, besides Lane, 'There were no other British Arabists or Islamists of note in the early to mid-nineteenth century'.)[19] The philosopher Georg Wilhelm Hegel had said, in his *Lectures on the Philosophy of History* of the 1820s, that 'Islam has long vanished from the stage of history, and has retreated into oriental ease and repose'.[20] But to ignore Islamic history altogether was to go further and place that culture in a kind of chronological limbo, from which it might sporadically emerge, sometimes in hopelessly outdated 'medieval' guise,

at other times representing a fantasy of the future. In the latter mode, Jerusalem could, as we have seen, represent the political pilgrim's dreamed-of destination. In the twentieth century, Orientalist imagery might (rather bizarrely) inform the visual culture of science fiction (fig.7). On a political level, the expectation of nineteenth-century observers that the Ottoman Empire might self-destruct at any moment encouraged a future-tense mentality when considering the entire region, for the question of what would or should take the Empire's place seemed ever pressing.

A Chain of Witnesses

Earlier in this Introduction I described the tension within British Orientalist painting between, on one hand, the tendency of images to replicate themselves, to form traditions across the work of succeeding artists, and on the other, the urge towards unique authenticity that propelled painters to the East. Writing of the traditions of European textual Orientalist scholarship, the leading British historian of the Middle East, Albert Hourani, suggested a parallel between the sequence of master–pupil relationships through which Orientalist learning was transmitted (in the period before such learning was subsumed within the modern university system) and the Sufi notion of a *silsila* – a chain of initiates within a brotherhood reaching back into the earliest history of Islam.[21] Hourani notes the central, patriarchal position of the great French scholar A.I. Silvestre de Sacy within the European Orientalist *silsila*, but also suggests that the British philologists were to an extent outside this line of master–pupil descent. Equally, the London art world, in contrast to the French, had largely abandoned the master–pupil arrangement in favour of centralised academic tuition in the late eighteenth century. Nevertheless, during the first decades of British Orientalist painting we can observe the hesitant emergence of a *silsila*

Fig.9
Early Morning in the Wilderness of Shur 1860
Frederick Goodall
Oil on canvas, 97 x 305
Guildhall Art Gallery, City of London

among the professional artists.

Although David Roberts was by no means the first British draughtsman to depict the Middle East, he was the first distinguished professional painter to do so. The drawings resulting from his tour of the late 1830s were soon shown around fellow artists, and they were an inspiration for Wilkie's journey of 1840–1, from which as we have seen he never returned.[22] During Wilkie's travels, the sites he passed regularly brought Roberts's drawings to mind, for example at Bethlehem.[23] After Wilkie's death, Roberts in turn worked up Wilkie's own sketch of Bethlehem into a finished watercolour (fig.8). Already we have an image taking on a life of its own across the work of two artists who were ostensibly independent witnesses. Wilkie, although the senior of the two, was in a sense Roberts's first Oriental follower. But Roberts's next attempt to pass on the baton was to a promising younger man, Richard Dadd, whom he recommended to Thomas Phillips.[24] Dadd's journey, however, like Wilkie's, ended tragically, and Roberts was again left without an heir. Hunt set out for his first visit to the East in 1854 with a religious mission really little different to Wilkie's. However, he deliberately neglected to refer to the obvious precedent set by Wilkie, explaining his ambitions instead in terms of the Pre-Raphaelite ethos of confronting the intricate visual truth of the world without compromise. It was not until 1860 that the chain was re-made with the very well-received appearance at the Royal Academy of Frederick Goodall's huge *Early Morning in the Wilderness of Shur* (figs.9, 90). Goodall had gone out to Egypt in 1858 bearing letters from Roberts, his early friend, and Goodall records his delight that Roberts himself was one of those to grant their approval to the painting. The heir had appeared not a moment too soon, as Roberts's Orientalist swansong, his final reprise of the ruins of Baalbek (fig.93), was shown the very next year (this as it happens was purchased by the same collector who bought Goodall's picture, Duncan Dunbar). Goodall's talent, however, was not such that he could sustain variations on his Egyptian themes over the years without falling flat. He became narrowly repetitious, and was the model for several unimaginative emulators in the decades before the First World War. Although the term Orientalist was not frequently used in the nineteenth century of British painters, Goodall's specialisation meant that in his case the label stuck.

Repetition and specialisation were also qualities of a much greater painter, Lewis, who stands proudly aside from anything like a tradition in British Orientalist painting. When he and Roberts were both working in Spain in the early 1830s, Lewis had it seems deliberately avoided his colleague, and again, in the 1840s, as Roberts's Oriental work reached an ever greater and grander audience, Lewis remained professionally silent in Cairo. He returned only after the staggering impact made by his *Hhareem* (fig.137) in 1850, nonchalantly cutting across any notion of indebtedness to assume, as if from nowhere, the rank of master Orientalist painter. Lewis rarely had much to say for himself. His letters are few and brief, as are most references to him by contemporaries, and as a result he is perhaps the most important Victorian artist never to have been the subject of a full biography. When, having been elected President of the Society of Painters in Water Colours in 1855, Lewis had to stand to address a dinner attended by his members, the great painter of Cairene life found himself unable to utter a word and could do nothing but sit down again, confirmed in his silence (he resigned in 1858).[25] The art critics of Victorian London found themselves similarly embarrassed when setting out to give an account of Lewis's work. It was beautiful, it was almost unbelievably intricate in execution, its colours and textures oozed preciousness.[26] But having praised these qualities, which were ever present, year in year out, what more was there to say? Nothing very much seemed

to be happening in Lewis's pictures, or at least there was rarely an easily legible narrative. The regularity with which the artist served up these exquisite, unexplained images eventually left even the critics speechless. Through Lewis, we might say, the Victorians learned that the modern Orient should be seen but not spoken of.

Lewis has often been portrayed as a precursor of the Aesthetic movement, the link between the English picturesque watercolour tradition and the pale, quiet beauty of a world such as that evoked by Albert Moore. He might also be seen as a prophet of Decadence, for the degree of work in Lewis's pictures sometimes seemed so excessive as to represent almost a decadence of labour, just as the condensed packing in of pictorial matter into his works suggested a coagulation of material, an exhaustion of beauty.[27] This idea of Lewis 'using up' the picturesque tradition is paralleled by the way other, more robust Orientalists played out the last act of another fundamental tradition within British painting which, for want of a better word, we must call the Classical: the methodical (perspectival) rendering in a picture of three-dimensional plastic forms. In France, avant-garde painting developed through the process of abolishing this practice in favour of an emphasis upon the subjectivity of vision, upon painterliness (non-linearity) and upon the necessary flatness of the picture plane. Thus in Paris, Orientalism became the *bête noire* of the Modernists for, if attending to modern everyday life and to the picture surface were now to be the duties of the painter, eloping to Algeria or Turkey appeared irresponsible. It seems to have been the critic J.A. Castagnary, a friend of Charles Baudelaire, who helped the word Orientalism into currency in the context of painting as a term of abuse for those who would 'abscond from the world around them'.[28] In London there were comparable tensions, Dante Gabriel Rossetti high-handedly ruling in 1862 that 'all the things that artists brought from the East were always all alike and equally uninteresting', thus helping cement the radical difference between his and Hunt's versions of Pre-Raphaelitism.[29]

What the Orient offered the Classical mode of painting was, quite simply, a future. To begin with, the Eastern Mediterranean presented a newly expanded version of the historical Greek and Roman world. The rediscovery in the 1750s by Europeans of Palmyra in Syria and Baalbek in Lebanon had been foundational in the development of Neo-Classical design, but the Oriental location of these sources was generally obscured by their being subsumed into an idea of Graeco-Roman style. The inclusion now in British visual culture of the sites themselves helped move the geography of Classicism away from a Eurocentric bias and back towards a shape closer to the actual limits of the Ancient Roman Empire (if ultimately only to reassert European cultural hegemony over that extra-European territory). For the artist, the Middle East offered an array of magnificent, brilliantly lit monuments – Ancient Egyptian, Roman, Byzantine, Islamic. Because such sites, and the landscapes between them, were distant and still relatively little visited by British tourists, what the painters reported of

them was not easily verifiable by their audience. Thus Orientalist pictures insisted on their subject matter's concrete actuality, but also demanded a leap of faith on the part of the viewer to accept their veracity, a leap which those who wanted to continue believing in the representational power of art longed to make. So, the defining virtue of Goodall's *Wilderness of Shur* was said to be its 'solidity', while the *Art Journal* declared of the same painting that 'We approach the work with a conviction of its unimpeachable truth in every item of its principal and accessory features'.[30] This suggestion of the viewer physically approaching, even passing into, the Orient through faith in the transparency of the image underlines a key element of the Classical picture, its inclusion of the viewer in its purported field. As subjective Impressionist, and visionary Symbolist tendencies undermined the Classical model of art in Europe, the Orient offered to that model a new habitat where it might continue to evolve and be of use.[31] This survival is, in the end, what the Orientalist picture 'wanted', although it could only ever have hoped for a stay of execution. After the full impact of Post-Impressionism on British art in the 1910s, the kind of picture-making with which this book is concerned comes to an end. Faith in the transparently truthful painting was no longer sustainable. Although some of the most significant British Modernist painters, such as Stanley Spencer (see fig.172) and Wyndham Lewis, were occasional Orientalists, the needs of the picture had changed: it no longer required to be fed with remarkable wordly experience.[32] British Orientalist painting as a professional category expired after the First World War, after eighty years of representing the region that British armed forces now occupied.

Looking Back

An especially interesting aspect of recent thinking about Orientalism has been the question of what Middle Eastern people felt about, how they replied to, Europeans' images of them.[33] In fact, a preoccupation with this question was already central to European Orientalist visual culture itself. The assumption was that Islam forbade the making of, and looking at, images of the human figure. But while this proscription is certainly well attested in theological tradition, it was an Orientalist assumption that theological tradition dictated all Middle Eastern culture.[34] The powerful had long been able to ignore the 'ban', as the great traditions of Turkish, Persian and Mughal painting make evident, and rulers themselves indulged in art, up to and including the Persian Shah Nasir al-Din who filled sketchbooks while on a visit to London in 1889, and the Ottoman Crown Prince Abdul Mejid II (the last person to bear the title Caliph) who exhibited paintings in Paris.[35] These were examples of elegant accomplishments, however. The use of mass-produced images for political purposes, to strengthen the personality cult around the ruler, was learned from the West only at the turn of the nineteenth century: seen against this new initiative, 'superstitious' iconophobia takes on a potentially democratic aspect. In 1806 Sultan Selim III commissioned the London engraver John Young to reproduce a corpus of

Ottoman dynastic portraits painted in Constantinople, but was overthrown before the work was done. Young finished it anyway on his own account, and his series of prints went on to found the iconography of the Ottoman sultans for much of the rest of the nineteenth century.[36] The sultans' early nineteenth-century Egyptian rival was not to be outdone. Leafing through Gaston Wiet's 1949 book, *Mohammed Ali et les beaux-arts*, the reader gets the impression that no artist visiting Cairo at this period was allowed to leave the country until the Pasha had sat to him.[37] In the 1920s and 1930s, Middle Eastern iconoclasm had in its sights the motifs of Orientalism themselves, not Western art, as the new Turkish Republic banned the veil and then the fez, while in Reza Khan's Iran it was even frowned upon to photograph camels, that classic sign of Oriental lethargy.[38]

What the visiting European painters had wanted, of course, was to feel the impact of their looking upon the Orient, to feel their gaze flexed as it captured sights that did not easily give themselves up. This rendered the motif all the more solid. In Gavin Hamilton's *James Dawkins and Robert Wood Discovering the Ruins of Palmyra* (fig.10), we see one of the Arab guides frowning disapprovingly at the explorers' artist, Giovanni Battista Borra, as he sketches the newly revealed ruins. Hunt encapsulated this mentality when he recalled of his visit to Hebron (al-Khalil, site of the supposed tomb of Abraham) in Palestine in 1854 that he had 'felt tantalised at the restrictions imposed' on his looking, and we have already seen that his *Lantern-Maker's Courtship* was an allegory on precisely this theme.[39] For the Oriental person to become an appropriately challenging impediment to the gaze, it had to be assumed that she or he could not understand the Classical European image, and indeed the inability of non-Europeans to grasp pictorial perspective is a leitmotif throughout Orientalist history. There are however all kinds of examples, predictable and unpredictable, of Middle Easterners responding to and recycling Western images, to be found across the period covered by this book and beyond. Thus (it has been claimed) the Egyptian army, defeated by Israel in 1967, distributed among its troops a reproduction of G.F. Watts's allegory of *Hope* as an emblem of national perseverance, and in 1974 (the year following another Arab–Israeli war) the same image was issued as a postage stamp in Jordan.[40] Since the 1970s, British Orientalist paintings have been collected by art lovers in the wealthy Gulf region, buying into a shared Arab history created by European artists. Economic and political power, or the lack of it, still guides Middle Eastern reactions to the beauties of Western painting to a greater extent than religion. The British graffiti artist Banksy tells a story of his visit to Israel and the Palestinian Territories in 2005 to paint ironically perspectival interventions upon the security wall then being built to mark the boundary between the two.[41] The artist is approached by an elderly Palestinian:

> *Old man:* You paint the wall, you make it look beautiful.
> *Me:* Thanks.
> *Old man:* We don't want it to be beautiful, we hate this wall, go home.

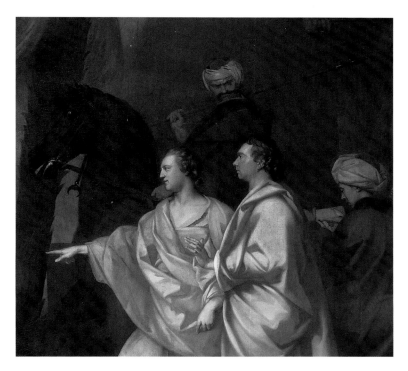

Fig.10
James Dawkins and Robert Wood Discovering the Ruins of Palmyra
1758 (detail of fig. 51)
Gavin Hamilton
Oil on canvas, 309.9 x 388.6
National Gallery of Scotland, Edinburgh

CULTURES CROSSED: JOHN FREDERICK LEWIS AND THE ART OF ORIENTALIST PAINTING

EMILY M. WEEKS

Disorientation

In the Bezestein, El Khan Khalil, Cairo, also known as *The Carpet Seller*, should be one of John Frederick Lewis's most straightforward pictures (figs.11, 54).[1] There is nothing, initially, to disturb or unsettle the viewer: the title identifies the subject and the setting, and the details of the composition, in turn, reflect the title.[2] After a few minutes of consideration, however, the tightly knit surface of Lewis's painting begins slowly to unravel. The face of the aged gentleman looks vaguely familiar – indeed, it is the same white-bearded countenance as in some of Lewis's later works, *An Intercepted Correspondence* 1869 most conspicuous among them (fig.20). It seems familiar, too, due to its uncanny resemblance to the distinguished artist himself, as he was portrayed in two photographs taken at about this same time (figs.12, 13). So striking are the similarities between the artist's appearance and the painted subject, in fact, that it is curious that this connection was not made by any of Lewis's contemporaries.[3]

The carpet seller of the picture's title sits on a low stool, which is barely discernible underneath the billowing folds of his blue trousers. The whiteness of his closely clipped beard and moustache is echoed by his loose-fitting shirt, spotless socks and expertly wrapped turban. Solid and pyramidal, he faces the viewer in an almost confrontational posture, an impression reinforced by the firm grip he has on the sword resting across his thighs.[4] The pointed tips of the carpet seller's red slippers are turned upwards and outwards, as if he is impatient with – or even, perhaps, exasperated by – the situation at hand. His eyes, buried beneath thick eyebrows, lock into the gaze of whoever stands before him. 'Well,' he seems to ask, 'What do you make of me?'

A brilliant white cloth, edged with gold, red and midnight blue, has been draped across a *mashrabiyya* (turned-wood)

partition behind the merchant. The starkness of the fabric recalls those used for photographic backdrops and here functions similarly, serving to separate the figure from the bustling market scene behind him. The sharp division between foreground and background is in fact an awkward one, a criticism rarely made of Lewis's generally seamless compositions. The glimpses of open stalls filled with colourful wares, the clusters of shoppers milling about under latticed windows, and the overhanging eaves of recently whitewashed buildings seem part of a different world.[5]

In the details, however, Lewis is at his best. Curled orange peels lie scattered about the carpet seller's feet, beside shards of a broken blue and white dish and, to the right, a sleeping dog. To the left, on a carpet-covered *mastabah* (low raised platform), a bill or account has been placed, suggesting that a business transaction is in progress. Further reminding us of the carpet seller's livelihood are the Oriental carpets and colourful fabrics surrounding the seated figure. They hang over railings and wave above the heads of distant groups of conversing men like celebratory banners. The cloth of these men's turbans is rendered with the precision of a confident and well-instructed artist. Different colours signify each man's religious sect or status in the diverse urban community of mid-century Cairo.[6]

Such incidental details are delightful, visually seductive and ultimately distracting. In the process of searching them out, the intellectual inconsistencies and sophisticated allusions consciously embedded in Lewis's Orientalist works are easily missed. Rather than a polished surface, perfect in every calculated and thoughtfully placed detail, each picture in fact offers a distorted and unsettling view of contemporary life, the geographic specificity of which becomes a matter of some debate. A re-examination of *The Carpet Seller*, for example, might inspire more probing questions. Is this an ethnographic

Fig.11
In the Bezestein, El Khan Khalil, Cairo (The Carpet Seller) 1860
John Frederick Lewis
Watercolour, 33.5 x 26
Blackburn Museum & Art Gallery

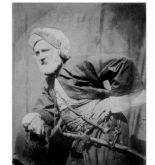

Fig.12
John Frederick Lewis in Oriental Costume
Undated photograph
Private Collection

Fig.13
John Frederick Lewis in Oriental Costume
Undated photograph
Trustees of the Royal Watercolour Society

document, objective in every detail? Or is it a self-portrait of the artist? Is it Lewis who is the vendor of wares, the merchant of hand-crafted goods, the metaphorical 'carpet seller'? Did he wish to present himself at this time – at the peak of his career – as an indignant victim of the marketplace and the capitalist society that drove it? Or did Lewis, in his elaborate guise and outward stare, intend the surface of his canvas to act as a mirror for his acquisitive viewers? Did he challenge them to question their own professions, their own practices and self-proclaimed morals, as they pulled out their wallets and settled their bill of sale? Were *they* the unsuspecting victims of a carpet seller – or perhaps a version of the vendor themselves?

Lewis's painting, though part of what is arguably the most sophisticated intellectual project in British Orientalism, is not unparalleled in the genre.[7] In the complexity of its surface and its ambiguity of meaning, *The Carpet Seller* can be seen as representative of the highly fraught nature of Orientalist art in general. For, despite the polemical and political interpretations that many Orientalist works have attracted in recent decades,

and though the genre has consequently become the most presupposed and predetermined in all of British art, these paintings have in fact much left to tell. Criticisms levelled against British society, once glossed over, await revelation; personal narratives, experiences and idiosyncrasies, long ignored in favour of an examination of broader imperial designs, look forward to articulation; and, perhaps most importantly, genuine moments of cross-cultural understanding, respect and commemoration have yet to be restored to the historical record. To better understand the reasons for the belatedness of this interpretive revisionism, and its inestimable value, it is first necessary to trace the historiography of Orientalism and, next, to look at another, seemingly transparent picture by Lewis, entitled *A Lady Receiving Visitors (The Reception)* (figs.15, 128). In so doing, the narrow lens through which we have grown accustomed to viewing Orientalist art will change, and a wider, far more interesting, view will take its place.

Orientalism

In 1978, Edward W. Said published his most famous and highly influential work, *Orientalism*.[8] Though the word 'Orientalism' had

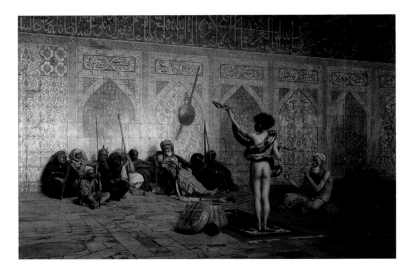

Fig.14
The Snake Charmer *c.*1880
Jean-Léon Gérôme
Oil on canvas, 84 x 122
Sterling and Francine Clark Art Institute, Williamstown, Massachusetts

originally meant something very specific in terms of British policy in India in the last quarter of the eighteenth century, and had long been used as a benign descriptor for such eighteenth- and nineteenth-century scholars and linguists as Sir William Jones and Edward William Lane, the controversial argument within Said's text would forever redefine it.[9]

Said used 'Orientalism' to refer to a hegemonic European strategy intended to dominate, restructure and gain authority over those peoples and nations known collectively as 'the Orient' or 'the East'.[10] In Said's formulation, Orientalism was at once 'a style of thought based upon an ontological and epistemological distinction made between "the Orient" and "the Occident"' and 'the corporate institution for dealing with the Orient … by making statements about it, authorizing views of it, describing it, by teaching it, settling it, ruling over it'.[11] This system of oppositional nomenclature, Said continued, in which a monolithic 'East' was pitted against a monolithic 'West', introduced an insidious new vocabulary to the international community, in which an imbalance of power between two 'irreconcilably different' terms was consciously and unconsciously accepted.

Initially, art historians attempted to extract themselves from the inflammatory debates engendered by Said's text. In 1982, Donald Rosenthal published his own book called *Orientalism*, the introduction of which made his nonpartisan position clear: 'In this study, French Orientalism will be discussed in terms of its aesthetic quality and historical interest and no attempt will be made at a re-evaluation of its political uses.'[12] What Rosenthal and other art historians were in effect proposing was that art should be seen as occupying an independent, aesthetic realm, immune to the infections of political knowledge and power. It was Rosenthal's remark about the threat of political influence in the discipline, in fact, that inspired Linda Nochlin to write 'The Imaginary Orient' one year later, an article that

stated a radically different view: art historians, Nochlin argued, needed – indeed, *had* – to consider the political motivations, meanings and consequences of artists and paintings, as well as the particular power structures that circulated around them. To do otherwise was, in Nochlin's view, academically (not to mention morally) irresponsible.[13]

After the publication of Nochlin's essay in 1983, a wealth of books and articles appeared in the field of art history reiterating the need to hold painters politically accountable for their visual texts. Though it was probably never Said's intention, the unfortunate grammatical intersection of the discourse he called Orientalism with the genre of Orientalist painting, or those European paintings of foreign – especially, now, Middle Eastern – subjects, led to an immediate and shared understanding that the two must be conceptual equivalents as well. Individual artists, techniques and compositional details seemed to matter less to scholars of this genre than the transcendent and universally corrupting world view that so obviously now informed them.

Perhaps because one of his pictures was chosen for the cover of the paperback edition of Said's book, Jean-Léon Gérôme's scientific, almost clinical mode of painting quickly became a *locus classicus* of artistic imperialism. Art historians argued that Gérôme's pseudo-documentary style should be regarded as the physical and literal style of imperial rule and colonial administration: the polished, pristine surface of a picture such as *The Snake Charmer*, for example, could not disguise its sordid imperialist agenda (fig.14). The architectural details that Gérôme has recorded are in fact an incoherent jumble, supposedly like the Middle Eastern culture from which they were drawn; insidious compositional devices such as crumbling walls and peeling paint are used to convey a sense of cultural and social decay; a snake and a naked boy intertwine in a fantastic dance that can only be meant to suggest the homoerotic tendencies and moral decadence of the region.

Critics in other academic disciplines, however, also increasingly preoccupied with the politics of their subject matter, soon discovered that such polemical interpretations and facile assumptions could not so easily be made. Once touted as brilliantly incisive, Said's text was now regarded as a deeply flawed interpretive tool and an inappropriate means by which to judge an expressive end. It was, some scholars asserted, ahistorical, gender-blind, inductively reasoned and ambiguous. Issues of class were ignored, as were specific political economies and local social circumstances; it vacillated between truth and ideology; its use of theory was eclectic; the influences of the mass media and popular culture were nowhere acknowledged; and, most detrimental to the tenability of Said's argument, the divisive language at the heart of *Orientalism* (that is, West versus East) was proving too simplistic and essentialist a vocabulary for confident usage.[14]

In sharp contrast to the theoretical advancements made in other academic disciplines, however, art history has been singularly reluctant to work through the faults of Said's

Orientalism and develop more nuanced lenses through which to view the Orientalist paintings that are still, by the unfortunate coincidence of terminology, believed to reflect its tenets.[15] Though it would be impossible (and foolish) to deny that instances of Said's brand of Orientalism existed in the visual arts, the continuation of such widespread interpretive confidence on the part of art historians – and the public who rely on them – is disturbing. Not only does it predetermine conclusions and preclude more subtle analyses of often very different artists and pictures, but it also allows the misdiagnosis or dismissal of situations, experiences, peoples and objects that are not complicit with Said's paradigmatic framework. Indeed, and as I mentioned earlier in this essay, I would like to suggest that Lewis's fractious placement in the conventional scenario – a case that I will now make more explicitly – might be true of all painters who share the loaded descriptor 'Orientalist'.

A Case Study

In 1873, more than two decades after his return to England from Egypt, Lewis painted *The Reception* (figs.15, 128).[16] Though this is the title by which it is known today, the picture was in fact first exhibited at London's Royal Academy under the more descriptive title *A Lady Receiving Visitors: The Apartment is the Mandarah, the Lower Floor of the House, Cairo*. Its composition was simple: a spacious room in an ornate Ottoman house, rendered in sharply receding one-point perspective, with several figures within. The meaning of the picture, however, has proven more difficult to summarise.

As in each of Lewis's works, it is the details of the picture surface that begin to tell a fascinating story. The room in *The Reception* is depicted as having three recessed bays, high ceilings and an open expanse of floor that occupies the entire bottom half of the panel. Sunlight floods this interior space, streaming in through *mashrabiyya* window screens and dissolving much of its contents into dazzling geometric patterns. In the centre of the room is a sunken reflecting pool, its marble borders inlaid with coloured stones. It contains a small but elaborately carved conical fountain. A wooden ceiling, brightly painted, and plain wooden structural beams complete the setting architecturally.

The lady of the house is placed just right of centre, in the middle recess of the room. She is draped languorously across a brilliant blue couch or divan, an attendant before her. This female servant gazes distractedly beyond the limits of the picture plane, a fan of feathers hanging at her side. As in so many of Lewis's pictures, the look outward serves to collapse the boundaries between the viewer's space and that which the figure occupies. To the left of these two women, a row of male and female attendants waits expectantly. They crane their necks towards the central pair, some almost doubled over in anticipation and enthusiasm. Each of them is dressed in vaguely Egyptian clothing: they wear long robes, gathered pants, head-shawls, a *fez* (red hat). The colours of their garments are reflected in those of the stained-glass windows above. On the right-hand

side of the picture, a young woman kneels at the edge of the pool, a gazelle beside her.

The detail with which these figure groups is rendered is almost overwhelming in its profusion, and the impression of ornamental excess is profound. But Lewis maintains a sense of order, clarity and visual coherence through the clear grid of strong diagonal, horizontal and vertical lines upon which the composition is built and into which each figure is securely placed. Convincing perspective and the illusion of brilliant sunlight, moreover, lend to the picture an air of overt frankness and, even, in an unexpected reference to religious iconography, a form of truthfulness that verges on the divine.[17]

Lewis's intimation that *The Reception* was an actual moment in time, an event witnessed and honestly recorded by the artist, seems also to inform his treatment of the attending female figures. These young women – all sumptuously but decorously dressed – demonstrate various forms of etiquette appropriate to members of nineteenth-century Egyptian society. Obedient, organised and mindful of their place, they contain their enthusiasm in the receiving line in which they stand with well-rehearsed control. Despite contemporaries' beliefs about the iniquities of the region, then, and of its women in particular, this Egyptian domestic situation is presented as being as exquisite and pure as the manner in which it was painted.[18]

The physical and symbolic relationships between furnishings and social practice in Egypt were of the utmost importance at this time, particularly with regard to those concerning women and the home. Lewis was highly conscious of this, and used his cultural knowledge to enhance the sense of respectability already conveyed by the formal geometry of the scene. The position of the central female figure, for example, draped across the blue divan, alludes correctly to contemporary Egyptian custom. The chief lady of the house (usually the first or principal wife in the harem) was always granted this privileged situation due to her exalted status among members of a gathered party.[19] So, too, the fan held by the attendant figure is an appropriate accoutrement for a respectable Muslim woman: it would have protected her from the elements as well as from strangers' glances. Finally, the gazelle in the lower right-hand side of the picture was a common house-pet of the Egyptian upper classes in the nineteenth century. Indigenous to the country, these animals had long been endowed with symbolic connotations.[20] Most commonly, they were regarded as poetic symbols for Middle Eastern women. Indeed, that a woman had the eyes of a gazelle was one of the greatest compliments she could receive.[21] Such details lend to Lewis's picture not merely additional evidence of its authenticity, but a compelling impression of the venerable traditions that stand behind the events that are unfolding.

That Lewis would exhibit such precision in *The Reception* and such a sophisticated understanding of Middle Eastern – particularly Egyptian – social mores would not have surprised his British audiences in 1874. The artist's remarkable intimacy with this region had been established years earlier with the publication of *Notes of a Journey from Cornhill to Grand Cairo* (1846) by William

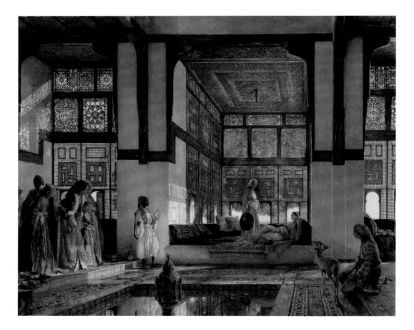

Fig.15
A Lady Receiving Visitors (The Reception) 1873
John Frederick Lewis
Oil on wood, 63.5 x 76.2
Yale Center for British Art, Paul Mellon Collection

Makepeace Thackeray. In this humorous account of the author's travels with the Peninsular and Oriental Steam Navigation Company, Thackeray had described being reunited with his old friend Lewis in Cairo, in the grand house he now occupied. There he found not the London man-about-town he had once known, but a 'languid Lotus-eater' who led the 'dreamy, hazy, lazy, tobaccofied life' of a privileged Turkish bey. Lewis, like his wealthy Muslim neighbours, had taken on several servants and a talented Egyptian female cook (about whose other household roles Thackeray teasingly speculated). In addition to abandoning all European manners and customs, Lewis had adopted new sartorial habits as well. He wore a 'handsome grave costume of dark blue … consisting of an embroidered jacket', trousers which, Thackeray noted, 'would make a set of dresses for an English family', and sported a 'Damascus scimitar on his thigh'.[22] This vivid textual description of Lewis's attire was reinforced years later through the circulation of carefully staged photographs of the artist, which mimicked the details of Thackeray's text almost exactly, and which we have seen before (figs.12, 13).

Such literary and visual documentation of Lewis's newly adopted lifestyle was highly compelling in the eyes of contemporary British audiences, and had a profound impact on the way in which his pictures were received. Some critics began to refer repeatedly to Lewis's dependable knowledge of even the most intimate moments of Egyptian domestic life, and spoke in enthusiastic terms about the value of such pictures for the armchair traveller. The artist and poet Edward Lear (widely admired for his own depictions of the Middle East: see figs.100, 102, 103) summarised the views of his compatriots

eloquently, when he penned the following words one year after the *The Reception* was exhibited:

> There never have been, & there never will be, any works depicting Oriental life – more truly beautiful & excellent – perhaps I might say – so beautiful & excellent. For, besides the exquisite & conscientious workmanship, the subjects painted by J.F. Lewis were perfect as representations of real scenes & people.[23]

The terms of Lewis's popularity were not lost upon this most market-savvy of artists. Lewis's own reputation, which had so declined during his years abroad that its restoration seemed unlikely, soared to new heights in the wake of Thackeray's account. Lewis, now the darling of the Victorian art world, was elected President of the Society of Painters in Water Colours in 1855 and, once he had decided to paint exclusively in oils, a Royal Academician in 1865 (he had been elected an associate RA in 1859).[24] To further capitalise on the intriguing persona that Thackeray had created, and despite such professional accolades, Lewis abandoned his old habits of social visibility and retreated with his new wife to an elusive and, in the words of one visitor, *Arabian Nights*-like existence outside London's metropolitan centre, in Walton-on-Thames, Surrey.[25] There, Lewis focused exclusively on his highly wrought pictures of the Middle East, keeping in mind both the public's desire for new and reliable information about this increasingly well-documented region, and the singular vantage-point that he was now believed to possess. His decision to concentrate on scenes of the harem proved an especially shrewd one, as this subject continued to captivate even the most informed and oversaturated members of his viewing public.

Perceptions about the harem, and the activities that took place within it, had been formed long ago in Britain, notably through the writings of Lady Mary Wortley Montagu (see fig.57) in the mid-eighteenth century. Her colourful, first-hand accounts of fashionable women's daily life in Turkey, published in 1763, began to fill in the tantalising blanks that had previously existed in the public's imagination, due to the gendered exclusivity and sacrosanct nature of the world in which they lived. Fuelled by such pioneering documentation, artists began to depict harem life with a growing confidence and in a more convincing manner, establishing the subject as firmly in the artistic record as in the literary and historical. Indeed, several motifs and events became conventional – even predictable – features within the genre. J-B. Vanmour's *Reception in a Turkish Harem* (between 1725 and 1737), for example, bears a striking resemblance not only to Montagu's own descriptions of this customary event and to the other, contemporary pictures that it inspired, but also to the overall composition of Lewis's scene of a reception.[26] Though Lewis has broken the symmetry of the eighteenth-century oil painting, grouping his figures on the left-hand side, he retains the emphasis

on windows, fountain and pool. So, too, though Lewis shows the women in his picture unveiled and more clearly distinguished one from another through their postures, countenances and accessories, in each painting the hostess is (literally) couched in the central section of a large, airy room. What separates Lewis's picture from Vanmour's most dramatically, however, are the self-conscious contradictions that it contains. Though the brief examination of *The Carpet Seller* has well prepared us for the sudden conceptual shifts that occur in Lewis's pictures, and for their visual and intellectual ambiguities, tensions and inconsistencies, the boldness of these gestures in *The Reception* comes as something of a surprise.

Lewis's subversive play between authenticity and implausibility can best be appreciated when the original title of the painting, and not its more recent referent, is remembered. Lewis first exhibited *The Reception* as *A Lady Receiving Visitors: The Apartment is the Mandarah, the Lower Floor of the House, Cairo.* The word *mandarah* identifies the setting of the picture as precisely as possible, an added detail that at least a section of Lewis's audience would have appreciated. Amateur ethnologists and dedicated Egyptophiles had become familiar with the term through its explication in *An Account of the Manners and Customs of the Modern Egyptians*, by the central early Victorian authority on modern Egypt, Edward William Lane:

> In general [in private houses in Cairo], there is, on the ground-floor, an apartment called a 'mandarah,' in which male visitors are received. This has a wide, wooden, grated window, or two windows of this kind, next the court. A small part of the floor, extending from the door to the opposite side of the room, is about four or five inches lower than the rest … In a handsome house, [it] is paved with white and black marble, and little pieces of fine red tile, inlaid in complicated and tasteful patterns, and has in the centre a fountain … which plays into a small, shallow pool, lined with coloured marbles, &c., like the surrounding pavement.[27]

Lane's vivid textual description was, in characteristic fashion, complemented by several wood engravings after drawings by the author.

Due to its unflagging popularity, *Modern Egyptians* had been republished by the well-established firm of John Murray in 1871, just two years before Lewis's picture was painted and three years before it was exhibited publicly. The close connections between the room named and described in Lane's text and that shown in *The Reception* may therefore have been recognised at this unique moment of historical intersection. The startling discrepancy between words and image would surely have been recognised as well: while Lane's definition of a *mandarah* had suggested the masculine nature of this space, Lewis portrays it as an explicitly feminine domain. Lane had even gone on to clarify the strictly enforced gendered geography of Islamic homes by describing and illustrating, in meticulous detail, those more

private spaces above the *mandarah*, which women were allowed to enjoy. Lane's account of the grandest of these rooms, the *qaʻa*, would in fact have seemed the more likely model for Lewis's own composition (see fig.16). The characterisation of the *qaʻa* by Lane as a 'noble saloon' and its clearly articulated function as a 'lofty' upper apartment in the harem, or women's quarters of the house, as well as its nearly identical architectural elements, would have made it a far more appropriate setting for Lewis's distinguished gathering.[28]

Such direct quotations would not have been perceived as exceptional or problematic in the nineteenth century – except, as I will soon argue, in Lewis's case. The popularity of Lane's *Modern Egyptians* among many of Lewis's colleagues, and their eagerness to put its text and 124 illustrations to use, is well documented. In 1843, for example, William James Müller had exhibited his *Prayers in the Desert* (fig.18) at the Royal Academy to great critical acclaim. The figures were painted from models dressed up in costumes Müller had brought back from Egypt in 1839, and were posed according to illustrations in Lane's book (fig.17).[29] Also drawing from Lane's book was William Holman Hunt's *A Street Scene in Cairo: The Lantern-Maker's Courtship* (fig.73). Hunt's picture, one of several of his scenes of Middle Eastern life, was even exhibited at the Royal Academy in 1861 with a quotation from Lane in the catalogue. Lewis's use of *Modern Egyptians* stands fundamentally apart from these examples, however, even in the profoundly intertextual milieu of the Victorian art world.

For many of the artists cited above, Lane served as a guarantee of accuracy, aiding both the memory of the artist and quieting the doubts of a discerning public. Although each artist had travelled through the countries they purported to document, and had presumably witnessed, at one time or another, their subjects first-hand, their cultural expertise was not self-evident. But Lewis's case was different. Both he and Lane were considered experts in all facets of modern Egyptian culture; even, by the 1870s, foremost in the field. Each had lived for extended periods of time in Cairo and had embraced a 'native' identity while there.[30] The two men had been friendly, on at least some occasions, and had exchanged correspondence in Cairo that made their familiarity with both the trials and tribulations of local daily life and the Arabic tongue abundantly clear.[31] In 1853, moreover, Lewis had exhibited *The Hhareem* (fig.137) at the Royal Scottish Academy, with a descriptive tag that made his appreciation of the intricacies of gender prescriptions surrounding Islamic architecture abundantly clear. The scene, Lewis had explained, took place not in the lower part of the house, as this was 'always appropriated to the men', but in the 'upper or women's apartments'.[32] This was a matter not of learnedness versus naiveté, then, or of shifting historical circumstances, but one of conception, intention and, perhaps, contradictory artistic missions.

Though unconventional in the Lewis scholarship, which often takes for granted the veracity of this artist's visual statements, the jarring comparison of Lane's text with Lewis's

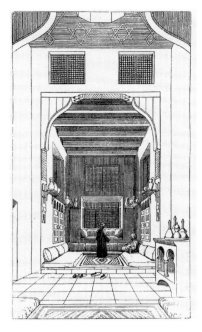

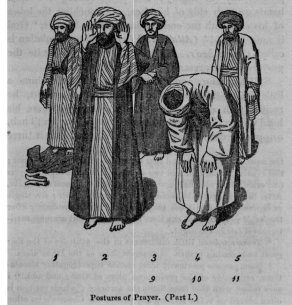

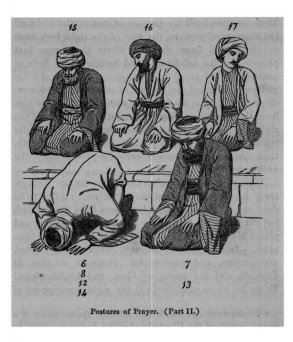

Postures of Prayer. (Part I.)

Postures of Prayer. (Part II.)

Fig. 16
Qa'a
Edward William Lane
from *An Account of the Manners
and Customs of the Modern Egyptians*,
London 1836
The British Library, London

Fig. 17
Postures of Muslim Prayer
Edward William Lane
from *An Account of the Manners and
Customs of the Modern Egyptians*,
London 1836
The British Library, London

picture is a useful and revealing one. As even the most cursory glance at *Modern Egyptians* demonstrates, Egyptian society was for Lane a kaleidoscopic array of facts and figures, which could, through painstaking research and characteristically Victorian hard work, be deciphered, defined, logically categorised, and presented objectively and coherently for the benefit and enrichment of the world at large. In such a format, the *mandarah* could have only one simple, strictly functional, definition: it was a public space of entertainment and reception on the first floor of an Islamic house, in which a man received his male visitors. This was the time-honoured purpose of the room, and this was therefore the end of Lane's concern with it.

Lewis's purpose in *The Reception*, on the other hand, was not that of Lane, as his playful reversal of a *qa'a* and a *mandarah* indicates. His objective was not to provide a scholarly definition of an Arabic architectural term, but was, instead, through a subtle transposition of women, to offer the more astute members of his viewing audience a knowing, even tongue-in-cheek, manipulation of the most basic characteristics of Muslim domesticity. Rather than being detrimental to the intellectual sophistication of *The Reception*, Lewis's departures from Lane's text compel an incisive and innovatory process of reading and thinking in which the layers of convoluted allusions and unexpected meanings in the picture can at last be recognised. The reasons behind Lewis's conceptual game, in fact, are decipherable only when *The Reception* is envisioned as engaging in just this kind of provocative dialogue with Lane's text, rather than existing in disturbing opposition to it, and when these figures and documents are placed more firmly within the historical record.

Orientation

When Lewis arrived in Egypt in 1841 the country had only recently emerged from a long period of internal political confusion. Muhammad 'Ali (ruled 1811–48), a Macedonian soldier of fortune, had proclaimed himself Pasha years earlier, in defiance of the nominal local ruler, the Ottoman Sultan Abdul Mejid (reigned 1839–61) (see figs. 44, 45).[33] Muhammad 'Ali's brazen efforts to achieve autocracy and his aggressive attempts to expand his realm beyond Egypt's borders concerned not only Ottoman powers, but European ones as well. British administrators, anxious to prevent any disruption to their valuable trade routes with India, asked Abdul Mejid to present Muhammad 'Ali with an ultimatum. Muhammad 'Ali refused to comply and, consequently, in November 1840, Britain and Turkey, with aid from Austria and other European allies, joined forces against Muhammad 'Ali in Syria at the siege of St Jean d'Acre. Muhammad 'Ali was soundly defeated. Nevertheless, after many lengthy negotiations, the fearless opportunist was awarded one small but significant prize, the hereditary pashipric of Egypt.

Throughout his long reign in Egypt, Muhammad 'Ali continued the ambitious programme of internal reform policies that he had begun early in the century. Printing presses were established at Alexandria and Cairo, and newspapers circulated at an unprecedented rate. Foreign diplomats were invited to visit, and Egyptian ones were sent abroad. European engineers and architects were hired, and tourism was actively encouraged. Muhammad 'Ali's rigorous building campaign, a harbinger of Parisian Haussmannisation, led to numerous local houses being

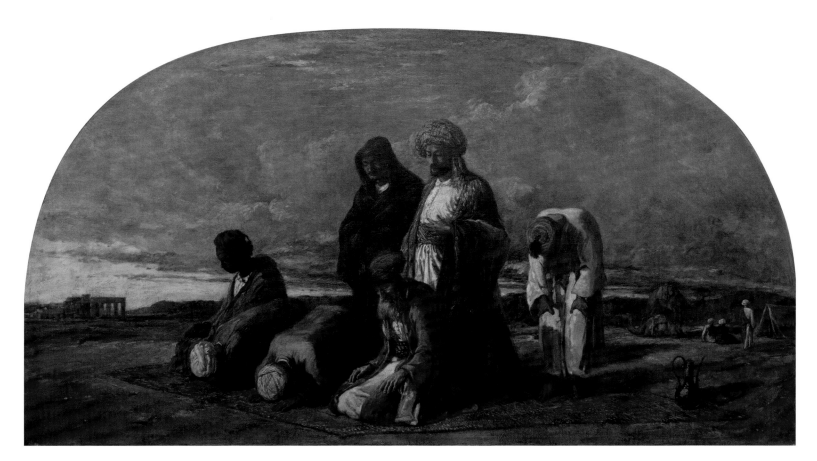

Fig.18
Prayers in the Desert 1843
William James Müller
Oil on canvas, 100.3 x 179.7
Birmingham Museums & Art Gallery

whitewashed, and to a ban on the wooden *mashrabiyya* balconies and windows that had characterised Egyptian architecture for centuries.[34] Religious toleration also reached extraordinary levels: church bells were allowed to ring in Cairo for the first time since the city's foundation by the Fatimids in the tenth century.[35]

Though Muhammad 'Ali turned his back on the indigenous culture of Egypt in these matters, he showed profound respect for the early and modern history of the country in others. In addition to making clear his own devotion to Islam, the Pasha began a campaign of archaeological preservation, recognising the importance that ancient sites and monuments had not only for the lucrative business of tourism, but also for the development of the public's pride in their Egyptian heritage and the creation of a unified national identity. Moreover, in contradistinction to his political precedents and contemporary counterparts in Ottoman Turkey, Muhammad 'Ali rejected French and other European military uniforms and clothing, instead retaining the traditional dress of Egypt.[36]

These seemingly paradoxical acts of cultural repression and revival begin to cohere in the context of Muhammad 'Ali's larger political designs. The Pasha believed that, through such diverse reforms, Egypt could gain the respect of European administrators and thereby compete more effectively on the global political stage. On the other hand, and just as importantly,

Egypt's position would not be confused by its own populace with that of a humble imitator. Muhammad 'Ali's emphasis on conservation, his celebration of certain local traditions, and his highly selective emulation of European culture, would reassure his public of Egypt's glory, and would earn him the internal support and enthusiasm needed for a successful leadership.

The intricacies of Muhammad 'Ali's remarkable reign necessitate profound changes to be made in the vocabulary and conceptualisation of cross-cultural encounters in Egypt in the mid-nineteenth century. Rather than an interaction between West and East, empire and other, individuals' experiences occurred in a framework that was not so neatly described. These individuals, too, must be recognised for the distinctive personas they adopted in this country and at this time. Certainly the once-clubby Londoner Lewis would frustrate those in search of a clear-cut imperial stereotype. Though representative of a metropolitan British culture, and therefore linked in some way to the fact of its empire, Lewis took great care to confuse nationalist issues. Sartorially and socially, he followed the lead of a small group of resident European scholars in Cairo, Edward William Lane among them, in adopting the lifestyle of a well-to-do Turkish 'bey'. Not quite the average Egyptian, and no longer overtly British, Lewis crafted an identity for which existing terminologies fall short.[37]

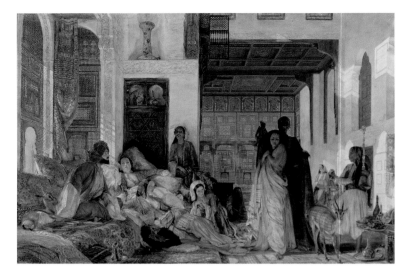

Fig.19
The Hhareem 1850
John Frederick Lewis
Watercolour, 88.6 x 133
Private Collection

Lewis's masquerade and his subsequent professional decisions had of course practical and self-serving motives, some of which have already been identified. But despite such predetermined consequences, Lewis's stubbornly ambiguous position vis-à-vis convention is worth exploring further. Indeed, it is ironically the complexity of this artist's literal and figurative locations, in both Egypt and in England, and the inadequacy of current vocabularies to describe them, that provide the best interpretative framework for *The Reception*. The application of Fatema Mernissi's notion of *fitna* – a theoretical source as unconventional as Lewis himself – and her essay in this book more broadly, also help to unveil this enigmatic artist and his work.

Reorientation

In *Beyond the Veil*, the feminist author and sociologist Fatema Mernissi argues that the fundamental principles of Islamic architecture and the patriarchal structure of Muslim society are determined by the concept of *fitna*. In Arabic, the word means chaos or social disorder, but, as the author explains, it can also refer to a beautiful woman.[38] Indeed, the two terms are thought to be interchangeable: 'The woman,' Mernissi writes, 'is *fitna*, the epitome of the uncontrollable, a living representative of the dangers of sexuality and its rampant disruptive potential.'[39] This is why, Mernissi continues, women in Muslim society are sequestered and contained by social and architectural institutions such as the harem: without such sexual space boundaries, men would be in danger of exposure to the powers of sexual distraction that all women possess. To quote Mernissi once more:

A woman is always trespassing in a male space because she is, by definition, a foe. A woman has no right to use male spaces. If she enters them, she is upsetting the male's order

and his peace of mind. She is actually committing an act of aggression against him merely by being present where she should not be.[40]

Mernissi's argument – that the patriarchal systems of order in Muslim society can be upset by *fitna* or the physical movement of women – gives to *The Reception* an unanticipated new meaning. Here, women are clearly shown to be in the 'wrong' place. While this displacement seemed at first inexplicable and illogical, or yet another point of (sometimes visually problematic) intertextual tension between Lewis and his sources, it now appears calculated, clever and fundamental to the picture's intellectual sophistication and broader political meanings. Behind its meticulously painted veil of realism and the eerie, almost palpable stillness of its doll-like figures, *The Reception* explodes architectural conventions and patriarchal systems of order, and leaves in their place a disquieting allusion to female power.

The unease that Lewis's picture would have caused among male viewers would not have been felt in the Muslim world alone, however. It was also a message that would have been received with considerable discomfort in Victorian England, and on the broader political stage. One of the longstanding justifications for intervention by Britain in the affairs of Egypt and the Middle East in the mid-nineteenth century was its promised liberation of the 'oppressed' and 'sexually exploited' women it envisaged there. The harem in particular was seen as a microcosm of all that was wrong with the region: it epitomised its sexual excesses, its 'barbaric' gender prescriptions, and it acted as a metaphor for the unjustness of its local governments.[41] Indeed, between 1872 and 1874 – precisely the time of *The Reception*'s execution and exhibition – the British government was making renewed efforts to intervene on behalf of (white) harem women in several Middle Eastern countries. In 1873, Sir Henry Elliot, British Ambassador in Constantinople, learned that slave families were being separated when sold. In an official break with British non-interventionist policy, Elliot made demands to the Ottoman Foreign Minister, Halil Pasha, to end the practice immediately.[42]

Both Inderpal Grewal and Mervat Hatem have argued persuasively that such examples of British officials' outrage at women's poor treatment abroad were more than legitimisations for slowly increasing administrative intervention. They also acted as a necessary tool for extending those powers beyond the formal borders of the British Empire. If the severe oppression of women in foreign countries was made clear, the authors allege, British women could ignore or at least favourably compare their own restrictive domestic situations.[43] Contemporary texts make this hypothesis all the more compelling. A writer in the literary magazine *Bentley's Miscellany*, for example, wrote the following in 1850:

Let her [the Turkish harem woman's] sister in the Western world, in the midst of her joys, think with pity on these sufferings, and when sorrow's cloud seems darkest, let her not repine, but learn resignation to her lot, as she

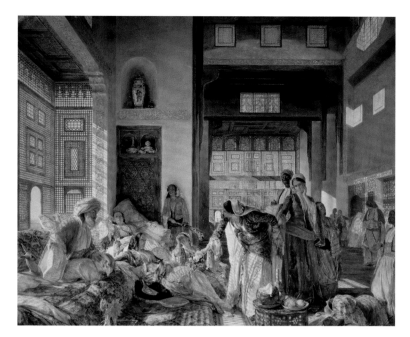

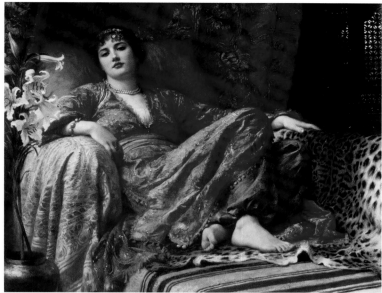

Fig.20
An Intercepted Correspondence 1869
John Frederick Lewis
Oil on wood, 74.3 x 87.3
Private Collection

Fig.21
Leila 1892
Frank Dicksee
Oil on canvas, 100 x 126
Private Collection

compares it with the condition of the women of the East; let her be grateful that she lives in an age and land where woman is regarded as the helpmate and consolation of man, by whom her love is justly deemed the prize of his life.[44]

However, although the arguments of Grewal and Hatem are insightful, and are supported by much mid-century literature, their conclusions do not find visual endorsement in *The Reception*. Lewis's harem women are depicted as in no need of aid or rescue. They are not oppressed, not helpless, not objects of pity or empathy. Rather, they enjoy the liberties that contemporary gender prescriptions in Egypt would not have permitted. Their physical transposition into the *mandarah*, the geographical and masculine centre of the Middle Eastern household, is not merely disruptive in the terms Mernissi has described, then – that is, to Muslim ideologies and social conventions – it is also, in this last framework, a threat to accepted rationalisations for British imperial and domestic policies.

While this alarming aspect of Lewis's work is admittedly an esoteric one, others would have troubled a number of Victorian viewers. Audiences had seen scores of the artist's harem pictures by the time of *The Reception*'s exhibition in 1874, and had come to expect certain conventions within the genre; even, in fact, within Lewis's own work.[45] Foremost among these was the artist's tendency to designate his pictures clearly, by way of title or descriptive tag, as pertaining to this particular social institution. An abbreviated list, drawn from this exhibition alone, demonstrates the point: *The Hhareem* (fig.137), *Hhareem Life, Constantinople* (fig.121) and *Indoor Gossip (Hareem)* (fig.123). Even

when such a title was not given by Lewis, the similarity of the work to others in his oeuvre rendered the subject unmistakable. *The Reception*, never explicitly identified by the artist as being about harem women, would presumably fall into the latter category. The women participate in an event that was known to occur within the harem, and closely resemble figures in others of Lewis's harem pictures, in both their dress and postures. The central pair of women is in fact remarkably similar to those in another composition, painted some sixteen years earlier and unambiguously titled *Hhareem Life, Constantinople* (fig.121). The comparison of this picture with *The Reception* is an especially intriguing one, for not only does it demonstrate Lewis's (later criticised) habit of compositional repetition, but it also points to another hallmark of Lewis's renowned harem style: the inferred presence of a male viewer.

In most of the artist's harem pictures, the presence of a dominant male figure is alluded to, even if only implicitly. Once recognised, it becomes an integral part of the picture's subject and interpretation. This figure is usually identifiable as the harem master, as in *An Intercepted Correspondence* (fig.20), or, in some instances, he is intimated to be the Victorian male viewer himself. In *Hhareem Life, Constantinople*, for example, a glimpse of the slippers and gathered pants of a man are accidentally caught in the mirror's reflection. The implication, of course, is that they are worn by someone outside and in front of the picture plane.

In *The Reception*, however, this recurrent device is absent from the composition. There are, moreover, none of the visual clues typically left by the artist indicating that it is a male visitor who enters the room. Certainly it would seem logical that the

mandarah, a public space of masculine entertainment, would be entered vicariously by the British male viewer, whose fantasies of Oriental indulgence had at last been fulfilled. But Lewis, on this occasion, makes no effort to aid us in this gender-biased conclusion. The self-confident postures and hard stares of Lewis's fully clothed women and their unquestionable domination of the expansive space they have invaded are hardly invitational, and are not what admirers of Orientalism's usually flirtatious beauties, contained in almost claustrophobically intimate interiors, had come to expect (compare, for example, *Leila* by Frank Dicksee, fig.21).

As if to make the departure from general and personal conventions even more adamant, Lewis's usual practice of portraying harem women as unveiled here takes on an unwelcome new meaning. In the harem, the lack of a veil would have been entirely acceptable and therefore unremarkable. In the *mandarah*, however, the lack of a veil would not have been allowed. This simple piece of cloth was fraught with denotative and connotative associations, and communicated specific and time-honoured cultural values.[46] It defined the wearer as a conservative member of the Islamic community and a practising Muslim, and it demonstrated that she was an obedient participant in men's strictures surrounding female dress. The veil, moreover, offered women protection from strangers' glances and reserved the visibility of their face for their husbands alone. Just as their placement in the *mandarah* indicates a powerful rejection of architectural and social traditions, then, so the bare skin of Lewis's women challenges viewers to reconcile the superficial purity and decorum on the surface of the canvas with another irreverent and even revolutionary act against the prescriptions of patriarchal society.

The frustrations to patriarchal power that have been elicited from Lewis's picture are, we now realise, not really so subtle at all. In fact, it can be argued that they are written across the very surface of *The Reception*, in a way that we have yet to acknowledge. Lewis's highly wrought technique is itself a provocative commentary on attitudes towards gender and perceptions of male and female power. In *Reading in Detail: Aesthetics and the Feminine* (1987), Naomi Schor observes that 'detail' has long been gendered as female, through its association with, on the one hand, the ornamental and decorative, and, on the other, the mundane and the everyday. Consequently, it has been regarded as less important than 'the overarching, intellectual concept' of a literary or visual work and as incapable of having an active role in the production of that work's meaning. Such beliefs, Schor claims, while not surprising, are incorrect. They are part of the well-crafted myths perpetuated by patriarchal society, meant to underscore and reinforce notions of female subservience and the inconsequentiality of the domestic realm.[47]

The basic tenets of Schor's argument are instructive with regard to my own gender-conscious analysis of *The Reception*. Here, and indeed in all of the artist's Middle Eastern works, Lewis devotes more energy to the marginal, the prosaic and the decorative aspects of the composition than to the more 'typical' artistic interests of principal subject or central action.[48] In Schor's framework, the attention to detail in Lewis's painting should be read as more than mere artistic preference, then. It should be interpreted as a powerful political statement, a demonstration of the belief in the importance of the domestic and the feminine, and a cautionary reminder of the subversive power of what is too often – and mistakenly – dismissed or overlooked.[49]

But what of other artists' use of detail? Surely not all were espousing the cause of women the world over. Gérôme's scientific mode of painting, after all, has already been identified as the quintessential expression of artistic imperialism. Legislated in every calculated, invisible stroke, it has been used to 'capture' anonymous subjects for the delectation and chastisement of European viewers – or so the story goes. Here, a detailed application of paint seems to champion masculinity, European civilisation and the French Empire. How is Lewis's chosen style different?

The answer to this question is both obvious and difficult to express. While our received wisdom concerning Orientalism would compel us to believe that Lewis used his technical prowess to celebrate Britain's convictions of cultural superiority in the nineteenth century, a new reading might suggest that he used it to question the beliefs of his subjects – and, more importantly, those who viewed them. The fundamental tenets of patriarchal power structures in Egypt stand on shaky ground in *The Reception*, to be sure, but those in Britain are placed on no firmer a footing. Male fantasies are frustrated; justifications for imperial intervention are problematised; women are accorded a power that would have threatened conventions surrounding accepted notions of domesticity both in Cairo and in London. This, then, is not imperialism of an artistic variety. This is a challenge to the organisation of two cultures that are, perhaps, not so very different after all.

SEDUCED BY 'SAMAR', OR: HOW BRITISH ORIENTALIST PAINTERS LEARNED TO STOP WORRYING AND LOVE THE DARKNESS

FATEMA MERNISSI

Are you afraid of the dark? Do you consider the night with its wild dreams to be a dangerous relapse into chaotic unconsciousness, or on the contrary to be a wonderful opportunity to fly away from reality's rigid frontiers? The answer to these questions depends on the civilisation that has programmed your mind. And, strangely enough, probing this question is worth the effort because it gives us the key to figuring out one of our twenty-first-century puzzles: why Islam, a religious world view, scares the science-powered West, which declares itself officially secular?

This exhibition gives us a wonderful opportunity to probe the link between the West's attitude towards the dark and its fear of Islam. Why? Because these nineteenth-century British artists' depiction of the Middle East reveals their fascination with two things that Islam glorifies and the West stamps as negative: the dark (the realm of dreams, as opposed to the day that is the territory of rational thinking) and the arabesque (the abstract symbol as opposed to the image of reality). Looking at these British artists' pictures of the Middle East will also allow us to see how the difference between the ways in which Islam and the West view dreams and the night reveals their equally distinct attitudes towards a strategic issue that our IT-powered twenty-first century has urgently raised: that of the frontier. The secular Western State – which anchors its identity in the defence of its geographic frontiers – programmes its citizens to erect the difference between the day (rationality) and the night (unconscious) into a dangerous border. Islam, by contrast, encourages its followers to aim at a universal *umma* (community), which transcends geography and programmes the faithful to dance skilfully between day and night, reality and dreams. This difference between the West's and Islam's psychological approaches to dreams and the night has of course an astronomical grounding: while the first limits its citizens to one, solar calendar, the second encourages its followers to juggle with two calendars, a solar one and a lunar one. In this text, we will limit ourselves to probing the psychological dimension of this contrast by focusing on *samar*, night and dreams as sources of creativity and delights.

The Arabic concept of *samar* is relevant because so many of the nineteenth-century British artists seem to have attempted either to paint it or to experiment with it. *Samar* can mean, among other things, 'to talk in the moonlight', an activity I practised with devotion when I was younger. As a woman brought up in a Muslim society, I discovered an amusing characteristic of our Western neighbours when I went to Europe as a student: they never really liked sleep and were suspicious of the moon. And don't think that their dislike started with the industrial age, when the principle of 'non-idleness' became (so the French philosopher Michel Foucault argued) the basis of ethics, and when 'It was forbidden to waste time'. It started much earlier, since Alexander the Great 'is reputed to have said that only sleep and sexual intercourse made him conscious of his mortality'.[1] And the famous 'Renaissance Man', Leon Battista Alberti (1404–72), whose book *On Painting* is still a bestseller, declaimed: 'I flee from sleep and idleness, and I am always busy about something.'[2] Alberti, who so disdained sleep, managed to be at once a 'prominent architect, city planner, archaeologist, humanist scholar, natural scientist, cartographer, mathematician, champion of the Italian vernacular, cryptographer and … inveterate measurer'.[3] However, with all his impressive achievements, he missed, as far as I am concerned, one important cosmic life experience: *samar*. The British artists featured in this exhibition, on the other hand, seem not only to have tasted *samar*, but to have captured it in their paintings.

The British painters celebrated 'samar' like we Muslims do

What else does *samar* mean? *Samar* is one of the Arabic language's magic words that weaves together the sense of 'dark colour' with the pleasure you get from opening up to the mysterious 'other', all the while being stimulated by the moonlight. The dark might however also be enchanting during the day, when you manage to create it artificially by retreating to an inner cocoon-like space, of which the archetype is the harem. Tunisian philosopher Abdelwahab Bouhdiba identified the harem archetype as the 'Kingdom of the Mothers'.[4] But how is it that the artists featured in this exhibition, supposedly the conquering sons of the invincible British Empire, were so lured by the power of women instead of focusing on the males, their official enemy? Before delving any further into this exhibition's painted harems, let us first continue seeking to understand *samar* more deeply. *Samar*, explains Ibn Faris, in his eleventh-century dictionary of the Arabic language, is formed from the three letters s, m and r, the same root from which derive the meanings 'the opposite of white in terms of colour' and 'the darkness of the night'.[5]

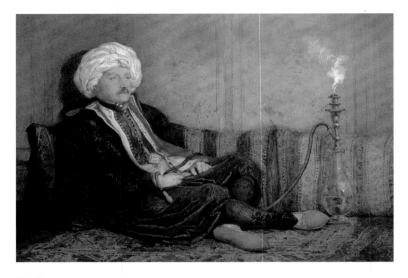

Fig.22
Sir Thomas Phillips Reclining in Eastern Costume 1842/3
Richard Dadd
Watercolour, 17.8 x 25.4
Bethlem Hospital, Beckenham

(سمر) السين والميم والراء أصل واحد يدل على خلاف البياض

In his famous fourteenth-century dictionary *Lisan al 'Arab* (The Tongue of the Arabs), which we still use today, Ibn Manzur reveals the strong connection between darkness and the moon, since *samar* can mean a 'light dark colour' precisely because it refers to 'the shadow of the moon', as well as to the pleasure people get from 'chatting in the night'.[6]

الأسمر، وهو لون يضرب إلى سواد خفي، والسمر : ظل القمر،
وأصل السمر : لون ضوء القمر، لأنهم كانوا يتحدثون فيه

With these definitions of *samar* in mind, you must once more look calmly at the paintings in the exhibition. The more you scrutinise this selection, the darker looms the Middle East these artists captured, while three puzzling qualities appear that all lead you to the fringe world of the night. The first is the compulsive attraction these artists felt for dark, inward-looking spaces, be they harems, sheltered courtyards, or cosy shops in the maze-like alleys of the umbilical traditional Muslim city. The second is the aggressive invasion of these dark spaces by abstract symbols, splashed over seemingly apolitical spaces, such as the artisan-crafted wall ceramics, the wooden windows and the finely woven textiles, particularly carpets. And last but not least is the artists' irresistible, if not visceral, reflex, as heirs of their Empire's conquering mission, to imitate the locals by jumping into wide pants and unisex robes, or squatting in their earth-embedded and carpet-cocooned homes. It just happens that these three striking features of this 'British Middle East', as mirrored in the artists' paintings, reflect the celebration of that dimension of human civilisation that Christianity and after it the secular State suppressed, but which Islam happens to have

embraced ever since its birth in the seventh century: *samar*, or the glorification of the night. Several scholars, including W. Montgomery Watt, a sophisticated British expert, have identified this lunar dimension as a fundamental feature of Islam. They trace it to the fact that Islam was born in a desert environment, where the sun can easily kill you and where the night is therefore survival itself:

> The Arab seems to have been fascinated by the alternation of night and day; and the Qur'an points out how the night is suitable for rest and the day for activity.[7]

He was referring to the verses in Sura 78, which point out that life would be unbearable for men if the whole time were day or night and that the blessing is the dance between the two: 'We created you in pairs and gave you rest in sleep. We made the night a mantle, and ordained the day for work.'[8]

It was when I saw that these artists really enjoyed painting *samar* (and some of them even practised it, like John Frederick Lewis, who organised nightly entertainment in his lavish Cairo house) that I suddenly realised that they escaped Edward Said's theory of an unbridgeable divide between conquerors and conquered. Said wrote in 1978:

> My contention is that Orientalism is fundamentally a political doctrine willed over the Orient because the Orient was weaker than the West, which elided the Orient's difference with its weakness … As a cultural apparatus Orientalism is all aggression, activity, judgment, will-to-truth, and knowledge.[9]

Is Orientalism really all judgement and knowledge? Was the conquering Westerner always sufficiently in control of his emotions to direct them towards attacking the conquered?

Were there not emotions that our conquering Westerner could not control as far as he would rationally have willed? I would like to suggest that enjoying *samar* – the dark in general and harems in particular – enough to want to keep recreating it in their paintings, shows that these British artists had a human dimension which transcended their own civilisation's programming. In fact, when it comes to the dark, even though his Empire programmed him to hate sleep as idleness and the moony nights as chaos-inducing realms, the artist's human instinct made him tilt towards the universal: he enjoyed drifting in *samar* even though that implied erasing the frontier that separated him as the conqueror from the conquered Middle Easterner.

For some of our Western neighbours, our delightful 'samar' is instead a dangerous jump towards 'lunacy'

Believe it or not, in some English and French dictionaries, the night and the moon are linked to distress and craziness. The night, states the *Random House Dictionary*, refers to 'a state or time of obscurity, ignorance, misfortune, etc.', and the moon relates to lunacy and to talking to while away the time: 'To moon the afternoon away' means 'to spend time idly'. As for the French dictionary, *Le Robert*, if you look up the word *lune* (moon), you will discover that '*être dans la lune*' (to be in the moon) means simply to be '*hors de la réalité*' (cut off from reality). And the adjective *lunatique*, which would be the equivalent of our Arabic *samar*, means '*soumis aux influences de la lune et, de ce fait, atteint de folie périodique*' (under the influence of the moon and, consequently, suffering from periodic madness). Whence the following enigma: after perusing the paintings I started wondering how we can explain these artists' fascination with *samar*, the delightfully entertaining darkness of the moonlit night, if it does not exist in the English language. Were they perhaps enchanted precisely by the 'dark' or 'unconscious' qualities of Islam that in their own civilisation were connected with danger? Is it an irrelevant detail that a European, even if he proclaims that he is an atheist, is likely to wear black to mourn his dead, whilst I, a Muslim from North Africa, am likely to wear white?[10] Was it pure chance that the French painter Henri Matisse, after his Moroccan trip in 1912, confessed that he had changed his attitude towards the symbolism of darkness: 'I started using pure black as a colour of light and not as a colour of obscurity'?[11] Are our European neighbours – who play tough and spend their time creating impressive monsters like Superman and Batman – just fragile creatures like me, although instead of singing about their vulnerability as our Arab singers do by celebrating *layl* (night) non-stop on the hundreds of Pan-Arab satellite TV channels, they try to make us believe they are invincible? At this point I started wondering whether there is a link, not only between *samar* and the artists' attraction to the Middle East, but at the same time a link between *samar* and other Westerners' *fear* of Islam. Could it be that the Westerner is frightened of Muslims because they mirror his own suppressed unconscious side?

I tried to educate myself by reading Western scholars who strove to decode how the West views the dark, sleepy body of the 'Oriental', such as the British psychologist Guy Glaxton, author of *The Wayward Mind: An Intimate History of the Unconscious*.[12] With that unmistakable refined British humour, Glaxton wonders about the relationship between the fear of Islam and the West's generation of a 'Beast in the Basement', through its anxiety over sleep and over trespassing into the territory of the night.[13] The modern Western man has an image problem, argues the witty Glaxton, because he still clings to the Cartesian superman who is always rational and never goes to sleep: 'Descartes said, in effect, that the unconscious was Not Me, Not Intelligent, and Not There.'[14] And since the 'unconscious, whatever else it is, is undomesticated and unpredictable,' adds Glaxton,

> the Western man has to camp himself in the position of the eternal fighter to subdue his internal enemy: it (the unconscious) threatens to subvert my carefully crafted and strongly maintained public image.[15]

It is this static abysmal frontier within the human being, between his rational and unconscious parts, that Islam transcends by a dynamic collaboration between the two, as 'Abd al-Rahman ibn Khaldun, the fourteenth-century Muslim scholar, suggested. How does a human being empower himself, asked Ibn Khaldun in his *Muqaddimah* (Introduction to History), a book he finished writing in 1377 but still read widely today. He answered this question by confirming that *thinking* may be the first source of power (it 'allows one to make a living' by rooting oneself in reality), but *dreaming* is another.[16] Man creates power in his sleep, says Ibn Khaldun, because the imagination takes over: 'Man lets the perception of his imagination roam deep in his inner self … free of time and space boundaries.'[17]

فالطور الأول : عالمه الجسماني بحسه الظاهر وفكره المعاشي وسائر تصرفاته التي أعطاها إياها وجوده الحاضر
الطور الثاني : عالم النوم، وهو تصور الخيال بإنفاذ تصوراته جائلة في باطنه فيدرك منها بحواسه الظاهرة مجردة عن الأزمنة والأمكنة وسائر الأحوال الجسمانية، ويشاهدها في إمكان ليس هو فيه.

Glaxton reminds his readers that Sigmund Freud, who suffered as a Jew from the persecutions of the Nazis, 'was deeply afraid that the suppression of the unconscious was partly to blame for the mayhem that he had witnessed'. Glaxton thinks that the current fear of Islam might have something to do with this as well:

> As I write, the tension between Islam and the West seems to increase daily … It would be absurd to draw facile parallels, but I wonder if, again, we are seeing a link between social events and an unbalanced and incoherent picture of the mind.[18]

He is far from being the only Western scholar to make such a link, I reassured myself, since many other psychoanalysts have been debating the question with their Arab colleagues since the 11 September 2001 terrorist attacks on the United States.[19] I was not the only one wondering if Islam scares the West because it mirrors the West's suppressed unconscious side.

Another way in which the artists in this exhibition seem to cross over from one culture to another is by stuffing so many arabesques into their paintings, behaving almost like iconoclasts. Iconoclasm, from the Greek *eikonoklasmos* (image-breaking), explains the *Catholic Encyclopaedia*,

> is the name of the heresy that in the eighth and ninth centuries disturbed the peace of the Eastern Church … It has been represented as an effect of Muslim influence. To Muslims, any kind of picture, statue, or representation of the human form is an abominable idol.

People forget today that the toughest battle fought between Islam and the West was not the military but the aesthetic one: the conflict of image versus symbol.

It's time we tried to define exactly what an arabesque is. Marshall G.S. Hodgson, a refined Western analyst of Islam, defines the arabesque as a network of abstract forms that induces you, like music, into a deeper reflective mood:

> Circles, triangles, squares, and other polygons were inter-woven in extraordinarily complex combinations, of which the overall effect cannot avoid being impressive, but which gain in power, like musical compositions, as one sorts out visually the various geometrical elements and observes how they are being fitted together.[20]

When you look at the arabesque you travel not only in space but in time as well, since it takes you back to ancient Mesopotamian mythology in which stars and crescents symbolised other forgotten myths, as Erich Neumann suggests:

> The favored spiritual symbol of the matriarchal sphere is the moon in its relation to the night and the Great Mother of the night sky … Throughout the world, lunar mythology seems to have preceded solar mythology.[21]

And Arab experts in Islamic art like Barakat Murad explain that the wonderful thing about Islam's decision to rely on the universal dream-language of symbols is its capacity to integrate other cultures and harmonise their diversity,

> despite the fact that people continued to think that these symbols represented forces which ought to be fought for fear of their emotional impact. The fact is that the Muslim artist managed successfully to integrate these symbols (*rumuz*) into Islamic art's most popular expressions in such a way that their original meanings vanished from

consciousness and they appeared as innocent, aesthetically attractive designs which carried no harm.[22]

ويجب أن نتنبه إلى أن المسلمين في رسومهم وتصاويرهم على المنسوجات التي صنعوها أو على كثير من الصناعات الاخرى، ظلوا محتفظين بكثير من الرسوم التي كانت موجودة قبل الاسلام، وقد ظلوا يعتقدون أنها تمثل قوى ينبغي مواجهتها خوفا من تأثيرها، غير أن الفنان المسلم تمكن بنجاح من أن يتمثل تلك الرموز ويدخلها ضمن المصطلح الفني الاسلامي الشائع.

Unlike the Christian churches, which declared war on the ancient symbols as devilish representations of goddesses, explains Barakat, the Prophet of Islam and the caliphs after him, skilled in communication, adopted those very geometrical pictograms which existed before Islam, instead of *suwar* (images), to gain universal sway via seemingly apolitical popular arts such as pottery, ceramics and the weaving of clothing and carpets.

The Prophet's fight against images and for symbols was a stand against frontiers

In order to explore the arabesque more deeply as Islam's aesthetic tool to erase boundaries, we'll need to jump for a few minutes into the Prophet's seventh-century Mecca, to grasp that his battle against the images he destroyed, and his preference for symbols (the visual language of dreams) – despite the violent opposition of the male elite of his Quraysh tribe – was a campaign for an Islam that meant the erosion of all kinds of ethnic and geographic frontiers.

The vision of the seventh-century Prophet coincides perfectly with what we now call globalisation, which is the collapse of a reality defined by frontiers and its replacement by a boundless dream-planet. This is why Muhammad decided to destroy the 360 idols at Mecca, which celebrated the Arabs' clannishly individualistic 'asabiyya (tribalism) that he condemned as pre-Islamic *jahiliyya* (ignorance), since each group worshipped the image of its own private god. The Prophet's battle against images in this context meant a stand against inequality and the narcissistic fathers' tribalism, and the promotion of abstract symbols as the language of universalism. *Jahiliyya* must be equated with 'asabiyya, stressed the famous and highly controversial Egyptian thinker Nasr Hamid Abu Zaid in his 1999 book *Circles of Fear: Decoding the Women's Discourse*.[23] Abu Zaid repeatedly demonstrated that Islam's campaigning for universalism meant fighting against all kinds of exclusions, be they racial or sexual: 'It (Islam) is a message against tribalism, clannishness and cliques … Islam is for the free human being, be it a man or a woman.'[24]

(الإسلام) رسالة ضد القبلية والطائفية والعشائرية، ومع الإنسان الحر - ذكرا وأنثى - في نضاله النبيل من أجل الحق والخير والجمال

Since universalism goes hand in hand with celebration of the mother (*umm*, which is the root of *umma*, meaning the global

Muslim community), many verses of the Qur'an attack the fathers as the defenders of anti-Islamic local clannishness:

> When it is said to them: 'Come to that which Allah has revealed, and to the Apostle,' they reply: 'Sufficient for us is the faith we have inherited from our fathers,' even though their fathers knew nothing and were not rightly guided.[25]

Albert Hourani summarises in his book, *A History of the Arab Peoples*:

> The concept of modern ethnic nationalism, that those who share a common language should live together in an exclusive political society, did not of course exist, nor did that of the territorial nation, living in a piece of land clearly marked off from others by natural frontiers.[26]

Art – adopting symbols instead of images – also played an important role in encouraging Muslims to dismiss frontiers and look forward to a universal community. We often forget that national state frontiers are a very recent phenomenon and a gift of the science-powered European Renaissance. According to Jared Diamond, in his *Guns, Germs and Steel: The Fates of Human Societies*,

> As recently as 1500 AD, less than 20 percent of the world's land area was marked off by boundaries into states run by bureaucrats and governed by laws. Today, all land except Antarctica is so divided.[27]

If geographic frontiers are a creation of the secular Western State that replaced the crusading Christian churches, no wonder that globalisation – the vanishing of boundaries – is likely to be perceived as a psychological Islamisation of the planet. Particularly if we keep in mind the role that art plays here: The opposite of abstraction is concretism', and 'The sacred art of Islam is an abstract art'.[28]

This is how Thomas W. Arnold starts his classic book, *Painting in Islam* (1928):

> Of the three great missionary religions of the world – Buddhism, Christianity, and Islam – each striving for the mastery of the world and endeavouring to win the allegiance of all men by various devices of propaganda, Islam alone has refused to call in the aid of pictorial art as a handmaid to religion.[29]

Muhammad's fight for universalism, by shifting from images to symbols, aspired to a dream-like evaporation of frontiers of time and space. The mysterious organisation of Neo-Platonic Arab philosophers from Basra in Iraq known as the Brethren of Sincerity observed this as early as the tenth century:

> Know that this power of the imagination is capable of many wonders. With this power, one can travel in a single hour in both East and West, roam on land and in the sea … One can imagine an unlimited space and even fly in time to the past and explore the beginning of the universe.[30]

فنقول : اعلم أنا قد ذكرنا أن لهذه القوة المتخيلة عجائب كثيرة، بهذه القوة، في ساعة واحدة، أن يجول في المشرق والمغرب، والبر والبحر، ويتخيل هناك فضاء بلا نهاية ، وربما يتخيل من الزمان الماضي وبدء كون

That Islam started as a dream is the first thing children are taught in Muslim school, and that is how Lalla Kelthoum, my Qur'an schoolteacher, taught me to appreciate the night as a wonderful gift. 'The Prophet's first experience of the revelation was a dream he had when asleep,' said Imam Bukhari, the great ninth-century compiler of *hadith* (records of the words and deeds of the Prophet), who decided to devote a whole chapter to the topic he called 'Dream Interpretation'.[31] It is not surprising then that, by the twelfth century, more than six hundred famous practitioners of the craft of dream interpretation were listed by al-Hasan ibn al-Husayn al-Khallal in his biographical dictionary, *The Generations of Dream Interpreters*.[32]

أول مابدىء به رسول الله صلى الله عليه وسلم من الوحي الرؤيا الصادقة في النوم.

Ta'bir (dream interpretation) was ranked by Ibn Khaldun as 'one of the sciences of religious law', and he added that 'It originated in Islam when the sciences became crafts and scholars wrote books on them … In any case, all human beings can have dream visions, and these visions must be interpreted'.[33] And in fact this venerable Islamic tradition of dream interpretation continues down to the present day. I was nine years old when my cousin Aziz pushed me to steal my father's copy of Ibn Sirin's manual *Interpretation of Dreams* to enable us to be as clever as the grown-ups.[34] Meanwhile, 'dream interpreters have become something of a prerequisite for successful Pan-Arab satellite television … with 150 channels to choose from, dream lovers in the Arabic-speaking world are spoilt for choice.'[35] In my childhood, playing chess, cards and reading Ibn Sirin's manual were more accessible and much cheaper than going to the movies. So you can imagine my surprise when I landed for the first time in London in 1967 to learn English as an *au pair*, to discover that in that city, you needed to go to a psychoanalyst and pay a fee to decode your dreams. That's when I discovered that poor Carl Jung had a lot of trouble convincing his fellow Europeans that they spoke 'symbols' like us Muslims.

Carl Jung and John Frederick Lewis: two Europeans standing up for symbols?

The famous Swiss psychoanalyst Carl Jung (1875–1961) showed his fellow Europeans that they shared with all humans, the savages included, a universal language of symbols:

> What we call a symbol is a term, a name, or even a picture that may be familiar in daily life, yet that possesses specific connotations in addition to its conventional and obvious meaning. It implies something vague, unknown, or hidden from us … It has a wider unconscious aspect that is never precisely defined or fully explained.[36]

He went on: 'As a general rule, the unconscious aspect of any event is revealed to us in dreams, where it appears not as a rational thought but as a symbolic image.'[37] That the Europeans had something in common with the savages was indeed a disturbing thought, and you had to wait until the 1960s hippy revolution to hear scholars like Jean Chevalier and Alain Gheerbrant, the authors of *Dictionnaire des Symboles*, declare proudly that they spoke an unconscious medium like Neolithic man:

> All through the day and night, in his language, his gestures or his dreams, whether or not he notices it, each one of us uses symbols. They give a face to desires.[38]

But if these two European gentlemen could express their pride in 1969 in speaking the universal language of dreams and desires, and boast of the 'primitive which lives within us', that was definitely not the case for nineteenth-century Europeans such as the painters in this exhibition – painters whose epoch associated dreams and desires with the Beast in the Basement.

For an artist such as John Frederick Lewis, systematically to spread geometric symbols all over his paintings was to escape the realism of the images his culture programmed him to favour, in order to taste the universal by delving into the uncharted territories of the boundless dream world. That is how you feel when you stare for hours at Lewis's *The Reception* (figs.25, 128), or in fact at almost any of his paintings in this exhibition. If you take the time to relax while looking at these paintings, you come to notice that geometric symbols are everywhere – on the walls, floors and clothes. But if you keep looking, you realise that among all of the patterns, Lewis seems to be entranced especially with the star encapsulated in a web of geometric figures, a symbol with a very long ancestry.

Lewis lived in Cairo from 1841 to 1851, and there he made numerous sketches that he turned into paintings after his return to England. He behaved as a man hypnotised by the dark and by abstract symbols, no matter if he was painting a harem (*The Reception*, fig.25; *Indoor Gossip*; *Hhareem Life, Constantinople*; *The Siesta*), a courtyard (*The Courtyard of the Coptic Patriarch's House in Cairo*), a school (*Interior of a School, Cairo*) or a shop (*The Arab Scribe, Cairo*, fig.24; *Kibab Shop, Scutari*).[39] The house Lewis chose to live

Fig.23
The author (right) with two friends in
the house of her cousin, Zineb,
in Fes in the 1980s
Photograph by Ruth V. Ward

in 'was characterised by a maze-like arrangement of rooms, typical of the grand old Ottoman (seventeenth- or eighteenth-century) houses in Cairo'.[40] The artist himself was described by his old friend William Makepeace Thackeray in his *Notes of a Journey from Cornhill to Grand Cairo* (1846) as 'a languid Lotus-eater' who led the 'dreamy, hazy, lazy, tobaccofied life' of a privileged Turkish pasha. To lead a 'dreamy, hazy' life, one needs adequate space for the task, and Lewis's Cairo abode, which was a 'queer, many-windowed, many-galleried house', seems to have inspired many of his paintings. Lewis certainly crossed cultures (as Emily Weeks puts it in the title of her essay in this book), but to say that he and the other painters in this exhibition betrayed their culture would be to deprive them of the wholesomeness of their human condition, of which the aspiration for the universal is an instinctive drive. This is why all of us, Easterners and Westerners, should use occasions like this exhibition to change our world vision and go beyond the old-fashioned binary categorisations such as colonial/colonised, First World/Third World, to identify what we all have in common, and the aspiration to the universal is one such thing. This forces me to go back briefly to Said's conception of Orientalism. Not only can we not condemn the nineteenth-century British artists as Middle Eastern 'aggressors', but we can go further and state that their suppressed dreamy side was nurtured by the conquered. And this means that even when sheer force tilts the balance to one party, the weaker side has still a cultural or a spiritual potential to share.

Now we have the code to elucidate this exhibition's enigma. Why were these gentlemen – coming from the centre

Fig.24
The Arab Scribe, Cairo 1852 (detail of fig.79)
John Frederick Lewis
Watercolour, 46.3 x 60.9
Private Collection

Fig.25
A Lady Receiving Visitors (The Reception) 1873 (detail of fig.128)
John Frederick Lewis
Oil on wood, 63.5 x 76.2
Yale Center for British Art, Paul Mellon Collection

of the science-empowered, rationality-worshipping and image-glorifying British Empire – mesmerised by a Middle East both dark and filled with abstract symbols? And why so much interest in relaxed bodies, particularly feminine ones, be they seated or sound asleep? You would have expected the British artist, coming from the heart of a triumphant and dynamic empire that had subdued the planet, to be more interested in performing, athletic bodies! And this performance-worship should have pushed them to focus on masculine bodies riding energetic horses, rather than idle women wasting time in seemingly useless tasks such as gossip, sleep or smelling flowers in timeless gardens. But now we can suggest that, even if these gentlemen were not consciously ready to surrender to a universal dream-world, their unconscious led them to this, despite themselves.

This brings me to the conclusion that the exhibition forces us to contemplate. The amazing thing about Europeans is that, although their thinkers and politicians invented a narcissistic culture embodied in the fiction of a secular nationalist state, which programmed them to repress their dreamy universal side and consider themselves as a unique science-worshipping breed, some miraculously escaped this brainwashing. When European citizens reject their state-imposed local identities to empathise with the colonised peoples, they have been able to launch wonderfully successful humanist projects, of which I will mention only three: the eighteenth-century anti-slavery movement, twentieth-century psychoanalysis, and finally our twenty-first-century anti-war protests.[41] These three movements testify that Europeans can transcend the national boundaries

of their secular states to feel empathy with strangers and identify with them, reclaiming their dreamy side, which their culture dismisses as archaic. And if we remember that the painters in this exhibition were living in an age torn by capitalist and colonial wars, as well as by the psychological conflict between, on one hand, those of limited vision who insisted on geographic boundaries, and on the other those humanists who ventured further, inspired by a dream of universality, we can gain an insight into what went on inside the minds of artists like Lewis and the others whose paintings we now have the chance to contemplate. Their encounter with a different world led not to conflict but to creativity, and we have much to learn from them.

REGARDING ORIENTALIST PAINTING TODAY

RANA KABBANI

I wrote about Orientalist painting more than two decades ago, seeking, as an 'Oriental', to analyse its meanings, to try to understand how it depicts my world.[1] On being invited by Tate Britain to reconsider this genre of painting for the purpose of this exhibition, I was struck at how little my strong feelings had been diluted over time. If anything, the interventions by Britain and America in the Middle East that we are presently witnessing have made it increasingly difficult for me to look at these pictures with anything like an indulgent eye. The past and the present have bled into each other.

Some of the works shown here were painted at a time when the British enjoyed military and economic mastery over the peoples and places the artists depicted. It is ironically fitting, therefore, that these remnants of a vanished colonial age should be resurrected and re-examined today when Britain has again participated in the occupation of an Arab country. Britain's nineteenth-century occupation of Egypt was believed by its Prime Minister, William Gladstone – who gave the order to bombard Alexandria – to be an act of civilisation.[2] Such a belief, common at the time, deserved to perish with empire. Instead, it was resuscitated in the imperialist spin that, at least initially, accompanied the Anglo-American action in Iraq, relying on what Edward Said has called 'intellectual lackeys' in the arts, the media and the political classes.[3] We have not moved far from the sentiments that the Victorian author Edward William Lane – a sculpture of whom in Eastern dress is exhibited here (fig.3), wearing an oversized turban that gives him the air of being an Oriental sage – expressed in his highly influential writings on Egypt and the Egyptians.[4]

If the British military occupation of Egypt inspired some of the striking paintings in this exhibition, what images might future generations retain of the present-day occupation of Iraq?

Photography – the art form most heavily influenced by the techniques and set-pieces of Orientalist paintings at the time they were first shown – would no doubt feature prominently. This time around, however, it would not be the work of professionals, formally assigned or informally patronised to make a visual record of war and conquest, of colonial landscapes, subjects and goods, as was the case in the past. Rather, it would be photography by amateurs, producing images that are not consciously formulaic. One example, familiar to everyone, is the photographs of prisoners abused at Abu Ghraib prison in Baghdad, casually taken by participating American soldiers. These images have acquired an emblematic cultural stature, inspiring artists from around the world. The Colombian sculptor and painter, Fernando Botero, based his own Classical European-style paintings of the abuse (fig.26) not only on the images, but also on the more detailed written reports he read in the press. Might such pictures, including the photographs themselves, come to be seen as the Orientalist art of the twenty-first century, born, like their predecessors of military conquest and colonial expansion, and fixed in commercial exploitation?

This may seem a stark comparison to be making about the Orientalist paintings in focus in this exhibition, some of which are undoubtedly of beguiling beauty. But one is obliged to bear it in mind if one is to look critically at these pictures, especially when they are presented in traditional art historical mode, as in this exhibition.[5] Delicately if disingenuously, nineteenth-century British Orientalist painting papered over its connection to the rough designs of Empire. It depicted a world unnaturally emptied of politics, airily overlooking the highly charged events of the period – the strikes, riots, rebellions, repressions and blockades; the impoverishment and famine; the communal punishments,

Fig.26
Abu Ghraib 57 2005
Fernando Botero
Oil on canvas, 140 x 193
Courtesy Marlborough Gallery, New York

Fig.27
The Turkish Bath 1862
Jean-Auguste-Dominique Ingres
Oil on canvas, diameter 110
Musée du Louvre, Paris

hangings and massacres – that were the marks of Britain's colonial 'moment' in the Middle East.[6] It is a genre of painting that also failed to register the turmoil taking place at the time in the Ottoman provinces, where most of the works were set and where internal conflicts – nationalism, religious reform, social upheaval and change, the fight for the liberation of women, and secular education – jostled each other for space. The old was fighting the new, the new was fighting the old, and both were fighting the grasping foreigner who had, by force of arms, planted himself in their midst.

Indeed, despite the considerable variations in their outlooks, talents and techniques, British Orientalist painters give us little or no indication of the transformations taking place around them as they put brush to canvas. They were content to paint a static world of exquisite surface: unchanging landscapes, air-brushed ruins or elaborate but staid interiors, peopled by ethnic prototypes (Africans, Arabs, Berbers, Turks, Albanians, Armenians, Circassians, Kurds, Jews), or by British men and women decked out in exotic fancy dress. These paintings faithfully reproduce decorative and architectural details. They depict cloaks, daggers and swords; turbans, sashes, shawls, slippers; robes and veils of silk, satin, fustian, damask, velvet and brocade; jewels, pipes, pens, ostrich fans, flutes, lutes, tambourines and scrolls; cushions, carpets and elaborately carved wooden screens; fretwork, tile-work, basins, fountains, doors, courtyards, arches and domes, all with 'photographic' exactitude. They constitute a pictorial catalogue of the 'goods'

of Empire, an exotic foil to popular Victorian paintings of cosy family scenes, their interiors crammed with the bric-a-brac of new industrial wealth, in which well-coiffed or beribboned wives, children and domestic animals gaze out at us with liquid and obedient eyes. But in presenting so carefully and minutely this rich panoply of covetable material wares, these paintings signally fail to meet the sterner challenge of uncovering the spirit of the people or the meanings of place. What is evoked by these painters or photographers, Leila Sebbar asks? The props, yes, 'but not the soul'.[7]

Yet urbane Western viewers of sophisticated cultural taste, who usually demand complexity from their works of art, continue to be seduced by these proffered morsels of sometimes cloying sweetness, Victorian Turkish Delight masquerading as authentic Rahat Loukoum. There is something about Orientalist painting as a genre that still captivates, engrosses, the Western eye. It can certainly draw extraordinary crowds, as, for example, the Louvre saw in 2006 when it presented the erotic fantasies of 'Turkish' bathing beauties by the ageing Jean-August-Dominique Ingres, who had never set foot in Turkey.[8] The different rooms of the *Ingres* exhibition spoke volumes. Around *The Turkish Bath*, that voyeuristic, keyhole composition (fig.27), there was a mad crush, but only emptiness in the room where the mythological and religious paintings were hung, even though the same nude blonde, whom he had cloned to fill his hammam (bathhouse) scene, also appears in these other works. Is this because a mythological setting renders female nudity

abstract and asexual, whereas an 'Oriental' setting, however far-fetched or imaginary, makes it sexually startling and available?

Centuries of stereotyping had so insisted on the lascivious sensuality of the East that, by the nineteenth century, 'Oriental' women had become the coveted prototype of what was sexually permissible in an inhibited and repressive age. A common technique of Orientalist painting was to reveal a woman's half-clothed or naked body which, in contrast to a well-dressed interior, made that body appear more alluring and arousing. The onlooker felt he could penetrate the interior, trespassing as he went, to gaze on the otherwise unapproachable 'Oriental' female, who was usually kept cloaked, veiled and hidden from view. One cannot escape the feeling that voyeurism is an important component of these paintings, even when they do not specifically depict nudity and are seemingly demure compositions of fully dressed women, as in the watercolours of John Frederick Lewis. They turn the very act of looking into an illicit, titillating, even hazardous undertaking, while at the same time awarding the onlooker a *droit de seigneur* to study at length the object of his gaze. There seems to me to be a suggestion, conscious or not, that jealously guarded harem doors and long centuries of fortifications can all be kicked open by the painter – as by a colonial jackboot – to let the Western voyeur in.

But what does it feel like to be looked at in this manner? This question remains problematic when posed by a non-Westerner in mainstream Western culture, which now allows less space for dissent than ever in matters of cultural representation. The recent attacks in several disciplines – including art history – on Edward Said's seminal work, *Orientalism* (1978), thirty years old this year, point to a reluctance by an increasingly conservative sector within Western scholarship to tolerate his conclusions. But not everyone can be compelled to celebrate Western writings or artworks on the Orient in the inflexible modes imposed by Western critical convention. Daring to challenge these modes has come to be considered an act of critical terrorism, deserving the severest of punishment, which makes the question even more vital: what, indeed, does it feel like to be looked at in this manner? If one is reduced to an object, to a body, to however colourful a spectacle, to a drama that is inherently violent or sexual, one cannot help but feel dehumanised. One cannot recognise one's own world in such reductive painting. One tries to be moved, if only by the apparent beauty of the pictures, but one cannot. This is someone else's story; someone else's Orient.

Travelling in North Africa less than a hundred years ago, the French writer Colette described the entertainment that tour guides arranged for European visitors. As a matter of course, it included the sight of Algerian women dancing naked. The fact that a transformation in attitude took place as soon as the dancer stripped was not lost on this early feminist, who had herself shed her clothes on the Parisian stage in a sensationalistic Orientalist mime. Although the dance itself remained unchanged, once naked, the woman stopped making eye contact with the audience, her contemptuous glance soaring above their heads to merge,

Fig.28
For Sale: Slaves at Cairo *c.*1871
Jean-Léon Gérôme
Oil on canvas, 75 x 60
Cincinatti Art Museum

in Colette's words, with the chaste grandeur of the desert beyond.[9] The fact that the dance took place in a harsh colonial context – with French army outposts scarring the very desert referred to so romantically – cannot have made the encounter tension-free for the dancer woman or, indeed, for the male musicians who accompanied her, and who turned their backs to the audience. In my view, the scene, an oblique summing up of the inability of both sides to look at or actually see each other, has an interesting relevance to Orientalist painting. Colette's account does not allow for any political empathy with the scene she is witnessing, but it does illustrate the mighty influence of French Orientalist images of North African women, which, drawn from *recherché* Salon paintings as well as from cheap pornographic postcards in wide circulation at the time, had saturated the popular imagination.[10] Colette arrived at the Oriental scene, as Gustave Flaubert and countless other European writers and artists had done before her, with a cultural predisposition to see it in a certain way. Her rendering of it is certainly highly coloured and painterly: it evokes the woman's face and body, her amulets and earrings, her silver belt and gauzy skirts, the oasis in the lilac light of evening, all depicted in carefully applied layers of picturesque prose, not unlike the

thin glazes that give Orientalist paintings their (far too exquisite) finish. Indeed, Colette's description of the dancer is so self-consciously pictorial, that it summons up the painted *almehs* by Jean-Léon Gérôme, far more than it does the living, breathing woman in her presence.

French Orientalist painting, as exemplified by the works of Gérôme (figs.28, 126), may appear more sensual, gaudy, gory and sexually explicit than its British counterpart, but this is a difference of style not of substance, at least if seen from an 'Oriental' vantage point. France and Britain, although neither would like to think so, shared much the same attitude towards the Orient as far as religious and racial prejudice and colonial ideology were concerned. Similar strains of fascination and repulsion convulsed the imaginations of their artists. The different methods of expression, reflecting different national temperaments, strike me as academic, since the resulting works, although divergent in technique, ultimately convey the same message. British Orientalist painting remained preoccupied with British social codes, even when the painters dressed up like Orientals, and played house like Orientals. Lewis, who lived for a few years in Cairo in a traditional Arab dwelling, evidently enjoyed his stay there, acting out the role of pasha, and dressing for the part in turban, sirwal and qamis. William Makepeace Thackeray, who visited him there, mused over the transformation in one who had been renowned in London's Regent Street for 'the faultlessness of his boots and cravats, and the brilliancy of his waistcoats and kid gloves'. No doubt, Thackeray commented wryly, back in London, the painter's 'neglected sisters tremble to think their Frederick is going about with a great beard and a crooked sword, dressed up like an odious Turk'.[11]

The disguise that Oriental dress provided the British, so amply documented in this exhibition – whether donned for convenience, amusement, polite integration or espionage – permitted its wearer to move as if by magic from one racial category to another. However, given the severe regimentation of their own hierarchical society, no Briton ever wished actually to become an Oriental by emulating Oriental speech, dress or habits, or to prefer the society of Orientals, unless it served a political or material purpose. Richard Burton, whose portrait as an 'Arab Sheikh' is shown here (fig.36), stained his skin with walnut juice to add to the effect of his costume, which managed, he claimed, to fool everyone. He recounts gleefully how he was cursed by two British colleagues who had failed to recognise him, and who had called him an 'upstart nigger' for venturing too near. He also tells how, when on his way to Mecca disguised as a wandering pathan, he was tipped off, in trusting religious complicity by another pilgrim, about riots being planned against the British in certain Indian provinces. Burton writes that he wasted no time in telegraphing this information to British Headquarters.[12]

Although in disguise, such travellers never really merged with the culture they were imitating. The more like the culture's inhabitants they appeared in dress and manner, the more distinct they felt themselves to be. This was the case with David Roberts, somewhat stiff in Oriental garb as represented by the painter Robert Scott Lauder (fig.39). Roberts explained that he only wore it in order to avoid unwanted local attention while sketching. Famed for his idealised landscapes of Classical ruins, he actually detested the contemporary Arabs marring the immaculate antique scenes he wished to convey.[13] And yet stylised groups of them appear in his paintings, to add a touch of colour or to demonstrate scale. Looking at these works, one feels admiration for his skill as a draughtsman but little emotion. The pictures seem static and forlorn.

The real unease of the British in the Middle East is best captured, however, by Augustus John's masterly and psychologically penetrating portrait of the British agent T.E. Lawrence (fig.60). He liked to masquerade in Arab clothes in order to perpetuate the 'Lawrence of Arabia' myth, which was the key to his glorification. He may have gone around in Arab skirts to sublimate his motives, but he was at heart a hard-core imperialist, who ultimately despised the Arabs among whom he moved, and who he wanted to turn into Britain's 'brown dominion'.[14] He believed that he knew better what they needed than they were capable of knowing themselves.

Orientalism has always rested on the peculiar premise that the West knows more about the Orient than the Orient knows about itself. This premise, most starkly obvious in political discourse – and disastrously so in today's White House – also underlies the 'softer' area of painting too. This made for an Orientalist canvas that posited itself not just as a mere picture, but as an important repository of knowledge. The super-realism of most of these paintings made them resemble archival or documentary photographs, conveying a deliberate impression that they had 'caught' the Orient exactly as it was. But this realism was ultimately deceitful. It masked but articulated particular sexual, religious, psychological or racial prejudices, rather than the internal logic and energy of an actual place. As MaryAnne Stevens has noted, 'The high finish and meticulous rendering of detail in most "ethnographic" painting encouraged the spectator to accept them as literally truthful images', bolstering the apparent 'truth' of their prejudices too.[15]

In fact Orientalist paintings of the first half of the nineteenth century were, if anything, far more like 'photographs' than were the early Western photographs of the Orient, as these had to contend with still cumbersome cameras and fragile film, which sometimes failed to develop satisfactorily, resulting in images that were often unfocused or unclear. After 1860, however, picture-taking by Oriental photographers became an important phenomenon, with the establishment of local studios in Constantinople, Baghdad, Aleppo, Damascus, Beirut, Jerusalem and Cairo by Syrians and Armenians. Many of these artists, like S.G. Harentz in Damascus, or the renowned Abdullah brothers in Constantinople and Cairo, who enjoyed the patronage of the Ottoman and Egyptian courts as well as of a wider public in these rapidly changing cities, produced an invaluable and sensitive record of the times.[16] If early Western photographers recreated the pat themes of Orientalist painting –

Fig.29
Old Damascus 1873/4
Frederic Leighton
Oil on canvas, 129.5 x 104.1
Private Collection

found themselves as a matter of course painting out of doors, if only for the pragmatic reason of being a continent away from their habitual studios. It was therefore in the Middle East and North Africa that this major shift in traditional artistic practice took place. As Stevens has put it, the awareness of the properties of strong natural light and its translation into paint was 'the most prominent contribution of Orientalist painting' to the art of the nineteenth century.[18] It was also the most enabling and invigorating. Stevens quotes the French critic Hector de Callias, who noted in 1864:

> French painting owes a great debt to the passion for the Orient. This passion has given it what until now has been lacking, light and the sun. What is, in effect, missing from the French gallery at the Louvre? It is neither style in drawing nor the science of composition, nor again the harmony of colour. It is the rays of the sun.[19]

He was writing just as Impressionism was erupting as a molten force with its radical policy of taking one's easel out into nature, the better to capture the shifting impressions of light.

Despite the wonderful gift of metamorphic light that it gave to nineteenth- and twentieth-century Western painting, which resulted in cataclysmic transformations in style and important experimentations with colour, Orientalist painting as a genre remained frozen in formula and fetish. Its general psychological thrust continues to strike me as quite unable, for complicated historical and political reasons, to conjure up an emotionally recognisable depiction of the world to which I belong. But, to give them their due, many of these paintings have managed to preserve a poignant visual record of places that are now altered beyond recognition, or have vanished forever. The poetic canvases of Edward Lear, summoning up atmospheric glimpses of Cairo, Beirut and Damascus, tug at my heartstrings, recalling as they do an age before these cities were devastated by massive over-population, modernisation and the horrors of war. Lear was never recognised as a major British Orientalist painter, having been out of tune with the 'Orient' then in demand. His paintings excited little enthusiasm in his own day, having nothing sensationalist about them. He died unhappy and unrewarded, writing that he had only managed to 'topographize' his life.[19]

And at a time when unique and invaluable areas of historic Old Damascus, dating back to Mamluk and Ayyubid eras, are threatened with demolition by government plans that have little but short-term greed in mind, it is a melancholic delight to view Frederic Leighton's exquisite painting of a traditional Damascene courtyard house (fig.29). This is Bait Farhi in the Jewish Quarter, still standing but much distressed and neglected. Its fate is similar to the other crumbling but once noble courtyard houses in different quarters of Damascus that Brigid Keenan records in her book on these fast-vanishing buildings.[20] In Leighton's painting, two women and a young girl, all drawn one assumes from European models, gather lemons from

harem scenes inhabited by languorous, half-naked odalisques, in which the models were prostitutes, beggars, impoverished members of minorities, or even European women – local photographers, by contrast, chose to depict Oriental women in their natural environments, working, socialising, picnicking, posing in elegant clothes with their children and retainers, and exuding a sense of dignity and gravitas that had been clearly lacking in Western pastiche images of them. It made for a world of difference.

Every Western painter arriving in the Orient immediately saw its immense artistic potential. Thackeray wrote: 'There is a fortune to be made by painters in Cairo … I never saw such a variety of architecture, of life, of picturesqueness, of brilliant colour, of light and shade. There is a picture in every street, and at every bazaar stall.'[17] Despite this ready wealth of potential pictures, however, not every painter had the technical ability or inventive gift to express what he saw. Most artists had been trained to draw and paint in studio or museum conditions. Painting in natural light was still considered an unconventional and ill-advised undertaking, and few Western artists attempted it, apart perhaps from the occasional watercolour in preparation for a studio picture in oils. But the artists who painted in the East

a traditional courtyard tree, no doubt to turn them into the preserved delicacy that today still appears on people's breakfast tables, even when they live in modern flats in newer parts of the city. Leighton has also left us an image of the interior of the great Umayyad Mosque in Damascus (fig.166), which, despite some flaws in the positioning of those he painted at prayer, shows the building before the damage caused by a later fire and recent and insensitive renovation. His obvious love for this city he visited, so movingly illustrated not only in these paintings, but in the extraordinary house he had built for himself in London, with its Damascene tile-work and marble fountain, still speaks to us down the years, and moves me to thank his departed shade. Orientalism is nothing if not seductive.

PORTRAITURE

TRAVELLERS AND SITTERS: THE ORIENTALIST PORTRAIT
CHRISTINE RIDING

The adoption of Eastern dress by the majority of Western travellers, up to the early decades of the nineteenth century, seems to have been one of expediency, comfort and private satisfaction.[1] Why British travellers should then elect to have their portraits painted in costume requires further examination. Other agendas and strategies, both of the sitter and the artist, must come into play. The art of portraiture itself has always been, one might argue, a matter of interpretation rather than mimicry. And furthermore, as the genre developed and diversified during the eighteenth and nineteenth centuries in Britain, an individual could project different identities, whether delusory, transitory or contradictory. In terms of Orientalism, however, recent scholarship has focused on cultural cross-dressing in art and in life, to quote Mary Roberts, as 'an eloquent distillation of the Western Orientalist's desire for power over the Orient', the paradigm of this 'desire for power' in Roberts's subsequent argument being John Frederick Lewis's masquerade as an Ottoman gentleman in Cairo.[2] A more complex model, in this context, is presented by William Holman Hunt, who painted himself in Palestinian costume (fig.55) despite the fact that he never adopted Eastern dress when travelling. Thus, as Judith Bronkhurst has recently noted, his self-fashioning as an Oriental cannot 'be interpreted as a gesture of solidarity with the Arab people' but rather demonstrates the importance Hunt placed on 'his role as artist/explorer', and above all asserts his place 'in an historical, colonialist tradition.'[3] Without undermining the resonance and relevance of Roberts's or Bronkhurst's comments, a parallel argument might be proffered that cultural cross-dressing also represents an Orientalist's 'desire for power' over a Western audience, as a visual expression of his or her distinct experience, understanding and authority.

East–West Encounters

Europeans, who travelled privately and for pleasure until the rise of steam-boat travel, package holidays and middle-class tourism in the 1830s, were by definition very wealthy men. However the early history of the British travelling to Eastern territories was not connected with education and recreation, but rather with the interrelated professions of warfare, commerce and diplomacy (to these may be added that of pilgrimage, given that the Ottoman Empire contained most of the sites recorded in the Bible). Expanding trade opportunities resulted in the creation of the Levant (or Turkey) Company in 1581, with factories (trading posts) established across the Ottoman Empire and in North Africa, and the English East India Company in 1600, members of which combined the roles of company agents and ambassadors until the eighteenth century, and whose presence undoubtedly facilitated independent travel. Such rarely experienced journeys were commemorated by portraits, incorporating appropriate dress and locations as a means of visual biography. Lord Denbigh, the first English aristocrat to tour India and Persia, was painted by Anthony van Dyck after his return in 1633, wearing the pyjama-style clothing that was worn by European men in India (fig.30). And Lady Mary Wortley Montagu's unorthodox decision to accompany her husband on a diplomatic mission to the Ottoman Empire (1716–18), which established her reputation as one of the first Western women to travel there, inspired the highly influential portrait of her, in Ottoman-style dress with a view of Constantinople in the background (fig.57), attributed to Jonathan Richardson. In the eighteenth century such travel portraits became something of a tradition, with merchants, ambassadors and independent travellers either including artists in their entourage, as was the case with Jean-Étienne Liotard who accompanied Lord

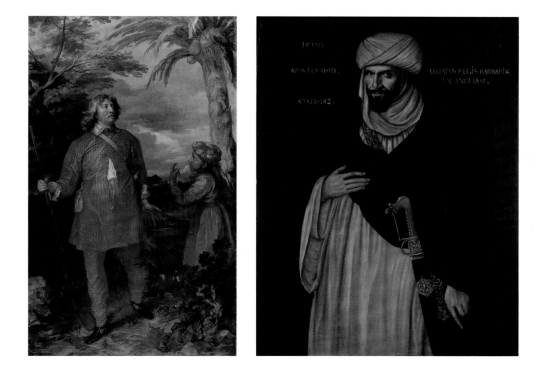

Fig.30
William Feilding, 1st Earl of Denbigh
c.1633/6
Anthony van Dyck
Oil on canvas, 247.5 x 148.5
The National Gallery, London

Fig.31
'Abd al-Wahid bin Masoud bin Muhammad al-Annuri, Moroccan Ambassador *c*.1600
Unknown artist, British School
Oil on wood, 114.5 x 79
The University of Birmingham Collections

Duncannon, later Earl of Bessborough, to Constantinople in 1738 and painted him in Ottoman costume in the early 1740s, or taking advantage of their presence abroad, as happened with the Italian artist Andrea Soldi, who seems to have been travelling in the Levant during the early 1730s. Soldi painted a number of English merchants in Aleppo, Syria, in the Ottoman dress they adopted while in residence.[4]

Trade and diplomacy also resulted in Eastern travellers to the West. Islamic states affected by Ottoman imperialism, such as the independent kingdoms of Morocco and Persia, sent delegations to Europe. In the case of Morocco at the end of the sixteenth century, alliances were also negotiated with European powers against Spain, such as occurred between Elizabeth I of England and Ahmad al-Mansur of Morocco.[5] The presence of 'Abd al-Wahid bin Masoud bin Muhammad al-Annuri in London in 1600 inspired an early example in British portraiture of an Arab sitter (fig.31), one of the first in a line of portraits of visiting ambassadors to Britain from Eastern territories, commissioned by private individuals and trading companies, or produced as speculative ventures by the artist.

Clearly the arrival of strangers in the West would not have made such an impression, positive or negative, were it not for the visual, particularly sartorial contrast that they presented. Dress was of great social, cultural and religious significance in Islamic territories, as evidenced by the plethora of sumptuary laws that were passed and, with varying degrees of success, enforced into the nineteenth century and beyond, affecting both Muslims and non-Muslims alike. Furthermore there is evidence that Western dress was often viewed as inappropriate for the public sphere. In 1810, Mirza Abul Hassan Khan, the Persian Ambassador to London, noted in his journal: 'As for English men's clothes, they are immodest and unflattering to the figure, especially the trousers which look just like under-drawers – could they be designed to appeal to the ladies?'[6] In the case of Ottoman and Persian ambassadors, their authority and prestige was closely related to the quality of their dress. In seventeenth-century Persia, for example, the final audience with the shah, prior to the departure of an embassy, was marked by the presentation of *khil'at* (honorific garments), as seen in the portrait of the English adventurer and diplomat Robert Shirley (fig.49), comprising gold-worked robes, turban cloth and accessories. Shirley conducted European embassies on behalf of 'Abbas I, Shah of Persia, between 1608–13 and 1617–24. The spectacle of his exotic entourage, including his Circassian wife, Teresia, progressing around the courts of Europe has been credited with 'pioneering the vogue for Europeans in oriental dress'.[7] Indeed he seems to have been painted on at least three separate occasions, by van Dyck, Richard Greenbury and by the unknown artist responsible for figs.49 and 50, which were probably painted in England during the first Persian embassy, when Shirley was received at the court of James I.[8] A portrait of Shirley's great rival, Naqd 'Ali Beg, also envoy to Shah 'Abbas and equally impressively attired, was commissioned from Greenbury in 1626 by the East India Company. Given that the purpose of their missions was simultaneously to negotiate a military alliance against the Ottoman Empire and the exclusive trade in silks for English merchants, their spectacular dress must also have served as a highly appropriate advertisement for luxury Persian textiles.

Eighteenth-Century Scholars and Travellers
During the eighteenth century (in contrast to the Victorian period), portraiture was the predominant form of contemporary art patronised by the British social elite. Thus for many artists painting portraits was a financial necessity. As demonstrated by

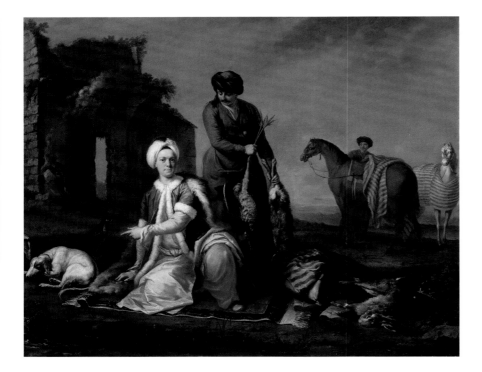

the works discussed here, some painters proved to be adept at manipulating existing portrait modes and other genres to fulfil the requirements of wealthy travellers, while exploring their own intellectual and professional ambitions. The portraits of Henry Lannoy Hunter (fig.32) and Francis Levett and Hélène Glavani (fig.56), for example, form part of eighteenth-century European genre painting (scenes of everyday life) and *tableaux de modes* (modern high-life subjects), which focused on the leisure activities and practices of the elite. Hunting, a favoured theme in European genre painting and portraiture, was perceived as an ennobling and heroic pursuit and had the added advantage of being equally esteemed across the Islamic world and often represented in Persian and Indian art. Soldi's portrait of Hunter, a Levant merchant, shows him dressed as an Ottoman gentleman and resting during a hunt, with his Armenian servants in attendance. Over and above the obvious pun on the sitter's surname, hunting with greyhounds and falcons (pictured to Hunter's right) was a favoured pastime of those residing in the Aleppo factory, especially in the mountains outside the city. This portrait may, in fact, have been executed after Hunter's return to England, when he joined the board of the Levant Company and acquired a country estate. Thus the portrait simultaneously signals Hunter's entry into the British landed elite and allows him to flaunt his exotic experience to his peers.

By contrast, Liotard's portrait of Glavani and Levett evokes the polite, cosmopolitan world of Western diplomats, merchants and travellers in the Ottoman capital, Constantinople (Istanbul), many of whom lived in Galata, which, during the eighteenth century and beyond, was the city's most Europeanised quarter. The meticulous, almost forensic observation of dress and furnishings (for example, Glavani, the daughter of the French Consul in the Crimea, is appropriately wearing the costume

of a Tartar, with fur-trimmed hat), coupled with the restrained poses and gestures, gives Liotard's painting a deceptively documentary quality, devoid, it seems, of the fantastical and erotic elements. It also contains details that were to become standard presentational devices over and above the authentic dress. For example, Levett, a Levant merchant, holds a *chibouk* (long-stemmed Turkish pipe), a distinctly 'Oriental' detail that is repeated in a number of portraits of male travellers (see Richard Dadd's portrait of Thomas Phillips, fig.22). Equally, the cross-legged or lounging pose habitually adopted on low-lying Ottoman seating was deemed appropriate for portraying the traveller throughout the eighteenth century and beyond, as demonstrated by the sculpture of Edward William Lane, the Orientalist scholar (fig.3). Glavani and Levett are thus not only dressing but also posing like 'Orientals'. Furthermore music, although often represented in European genre scenes, was one of the standard activities of harem women, as described by Orientalist artists and travellers (the long-standing nature of this association can be seen in harem photographs produced for the tourist market in Constantinople in the second half of the nineteenth-century). While promoting an idea of polite sociability *à la Turque*, Liotard's painting can also be read as a glimpse into the forbidden world of the harem.

Over and above professional travellers and their families, artists also catered to gentlemen tourists and scholars on the so-called grand tour. Rome, with its atmosphere of the Ancient world, remained the *locus classicus* of the grand tour itinerary, and where, by the mid-eighteenth century, a colony of British and European artists had been established. These included Gavin Hamilton, who produced one of the most artistically ambitious portraits on an Oriental theme, *James Dawkins and Robert Wood Discovering the Ruins of Palmyra* (fig.51). Scholarly interest in

Fig.32
Portrait of Henry Lannoy Hunter in Oriental Dress, Resting from Hunting, with a Manservant Holding Game
*c.*1733–6
Andrea Soldi
Oil on canvas, 118.5 x 146
Tate

Fig.33
Portrait of Richard Pococke 1740
Jean-Etienne Liotard
Oil on canvas, 202.5 x 134
Musée d'art et d'histoire, Geneva

Classical sites necessitated extending the itinerary from Italy, Magna Graecia and Sicily, to the Ottoman Empire itself. Liotard's full-length portrait of the scholar and cleric Richard Pococke (fig.33), commissioned by the sitter and painted in Constantinople in 1740, is, on one level, the grand tour portrait par excellence. Such portraits followed the conventions of grand society portraiture (epitomised in Britain by the work of van Dyck, which characteristically ennobled the sitter by suggesting natural grace, intellect and authority), but were distinguished by Classical references within the composition, such as the sitter sporting toga-like drapery, the addition of Classical antiquities or a view of an Ancient Greek or Roman site. While incorporating many of these artistic references and conceits, the full-length portrait of Pococke, like that of Lady Mary Wortley Montagu, is nonetheless a spectacular point of departure. Having completed a conventional European tour, Pococke embarked on a far more ambitious and unusual journey for the time, into the Near East. As stated in his *Description of the East* (published 1743 and 1745), his aims were to be pioneering and inquiring, surveying places that now 'are visited by few persons' but which were 'formerly very remarkable in antient [*sic*] history, or are curious at present with regard to natural history'.[9] This sense of scholarly endeavour defines Liotard's portrait, which is remarkable for its sombre grandeur, in stark contrast to other portraits discussed here that revel in the visual luxury of colour, texture and exquisite detailing. Bearded and wearing the clothes of an Ottoman gentleman or official, Pococke leans on an ancient altar, pausing from his reading to take in the view of Constantinople from the hill at Pera.

If the portrait of Pococke celebrates a pioneering traveller and scholar, then Hamilton's epic painting is a manifesto image that elevates the achievement of two British archaeologists to the level of a national event.[10] Between 1751 and 1753, James Dawkins and Robert Wood, accompanied by the artist, architect and draughtsman Giovanni Battista Borra, made an extensive tour of Classical sites on the Mediterranean coast and in the Near East. This resulted in two scholarly and much-lauded publications by Wood, entitled *The Ruins of Palmyra* (1753) and *The Ruins of Baalbec* (1757).[11] As befitted the traditional requirements of history painting, Hamilton approached his subject, a pivotal moment in the Classical revival of the eighteenth century, as if it were a grand and heroic subject from Classical history or literature. The toga-clad central figures of Dawkins and Wood are appropriately restrained and frieze-like, embodying the spirit of classicism.[12] They are contrasted with the dynamic figures of the mounted Arab escorts, one of whom turns with an expression of aggressive incomprehension at the turbaned figure of Borra, who is shown sketching the view of the Ancient site, just revealed to the travellers, which Hamilton based on a perspective view published in *The Ruins of Palmyra*. Cast as uncivilised, Hamilton's Arab figures act as a foil to the cultivated Dawkins and Wood and thus conform to the then prevailing associations of the East as wild and irrational (that is, anti-Classical). Paradoxically, these representations also tapped into another Orientalist theme of a static, Ancient world. Wood, for example, noted that the qualities of Homeric and biblical man prevailed within various communities of the Ottoman Empire. Pococke, too, made connections between Classical texts and historical and biblical geography, and the customs of the inhabitants of the Holy Land. Although a scene of contemporary history, Hamilton's painting incorporates a distant location, replete with ancient ruins, palm trees, a camel and turbaned figures, thus confusing the division between past and present,

resulting in an image that to his contemporaries would have seemed strangely timeless.

The Orient Performed

As we have seen, the idea of performance, or role-playing, was a theme of Oriental-costume portraiture. This was emblematic not only of familiarity with the Orient as mediated through European theatre, art and literature, but also of the more interactive theatrical experience that developed within eighteenth-century urban culture called the masquerade. Originating from Italian *carnevale* and *commedia dell'arte* theatrical troupes, masquerades were staged as public events in London theatres and pleasure gardens. The attraction was the undoubted frisson of adopting a variety of costumes and identities and, thus masked and in disguise, to socialise anonymously and indiscriminately, underlining the correlation often made between cross-dressing, emancipation and transgression (contemporary costume books not only provided a plethora of dress examples from across the Empire, but also the accompanying text often provided ideas on how to be 'in character'). Importantly, it was the tremendous vogue for masquerades that resulted in the demand, from beyond the traveller, for fancy-dress portraits. Lady Montagu's descriptions of Ottoman dress in her *Letters* (1763), and the portraits painted of her (fig.57), were copied and adapted by female masqueraders and by portrait painters: Mrs Delaney, for example, commenting on the King of Denmark's masked ball at the Haymarket Theatre, London, in 1768, noted that Mary, 3rd Duchess of Richmond attended 'as the Fatima described in Lady Mary W. Montague's letters'.[13] The sartorial effect, a European approximation rather than authentic Ottoman dress, can be gleaned from the portrait of the Duchess by Angelica Kauffmann, dated 1775 (fig.40),

which also illustrates the link we have already noted between the Antique and Ottoman dress.

The fact that Ottoman-style dress was second only to historical characters in popularity for eighteenth-century masquerade costume requires further explanation. For example, concurrent with the rise of the masquerade, and alongside the increasing popularity of travelogues, came the literary conceit of assumed Oriental persona – correspondence written in the voice of an Eastern informant residing in a European city, the genre defined by Montesquieu's satirical *Persian Letters* (1721). The notion of disguise itself tapped into the long-standing association in Europe of deception and impersonation with the Islamic world, underlined by the custom of veiling, which Lady Montagu pointedly described as 'this perpetual Masquerade'.[14] Furthermore, in Christian tradition, the prophet Muhammad himself was often referred to as an impostor, and was described as such in the first English translation of the Qur'an in 1649.[15]

In addition to the idea of impersonation was that of fantasy. The form of narrative invariably associated with the East, because it was perceived as 'backward' and regressive, was the ancient fable or tale, the most celebrated being the collection of traditional Persian and Arabic tales *Alf Layla wa-Layla*, translated from 1704 by Antoine Galland as *Les Mille et un Jours, Contes Arabes* and known in Britain as the *Arabian Nights Entertainments*.[16] Replete with jinn, magicians, fairies, physical transformations and legendary places mixed with historical figures and actual locations, these tales had a powerful and lasting effect on Western imaginings of a fantastical, as well as unchanging East, inspiring numerous European versions by male and female authors, and conditioning the expectations of even the most enlightened travellers into Eastern territories.[17]

Without doubt such fantastical associations with the

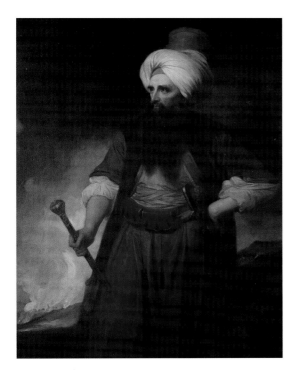

Orient encouraged role-play beyond the masquerade proper and into other recreational activities. A case in point is the short-lived Divan Club, established in 1744, which was set up specifically for gentlemen travellers to Ottoman territories, just as the Egyptian Club (1741–3) and the Society of Dilettanti (1734–2003) were for travellers to Egypt and Italy respectively. Its membership, many of whom were portrayed in Ottoman dress, included Lord Duncannon, Richard Pococke (fig.33), Robert Wood (fig.51), Edward Wortley Montagu (fig.35) and Sir Francis Dashwood (fig.34). Meeting once a fortnight in the Thatched Tavern in St James's Street, those attending sported blue turbans, sumptuous Ottoman robes and daggers, and referred to each other with Turkish titles, such as El Faquir Dashwood Pacha or Dashwood Effendi. In addition the Master of Ceremonies was called Reis Effendi, his minute-book The Koran, and the standing toast The Harem. Such theatrical antics, visually expressed in the humorously animated portrait of Dashwood in Divan Club costume by Adrien Carpentiers, may in the present seem faintly comic, if not bizarre. However, as Geoffrey Ashe has observed in the context of clubs and masquerades, the clue to an understanding of this carrying-on 'lies in the rigid consensus of a society where it remained difficult to rebel, difficult to assert freedom or dissent, except by eccentricity'.[18] Most participants were it seems able to separate recreational role-play from everyday life. Edward Montagu, however, did not. Disdaining convention and 'incapable of distinguishing fact from fiction', he lived for many years in Oriental style abroad, even claiming to the gullible European tourists he encountered that he was the son of the Sultan, conceived during the visit of his mother (Lady Mary Wortley Montagu) to the 'imperial *Seraglio*' (hence the appropriateness of his 'Ottomanisation').[19] Montagu's inveterate role-playing and celebrity was utilised by a number

of artists, including George Romney, who met him while in Venice. In the heroic swagger of the figure, and the dramatic lighting and background showing smoke-filled skies and a skirmish of (turbaned) figures, Romney's portrait is a spectacular Oriental adaptation of a brand of portraiture associated with military figures, which was developed from the mid-eighteenth century by Joshua Reynolds (see also Thomas Phillips's portrait of Lord Byron, fig.37, and James Sant's portrait of Captain Colin Mackenzie, fig.58). It casts the sitter in a very different character to the contemporary portrait by Matthew William Peters of Montagu as a venerable 'Rembrandtesque Rabbi' (1775).[20]

That the conflation of genre painting, portraiture and performance survived well into the nineteenth century is underlined by John Frederick Lewis's *A Frank Encampment in the Desert of Mount Sinai* (fig.101), and by the artist's own self-fashioning as an Oriental gentleman, in life and in art (discussed below). The latter bears a strong resemblance in attitude and desired effect to the best-documented performance in Oriental guise of the nineteenth century, namely Richard Burton's 'pilgrimage' to Medina and Mecca in 1853. Renowned later in life as a linguist, ethnographer, explorer and scholar, Burton was in the early 1850s a virtually unknown infantry officer in the Bombay Army. Thomas Seddon met him in Cairo after Burton had completed the pilgrimage and portrayed him 'in full Arab costume, with a camel, for an account he is going to publish of his travels in Arabia, and his journey to Mecca'.[21] The portrait (fig.36) was published as a lithograph in *A Personal Narrative of a Pilgrimage to El-Madinah and Meccah* (1855) under the 'disguise' title 'An Araby Shakh in his Travelling Dress'. On the one hand, Burton's elaborate parade as an Afghan Pathan (among other personae) underlines his self-fashioning as the man apart, whose vagrant existence, ambitious disguises and fluid identity was emblematic

Fig.37
George Gordon, Lord Byron 1814
Thomas Phillips
Oil on canvas, 127 x 102
Government Art Collection, UK

Fig.38
An Arab Muleteer 1841
David Wilkie
Watercolour and chalk, 54.6 x 38.3
National Gallery of Scotland,
Edinburgh

Fig.39
**David Roberts Esq. in the Dress he
Wore in Palestine** 1840
Robert Scott Lauder
Oil on canvas, 133 x 101.3
Scottish National Portrait Gallery,
Edinburgh

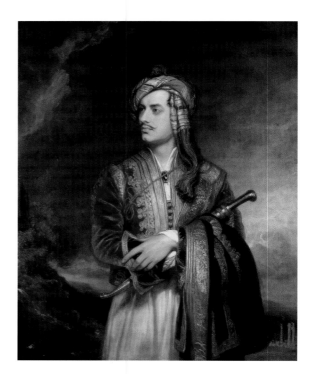

of a broader impatience with the conventions and social
mores of contemporary Victorian society. Conversely and
paradoxically, it also underlines Burton's life-long desire for public
recognition, as a scholar of Islam and as an Orientalist, and his
own craving for celebrity, thus blatantly playing to his audience's
delight in performance and daring enterprise, all in the laudable
service (as it would have been understood at the time) of
knowledge and discovery. However, the insensitivity of such
a deceit, in particular his enactment of the rituals sacred to
Muslims, while covertly gathering information for his narrative,
can perhaps only be understood in the broader context of
mid-nineteenth-century British culture and tourism.[22]
Burton's competitiveness was surely stirred by British residents
in Cairo, such as Lewis, or previously, Edward William Lane
(fig.3), who adopted the dress and lifestyle of the Ottoman elite,
even using the alias Mansur Effendi, to aid his research into
An Account of the Manners and Customs of the Modern Egyptians
(1836). Burton was also acutely conscious of other non-Muslim
Europeans (albeit few) who had made the hajj, and, in the
age of steam-boat travel, the growing presence of European
tourists in Egypt and the Holy Land and the abundance of
Eastern travelogues. Burton's aim was thus to outdo everyone
else. Indeed, his *Personal Narrative* caused a sensation and made
him famous.

Celebrity and Self-Promotion

Many of the portraits described so far were displayed in private
residences or the quasi-public environments of clubs and trading-
company premises. Other portraits and self-portraits, particularly
those described in this section, were conceived specifically
for public display in exhibitions and galleries and/or wider
distribution through the ever-expanding possibilities of the

eighteenth- and nineteenth-century print and media culture.
The first London public art exhibition in 1760, at the Society
of Artists, has been described as 'the inauguration of a new era
in the nation's visual culture'.[23] Likewise, the annual exhibition
at the Royal Academy, established in 1768, was a fashionable
form of urban entertainment, as well as the premier public space
for the exhibition of contemporary art, a position it retained into
the twentieth century. This highly commercial and contested
environment, frequented by patrons, the art-interested public
and critics alike, quickly made its influence felt on the production
of art, with artists literally vying with each other for the viewer's
attention. Unsurprisingly, given the predominance of portraits
within the crowded exhibition walls (between 1788 and 1820
portraits constituted approximately forty-five per cent of the
exhibits), portraitists learned to be highly strategic when
submitting works, often taking advantage of the celebrity status,
topicality or exotic appeal of the sitter, as did Joshua Reynolds
with his speculative portrait of the society beauty, Jane Baldwin,
exhibited in 1782 under the title of 'Portrait of a Greek Lady'
(fig.53). Baldwin had already established herself as a figure of
public interest before arriving in London in 1781, having been
admired in European courts and painted by numerous artists.
Although born to British parents, she had a claim to an authentic
experience of Ottoman life (she is shown holding an ancient
coin from Smyrna, now Izmir, her birthplace) denoted by her
sumptuous costume, which might otherwise have seemed an
absurd affectation or, in the case of her impolite, cross-legged
pose, gratuitously risqué.[24]

A more complex self-promotional strategy can be seen
in Thomas Phillips's now-celebrated portrait of Lord Byron,
exhibited at the Royal Academy in 1814 as 'Portrait of a
Nobleman in the Dress of an Albanian' (figs.37, 59). On a prosaic

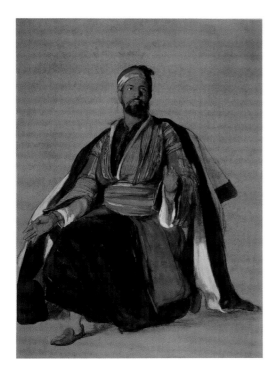

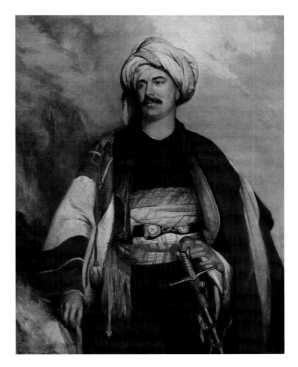

level, as Aileen Ribeiro has noted, portraits of men in exotic costume painted during the Romantic period, 'like braided [military] uniform … served the cause of masculine vanity in an increasingly sober sartorial age'.[25] Phillips's portrait also underlines Byron's desire to be seen to be distinctive as a traveller and as an Orientalist poet. While Greece was relatively well known by that time, largely due to the customary practice of the grand tour, Albania was a more truly remote, hazardous and thus unvisited region, underlining Byron's characteristic determination to 'take a wider view than is customary with travellers'.[26] Most important, however, was the nature of Byron's celebrity at this time. Prior to the RA exhibition of 1814, speculation had abounded about how far the contents and characters (especially the brooding, disenchanted 'Byronic hero') of *Childe Harold's Pilgrimage* (1812–18) and *Turkish Tales* (1813–14) were autobiographical. As prescribed in 'The Giaour', the first of Byron's *Turkish Tales*, the eponymous 'hero' is dressed for his deadly combat with the Turkish lord, Hussan, as a Suliot, or Albanian Christian, the same costume that Byron wears in his portrait.[27] While Byron was not 'disguising' himself, he clearly sought to confuse the division between his poetry and his own biography and identity by playing to the idea of the character of the Giaour as a disguised self-portrait, thus infusing his own public persona with ambiguity and romance.[28]

In its direct referencing of van Dyck, its grandeur of scale, bold use of colour, contrasts in light and unashamed exploitation of the newsworthy, James Sant's portrait reproduced here (fig.58) is the exhibition portrait par excellence. It was shown at the Royal Academy in 1844 with the title *Captain Colin Mackenzie, Madras Army, lately a hostage in Caubool, in his Affghan dress*. Mackenzie was a survivor of the First Afghan War (1838–42), which, from the British point of view, was an unmitigated disaster, involving the

massacre of over sixteen thousand British and Indian soldiers and camp followers during the retreat from Kabul to Jalalabad.[29] Mackenzie himself was taken prisoner and held at Kabul by Muhammad Akbar Khan, the son of the ruler of Afghanistan, Dost Muhammad, who had been deposed by British forces. According to another hostage, Lady Florentian Sale, whose bestselling journal was published in 1843, Mackenzie was presented with 'handsome' Afghan dress by Akbar Khan himself.[30] The hostages were subsequently released by a relief force, the so-called Army of Retribution. While the portrait thus plays to the jingoistic sentiments of the British public, casting dramatic events in contemporary British history and the so-called 'Great Game' in a heroic and glamorous light, it also registers the vicissitudes and accompanying anxieties of the nation's imperial ambitions.

Self-portraits and portraits of painters, so crucial to self-fashioning and self-promotion, were regularly exhibited at the Royal Academy and other venues. Both Roberts and Hunt used authentic costume in portraiture to imply their authority as Orientalist painters of landscape and biblical subjects respectively to a British audience, resulting from their extensive personal experience and observations. Thus Robert Scott Lauder's portrait (fig.39) was exhibited with the title 'David Roberts Esq. in the Dress he wore in Palestine', alongside the sitter's own first Eastern landscapes, at the Royal Academy in 1840. Unlike Roberts, Hunt doggedly refused to wear Oriental dress during his travels and even ridiculed his companion Seddon for doing so. Thus his self-portrait (fig.55) in Palestinian/Syrian dress, a simple blue-striped, wrapover gown or *qumbaz*, tied with a cashmere sash which, combined with the full beard and the painter's palette, is clearly calculated to project an image of the artist, at once contemporary and 'biblical', as the foremost

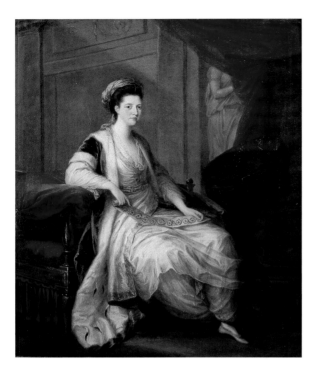

religious painter in Britain. Hunt was photographed in similar guise by Julia Margaret Cameron in 1864 and the following year depicted by John Ballantyne in his studio, painting a version of *The Finding of the Saviour*. The self-portrait was variously exhibited with religious works such as *The Scapegoat*, *The Shadow of Death* and the contemporary religious scene *The Miracle of the Sacred Fire, Church of the Holy Sepulchre* (fig.140), culminating in his one-man show of 1906, before being donated to the historic collection of self-portraits at the Uffizi Gallery in Florence.[31]

While the strategies of Roberts and Hunt are fairly transparent, a more subtle, even mischievous self-promotional campaign was played out by J.F. Lewis. In 1861, he exhibited *In the Bezestein, El Khan Khalil* at the Royal Academy (see fig.11 for the watercolour version of this composition), which was accepted by a critic in *The Athenaeum* as a straightforward Cairene genre scene, depicting 'a portly easy-going Oriental merchant, seated in a state of delicious do-nothingness in the front of his counter in the great bazaar'.[32] In fact, the figure and costume bear a striking resemblance to Lewis himself, as evidenced by contemporary photographic portraits of the artist (figs.12, 13). Without doubt Lewis's depictions of Oriental and, in particular, harem life were given greater veracity in the eyes of his European audience because of his well-publicised adoption of an elite Ottoman lifestyle, a metamorphosis first described for a British audience by William Makepeace Thackeray's *Notes of a Journey from Cornhill to Grand Cairo* (1846), in which the artist was described as existing 'far away from the haunts of European civilisation, in the Arab quarter' of Cairo.[33] It is highly likely that this colourful 'advertisement' was a collaborative venture between Thackeray (who, on his return to London, regaled listeners with fabulous tales of harem life while lounging in Turkish dress and smoking a pipe) and Lewis himself, in advance of the exhibition of

The Hhareem (fig.137) in 1850. Indeed Emily Weeks has described it as 'a calculated business deal between an author and an all-but-forgotten artist, about to re-enter the Victorian art world'.[34]

Women's Orients

Very few women travelled to Eastern territories during the seventeenth and eighteenth centuries. Those that did so tended to be the wives and female relatives of merchants, diplomats and other professional travellers, like Lady Mary Wortley Montagu, Hélène Glavani and Jane Baldwin, and additionally from the early nineteenth century, Oriental scholars. Thus a portrait of a female traveller in Oriental dress, such as David Wilkie's portrait of Elizabeth Young (fig.52), wife of the first British consul in Jerusalem, is relatively rare. Given the often sexually loaded contexts of Eastern women in Orientalist art, how did artists negotiate their representations of Western women? A case in point is Henry William Pickersgill's unusual double portrait of the writer and traveller James Silk Buckingham and his wife Elizabeth (fig.41), exhibited at the Royal Academy in 1825. On one level, the image can be understood in the context of masquerade and role-play, previously discussed, with husband and wife cast as Persian shah and harem favourite and, in a biographical context, functions as a statement of Buckingham's personal experience and intellectual interests: he had travelled extensively in Egypt, Palestine and Persia, and had the year before the exhibition established the journal, *Oriental Herald and Colonial Review* (1824–7). However Buckingham's evident affection for his wife, from whom he had been parted during his travels, underlined by the intimate yet respectful look and gesture, and the general atmosphere of marital contentment and sexual exclusivity, undoubtedly projects (intentionally or not) a more positive image of harem life.

Fig.40
Portrait of Mary, Third Duchess of Richmond 1775
Angelica Kauffmann
Oil on canvas, 73.8 x 61.3
The Trustees of the Goodwood Collection

Fig.41
James Silk Buckingham and his Wife Elizabeth in Arab Costume, Baghdad
1825
Henry William Pickersgill
Oil on canvas, 145 x 115
Royal Geographical Society, London

Fig.42
Isabel, Lady Burton *c*.1869
Unknown photographer
Hand-coloured albumen *carte-de-visite*,
5.3 x 9.1
National Portrait Gallery, London

The rise of female travellers in the nineteenth century saw the development of harem literature by Western, and later Eastern, women, a distinct literary genre that, as Billie Melman has argued, 'presents the most serious challenge to Orientalist and patriarchal authority'.[35] Harem literature was instigated in the eighteenth century by Lady Mary Wortley Montagu, who has the reputation of being the 'first female orientalist' and whose *Letters* 'acquired the status of an authority on things oriental'. Given the paucity of travelogues written by women pre-1801 – Richard Bevis lists one between 1500 and 1763 and three between 1763 and 1801, as opposed to two hundred and forty between 1801 and 1911 – Montagu's totemic status, from the eighteenth century and into the present, is unsurprising. Indeed when Hector de Callias reviewed Henriette Browne's paintings in *L'Artiste*, there is a degree of inevitability about his analogy that the artist had 'journeyed in the Orient. Like Lady Montagu, she penetrated into the harems.'[36]

While the scope of Montagu's observations is broad, what dominates the *Letters* is her acute awareness of the gender restrictions to her privileged status in Britain, as contrasted with the legal and social position of the women she encountered within the urban elite of Sofia, Adrianople and Constantinople. In response Montagu deliberately set out to contradict received male wisdom – naming specific travellers as culprits in projecting unfounded Eastern fantasies – presenting instead the positive aspects (as she saw it) of Ottoman culture and costume, especially of veiling, which to her signified freedom of movement and thus social and sexual freedom, and the advantages of gender segregation, with the harem as an exclusive female space with its own distinct culture and rituals.[37] The commanding portrait of Montagu (fig.57) can thus be appreciated in the context of her authority as a specifically female commentator, her championing

of 'liberating' Turkish female dress, and, in tandem with the *Letters*, her promotion of the idea of greater empowerment for (aristocratic) women in the West. It is in this context that Angela Rosenthal has recently re-evaluated a group of portraits of female sitters in Ottoman costume, painted by the Swiss artist Angelica Kauffmann in the late 1760s and 1770s, that is, after the publication of Montagu's *Letters* in 1763.[38] These portraits, like that of Montagu, may project sensuousness, even languor, but they do not pander to the then prevailing ideas of the East as a site of female enslavement and sexual exploitation. Thus rather than appreciating them as simply reflecting the European-wide vogue for *turquerie* or fancy-dress/masquerade portraits, Rosenthal interprets Kauffmann's portrait of Mary, 3rd Duchess of Richmond (fig.40) and other aristocratic sitters, as being located 'metaphorically – from within the feminine space of the harem' as promoted by Montagu.[39] It is additionally poignant that such images were created by a professional female artist, who consistently asserted her position in a male-dominated sphere.

While nineteenth-century female authors were projecting a very different vision of the harem, one that was desexualised and domesticated, Ottoman dress was at the same time being employed as part of a re-evaluation of Western female fashion, focused specifically on the trouser-style garments worn by men and women in the Ottoman Empire; hence such terms as 'harem costume', made up of short skirts or 'harem skirts' with 'Turkish trowsers', which were used to describe so-called reform dress.[40] In the West, until the twentieth century, trousers were strictly coded as male. Thus if trousers represented physical freedom (as opposed to cumbersome, full-length skirts), then it was not a huge mental leap to view wearing them as emblematic of being liberated from wider societal restraints. Interestingly

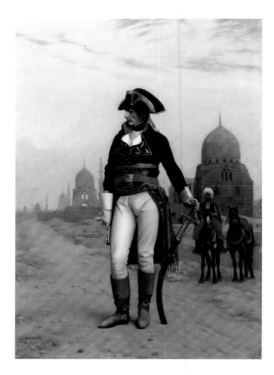

Fig.43
Napoleon in Egypt *c.*1863
Jean-Léon Gérôme
Oil on wood, 35.8 x 25
Princeton University Art Museum

Fig.44
Muhammad 'Ali, Pasha of Egypt 1841
David Wilkie
Oil on board, 61 x 50.8
Tate

Fig.45
Sultan Abdul Mejid 1840
David Wilkie
Oil on board, 80.7 x 58.4
The Royal Collection Trust

analogies were made by some reformers (in direct contrast to Lady Montagu) between the relative 'oppressions', the harem and the skirt, as experienced by women in both cultures, as this poem from 1864 makes clear:

> Talk of Turkish women
> In their harem-coop,–
> Are we less inhuman,
> Hampering with a hoop?
> All free motion thwarted;
> Mortals *à la mort*;
> Life's a thing aborted,
> Through your draggle-skirt.[41]

Despite the fact that there was no intention to blur the line between the sexes, most diatribes against the reform of dress in the British and American press focused on the idea that wearing trousers, thus 'gender crossing', would somehow de-feminise women, making them more 'male' in appearance and behaviour. Such charges of indecorum were also present in the eighteenth century, even in the make-believe world of the masquerade. The frisson of Ottoman masquerade costume, when worn by women, was thus twofold: first, from its inevitable association with the sexually loaded idea of the harem; and second, to quote Terry Castle, that 'transvestite costume was always symbolically charged, evoking realms of perverse and ambiguous sexual possibility'.[42]

In this context, how are we to understand Isabel Burton's self-visioning in the *carte-de-visite* produced in about 1869 (fig.42), in which she is shown reclining wearing an adaptation of male Arab dress? Like Lewis's photographic portrait (fig.12), this image was created for circulation among her intimate acquaintances

and may, also like Lewis's, constitute a private joke, hence the smile on her face. Isabel Burton records how she and her husband would don Arab dress – which she admitted, in her case, would appear indecent to her readership – to wander through the streets of Damascus, or to make excursions into the desert, with Isabel posing (somewhat implausibly) as her husband's son. She was in fact one of a number of nineteenth-century female travellers who wore male dress abroad as part of the liberating and emancipating experience of travel, examples in Eastern territories being the female adventurers Lady Hester Stanhope and Jane Elizabeth Digby, the latter an acquaintance of the Burtons. Dane Kennedy has recently concluded that the Burtons' affinity for impersonation should be understood almost purely in terms of 'private satisfaction', because it 'provided a way of transgressing against the codes and conventions that governed [Victorian] society'.[43] This must have been especially poignant for Isabel Burton, given the additional restrictions she would have experienced as a woman in Britain. In which case, whether her disguise duped anyone is largely irrelevant.

Modernising Modes
In an essay published in 1920, T.E. Lawrence ('Lawrence of Arabia') noted with regret that 'the East is to-day the place of change – of changes so great and swift that in comparison with it our Europe is standing still'. Writing in the aftermath of the First World War, Lawrence attributed this rapid change to the European presence in the eastern Mediterranean, which had accelerated the absorption of the concepts of self-determination and nationality: what he termed 'the civilisation-disease'. Where previously faith had determined allegiance, Lawrence opined, now Muslims perceived themselves as Turks, Arabs or Egyptians. 'Europe,' he concluded, 'is not a thing easily digested.'[44]

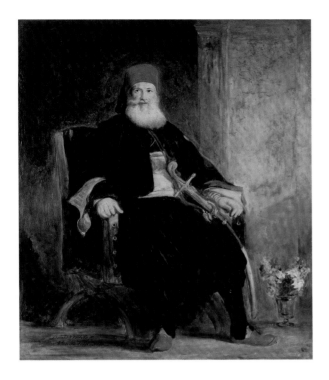

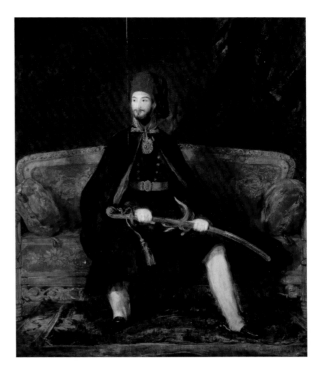

From the end of the eighteenth century, various reform programmes had been implemented by the Ottoman sultanate based on European models in military, technological and scientific fields. It is generally accepted, however, that a new era was heralded by the invasion of Egypt by Napoleon's army in 1798, through its dual representation of modernity and colonialism. The Muslim Egyptian historian, 'Abd al-Rahman al-Jabarti, and the Syrian Christian poet, Niqula al-Turk, observed the invasion and subsequent actions of the French in Egypt and Syria. Whilst critical and aggrieved, both Al-Jabarti and Al-Turk, as Rasheed El-Enany has recently described, recognised in Napoleon 'the modern age, the age of science, invention, advanced weaponry and battle tactics, the age of sophisticated administration and civil rights for the people'.[45] Albeit shortlived, the invasion galvanised the view among the ruling classes of the Ottoman Empire that, if Western Europe did indeed represent progress, then in order to meet it with any degree of equality and political independence, elements of the Western life model had to be adopted. The question was how much, the dilemma at what cost – social, cultural and spiritual.

A sense of the confrontation between modernity and tradition can be seen in Jean-Léon Gérôme's *Napoleon in Egypt* (fig.43). The figure of Napoleon, a visual embodiment of European power – modern, martial and secular – constitutes an abrupt, uncompromisingly alien presence before the domed structures and minarets of Cairo's City of the Dead, the sprawling cemetery outside the city that was a resonant symbol of Egyptian history and tradition. Painted more than forty years after Napoleon's death in exile in 1821, Gérôme's painting exudes the nostalgic quality of the Napoleonic legend as it developed in nineteenth-century visual culture, through the work of Paul Delaroche, Gérôme (his pupil) and other European painters. But it also chimes with the blunt propagandist imagery produced by French artists during and after the Egyptian campaign itself, such as Antoine-Jean Gros's *Bonaparte Visiting the Plague-stricken at Jaffa* 1804 or Pierre-Narcisse Guérin's *Napoleon Pardoning the Rebels at Cairo* 1808, which similarly contrasted Napoleon's 'enlightened' modernity with the 'primitive' figures of Egypt's ruling elite, defeated and discredited.

The Egyptian and Ottoman reform programmes during the nineteenth century were to have a profound influence on the society and culture of the eastern Mediterranean. That there was an attempt to be selective, rather than accepting wholesale changes, can be gleaned from the carefully worded title of Rifa'ah al-Tahtawi's influential travel account, *Takhlis al-Ibriz fi Talkhis Bariz* (*An Extraction of Gold in a Summary of Paris*) first published in 1843.[46] Al-Tahtawi was a senior member of the first mission of Egyptian scholars sent to France in 1826–31 by Muhammad 'Ali, Pasha of Egypt, the Albanian soldier who had accompanied the Ottoman army to relieve Egypt in 1801 and established himself de facto as its absolute ruler. In 1840 Muhammad 'Ali was granted hereditary rule as a concession by the Ottoman authorities, after his imperial ambitions in Syria and Palestine had failed. David Wilkie's portrait of 1841 (fig.44) thus came at a pivotal moment in his career and the history of Egypt. According to the artist, it was Muhammad 'Ali himself who commissioned the portrait and took an active part in its realisation, with Wilkie's near-contemporary portrait of Sultan Abdul Mejid clearly in his mind (fig.45). Indeed the two portraits hung side by side at the Royal Academy exhibition of 1842. Abdul Mejid, who had received a European education and spoke fluent French, succeeded his father Mahmud II in 1839 at the age of sixteen. Like other nineteenth-century sultans, Abdul Mejid sought to encourage

'Ottomanism', including the adoption of an Ottoman national anthem and flag, to counter burgeoning nationalist and separatist movements within the Empire itself, epitomised by Muhammad 'Ali. Wilkie depicts the young Sultan seated on a French-style sofa, dressed in sombre military uniform, an adaptation of French examples, comprising a long-skirted frock coat with cape and a tall fez cap with long tassel, replacing the turban, and holding the traditional scimitar. Muhammad 'Ali too, wears the fez, perceived at that time as a symbol of modernisation.[47] But he pointedly adopts the costume traditional to Cairo, such as the baggy trousers and slippers, and (unlike Abdul Mejid's close-cut beard) he wears a full, long beard, all of which contradicted recent Ottoman reforms and dictates.[48] His portrait was thus carefully conceived for a British audience: an image of the reformer and moderniser, like Abdul Mejid, but one who also seeks independence and a separate identity.

The portraits of the Sultan and the Pasha, one might argue, are variations on the same theme: attempts to present a brand of Eastern modernity that is influenced by, but distinct from, Western Europe. And further, that a claim is being made (to apply Michelle Woodward's analysis of Ottoman modernisation and Turkish photographers of contemporary urban life) to the effect that this modernity was in fact emerging from a rich indigenous culture and history.[49] Photography was promoted by successive sultans (Abdul Hamid II was a photographer himself) soon after its beginnings in 1839, because of its propaganda value for their modernising programmes, not least in being technologically cutting-edge. Dressed in westernised clothing and holding a fez, the photographic portrait of Osman Hamdi Bey with his daughter Nazli (fig.46) thus neatly underlines the wholehearted engagement by this pioneering artist, archaeologist and museologist with Ottoman

modernisation and modernity. Modernisation had its detractors, not least among European travellers and Orientalists, whose horror at the rapid changes stemmed in part from the treasured Western myth of a static world, whose inhabitants could be categorised by character-types familiar from the Bible and that perennial point of cultural reference, *The Thousand and One Nights*. This is certainly the case with Stanley Lane-Poole, who in the editor's preface to his revised edition of Edward William Lane's translation, published in 1859, lamented the cultural and architectural changes to Cairo instigated by Muhammad 'Ali, stating that 'Mr Lane's first two visits to Egypt were made when, for the last time, Arab manners and customs as they existed in the age of the Arabian Nights could be studied', concluding that his uncle 'saw the last of Cairo in its integrity'.[50]

If the urban centres of Cairo and Constantinople and elsewhere were changing out of all recognition by the early twentieth century, the rural communities, in particular the northern nomadic Arab tribesmen or Beduin, with 'their connection to the land' and 'the mystery of their ancient culture', could still furnish Western romantic notions of an unchanging East, as evidenced by John Singer Sargent's evocative images of Beduin, executed during his travels in Syria and Palestine in 1905–6.[51] Indeed, when Lowell Thomas, the American travelogue lecturer, broadcaster and showman, was sent by the US Government to gather film footage to garner popular support for America's entry into the First World War, he bypassed the uninspiring carnage of the Western Front for the exotic potential of General Edmund Allenby's campaign against the Ottoman Empire in Palestine and Arabia. There he met T.E. Lawrence, who served as the liaison officer between Emir Feisal and the British Army from late 1916 until the fall of Damascus in October 1918. Lowell's dramatic film footage was reworked

into a two-hour, travelogue-film exhibition entitled *With Allenby in Palestine and Lawrence in Arabia*. The second half focused on Lawrence, packaging him in highly romanticised terms as the warrior hero and 'uncrowned King of Arabia'. It toured the United States, Great Britain and parts of the British Empire to tremendous popular and critical acclaim, from 1919 until about 1926, and was seen by an estimated four million people. Lawrence, who was deeply sympathetic to Arab culture and traditions, adopted Arab dress during wartime largely as an expedient.[52] In the aftermath of the First World War, however, he adopted this traditional dress, now emblematic of Arab nationalism, as a show of solidarity with Emir Feisal (fig.47) and other delegates negotiating Arab independence at the Peace Conference of 1919, which the British (including Lawrence) had promised in order to secure Arab support. Augustus John, the Official War Artist recording the conference, painted Lawrence several times in Arab dress (figs.48, 60), as did Eric Kennington and others, and these were included in the *War, Peace Conference and Other Portraits* exhibition at the Alpine Club Gallery in 1920. If taken at face value, however, as a portrait of a European in Eastern costume, separated from its historical context, John's portrait of Lawrence is a fairly conventional, not to say unremarkable, portrait, one that slips easily into one or all of the cultural and artistic strands discussed in this essay. What if we insert the image back into the years following the First World War? That such an image, of a blond, English officer, dressed as an Arab *sharif*, should have become the most resonant of the war in the East was the responsibility, not of Augustus John, but of Lowell Thomas, with the blessing to a greater or lesser extent of Lawrence himself. As Steven C. Caton has observed, Lowell's 'Orientalised portrait of Lawrence' was 'one of the most remarkable examples of the creation of a celebrity in the

history of mass media', one that was fabricated and marketed at a moment when British influence was consolidated in the Near and Middle East.[53] Indeed Lowell's 'portrait' (and thus John's portrait) constituted, in Caton's words, a 'complete justification for British imperialism', representing Lawrence as:

> this blue-eyed poet of Gaelic ancestry [who] succeeded in accomplishing what no caliph and no sultan had been able to do in over a thousand years. He wiped out the century old blood feuds and built an army and drove the Turks from Holy Arabia.[54]

Clearly there is no attempt at disguise. Lawrence is not posing as an Arab. How could he? But perhaps that is exactly why images like John's portrait resonated with the British and Western public. Not only because it represents 'an eloquent distillation of the Western Orientalist's desire for power over the Orient',[55] but also because it suggests that this power, now formally achieved, and instilled in the figure of Lawrence, will be exerted with knowledge, understanding and empathy.

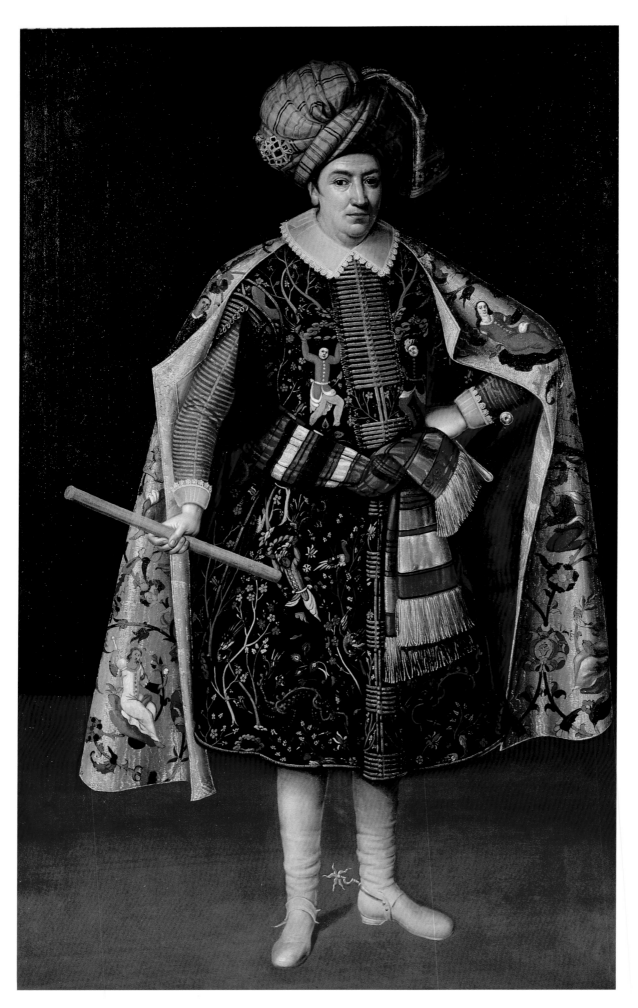

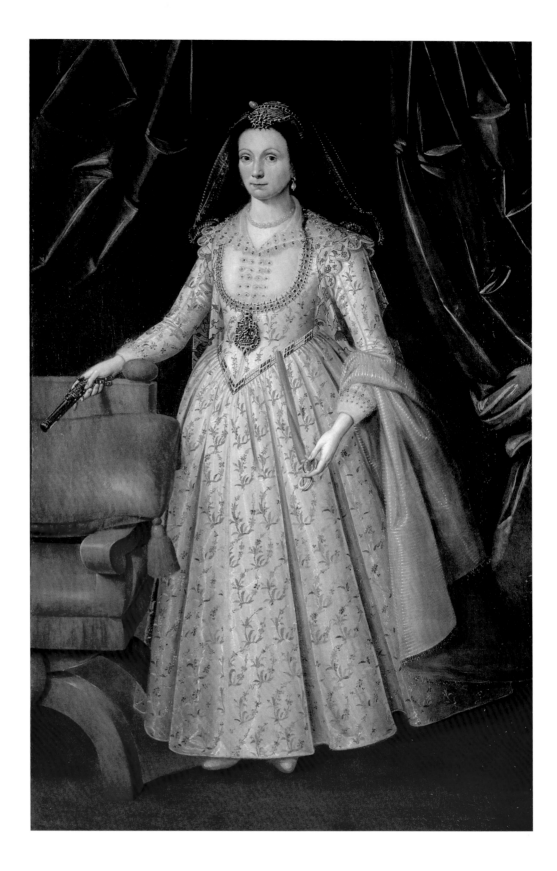

Fig.49
Sir Robert Shirley, Envoy of Shah 'Abbas of Persia to the Courts of Europe before 1628
Unknown artist, British School, 17th century
Oil on canvas, 195 x 105
Trustees of the Berkeley Will Trust

Fig.50
Lady Teresia Shirley before 1628
Unknown artist, British School, 17th century
Oil on canvas, 214 x 124
Trustees of the Berkeley Will Trust

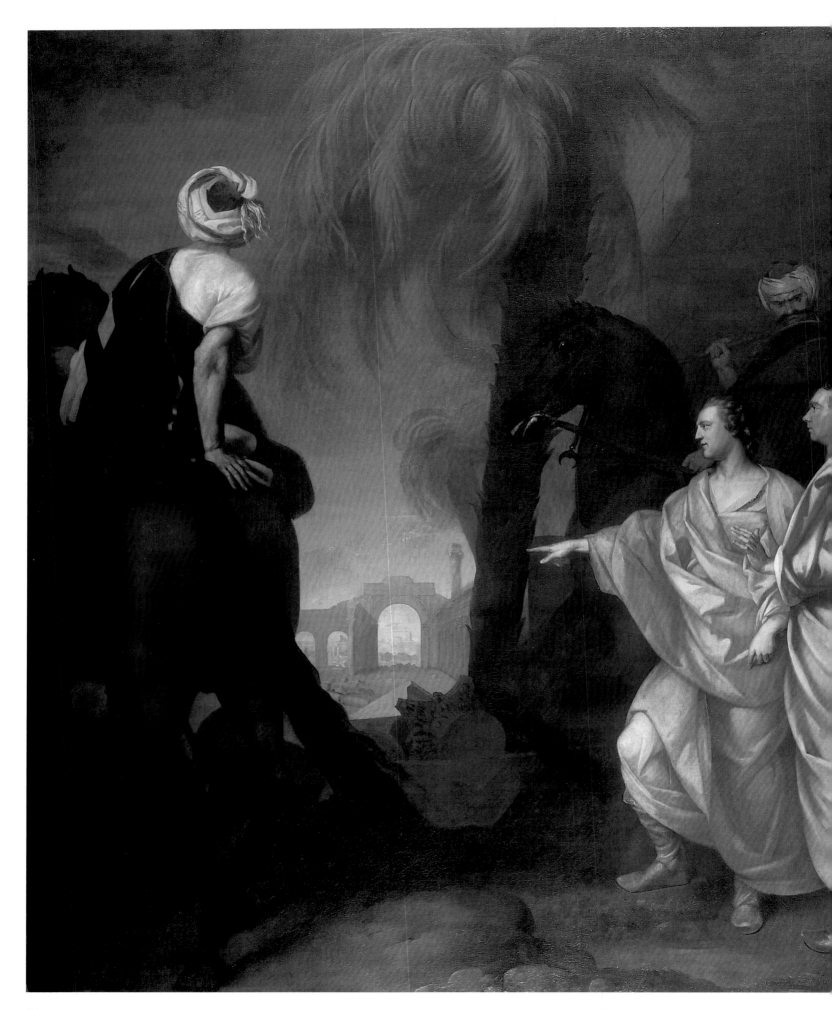

Fig.51
**James Dawkins and Robert Wood
Discovering the Ruins of Palmyra**
Gavin Hamilton
1758
Oil on canvas, 309.9 x 388.6
National Gallery of Scotland,
Edinburgh

Fig.52
Elizabeth Young in Eastern Costume
1841
David Wilkie
Watercolour, 49.5 x 33.7
Tate

Fig.53
Mrs Baldwin 1782
Joshua Reynolds
Oil on canvas, 141 x 110
Compton Verney

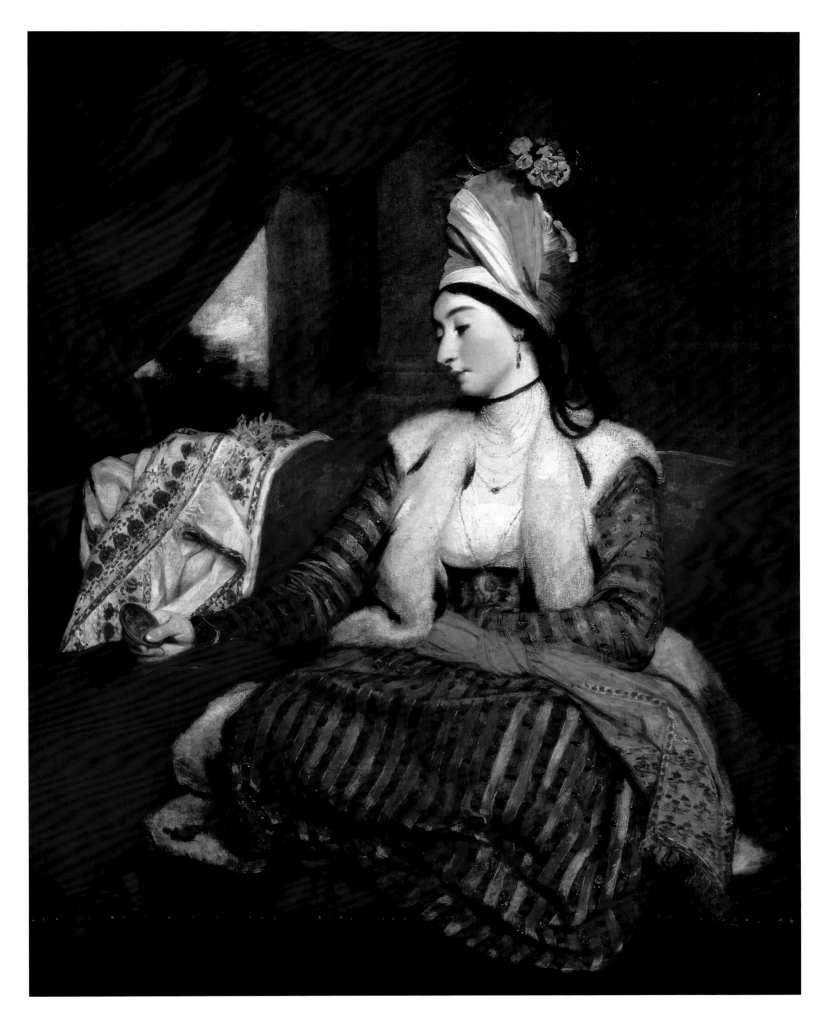

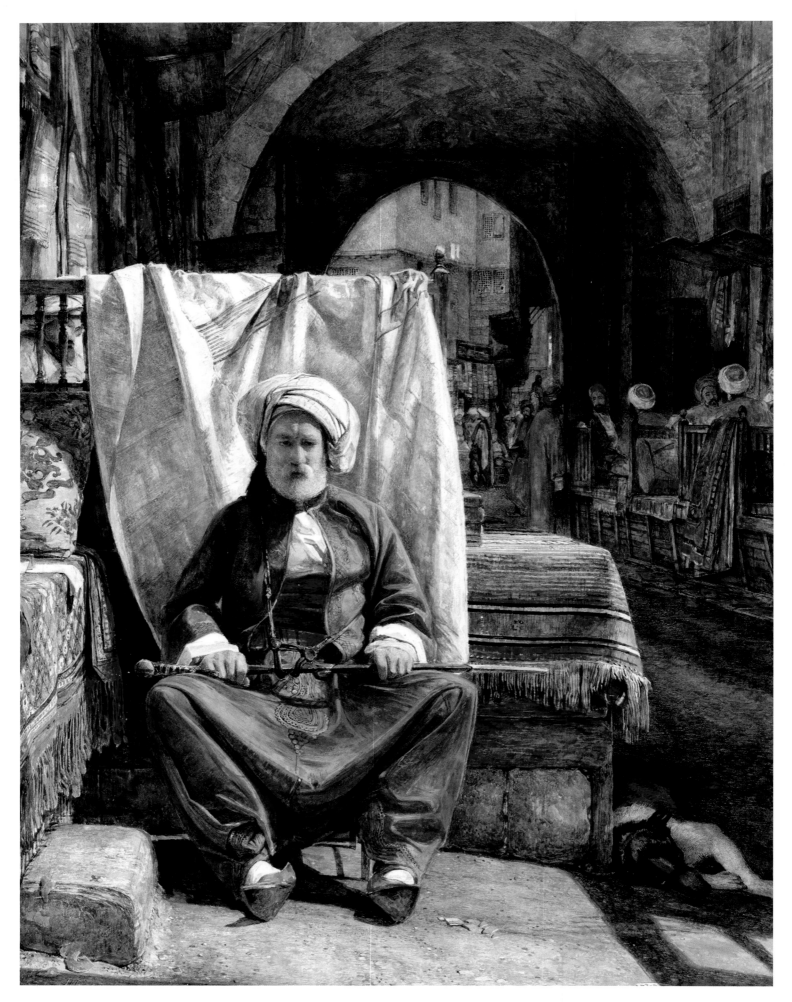

Fig.54
**In the Bezestein, El Khan Khalil, Cairo
(The Carpet Seller)** 1860
John Frederick Lewis
Watercolour, 33.5 x 26
Blackburn Museum & Art Gallery

Fig.55
Self-Portrait in Oriental Costume
1867/75
William Holman Hunt
Oil on canvas, 105.3 x 73
Uffizi Gallery, Florence

Fig.56
Portrait of Francis Levett and Hélène Glavani *c.*1740
Jean-Etienne Lio
Oil on board, 24.7 x 36.4
Musée du Louvre, Paris
See opposite for detail

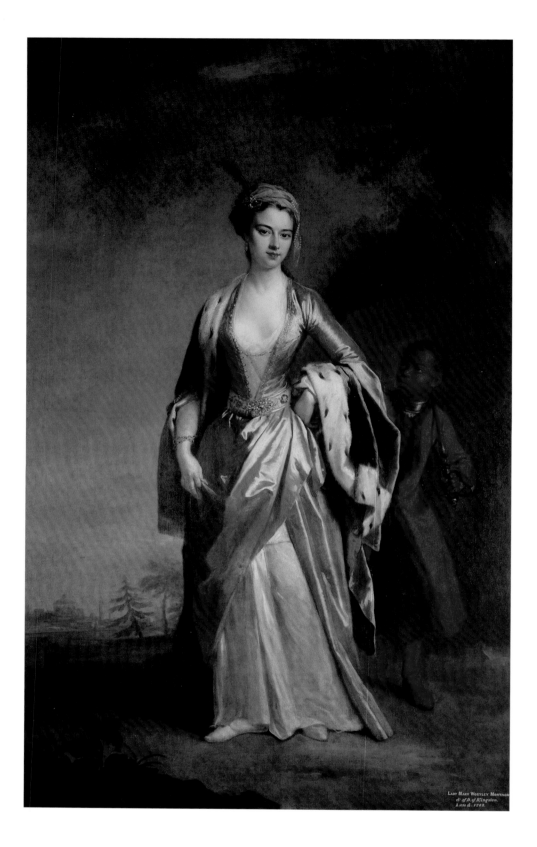

Fig.57
**Lady Mary Wortley Montagu in
Turkish Dress with Page** *c.*1725
Jonathan Richardson (attrib.)
Oil on canvas, 239 x 144.8
Private Collection

Fig.58
Captain Colin Mackenzie *c.*1842/4
James Sant
Oil on canvas, 237 x 145
National Army Museum, London

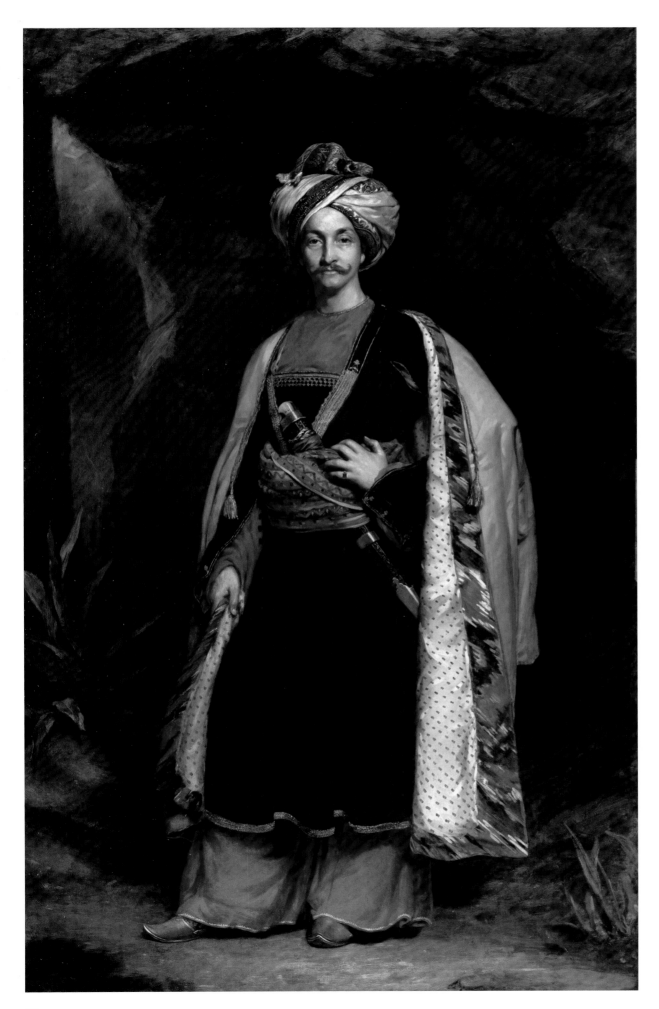

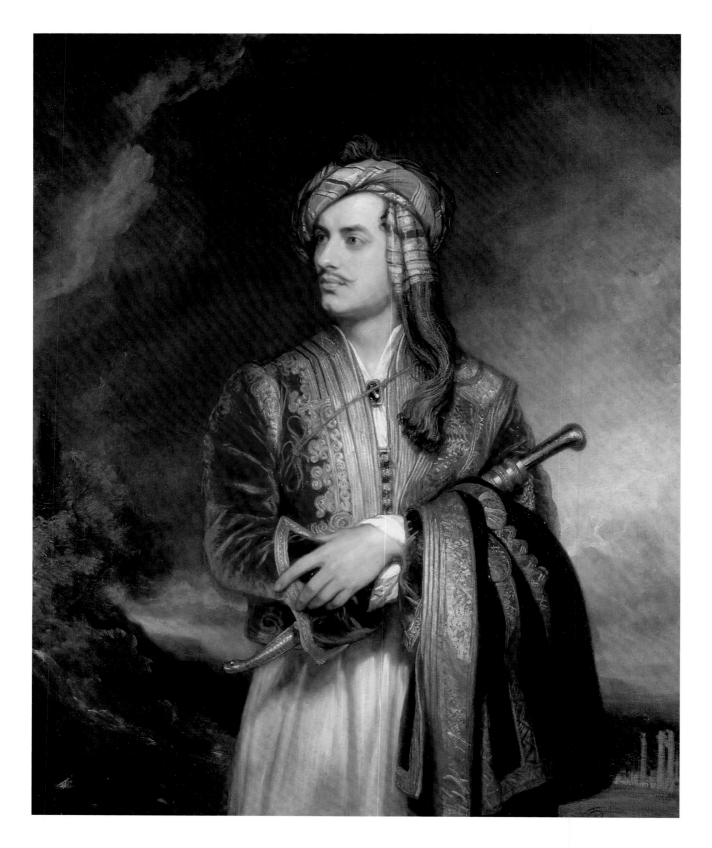

Fig.59
George Gordon, Lord Byron 1814
Thomas Phillips
Oil on canvas, 127 x 102
Government Art Collection, UK

Fig.60
Colonel T.E. Lawrence 1919
Augustus John
Oil on canvas, 80 x 59.7
Tate

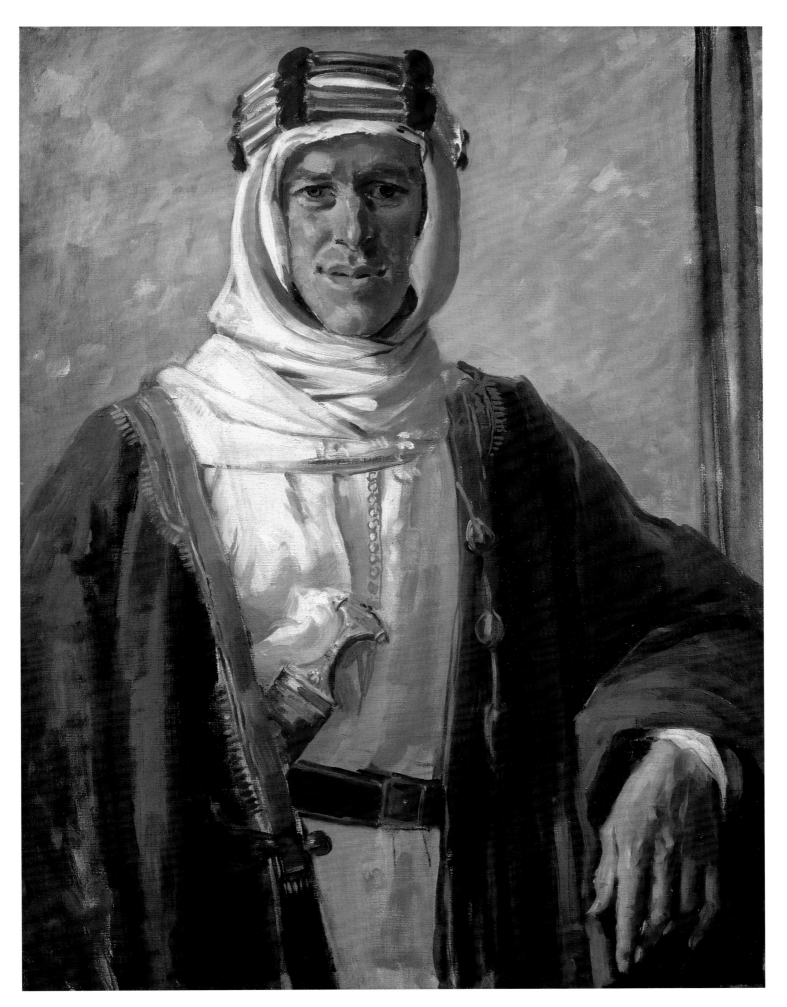

GENRE

GENRE AND GENDER IN CAIRO AND CONSTANTINOPLE
NICHOLAS TROMANS

Genre painting – scenes of anonymous everyday life – was central to British art in the early nineteenth century. It was the format through which modern society sought to describe, analyse and understand itself.[1] It was able to offer intriguing reports of what life looked like at home and abroad, but also, through representing domestic life, it could enter into the emotive and controversial fields of gender and family relations. In the Middle East, where domestic life was often structured, both culturally and architecturally, in ways different to European norms, British genre painters found themselves faced with novel problems. This section of the exhibition investigates the fate of the traditions of British genre painting once translated into an Oriental location.

David Wilkie, the great genre painter and superstar of the early nineteenth-century London exhibition scene, arrived in Istanbul (Constantinople as the British still knew it) in 1840 en route to the Holy Land. Finding himself stranded there because of the struggle taking place in Palestine between the Pasha of Egypt and Ottoman forces supported by their new European allies, Wilkie sought to make use of his time by looking out for likely genre subjects. He was however largely frustrated, finding he had more or less no access to local domestic life, and seeing few women out on the streets. Having based his entire career upon painting mixed-sex subjects, he felt at a loss without having women to paint. Wilkie contented himself with the sight of two women at the stall of a public letter-writer, a subject that was to become something of a staple among British Orientalist painters, apparently on account of the rare opportunity it offered them to observe women transacting prolonged business in public.[2] Excluded as he felt from the authentic Orient, Wilkie sought to compress as much of the polyglot Ottoman metropolis as he could into his images. Thus in *The Turkish Letter Writer* (fig.62) we have both a veiled Muslim and an unveiled young Greek, and

in Wilkie's only other major composition sketched out in Istanbul, *The Tartar Messenger Narrating the Fall of Acre* (fig.61), the painter offers a kind of ethnic survey of the Ottoman Empire. This picture, celebrating the expulsion of Muhammad 'Ali's troops from Palestine and the consequent cementing of the alliance between the Ottomans and the British, is set in a café and is therefore a masculine subject. The fact that Wilkie eventually smuggled two little girls into the foreground of the scene suggests how against the grain it went for him to paint such a thing. *The Tartar Messenger* inevitably calls to mind Wilkie's most famous picture, his patriotic *Chelsea Pensioners* 1822, showing the moment at which the news of the defeat of the French at Waterloo in 1815 reached a working-class London street. In both pictures Wilkie suggests a microcosm of an imperial power compressed into a boxed space. But the real emotional drama that the artist was able to include in the *Chelsea Pensioners*, through the figure of a young woman who fears she has lost her husband in the battle which everyone else is celebrating, is absent from its later Ottoman counterpart. Here there is no hint of tragedy, only jubilation, although the picture still has an important sentimental aspect in that it invites a British viewer to enter into sympathetic feeling with ordinary Turks, people who for centuries had been the traditional enemies of Christian Europe. As he had with his romantic depiction of an Irish Catholic rebel in the *Peep-o'-Day Boy's Cabin* 1836, Wilkie challenges his British contemporaries to look upon old antagonists as everyday people.

If it was not possible for British artists to conceive of Oriental genre subjects in which both male and female characters both played active roles, then one solution to this was to paint pairs of images in which male and female are brought together in tidy separation. Wilkie effectively paved the way here with his two Istanbul oil paintings, and among later pairs are those of Richard

Dadd and John Frederick Lewis. Dadd's pair of watercolours of *Fantasies Egyptiennes* 1865 show a harem interior and a male street scene (fig.63); they are inscribed 'par Mons.r Rd. Dadd – Broadmoor – Berks', the artist having been moved to the new high-security hospital for the criminally insane in the previous year. Lewis's *Indoor Gossip* and *Outdoor Gossip* (that is, the female and male varieties respectively, figs.123, 124) were shown together at the Royal Academy in 1874, each image playing on the idea of conversations being surreptitiously overheard by harem women. Lewis's conceit is thus that gossip and rumour flourish across Cairene society regardless of any social or architectural barriers that might be erected. Those barriers are effectively construed as decidedly flimsy. We might compare the writings of Fatema Mernissi on the huge implications for Arab society of satellite television and the Internet. The prominence of women in these new media has meant that they are seen and heard as never before despite the apparent persistence of the mutual regulation of space and gender: the barriers turn out to have been thoroughly porous all along.[3]

European Orientalist painting is by reputation voyeuristic: it worked itself around the barriers that we have just been describing. The myths that surround it, and which indeed supported it in its own day, turn upon the notion of Middle Eastern people not wanting to be looked at but being looked at anyway by persevering or imaginative European artists. Wilkie complained that Muslim society 'appears to take shelter in a system of exclusion from the observation of all strangers, till curiosity loses its interest'.[4] This smacks above all of Wilkie's own frustration at Muslim society not offering up to him what he had a professional interest in – the picturesque. Wilkie wanted to see, to capture, this material with his own eyes, and in this was perhaps typical of an empiricism that was more pronounced in

British than in French Orientalist painting. Eugène Fromentin had his fellow French Orientalist artists, and French colonial Algeria, in mind when he warned in the 1850s that:

> This people should be considered from the distance at which it prefers to show itself: its men, from close at hand; its women, from afar; and the bedroom and mosque, never. In my opinion, describing a woman's apartment or reporting on Arab religious ceremonies is an offence worse than fraud; it amounts to committing, under the guise of art, an error of viewpoint.[5]

The error, for Fromentin, was a lack of respect for other people's culture, but also and perhaps equally a lack of respect for painting itself, which he thought of in terms of an authenticity likely to be compromised in places where an artist was not welcome to gaze – that is, fantasy would be the recourse of the frustrated gaze. Frederic Leighton, who first visited Algeria in 1857, appears to have followed Fromentin in painting only who or what would allow it, writing home philosophically of the local population that 'if it were not vexatious, it would be quite amusing to see how they slink away when they perceive you are trying to sketch them'.[6] His exquisitely elegant oil sketches that survive from visits to Algiers and other Arab cities seem honestly to represent this vacated streetscape, emptied by the very eye that records it (fig.64). Leighton did, however, manage to make pencil studies of heads and faces in Algeria from particular consenting models, and later allowed himself complete artistic licence when imagining female domestic subjects such as his *Odalisque* (fig.119) and *Music Lesson* (fig.135).

A key method via which painters could lend authenticity to their Middle Eastern work when their eye had failed to turn

up exactly what was needed to make a meaningful picture was to appeal to Orientalist literature. Extracts from famous or authoritative texts, printed in exhibition catalogues, could lend meaning to a genre scene whose narrative might otherwise appear opaque or banal. This however was a potentially compromising strategy: the artist might borrow respectability, but at the risk of conceding painting's inferior status as a mode of investigating the Orient.

William James Müller, who trained as a landscape painter in the early 1830s, was, by his own admission, 'no figure painter'.[7] Today his most powerful images of Egypt, which he visited in 1838–9, seem those in which the figures are subsumed within an Old-Masterly shadow world, such as the Rembrandtesque watercolour of an *Opium Seller, Egypt* (fig.80) or the oil of a *suq* in Cairo (*The Carpet Bazaar, Cairo*, fig.72), which seems to translate Piranesi's macabre prison fantasies into Oriental mode. Nevertheless, Müller's larger Oriental figure subjects, such as his *Prayers in the Desert* (fig.18) and *Chess Players*, were hugely valued by the Victorians, who were it seems entirely willing to believe in these pictures' complete authenticity.[8] One supporting plank of this aura of authenticity was supplied for Müller and other British artists by the acknowledged English expert on contemporary Egypt, Edward William Lane, author of *An Account of the Manners and Customs of the Modern Egyptians* (1836; see the Introduction, pp.13–14, and fig.3).

The archetypal Orientalist, Lane appeared – and can still appear – seductively omniscient. So densely packed are his data that it is a brave reader who would point confidently to the joins – the gaps and elisions – in his text, and the authority of Lane's words transferred unquestioned to his illustrations. Müller's *Prayers in the Desert* clearly borrows from two of these engravings illustrating the postures of the cycles of Muslim prayer in Lane's

book.[9] The authenticity derives not simply from association with specific evidence adduced by an anthropologist (to term Lane so may be strictly anachronistic but he was understood to be a social scientist not a travel writer), but from the generic relation to Lane's illustrations and closely focused verbal descriptions. Müller and other British Orientalist genre painters seemed to offer comparably characteristic slices of Eastern life in which were demonstrated activities summarily defining Oriental society. The meaning of such pictures was thereby displaced from the images to the texts. The detailed truth about the Orient was, so it was presumed, to be found in books such as Lane's, which the viewer might or might not trouble to consult. In either case, the pictures could be enjoyed on the understanding that scientific anthropology was not the concern of either the artist or the viewer. Lewis also makes repeated references to Lane – to both his text and his illustrations – and again does so, I would suggest, in order precisely to displace the responsibility for explanation.[10]

Lewis spent an entire decade, from 1841 to 1851, in Cairo, the Middle Eastern city that British artists most thoroughly investigated. Founded by the Fatimids in the tenth century, Cairo held a spectacular concentration of Islamic architecture from the period of Mamluk ascendancy during the centuries leading up to Ottoman conquest in the early sixteenth century. With al-Azhar university-mosque, the global headquarters of Islamic learning, at its centre and the Pyramids on its outskirts, and with its array of non-Muslim ethnic communities, Cairo was simply the most magnificent Oriental city within relatively easy reach of Europe. During his time there Lewis seems to have accumulated a large archive of drawings from which, following his return to England, he derived his exhibition watercolours and oil paintings for the remaining twenty-five years of his life. These studies included faces and figures, but there was just as much of

Fig.62
The Turkish Letter Writer 1840
David Wilkie
Oil on board, 71.7 x 54
Aberdeen Art Gallery & Museums

Fig.63
Fantasie Egyptienne 1865
Richard Dadd
Watercolour, 25.7 x 17.8
Bethlem Hospital, Beckenham

Fig.64
Courtyard in Algiers *c.*1879
Frederic Leighton
Oil on board, 20.5 x 11
Leighton House Museum,
Kensington & Chelsea, London

Fig.65
Entrance to the Baths of the Alhambra 1833/4
John Frederick Lewis
Watercolour, 37.5 x 27
Ashmolean Museum, Oxford

a focus upon architecture, or, more accurately, urban spaces.[11] Lewis had first taken an interest in architecture in Andalusia in the early 1830s when, in informal competition with David Roberts, he had studied the remains of Islamic architecture at Granada and elsewhere (fig.65). At Cairo, Lewis turned the narrow streets and confined spaces, about which so many other artists and tourists complained, into opportunities for virtuoso studies in which the eye ricochets through a sequence of receding planes. As has long been recognised, there is something of the seventeenth-century Dutch master of urban topography Pieter de Hooch in the way that Lewis teases the gaze, now trapping it, now releasing it onwards. (Some of his harem pictures, meanwhile, echo Jan Vermeer.) Lewis's long reliance upon this archive of sheets helped make him into an artist, like Jean-Antoine Watteau or Stanley Spencer, whose images link up with or overlap one another to create the sense of an alternative world, both convincing in its completeness and artificial in its alterity.

Riven through Lewis's mature work are two principles of division, one iconographic – the male/female divide – and one technical: the distinction between watercolours and oils. Lewis originally specialised in hunting and sporting (that is, male) subjects, working in both watercolours and oils. He became a full-time watercolourist from the early 1830s but then turned back to oils in the mid-1850s, perversely at precisely the moment he became President of the Society of Painters in Water Colours. Even after switching from that Society to the Royal Academy at the end of the decade, and ostensibly making oil his leading medium for financial reasons, Lewis continued to work in both media, very often making two versions of each major composition, one in oils and one in watercolour and bodycolour (or gouache – opaque watercolour). Collectors and curators have long enjoyed themselves spotting subtle differences between each

pair and perhaps Lewis wished to encourage such minute connoisseurship of his work in this way.

Fromentin, quoted above, was the most respectful of Orientalist painters, and yet he suggested that Arab men – in contrast to women – liked to be looked at. With Lewis's male subjects, we certainly seem to have entered into some sort of clubbable world from which all anxiety of intrusion has been banished. Whether quietly passing the time in a kibab shop in Turkey or boisterously telling stories to one another in the Khan al-Khalili bazaar of Cairo (fig.77), Lewis's men are at ease with one another in a way that would perhaps be hard to find in the general run of male-only genre paintings set in Britain, in which the exhibition-going public were on the whole used to seeing men behaving badly when left to their own devices. Orientalist painting was itself, as a professional activity, virtually a male-only artistic genre, and its imagery – certainly in the case of Lewis – seemed to project a very positive picture of masculinity based upon its potential for emotional self-sufficiency, rather than its forming just one of the necessary components for the family unit, which in British genre painting was conventionally the only place where male self-realisation could be achieved.

The Mid-day Meal (figs.67, 83), exhibited in the year of Lewis's death, is the most welcoming of all his male subjects. Again Lane hovers in the background, for the Egyptian dinner was one of those set-piece occasions of which he delighted in offering an apparently definitive account, complete with an engraving of male diners that Lewis appears to have recycled (fig.66).[12] The scene is set within a *maq'ad*, a first-floor reception room open to the courtyard, resembling a loggia. The house shown here seems to be made up of components that had appeared in Lewis's *The Courtyard of the Coptic Patriarch's House*

A Party at Dinner or Supper.[9]

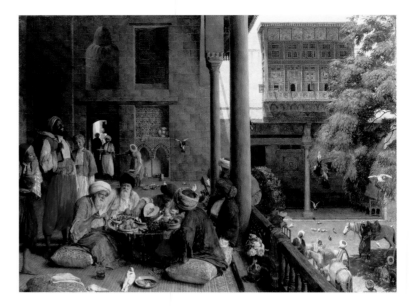

in Cairo of 1864 (fig.134). The artist-turned-writer William Makepeace Thackeray visited Cairo in 1844 and left in his resulting travel book a rare and much-cited account of Lewis's domestic life there. Lewis is described as completely assimilated into the local culture, albeit with the old-fashioned costume and lifestyle of a member of the Turkish upper classes. Thackeray particularly recalls the excellent dinners that Lewis served up to his guests and, not for the first time, a flavour of autobiography hangs about this last major work of the artist.[13]

The bonhomie of *The Mid-day Meal* embraces both the wealthy diners and their servants, who join in the jokes as part of the same masculine circle, undivided by social class. The invitation clearly also extends outwards to the viewer, for directly before the spectator is an empty place at the feast, from which a diner seems hurriedly to have departed, leaving a half-eaten plate on the floor at which a white pigeon picks. That invitation, however, could of course only be accepted by a male viewer. The notion of the harem as a female-only space, forbidden to men, is ubiquitous in the Orientalist tradition. Less emphasised has been the complementary notion of spaces from which women were excluded. When Lewis's great *Hhareem* (fig.137) was shown at the Society of Painters in Water Colours in 1850, one critic enthused: 'This is a marvellous picture, such as men love to linger around, but such as women, we observed, pass rapidly by.'[14] Lewis seems then to have projected supposedly Oriental gender segregation out of his pictures and into the polite spaces of London's exhibition rooms. This fascination with the dramatic potential of gendered space is further complicated in Lewis's impossibly beautiful painting of *A Lady Receiving Visitors* (also known as *The Reception*: fig.128), in which the women of a grand Cairene house and their female visitors seem to have taken over the ground-floor apartment reserved for the reception of male visitors (see the essay by Emily Weeks above). Lewis's attitudes towards gender keep us guessing, just as his decision to marry while in Cairo astonished some of the fellow British expatriates who knew him there; whether because of a previous lack of sexual interest in women, or perhaps an excessive interest, is not clear.[15]

Lane, in his encyclopedic *Modern Egyptians*, is careful to stress that Muslim women were far from being the prisoners in the harem that many Europeans fondly imagined, and were quite able to make visits and generally move about the city. Indeed, women are by no means entirely absent from paintings of the commercial public spaces of the Middle Eastern city. They are however often shown moving discretely along the margins of the picture, and seem only to come to the fore in troubled circumstances. Most dramatically, in Hunt's *Lantern-Maker's Courtship* (fig.73), a girl visits her fiancé at his market stall, where the young lantern-maker, frustrated at not perceiving her features behind her veil, seeks to feel them with his hand (this was another picture to borrow from Lane, in this case a gobbet of text for Hunt's catalogue entry: see the Introduction, p.16). In Lewis's *Seraff* (fig.75), subtitled *A Doubtful Coin*, women are shown presuming to become traders in the marketplace, with awkward results. The women are in dispute with a merchant with regard to the value of a coin, which either he is unwilling to accept from them or vice versa. They appeal to a *seraff* (banker or money lender) for a judgement. Lewis's gentle drama of embarrassment is of course predicated upon women making a spectacle of themselves. But as so often with Lewis, it is not clear whether a further layer of meaning is present. The provision of financial services in Cairo was frequently the profession of members of the Jewish community who, according to Lane – from whose representation of Egyptian life Lewis seems so

Fig.66
A Party at Dinner or Supper
Edward William Lane
from *An Account of the Manners and
Customs of the Modern Egyptians*,
London 1836
The British Library, London

Fig.67
The Mid-day Meal 1875
John Frederick Lewis
Oil on canvas, 88.3 x 114.3
Private Collection

Fig.68
The Slave Market, Constantinople
1838
William Allan
Oil on canvas, 129 x 198
National Gallery of Scotland,
Edinburgh

often to borrow – might suffer severe punishment for slight infringements of the Pasha's decrees.[16] The person in danger here may then be the banker as much as the women who are asking his advice.

In one particular sub-category of Orientalist painting, women's vulnerability in the marketplace takes on a tragic cast as they are represented as the commodities in the iconography of slavery. The slave subjects of the leading French Orientalist painter Jean-Léon Gérôme have often been pointed to as outstanding examples of offensive prurience – effectively as sadistic pornography masquerading as anthropological reportage (see *For Sale: Slaves at Cairo*, fig.126).[17] Every British visitor to the Orient wanted to see slave markets, just as they all wanted to see the harem, for these were the phenomena that defined the East against Britain (and both were traditionally off-limits to European male visitors).[18] The United Kingdom Parliament emancipated slaves held within the British Empire by an Act of 1833, immediately prior to the arrival of British painters in the Middle East, where the persistence of slavery might now be imagined a special characteristic of Oriental despotism.

The Scottish painter William Allan had travelled through the Russian Empire, including the Caucasus, during his decade of adventure between 1805 and 1814, after which he was to become the leading painter of romantic Scottish historical subjects. In 1829 he returned to the East, arriving in Constantinople with the British and Russian ambassadors on their way to conclude the Treaty of Adrianople, which ended the Greek War of Independence against the Ottomans.[19] Among the provisions of that treaty was the release of the large number of enslaved Greek prisoners taken during the 1820s, a gesture that extended to all Christian slaves who had retained their native faith. The subsequent history of Ottoman

abolitionism is prolonged and complex, with British pressure for the suppression of slavery being only one factor. An important gesture offered by the Ottoman authorities was the closure of the principal Constantinople slave market, the *Esir Pazari*, in 1847.[20] Allan's melodramatic painting of *The Slave Market, Constantinople* 1838 (figs.68, 74) should be imagined as set at the *Esir Pazari* (the mosque in the background is the nearby eighteenth-century Nuruosmaniye) during the 1820s: its central subject is the splitting up of a captive Greek family by Turkish slavers. For all its obvious intention to illustrate Ottoman cruelty (the picture was executed just before Britain and Turkey united to defeat the Egyptians), the image nevertheless represents precisely the accommodation of traditional British genre painting to Orientalism. Back in 1818 Allan had exhibited in London a dramatic and controversial picture (now untraced) of a *Press Gang*, showing a young man being torn away from his family to be forcibly conscripted into the British navy.[21] The dramatic structure of that scene is in effect now transported to Turkey, where the collision of genders allows it to take on a new level of meaning in Oriental mode.

The Slave Market, Constantinople was Allan's best-known Oriental painting, but it did not establish a tradition in British art. Wilkie evidently considered following his fellow Scot's lead while in Constantinople, for among the drawings in his posthumous 1842 studio sale was a now untraced sheet (an elaborate one to judge by the price it fetched) titled *Bargaining for a Circassian Slave*. But what he would have made of this, if anything, can only be guesswork. During his time in Turkey in 1840–1 Lewis also made a detailed drawing of the *Esir Pazari*, depicting the male customers in their booths around the display area but, intriguingly, omitting any detailed representation of the female slaves themselves: the place allotted to them has been left as

Fig.69
Bedouin Exchanging a Slave for Armour 1858
John Faed
Oil on board, 43.7 x 61
Private Collection

Fig.70
Cock Fight 1881
Arthur Melville
Watercolour, 75 x 60
Private Collection

Fig.71
Theological Students in the University Mosque, el Azhar, Cairo 1895
Walter Charles Horsley
Oil on canvas, 127 x 102
Private Collection

a large blank.[22] A decade later, Lewis's first major Orientalist painting to be exhibited, *The Hhareem* (fig.137), was on the subject of the female slave trade, but he never returned explicitly to the theme and it was left to Gérôme to represent the subject to the Royal Academy's Victorian public (see fig.126 and pp.135–6).

By the 1850s Oriental genre painting had its own established repertoire of locations and subjects. Its basic rules were easy to learn, and for a technically gifted artist this kind of picture could it seemed be mastered, at least to the satisfaction of the critics of the day, fairly easily. No in-depth knowledge of Middle Eastern society was necessary to get by, just the ability to paint in the required components. Thus an artist such as the Scot, John Faed, could become an overnight Orientalist master, exhibiting only a single modern Oriental picture in 1858, *Bedouin Exchanging a Slave for Armour* (fig.69), but instantly achieving with it his masterpiece, according to a feature on his work published in the *Art Journal* in 1871.[23] There was indeed, by around 1860, some question of whether an Orientalist needed to go to the Orient at all. Henry Warren, for one, managed to turn out perfectly respectable Orientalist paintings without leaving home.[24] Even in the work of Lewis, in which critics sometimes pointed to the figures as the least interesting parts, Orientalist genre painting never aspired to the levels of symbolism and social critique that William Hogarth had achieved in the eighteenth century with his 'modern moral subjects'. In the Hogarthian tradition – continued in the Victorian period by painters such as Richard Redgrave and William Powell Frith – all is explained in the picture itself. Clues in the still-life elements and in the costumes and physiognomies of the figures combine to tell a story, as often as not, one invented by the artist on the basis of the repertoire of traditional plots and stock characters. This is not

how Orientalist genre painting worked. The Hogarthian model could only operate when the public could recognise all the cultural pointers that went to make up the narrative, but this could never function in Cairo or Constantinople, and we have already seen how writers such as Lane were needed by the artists to shore up their generally minimal narratives. Such a basic principle of genre painting as individuating and characterising figures through their dress was only minimally developed in Orientalist painting.[25] This is not to deny that leading Victorian Orientalist genre painters such as Carl Haag or Frederick Goodall included a range of carefully discriminated ethnic types in their pictures. The point is that they were unable to go much beyond this, having no access to the great range of tales and characters from traditional Turkish and Arabic popular culture, the equivalent to the popular culture from which British painters drew their own richly nuanced national genre tradition. To get a real *story* off the ground – as opposed to an emblematic image of Oriental life – we have seen that Wilkie's *Tartar Messenger* and Allan's *Slave Market, Constantinople* both referred back to definitive works of these artists' earlier careers: the story was carried over from existing British models.

Stories are rare things in the work of Lewis. His paintings are sometimes so complex and full of detail that we are tempted to look for some sort of Hogarthian interpretation, but none of his pictures have yet been shown to contain such embedded narratives. For the critics his images remained beautiful but impossible to read, and the artist himself seemed utterly unwilling to help them; only his *Hhareem* (fig.137) was given a full explanatory catalogue text when it was exhibited in Scotland in 1853, presumably because of comments made regarding its opacity of meaning at its first appearance in London. Lewis referenced the obvious Orientalist authors –

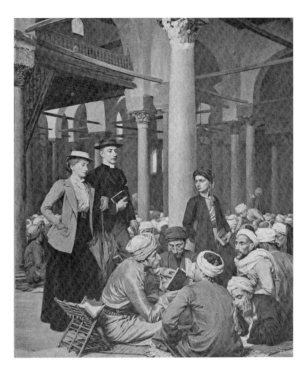

Byron and Lane – when exhibiting other pictures, but almost with a nonchalant acceptance that this is what was expected. As we have suggested, Lewis was an artist who, paradoxically given his long first-hand experience of the Middle East, unparallelled among British artists, embraced repetition and the sense of other-worldly artificiality that went with this. Wilkie and Hunt (tireless writers of letters and journals, in stark contrast to Lewis) worried at length over originality, over avoiding the pictorial clichés of the past. Lewis again seems unconcerned in his acceptance of the impossibility of pure originality or authenticity. When modern scholars, in the wake of Edward Said, describe Orientalism as a pattern of repeated statements deceptively appearing to generate a form of knowledge that turns out to have no scientific basis, Lewis's pictures seem silently to answer that this is not news to them.

Lewis, the Old Master of British Orientalist painting following the death of Roberts in 1864, remained a feature of the London exhibition season almost every year up to his own death in 1876, but otherwise Orientalist genre painting fell into the doldrums, to be rescued only in the 1880s by two very different talents, Arthur Melville and Walter Horsley. Melville, representing the revival of the Scottish tradition of Orientalist painting, travelled in the Middle East in 1881–3, and became associated with a watercolour style which, rather like that of Lewis in his early years, teetered between virtuosity and flashiness. On his way East in 1881, Melville depicted a men's Turkish bath in Paris, and in several of his subsequent Oriental subjects, for example his *Cock Fight* (fig.70), there is a Lewis-like emphasis on the enjoyment of male company. Horsley was the son of the leading conservative Victorian academician J.C. Horsley, and his oil technique is as plain as could be. His Oriental subject matter, however, is fascinating, illustrating

awkward encounters between British characters and the Egyptian society into which imperial fate had delivered them after the occupation of 1882. In a picture of 1895 (fig.71), a young Anglican clergyman and his wife listen in to a lesson taking place at al-Azhar: the visitors are attentive, respectful, uncomprehending. Horsley's paintings, executed in the period of the British Empire's maximum expansion, explicitly describe the European observer of the Orient, that subjective viewer in whose presence, in the work of earlier painters, we are encouraged to suspend belief. If Lewis had repeatedly evoked (or, as we have suggested, in effect hidden behind) the absolute authority of Lane's book on modern Egyptians, then by the end of the century the Orientalist scholar had found their way into the picture itself, where their perspective was revealed to be human and fallible.

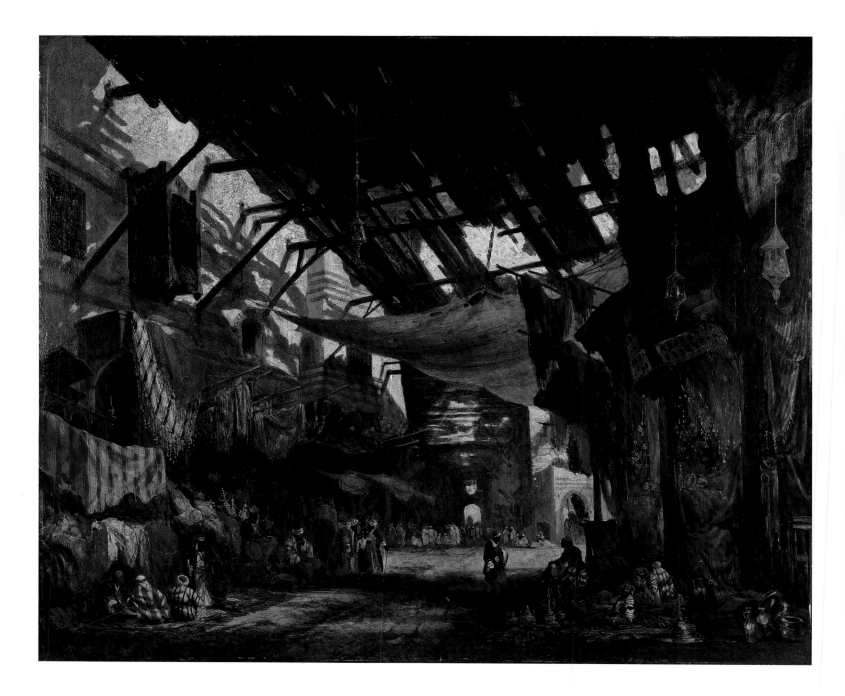

Fig. 72
The Carpet Bazaar, Cairo 1843
William James Müller
Oil on panel, 62.2 x 74.9
Bristol Museum and Art Gallery

Fig. 73
A Street Scene in Cairo: The Lantern-Maker's Courtship 1854–7; 1860–1
William Holman Hunt
Oil on canvas, 54.6 x 35
Birmingham Museums & Art Gallery

Fig. 74 (overleaf)
The Slave Market, Constantinople
1838
William Allan
Oil on canvas, 129 x 198
National Gallery of Scotland,
Edinburgh

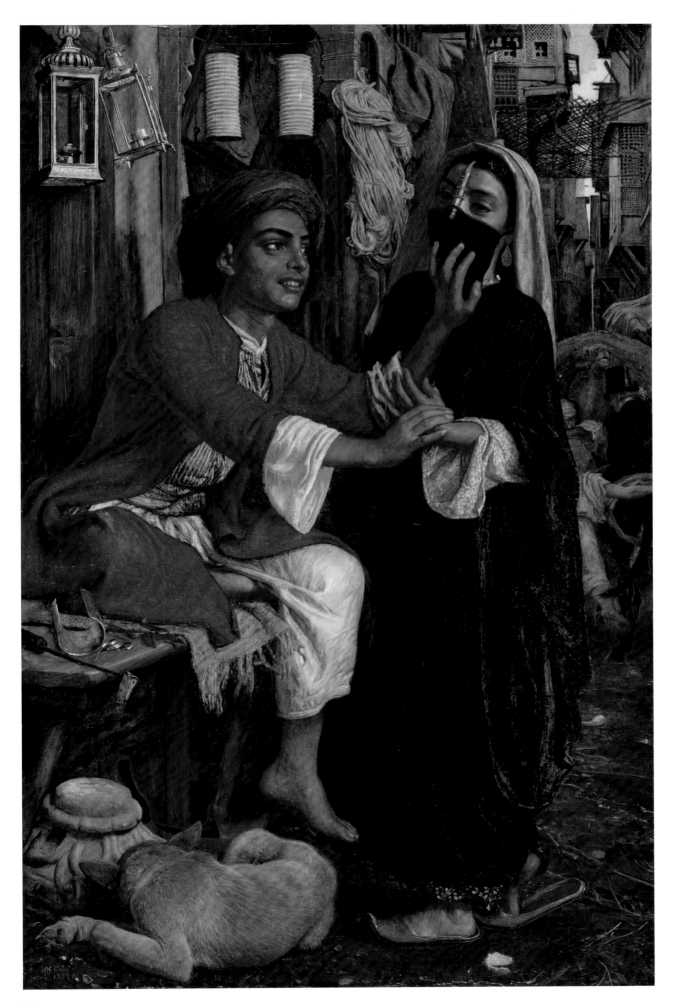

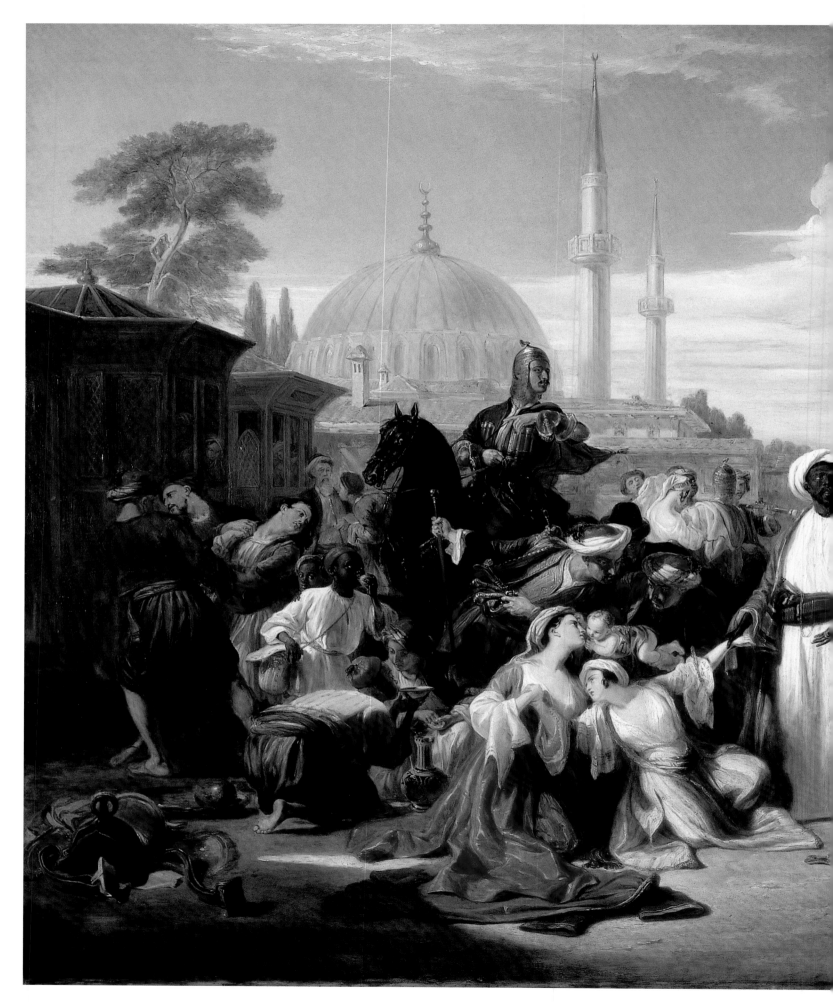

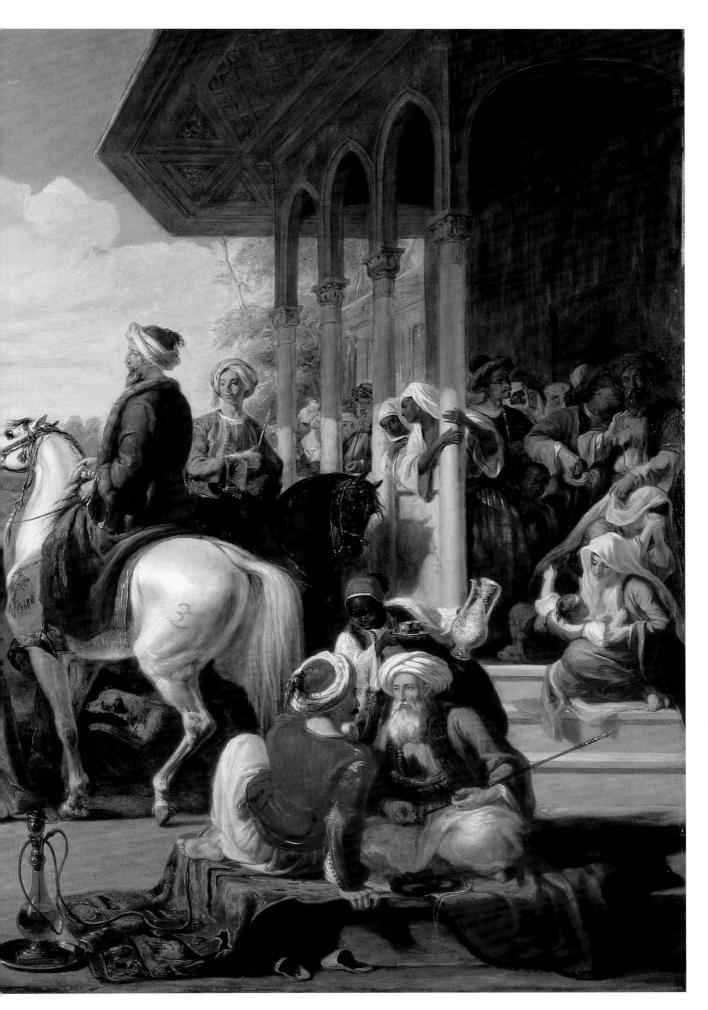

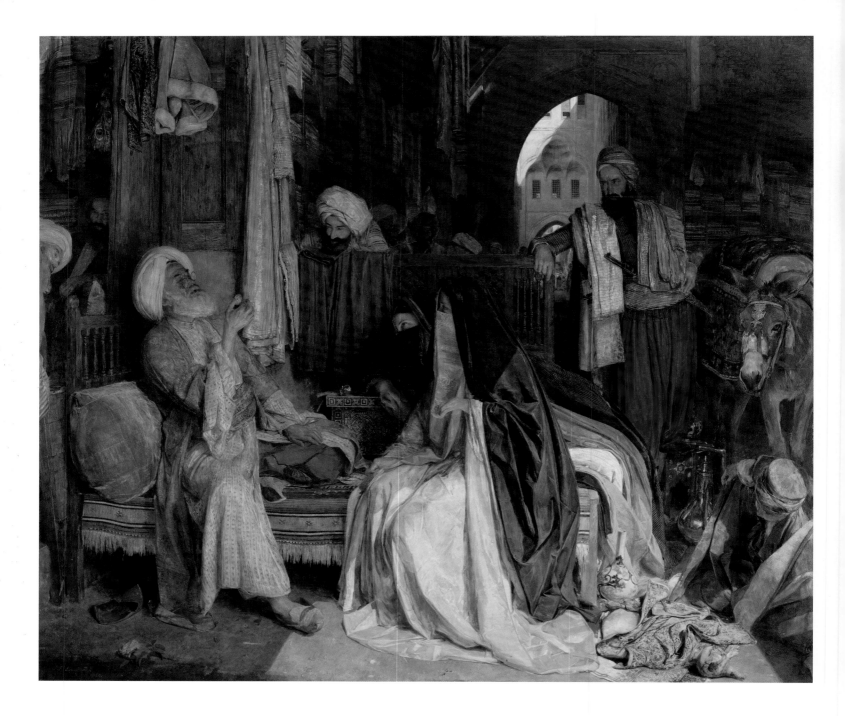

Fig.75
The Seraff – A Doubtful Coin 1869
John Frederick Lewis
Oil on canvas, 74.9 x 87.3
Birmingham Museums & Art Gallery
See opposite for detail

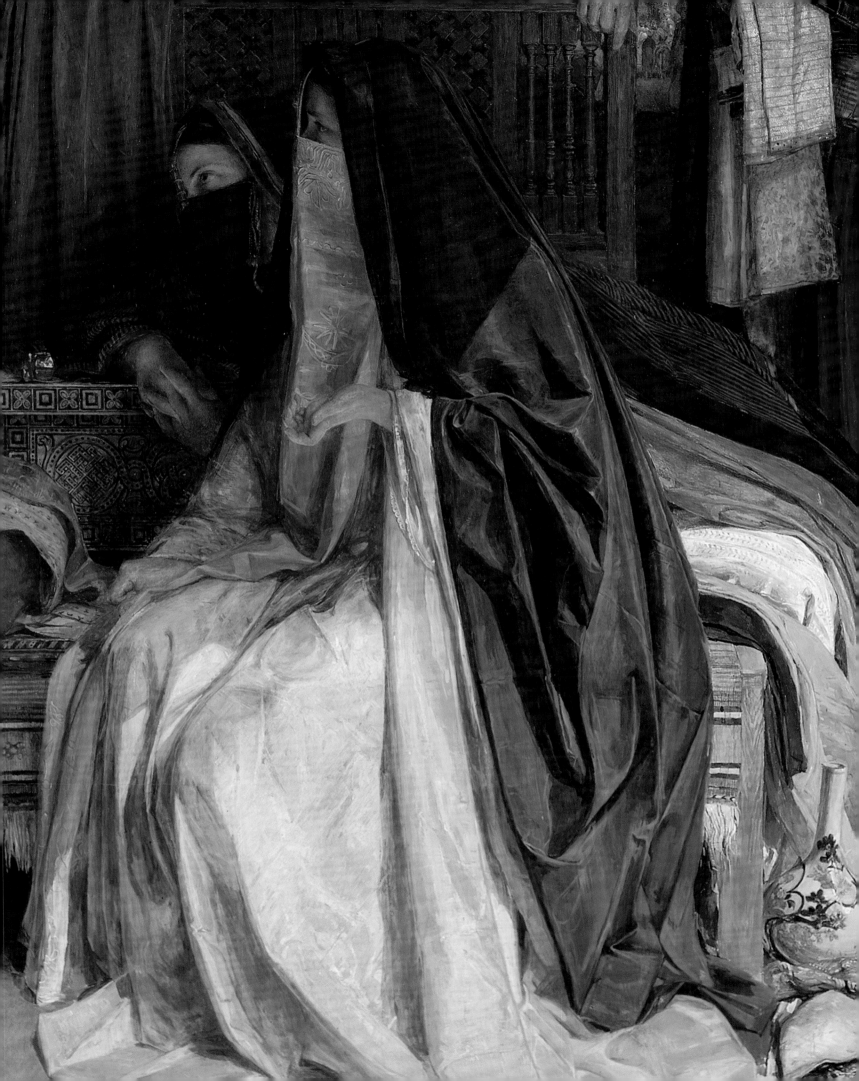

Fig.76
**The Bazaar of the Ghureyah from the
Steps of the Mosque of al-Ghuri,
Cairo** *c.*1841/51
John Frederick Lewis
Watercolour, 54 x 37.9
Tate

Fig.77
**The Bezestein Bazaar, El Khan Khalil,
Cairo** 1872
John Frederick Lewis
Watercolour, 57.3 x 43
Cecil Higgins Art Gallery,
Bedford, UK

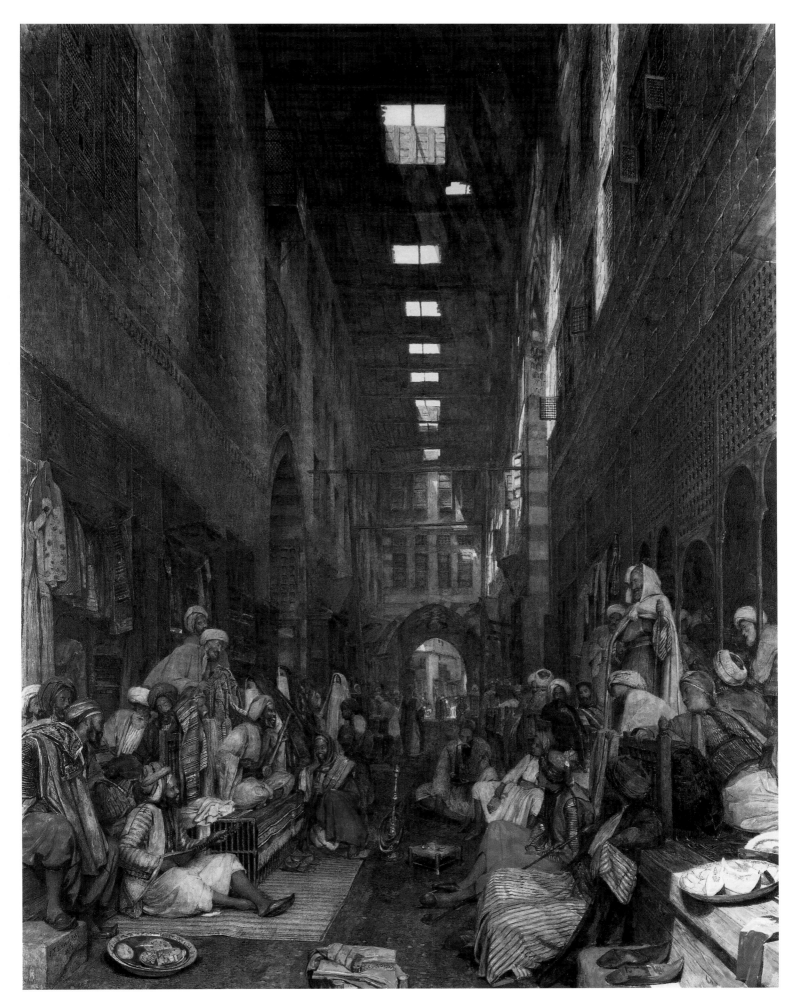

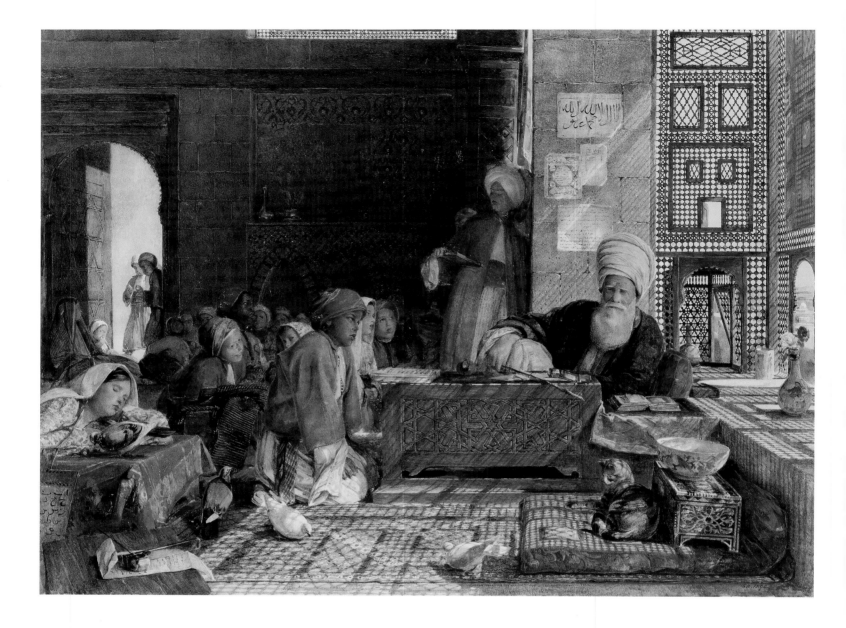

Fig. 78
Interior of a School, Cairo 1865
John Frederick Lewis
Watercolour, 47.1 x 60
Victoria and Albert Museum

Fig. 79
The Arab Scribe, Cairo 1852
John Frederick Lewis
Watercolour, 46.3 x 60.9
Private Collection

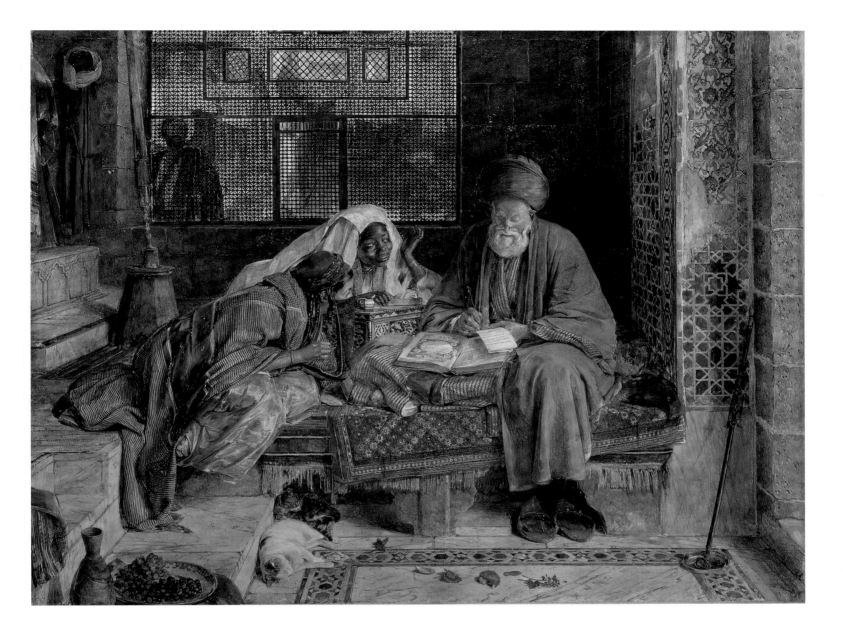

Fig.80
Opium Seller, Egypt 1838/9
William James Müller
Watercolour, 33.7 x 25.4
The British Museum, London

Fig.81
Seated Man with Chibouk 1842/3
Richard Dadd
Watercolour, 25 x 19.7
Fine Arts Museums of San Francisco

Fig.82
An Arab Interior 1881
Arthur Melville
Oil on canvas, 95 x 72.8
National Gallery of Scotland,
Edinburgh

Fig.83
The Mid-day Meal 1875
John Frederick Lewis
Oil on canvas, 88.3 x 114.3
Private Collection

LANDSCAPE

THE ORIENT IN PERSPECTIVE
NICHOLAS TROMANS

Romantic landscape imagery in Britain famously aspired to capture the immediacy of experience. The more intense the experience, it often seemed, the less need there was to travel to see more: think of Blake or Constable. People in early nineteenth-century Britain searching out images of distant lands in illustrated travel literature generally had to make do with images that were already second- or even third-hand, retaining little or no immediacy. Landscape painting was traditionally a highly refined art, full of those tricks of the trade necessary to create depth, structure and drama from untidy natural phenomena. Those who had actually travelled to, and sketched in, faraway places were, however, far more likely to be connected to military or engineering projects than to the art world. The solution was therefore often to combine the two kinds of artist, the London professional artist translating the raw material of the soldier, surveyor or architect into something publishable (the professionals' drawings then being reproduced by yet another kind of specialist, the engraver). David Roberts and John Frederick Lewis, for example, were both introduced to Middle Eastern imagery through this route, Roberts (along with Turner and others) being employed on the Finden brothers' *Landscape Illustrations of the Bible* (1836), and Lewis working up the sketches of Constantinople made by J.R. Coke Smyth (1837). But soon these two painters were themselves heading East, seeking direct experience of places they had hitherto represented only vicariously. From the later 1830s the professional artists take Orientalism into their own hands.

Roberts had trained as a painter-decorator in Edinburgh and had then moved into a successful career as a theatrical scene-painter in Scotland and London, a background often on show in the vertiginous perspectival schemes and sheer scale of some of his later architectural paintings. Roberts became an artist who

bridged the parallel cultures of the Royal Academy exhibitions on one hand and the epically proportioned views on show at London's panoramas and dioramas on the other. The ability of the panoramic view to transport audiences to the Orient had no equivalent in 'fine art' until Roberts began to exhibit his Eastern paintings in the 1840s. It had been Constantinople that in 1801 had marked the first attempt of the original London panorama in Leicester Square to move beyond Britain. As was suggested in the Introduction (p.17), the magnificent cityscape of the Ottoman capital seemed made for the panorama, and painters of easel pictures, including even Roberts, did not generally attempt it. Roberts made up for this however by painting a whole series of large-scale pictures of Jerusalem seen from different angles, and in 1847 his drawings of Cairo (fig.84) were used as the basis of a Leicester Square panorama, a very rare collaboration on the part of such a distinguished Royal Academician.[1]

Roberts's Eastern venture lasted eleven months and was a tour de force of focused industry. Arriving in Egypt in September 1838, he worked his way south along the Nile in a modest boat displaying a Union Jack, but made most of his sketches of the Ancient Egyptian remains as he sailed his way back again, now with the current, to Cairo. He was back there before the end of the year with over one hundred drawings. 'I may not have done them justice,' he wrote home, 'but few artists of my standing could afford more time, and I daresay few could have produced more in the same number of days'.[2] In the new year Roberts headed east through Suez and across the Sinai Peninsula, visiting the monastery of St Catherine's, then on to spectacular Petra in modern Jordan, capital of the powerful Arabian Nabataeans in the first century BCE, before turning north to enter the Holy Land. By the time he headed home, Roberts had increased his tally of sheets to something

Fig.84
Panoramic View of Cairo 1839
David Roberts
Pencil and watercolour, on
four joined sheets, 52 x 299.7
Private Collection

approaching three hundred, in addition to filling several
sketchbooks. This trove had taken considerably less time
to assemble than the decade that Lewis spent in Egypt, but
Roberts knew he already had enough to support his career
for years to come.

Back in London, Roberts maintained his momentum.
The drawings were put on tour to raise subscribers for their
publication as lithographs (see figs.86, 143), and by the spring
of 1840 the artist had five substantial Oriental oil paintings
ready for the Royal Academy exhibition (including *Church of the
Nativity, Bethlehem*, fig.154, and *The Temple at Edfou, Egypt*, fig.85).
These pictures suggest the range of historical cultures of the
Middle East, representing Ancient Egyptian, Roman and later
Christian structures. These themes were developed for twenty
years, as Roberts transposed his sketches into paintings and
(with the necessary technical assistance) prints, reaching his
'grand finale' as he described it in 1861, with the last of several
versions of the huge Roman Temple of the Sun at Baalbek
(Ancient Heliopolis) in modern Lebanon (fig.93). The ruins
of Baalbek had been carefully picked over long before Roberts
reached them, and in his first painting of the site of 1841
Roberts inscribes, as if recording actual graffiti, the names
of his European archaeologist predecessors, including
James Dawkins and Robert Wood who explored Baalbek
before 'discovering' Palmyra in Syria (see fig.51).[3] The presence
of these still-spectacular cities, located in what to a European
seemed the middle of nowhere, had been – for their pioneering
British explorers and ever since – an object lesson in comparative
economic history. Civilisation followed wealth, which in turn
was built up at the crossings of trade routes, especially in places
that retained political independence thanks to the protection
of the desert (Palmyra) or the sea (Britain). But once

independence or commerce were neglected, the cultural
superstructure would topple. We can imagine Roberts's audience
contemplating this lesson in imperial nemesis while admiring his
increasingly grandiloquent paintings of Baalbek.[4]

Roberts's architectural structures pull the viewer not only
into an alternative Oriental world over which the beholder's gaze
is flatteringly constructed as magisterial, but sometimes inside
the buildings themselves so that there is a quasi-panoramic sense
of being entirely embraced by the view. By bringing the spectator
so intimately into these exotic spaces, Roberts's pictures were
able to give audiences the impression of really comprehending
them, not merely contemplating them from afar. The notion that
there was now nothing very strange about the Ancient Egyptian
world was encouraged by the notes to Roberts's Egyptian
lithographs compiled by William Brockedon, who told purchasers
of these that 'now Thebes has become to the English traveller
what Rome formerly was, and a visit to the Nile is not an
adventure but an excursion'.[5] This was an exaggeration of
course, signalling the intellectual's habitual disdain for the tourist,
but also perhaps helping reassure the owners of the prints that
their lithographs offered quite as much authenticity as they were
likely to find were they to pitch up on the actual modern
cockneyfied Nile.

Roberts himself was evidently keenly aware of the
development of Egyptian tourism, of which he himself was
forming a part. In a watercolour of the Valley of the Kings,
the great pharaonic cemetery lying across the Nile from Karnak
at Thebes (fig.87), Roberts depicts in the foreground a party
of tourists admiring the view and imagining, no doubt, the great
wealth of art and architecture still lying hidden under the sands.
In the middle distance is a further group of figures at the entrance
to a tomb, identified in the notes to Roberts's prints as one

of those excavated by Giovanni Battista Belzoni in his phenomenally successful season of digging in 1816–17.[6] It was the spectacular finds of Belzoni, a circus strongman and explorer working nominally for the British Consul-General Henry Salt, which sparked the Egyptomania in Britain that possessed, among many others, Edward Lane. In another finished drawing (fig.86) Roberts represents himself sketching at Deir el-Medina, a site adjacent to the royal monuments of Thebes that was subsequently identified (appropriately for the location of Roberts's image of himself) as the village where the artisans who built and decorated those grand structures were housed. He shows himself, as we imagine he must often have been, tucked tight inside the architecture, but dressed in Arab clothing, as we know he was not (Roberts's Oriental guise, as recorded and no doubt elaborated in R.S. Lauder's portrait, fig.39, was only adopted early in 1839 in order to facilitate access to the mosques of Cairo). Perhaps Roberts wanted to imagine himself the traveller, not the tourist, and perhaps he wished to suggest that a disguise was necessary to conduct his research for fear that this might be construed as some form of espionage. Certainly the right that European artists felt their calling gave them to stare at anyone and anything often caused offence in the Middle East and, as has previously been suggested (p.21), Orientalist painters could in turn find satisfaction in this evidence of the impact of their gaze.[7]

Orientalist landscape painting related to various other specialised topographic forms of visual culture, including illustrated travel literature, the panorama and maps. Mapping produces images that are intended to reassure through their scientific objectivity, but their making has historically been associated with conflict. Georg Braun's introduction to the first volume of his *Civitates orbis terrarum* (Cologne 1572), the pioneer

atlas of city plans, explained that his maps included men and women in local costumes as a precaution against their being used by the Ottoman enemy who, it was considered, could not look at images of the human figure.[8] Towards the end of the First World War, when the forces of Britain and its allies occupied the Middle East, a wholly new technique of viewing cityscapes was available in the form of aerial surveying, courtesy of the Royal Flying Corps (soon the Royal Air Force). After spending the War in the RFC, largely painting planes with camouflage, Richard Carline became an Official War Artist in 1918 and was sent to the Middle East the following year. His 1920 painting of *Damascus and the Lebanon Mountains from 10,000 Feet* (fig.107) suggests both the privileged viewpoint of the Allies over territory they would soon partition, and the potential importance of aerial surveying for archaeology and urban history.[9] Carline re-makes the panorama in an upright format, suggesting the epic distance of the airborne artist's view as opposed to the epic breadth of the traditional land-based panorama.

During the nineteenth century the British surveyed cities and landscapes across the Middle East in circumstances that frequently had military contexts. The first detailed street plan of modern Baghdad, for example, was surreptitiously mapped by a surveyor in the Indian Navy in the 1850s; the local Ottoman governor was in search of a copy as late as 1912.[10] Some of the professional artists became surveyors in a modest way. Wilkie helped to measure the depth of the Dead Sea (see p.166), Roberts drew plans of the Ancient Egyptian structures he visited to facilitate his later pictures of them, and William Holman Hunt made a 'map-like sketch' of Jerusalem from the Dome of the Rock in 1855.[11] It is not suggested that the early British painters of the Oriental landscape were in direct collusion with military operations in the way that, notoriously,

Fig.85
The Temple at Edfou, Egypt 1840
David Roberts
Oil on canvas, 110 x 142
Private Collection c/o Peter Nahum at
The Leicester Galleries, London

Fig.86
**View from Under the Portico of Deir
el-Medina, Thebes**
L. Haghe after David Roberts
Lithograph, London 1848
Kenneth Sheppard, Medina Arts, Inc

Fig.87
**The Valley of the Kings: Entrance to the
Tombs of the Kings** 1838
David Roberts
Watercolour, 63 x 83
Frits Lugt Collection, Institut
Néerlandais, Paris

T.E. Lawrence's ostensibly archaeologically motivated 1914 survey of Negev was to be.[12] The relationship of these images to power emerges, more obliquely, through their apparent intimacy and objectivity. Roberts allowed the mid-Victorian public to feel they had a clear picture of Egypt, a clearer picture indeed even than those who lived near the ruins – clearer *especially* than those impoverished Egyptians who had built humble dwellings up against the ancient structures, prompting many a contemptuous tourist's remark on how the mighty civilisation of the pharaohs had fallen.[13] The modern Arabs often shown in the Oriental landscape (frequently desert-dwelling Beduin), present of course in part to provide a measure of scale, do also generally seem to be entirely oblivious to the beauty and history around them, in contrast to the admiring Western tourists in the Valley of the Kings in fig.87. If only the European eye truly appreciated these sites, then perhaps this was, as a recent essay on 'The Imperial Landscape' claims, the 'aesthetic prelude for conquest'.[14] In a few images included in this exhibition, on the other hand, there are hints of the dynamic working in the opposite direction. In Spain in the early 1830s, Lewis had made sketches of the interior of the Moorish palace of the Alhambra, in which modern Christians squat, blindly ignorant of the culture that surrounds them (fig.65): the roles have been swapped. In Dadd's study of a seated Arab man (fig.81), lazily smoking according to the presumed Oriental norm, the man stares back at us with a knowing look, seemingly aware of something that we, the European interlopers, have entirely missed.

Before Roberts travelled to Egypt, the great corpus of images and texts against which new Orientalist projects had to measure themselves was the Napoleonic savants' *Description de L'Egypte* (published in many volumes from 1809). Certainly Roberts had seen it as his task to surpass this, but from the 1840s

the success of his own comparably epic body of work meant that it in turn became the target of accuracy which subsequent artists sought to better. Thus Hunt criticised Roberts's *Simoon* 1850, in the collection of Charles Dickens, for showing the Great Sphinx at Giza wrongly aligned in relation to the rising or setting sun. In his own watercolour of the Sphinx of 1854 (fig.104), Hunt strikingly elects to show the view from behind the structure, so that the spectator looks over its shoulder towards the cluster of pyramids at Saqqara. As Hunt further lectured Dickens, the Sphinx's own eastward orientation suggested its patient anticipation of the dawn of the era of truth (Christianity).[15]

Hunt's comments underline both his determination to see the East for himself and not in any way build upon the work of his predecessors, and his explicitly Christian interpretations not only of the history of the Holy Land but of more or less all the world. One of the original 1848 Pre-Raphaelites, Hunt had seen the future of the movement as having a global destiny, with painters committed to telling the whole truth about Nature going out into the world 'two by two', as Christ had sent out his disciples to preach.[16] During his first visit to Egypt in 1854 Hunt indeed worked alongside Thomas Seddon, not one of the original Pre-Raphaelites, but a sympathiser who also shared with Hunt a tradesman's family background and a born-again religious enthusiasm. The two then travelled together up to Jerusalem. There were vague plans for a third friend, Edward Lear, to join them in Cairo. Lear, a committed but frustrated landscape artist, had turned to Hunt for lessons in 1852 and had received a brief course of Pre-Raphaelite instruction. But in 1854 Lear went off up the Nile without waiting for Hunt to arrive, and the two never met up in the Middle East.

Lear's most extensive Middle Eastern tour took place in 1858, when he returned to Egypt and travelled through Palestine,

also visiting Petra, Beirut and Damascus (see figs.102, 103). Lear's paintings of these last three cities are probably in each case the most dramatic general views made by a Victorian artist, although he never had time to explore any of them in detail. In the case of Petra, he only completed a couple of days' work at the site before being compelled to leave due to a scene caused by rival groups of local people demanding protection money, in effect tax for using their territory. Nevertheless in 1859 Lear was able to work up from his sketches two magnificent paintings (fig.102) of this other-worldly, deserted city's remains, lying in a wadi of impossibly lushly coloured sandstone, of which he had written in a breathless letter to his sister:

> I had expected a great deal, but was overwhelmed with extra surprise & admiration at the truly beautiful & astonishing scenes. The whole valley is a great ruin – temples – foundations – arches – palaces – in inconceivable quantity & confusion; & on 2 sides of the valley are great cliffs, all cut into millions of tombs – magnificent temples with pillars, – theatres etc. so that the whole place is like magic; & when I add that every crevice is full of Oleander & white Broom, & alive with doves, gazelles, & partridges – you may suppose my delight was great. All the cliffs are of a wonderful colour – like ham in stripes; & parts are salmon colour.[17]

Lear's views of Beirut and Damascus, and his 1865 painting of Jerusalem seen from the north-east (fig.144), all seem to carry echoes of Hunt's influence. In his Egyptian watercolours, such as *The Sphinx, Giza, looking towards the Pyramids of Saqqara* (fig.104) and *The Great Pyramid* (fig.106), Hunt had composed with an almost deliberate crudeness, boldly breaking the

image into simple geometric forms, as if proudly taking head-on the Orient's refusal to accommodate the standard naturalising formats of Western landscape painting. Little distinction is made between man-made and geological forms, so equal does each appear to the other's efforts to dominate the landscape; in *The Sphinx*, this ancient sculpture seems to decompose back into the desert stone from which it was carved. Hunt also often adopts both a high horizon line, and patterns of horizontal banding suggesting geological layers, as in the landscape of *The Scapegoat* (fig.151). Lear, who could be limitingly self-conscious when painting large oils as opposed to his vivacious sketches, blocks in his Beirut and Damascus cityscapes in a comparable way. In the former (fig.103), the city itself and the mountains beyond are conceived almost as mirror images of one another, rather as Hunt uses reflection in his *Great Pyramid*. Lear's 1873 view of the acacia-lined road built as a European-style avenue linking Cairo to the Giza Pyramids by the French in 1868 in preparation for the celebration of the opening of the Suez Canal the following year (fig.88), is the ultimate in geometric Victorian Orientalist landscape painting. By adopting a sightline down the avenue (recalling Meindert Hobbema's *Avenue at Middelharnis* 1689, acquired by the National Gallery in 1871), Lear uses this example of European infrastructure to force a perspectival pictorial scheme upon the desert. In his view of Constantinople from the old Ottoman cemetery at Eyüp (fig.89), painted in 1858, on the other hand, Lear seems ironic in adopting such a dainty little upright format, so deliberately different from the structure of the panorama which, as we have seen, seemed the natural genre for that particular cityscape.

In these pictures the focus upon a readily identifiable location meant that Lear was able easily to communicate a sense

Fig.88
View of the Pyramids Road, Giza 1873
Edward Lear
Oil on canvas, 52.1 x103.2
Private Collection

Fig.89
Constantinople from Eyüp 1858
Edward Lear
Oil on canvas, 38 x 24
Private Collection

of place. The landscapes between the cities, and especially desert areas, however, presented the problem of disorientation. With no reliable detailed maps, and with individual place names – in languages that British travellers anyway had trouble transcribing – varying between different local communities, artists often were perplexed in putting words to their images. Lear, a wonderfully original poet of course as well as a painter, habitually made elegant inscriptions around the lower parts of his drawings, recording colour impressions and details of his location. On an 1858 drawing of the western shore of the Dead Sea (fig.100), however, Lear's inscriptions record his inability to name his viewpoint. 'Wady Mabookos?' he hazards, before groping for an equivalence with places named in recent travel literature: 'Wady Mubughghik (Lynch) … Wady Maiet-Embarrheg – De Saulcy?'[18] The place was, it seems, in fact between the points – En Gedi ('Ain Jidi) and Oosdoom (Sedom) respectively – at which Hunt had begun to paint the landscape backgrounds for his two versions of *The Scapegoat* four years previously, an appropriate relationship given that picture's theme of banishment from the known, named homeland. Thinking of this ambiguity of place, of *The Scapegoat*, and of Britain's leading role in the twentieth century in dividing the Middle East up along precisely defined borders, we are led to such parallels as that suggested by Edward Said:

> Just beyond the perimeter of what nationalism constructs as the nation, at the frontier separating 'us' from what is alien, is the perilous territory of not-belonging. This is where in primitive times people were banished and in the modern era, immense aggregates of humanity loiter as refugees and displaced persons.[19]

John Frederick Lewis's *A Frank Encampment in the Desert of Mount Sinai, 1842*, shown in London in 1856 to the famously hyperbolical praise of John Ruskin, is first and foremost an unsurpassed technical masterpiece that took the exhibition watercolour to an entirely new level of sophistication (fig.101).[20] It is, superficially, a kind of *ne plus ultra* of sporting art: no reason for the encampment's presence is apparent beyond the game that litters the foreground. More fundamentally it is a riposte to the disorientation and placelessness threatened by the desert. The picture was commissioned by Viscount Castlereagh (nephew of the Regency Foreign Secretary) during his Oriental tour of 1842, and represents the author of *A Journey to Damascus* resting in his tent before the Orthodox monastery of St Catherine, built in the sixth century CE towards the southern tip of the Sinai Peninsula, at the foot of what was traditionally identified as Mount Sinai (Mount Horeb), where Moses received the Ten Commandments. There was thus a delay of some fourteen years between commission and exhibition of the work, during which time relations between artist and patron evidently came to an end, for soon after the picture's completion it was in the hands of a leading London dealer.

Lewis shows Castlereagh confronting the local Beduin sheikh, Hussein, although with characteristic ambiguity it is not clear what the encounter means, beyond the opportunity it gives Lewis dramatically to reverse the more familiar scenario of the European (Frank) approaching with trepidation the peripatetic court of the Oriental potentate. Castlereagh's composure is absolute, as well it might be, for every conceivable convenience, both Western and Eastern, is at hand (among the former we can see English-language newspapers, a bottle of Harvey's sherry and a map of 'Syria Ancient and Modern'). This is an image about the English gentleman whose

'complacency', as one critic saw it, was not to be ruffled merely by a desert.[21] Working towards the further reassurance of our Frank sheikh is the presence in the distance of St Catherine's, the most romantic of all Oriental Christian monasteries, and a stopping place for many an early British tourist. One of the most famous stories that attached to the monastery related that its survival through the Muslim centuries had been on account of its possessing a letter of protection granted by the Prophet himself in return for the monks' assistance to him (the foundation indeed includes a mosque). Thus the desert location is identified, connected with ancient Christian tradition, and the safe passage of the Frank lord even guaranteed by absolute Islamic authority.

In Frederick Goodall's *Early Morning in the Wilderness of Shur* (fig.90), we have an encampment of Beduin, breaking up at dawn, in a wilderness that is also site-specific. This is Elim (Wadi Gharandel), where the Israelites, after crossing the Red Sea and having wandered through Sinai for three days without drinking water, found an oasis of twelve springs and seventy palms. Goodall spent three days there in 1858, claiming to have found little had changed.[22] The wilderness thus turns out to be nothing of the sort, for the God of the Israelites – the ancestor of the modern protecting deity of the British – had imposed an obscure but benevolent plan upon it. Even William Blake Richmond's study of *The Libyan Desert, Sunset* (fig.92), apparently a genuinely empty wilderness, in fact records the artist's journey through the desert from Alexandria towards the cluster of Coptic (Egyptian Christian) monasteries at Wadi Natrun, north-west of Cairo, where the Holy Family are supposed to have rested during their flight into Egypt.[23] For British artists, the desert was thus a purgatory with a redemptive destination almost, or already, in sight. There was little sense of the Christian anchorite's desert, a non-place in which to abandon the world and find oneself and God.

Richmond's desertscape takes, to an almost abstract extreme, the fascination with the pink and lilac hues that had always been part of Orientalist landscape painting (the word lilac has, incidentally, an Arabic and Persian etymology). For the Pre-Raphaelites Hunt and Seddon, the Middle East had provided the opportunity to push further the practice of painting shadows in colours from the violet end of the spectrum, which had been pioneered by another Pre-Raphaelite sympathiser, Ford Madox Brown. Hunt's *Sphinx* (fig.104), for example, was considered 'remarkable for … the violet duskiness of the shadows',[24] and the whole lower half of Seddon's *The Mountains of Moab* (fig.91) is given over to an exploration of tinted shadow. Seddon's watercolour, showing a view at dusk from near Jerusalem out towards the Dead Sea, was it seems completed by Hunt with the intention of fitting it as a pendant to a watercolour of his own showing a similar view in the early morning.[25] Hunt's view was in turn exhibited in 1861 as one of a group of five of his Middle Eastern watercolours that formed a loose cycle depicting a sequence of times of the day.[26] Many of the images we have mentioned represent daybreak or sunset, in order to take advantage of the wonderful colours of the landscape at those times. But with this sequence Hunt may well also have been reflecting upon the Islamic tradition of dividing the day according to the positions of the sun (each day beginning at sunset), which form the cues for the series of five daily prayers.

The traditional Islamic calendar measures longer temporal phases by the moon's appearance, each lunar month commencing with the sight of a new crescent moon – an image that has become one of the most enduring symbols of Islam. A special category of Orientalist landscape watercolour painting

Fig.90
Early Morning in the Wilderness of Shur 1860
Frederick Goodall
Oil on canvas, 97 x 305
Guildhall Art Gallery, City of London

Fig.91
The Mountains of Moab 1854
Thomas Seddon
Watercolour, 25.1 x 35.2
Tate

Fig.92
The Libyan Desert, Sunset 1888
William Blake Richmond
Oil on wood, 29.2 x 40
Tate

focused upon moonlit scenes, such as William James Müller's *Moonrise on the Nile* (fig.97), Roberts's view of the Temple at Philae (fig.98), and Hunt's *Nile Postman*, which dates from his last visit to the Middle East in 1892. In a class of its own within this category is the stunning picture by Dadd of *The Halt in the Desert* (fig.99). Dadd, along with his employer Sir Thomas Phillips, reached Jerusalem in November 1842, from where they rode out to see the Dead Sea in the company of some British naval officers, several of whom were with a survey ship, the *Beacon*. At dusk they and their Beduin guides briefly set up camp on the shore of the sea and waited for the moon to rise to give enough light by which to set off again through En Gedi (which as we have seen was where Hunt began the first version of his *Scapegoat*).[27] This is the moment of anticipated enlightenment depicted here in an image of great stillness and intensity. Dadd was by this time already aware that his mind was in danger, and within a few months he had become murderously deranged. The picture itself was probably executed from memory at Bethlem Hospital in London about 1845.

It was the painter Augustus Egg who in 1843 spread the news of Dadd's madness among their mutual artist friends in London. Egg himself later spent time in the Orient, travelling not for the sake of his art but of his health, and he died in 1863 in Algiers. The British artist's Oriental landscape, as we have seen, had focused upon Egypt and Palestine. From the 1850s, however, an increasing number of artists began to visit Morocco and Algeria, which became identified as healthy resorts with, especially in the case of Algeria, the added bonus (for the tourist) of being thoroughly under the military subjugation of a more or less friendly European power, France. The first British artist to become especially associated with Algeria was the famous Victorian feminist Barbara Leigh Smith, who on her first visit

there in 1856–7 met a French doctor, Eugène Bodichon, whom she married soon afterwards. She bought property at Algiers, where an informal expatriate feminist circle was established, and exhibited her Algerian work in London at Ernest Gambart's French Gallery.[28] Among full-time professional painters, Leighton soon followed in Leigh Smith's footsteps, making his first visit to Algiers in 1857 (see fig.64). Framed as it was by the fully developed structures of French colonialism, the Algerian landscape seemed to offer itself up to the visiting painter effortlessly, and perhaps for this very reason did not challenge British painters to produce original work.[29]

Roberts and Lewis had both visited Morocco in the early 1830s during their tours of Andalusia, but thereafter the British painters left it to their French counterparts (Delacroix was there in 1832). Later in the century, however, Tangier followed Algiers in being developed as a kind of Oriental seaside resort, with a more pronounced identity as a haven for heterodox lifestyles (eventually with an openly flourishing community of gay artists and writers). John Lavery, although himself not much of a Bohemian, was one of the British artists, Scots preponderant among them, to become a regular visitor to Tangier.[30] His 1893 painting *Tangier: The White City* (fig.108), offers a sweeping vista along the beach up to the walled town jutting out into the sea. The swerve of Lavery's composition provides the completing segment of a full circle, as British Orientalist painting is brought back to Europe: his 'white' city is an Edwardian resort with as much in common with San Sebastián or Cannes as with the Middle East.

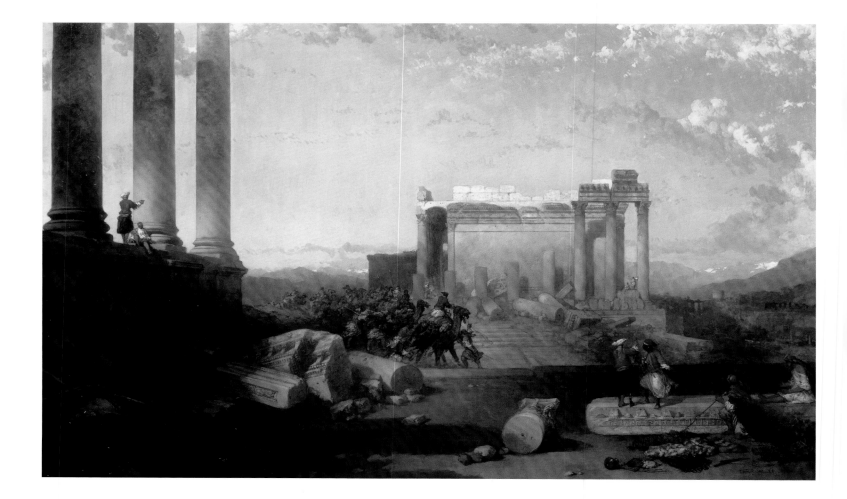

Fig.93
The Ruins of the Temple of the Sun at Baalbec 1861
David Roberts
Oil on canvas, 158 x 251
Sharjah Art Museum

Fig.94
Ruins of the Great Temple of Karnak 1845
David Roberts
Oil on canvas, 144.8 x 237
Private Collection

Fig.95
Edfou, Upper Egypt 1860
John Frederick Lewis
Oil on wood, 29.8 x 77.5
Tate

Fig.96
A Halt in the Desert 1855
John Frederick Lewis
Watercolour, 60 x 72.5
Victoria and Albert Museum

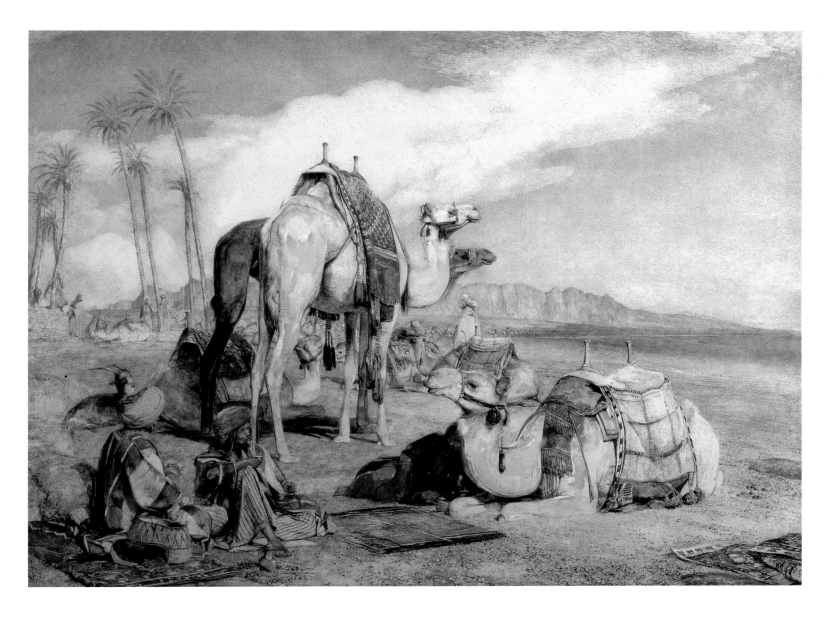

Fig.97
Moonrise on the Nile 1839
William James Müller
Watercolour and graphite, 20.6 x 31.2
The British Museum, London

Fig.98
Temple at Philae 1838
David Roberts
Watercolour, 29.2 x 49.5
Private Collection

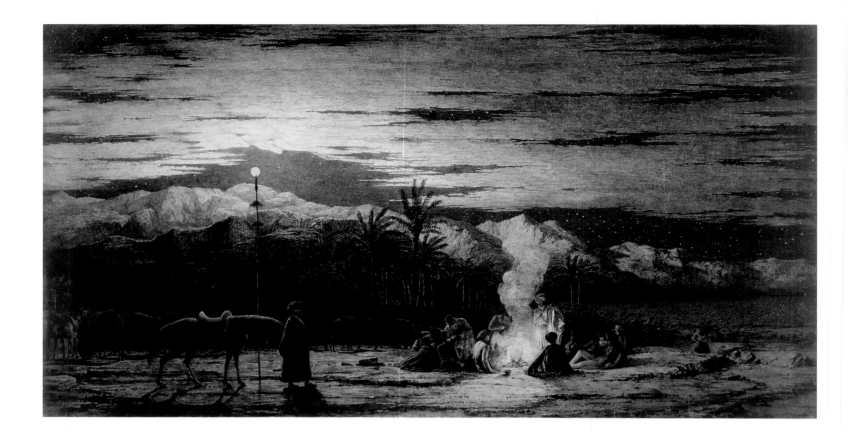

Fig.99
The Halt in the Desert *c*.1845
Richard Dadd
Watercolour, 36.8 x 70.7
The British Museum, London

Fig.100
The Dead Sea 1858
Edward Lear
Pen and ink with watercolour,
36.8 x 55.2
Yale Center for British Art, Paul
Mellon Collection

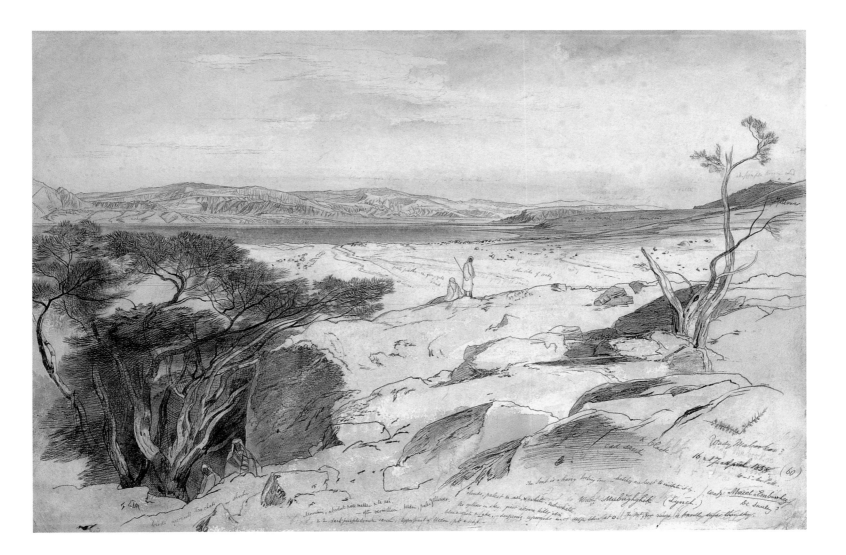

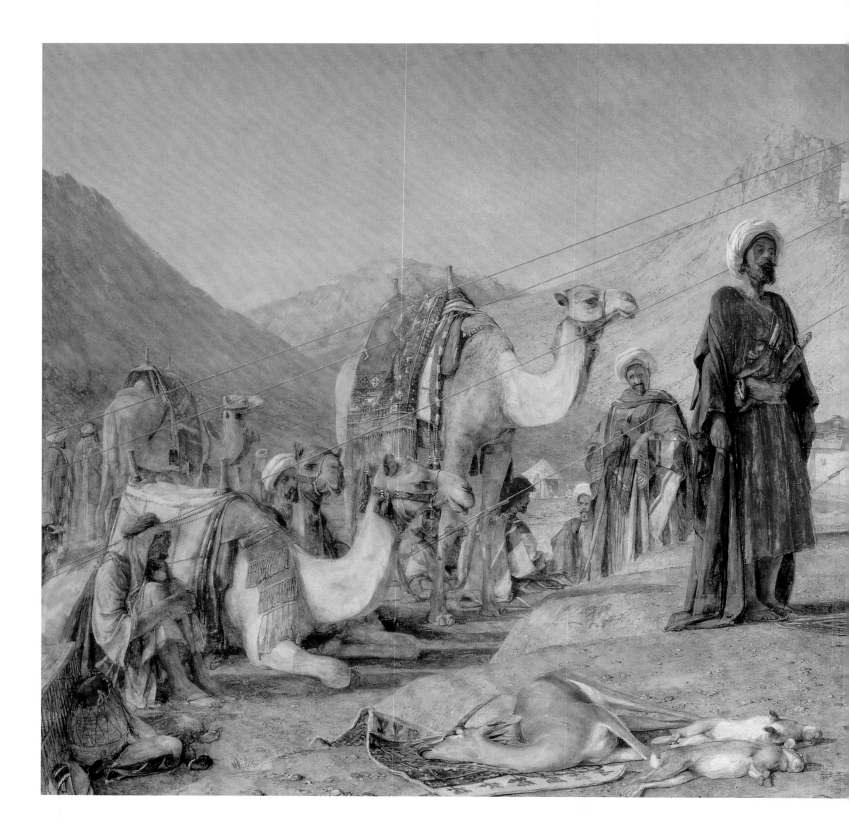

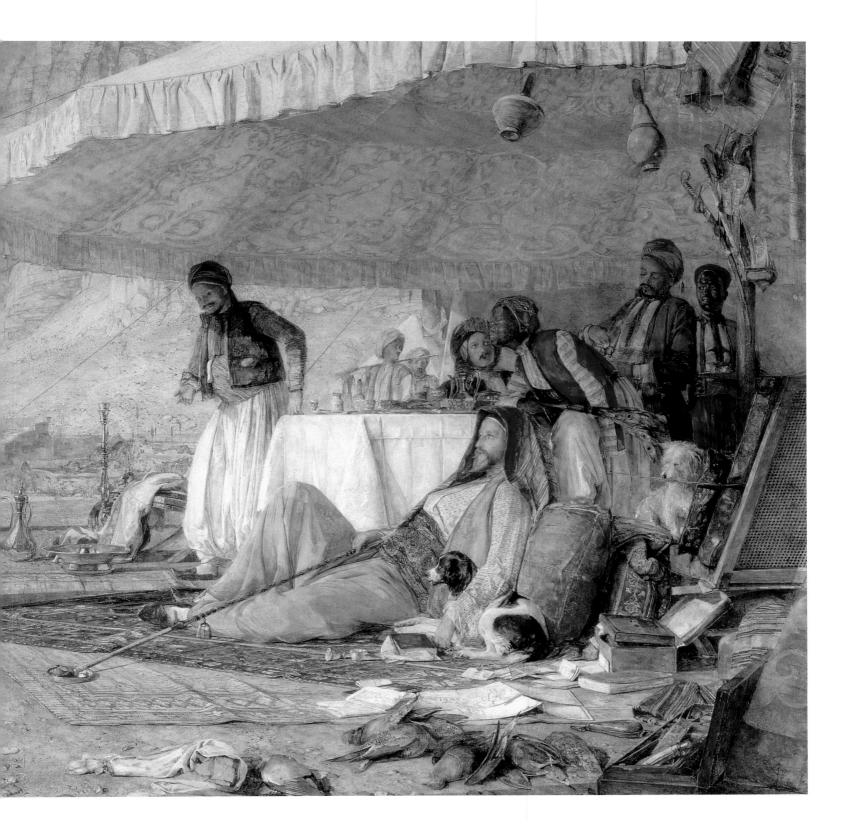

Fig. 101
A Frank Encampment in the Desert of Mount Sinai, 1842 1856
John Frederick Lewis
Watercolour, 64.8 x 134.3
Yale Center for British Art, Paul Mellon Collection

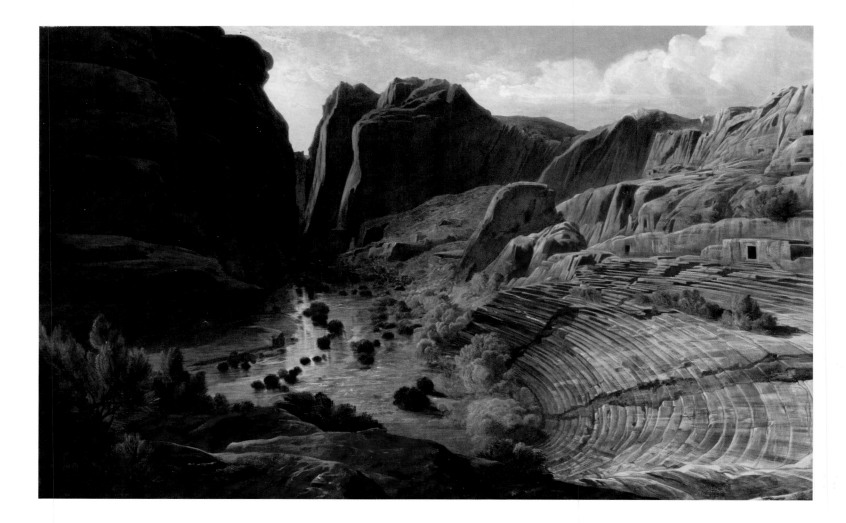

Fig. 102
Petra 1859
Edward Lear
Oil on canvas, 69.7 x 115.5
Private Collection

Fig. 103
Beirut *c*.1861
Edward Lear
Oil on canvas, 45.9 x 69.3
Government Art Collection, UK

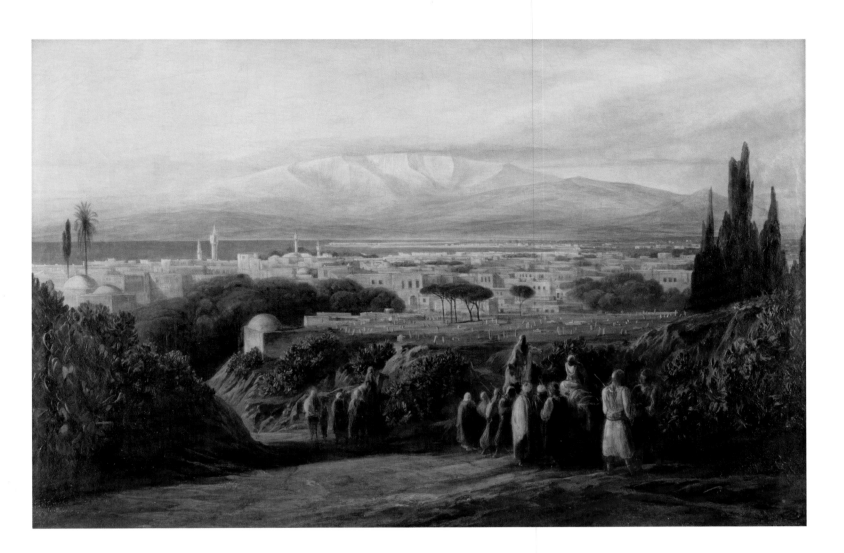

Fig.104
The Sphinx, Giza, looking towards the Pyramids of Saqqara 1854
William Holman Hunt
Watercolour, 25.4 x 35.5
Harris Museum and Art Gallery, Preston

Fig.105
The Pyramids 1861
George Price Boyce
Watercolour, 18.5 x 26.5
The Robertson Collection, Orkney

Fig.106
The Great Pyramid 1854
William Holman Hunt
Watercolour, 17 x 24.7
Courtesy of Peter Nahum at The Leicester Galleries, London

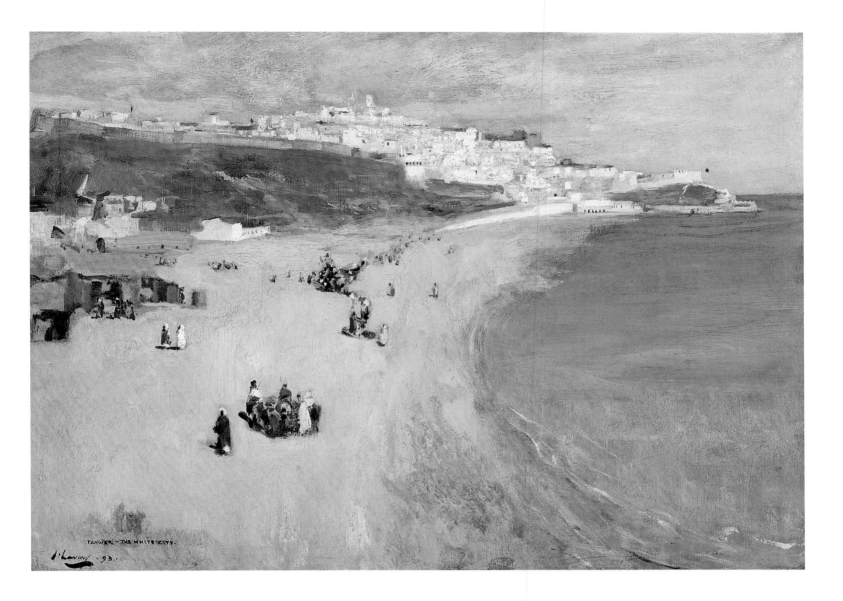

Fig. 107
Damascus and the Lebanon Mountains from 10,000 Feet 1920
Richard Carline
Oil on canvas, 143.5 x 105.4
The Imperial War Museum, London

Fig. 108
Tangier: The White City 1893
John Lavery
Oil on canvas, 61 x 81.4
Private Collection. Courtesy of Karen Reihill Fine Art, Dublin

HAREM

HAREM AND HOME
NICHOLAS TROMANS

The harem was the defining symbol of the Orient for Europeans, and is today the definitive category of Orientalist imagery for us. What the West thought it knew about the East was that there, women were kept as chattels, imprisoned in segregated spaces, the slaves or sex-toys of their masters. From this image derived one of the key meanings of 'Oriental' in European languages: unfettered masculine power. Sexual despotism is the theme of some of the most famous French Orientalist paintings, beginning with Eugène Delacroix's *Death of Sardanapalus* 1827. Later treatments of the harem theme by artists across Europe adopted a less violent but still eroticised tone, imagining the harem as a place of refined female sensuality. In this mode, with its efforts to isolate and distil beauty, harem painting could come to embody kitsch. In this section, the British vision of the harem is explored, a vision which could on occasion lean precariously towards the cruel or the kitsch, but which could also offer fascinating insights into Victorian thinking about the Orient and about domestic life at home.

One meaning of *harim*, denoting what is restricted or forbidden, refers to those people who may not be looked at. In Islamic tradition, beginning with certain prescriptions of the Qur'an, women were enjoined to present a modest appearance, especially when in the presence of men outside their close family. Modesty was achieved partly through the use of head- and face-coverings, and privacy through the dedication of parts of private houses to the women and children of the family (the *haremlik*, as such an apartment was known through much of the Ottoman Empire). How the architectural expression of the harem functioned depended of course upon the wealth of the family, and it was generally the structures of only the grandest establishments that dictated the idea of the harem to the West. Above all others there was the 'seraglio' of the

Ottoman Sultan at Constantinople, where the harem took up a large portion of the Topkapı Palace. This unique institution, closed down in 1909 in the last years of the Empire, guided European mythologies of the harem for centuries. Islamic law allowed a man to take up to four wives at any one time, in addition to any concubines he had purchased as *odaliks* (slaves). From the mid-fifteenth century, however, the Ottoman Sultans gave up the notion of marriage in favour of their concubines, traditionally fair-skinned women taken from the north-eastern Caucasian frontiers of the Empire (Georgians and Circassians), who became the mothers of future Emperors.[1] The idea of the Oriental lord, flicking a handkerchief at whichever of his concubines he fancied for the night, thus entered European fantasy as the standard Middle Eastern state of affairs.

The reality, needless to say, was rather different. As British travellers explored the Middle East in larger numbers from the 1840s onwards, they were able to see, or at least hear, for themselves that for the vast majority of families, not only was the notion of platoons of concubines absurd, but that even polygamy had little to do with actuality. Edward William Lane, recognised as the leading British authority on modern Egypt, reckoned that in the 1830s no more than five per cent of Cairene men had more than one wife, and by the time the new Turkish Republic outlawed polygamy in 1926 it was already a moribund institution. The harems that Victorian artists generally painted, then, were not the scenes of orgies or massacres supposedly the staple of everyday life in the sultan's 'Grand Seraglio', but places that were shown as being in essence little different to the middle-class British homes of the artists' own first-hand acquaintance. In Cairo especially, British artists and architects were drawn to the traditional domestic architecture of the sixteenth, seventeenth and eighteenth centuries, for these

Fig.109
**Exterior of the House of Radwan Bey,
Cairo** 1870
Frank Dillon
Gouache, 30.5 x 40.6
Victoria and Albert Museum

houses – modest or even invisible from the outside, sumptuously decorated inside – seemed to express a bourgeois architectural approach to the harem, that is, an elegant but discreet and functional spatial design.

It is again to Lane that we feel compelled to turn for the definitive guide in English to the Cairene house. But, as always, we need to beware the all-too-helpful straightforwardness of his taxonomy, for Lane seems to want to define fixed usages and terminologies for Oriental domestic spaces that were not in practice so clearly designated. Although Lane warns us against exaggerating Oriental restrictions upon women, he nevertheless himself appears to proceed to develop his own subtle form of prescription of movement through his account of the gendered spaces of Egyptian architecture. Essentially, explains Lane in *An Account of the Manners and Customs of the Modern Egyptians*, the harem was upstairs, with the men's reception area (the *mandarah* as Lane terms it) on the ground floor, looking on to a courtyard (*hosh*).[2] The women's quarters made use of *mashrabiyya* (latticed woodwork) screens across the windows, allowing the occupants to look out but preventing anyone looking in. The patterns of strong sunlight falling through these screens into an interior became a favourite motif of British painters: we see it regularly in the work of John Frederick Lewis, and also for example in Arthur Melville's painting of a solitary man of 1881 (fig.82). The number of well-preserved examples of grand old Cairo houses was however fast shrinking, due to fire (the wooden balconies with their pretty screens were a hazard) and especially to Muhammad ʻAli's urban redevelopment programme. The few accessible old houses became tourist destinations, such as the sixteenth-century *manzil* (house) of al-Sadat al-Wafaʼiya, with its famous first-floor *qaʻa* (the main family room within the harem); the palace built by Radwan Bey near the

Zuwayla Gate in the mid-seventeenth century; and the house occupied for most of the second half of the nineteenth century by the supreme mufti (judge) of Egypt, Sheikh al-ʻAbbasi al-Mahdi. In the 1870s the watercolourist Frank Dillon made careful studies of these during his visits to Egypt (figs.132, 109, 131) as records of an architectural tradition in dire need of preservation.[3] Dillon's images closely parallel the interiors of Lewis, who we know himself lived in a house such as these in Cairo throughout the 1840s, although no clear evidence is as yet available regarding its precise location.

What did the British imagine went on inside a harem? There was all the mythology that surrounded the Grand Seraglio but little first-hand evidence. This was necessarily so given Western men's exclusion from the harem, and the general exclusion of women, who might become reporters on the harem, from the European literary and artistic professions. Hence the great interest shown in the *Letters* of Lady Mary Wortley Montagu, which were published posthumously in 1763. Montagu, one of the most ambitious British women writers of the early eighteenth century, had accompanied her husband to Constantinople, where in 1717–18 he was briefly Ambassador (see fig.57 for Richardson's portrait of Lady Mary, and fig.35 for Romney's portrait of her spectacularly eccentric Orientalist son Edward). After her return home, Montagu worked up a sequence of 'Embassy Letters', based upon her journal and her actual correspondence whilst abroad, and circulated them in manuscript form. This text delights in overturning received wisdom regarding the Orient, and especially revels in describing those places – the harem and women's baths – to which scarcely any earlier European writer had had full access. If, so the 'Letters' implied, one was a woman of self-sufficiency, the harem represented a release into a kind

of feminotopia: Turkish women, Montagu concluded, were more, not less, free than their European sisters. This was all appropriately shocking stuff, and Lady Mary threw in for good measure a hint at a same-sex *tendresse* and a wish that she could have had with her her friend the society portrait painter Charles Jervas to record the scenes she witnessed in the baths at Sofia.[4] Montagu's 'Embassy Letters' thus set down an alternative archetype for the British representation of the harem, one based upon personal experience and which put aside ethics and gender politics to focus upon the sheer pleasure women could have together if left alone. It was a version of the harem that was only to be fully explored in art during the Victorian period, a century after the publication of the *Letters*, and thus necessarily in a very different historical context.

Between Montagu's letters and the pictures of Lewis came the Romantics' cavalier approach to the harem in which it is typically used as a fantastic backdrop to episodes in the main story, as in Cantos V and VI of Byron's *Don Juan* (1820–2). As the nearest thing English literature could boast to an Orientalist Romantic poet, Byron's verse was regularly referenced by painters of Oriental subject matter (the theme of Delacroix's *Sardanapalus* was borrowed from his eponymous play of 1821). His lyric of 1810, 'The Maid of Athens', especially appealed to painters of harem scenes on account of its reference to the so-called language of flowers, the system of communicating silently or surreptitiously through meaningfully arranged bouquets: 'the token-flowers that tell / What words can never speak so well'.[5] These lines were cited by Henry William Pickersgill when he exhibited his *Oriental Love Letter* (fig. 118) in 1824, in which a distinctly Caucasian-looking lady has received a discreet billet-doux, the forms of which are echoed by the floral patterning all over the rest of the picture. (Pickersgill's interest in this theme

may well have been prompted by his wife, the author of a book of verse, *Tales of the Harem*, published in 1827.)[6] The iconography and the quotation from Byron were repeated when in 1855 Lewis exhibited an Oriental oil painting for the first time, his *Armenian Lady, Cairo – The Love Missive*, while Lewis's *An Intercepted Correspondence* (fig. 110) is a far more involved composition in which an illicit communication has been found out by the recipient's jealous fellow harem inmates. This preponderance of flowers (see also *Lilium Auratum*, fig. 111, and *The Bouquet*, fig. 120) suggests the age-old equivalence between the female and the natural. The nude in British art was typically imagined outside, at one with nature, but now if women were to be shut up, so runs the implication, then nature must go to them (consider the number of animals that often appear in harem scenes). The secret language of flowers also suggests the silence of the seraglio, the idea that it was a place of jealously guarded behaviour (the master's multiple partners were assumed to be permanently jealous of one another), where the only talk was hushed gossip (see *Indoor Gossip*, fig. 123).

The negative image of the harem was, as suggested above, corrected from the 1840s as Europeans were able to discover more of the actuality of social life in the Middle East. Lane, like Montagu, stressed how fantastical the traditional notion of immurement had been. Of course married Egyptian women were free to come and go as they saw fit, he assured his many readers (as free at least as Englishwomen); of course their husbands could not just treat them as they pleased; and of course Egyptian men did not really all have multiple wives, indeed very few had more than one.[7] It would appear that it was also in this generation that the British began to abandon the myth that Islam denied that women had souls (although one of the last refuges of this calumny was to be in art criticism). The harem remained

Fig.110
An Intercepted Correspondence 1869
John Frederick Lewis
Oil on panel, 74.3 x 87.3
Private Collection

Fig.111
Lilium Auratum 1871
John Frederick Lewis
Oil on canvas, 136 x 88
Birmingham Museums & Art Gallery

Fig.112
**A Visit: Harem Interior,
Constantinople, 1860** 1860/1
Henriette Browne
Oil on canvas, 89 x 114
Private Collection – Courtesy of
Marco Frignati Art Advisory, London

as a symbol of the Eastern way of doing things, but that way now seemed characterised not so much by tyranny and intrigue as by a devotion to domesticity.[8] It had been the ideas of polygamy and promiscuity that had offended Europeans, but if these sins were now being revealed as largely fictions, then perhaps the Oriental woman's life was not so much to be pitied as envied.[9] This shift in perspective was not unanimous, however, and opened up new lines of division between British commentators on the harem. For those championing women's rights to positions in the public sphere, the harem remained as offensive as ever. In the 1790s the feminist Mary Wollstonecraft had adopted its image as a sign of the despotism of patriarchy, and so it remained for later generations of women who did not relish staying at home. The economist, journalist and feminist Harriet Martineau, who travelled in the Middle East in 1847, left what is perhaps the most bitter denunciation of the harem ever published. It was polygamy which, as ever, was the most atrocious of vices – nothing less than 'a hell upon earth' for Martineau – but we get the sense that a life spent gossiping and visiting (as she believed harem life to consist of) was equally vile in her eyes.[10] On the other hand, for those in Britain who championed a cult of domesticity and the doctrine of separate spheres for the two genders, then the harem could come to seem, in absolute contrast to Martineau's views, a model of civilised modern living. Montagu's aristocratic, blue-stocking archetype was revived in suburban guise.

By the middle of the nineteenth century, with the library of Oriental travel literature bulking ever larger, amongst it an increasing number of books by female authors to whom the harem was not off limits, the public could insist upon first-hand evidence of Eastern domestic life. The French poet and critic Théophile Gautier even declared in 1861 that only women

should bother travelling to the Orient, as a male tourist's experience would necessarily be so much more limited. This comment was prompted by the appearance at the Paris Salon of a great novelty: paintings of a harem by a woman who had it seemed derived her pictures from her own experience. This was Henriette Browne, the almost-English professional pseudonym of Sophie De Saux, who (similarly to Montagu) accompanied a diplomat husband to Constantinople for a fortnight in 1860 and the following year exhibited in Paris *A Visit* (fig.112) and *A Flute Player*, both pictures being subtitled *Harem Interior, Constantinople, 1860*; one at least of the pair was shown at Ernest Gambart's French Gallery in London in 1862.[11] In the painting reproduced here, Browne depicts Martineau's idea of pure suffering, the visit of one harem to another, a saga of politeness which might easily take up a whole day. One group of women, lightly veiled with yashmaks for their journey, ascend to their hostess's sparsely furnished apartment (they have brought their own cushions), where only one of the assembled ladies makes any effort to greet them. The leading visitor makes the conventional salutatory gesture of touching her forehead, lips and chest with her right hand; a child with the visitors is not at all at ease; while an older woman on the far left holds a cigarette before her in a decidedly unwelcoming pose.[12] Perhaps we should see a gentle comedy of embarrassment here, along the lines of David Wilkie's classic *Letter of Introduction* 1813, or perhaps an authentic evocation of the slow beginnings of a social ritual that was in no hurry to unfold. In either case, as a picture, what distinguishes it from the harem scenes of Lewis is its acute emptiness. Lewis's *A Lady Receiving Visitors (The Reception)* 1873 (fig.128) is a close parallel in terms of subject matter, but the large expanse of sunlit wall looming over the figures in Browne's picture makes for a sharp contrast with the *horror vacui* of Lewis's

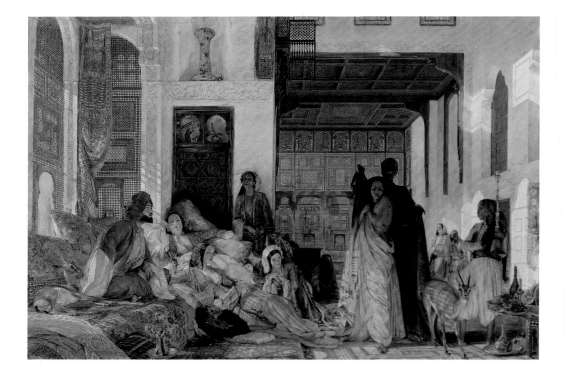

Fig.113
The Hhareem 1850
John Frederick Lewis
Watercolour, 88.6 x 133
Private Collection

endlessly reticulated surfaces.[13] The comparison may well send us back to Lewis with a slight sense of claustrophobia.

Lewis inaugurated his public career as an Orientalist painter in 1850 with the most ambitious harem painting ever attempted by a British artist (fig.113). He called it *The Hhareem*, the double 'h' indicating the Arabic letter ح and thereby seeming to announce in the very spelling of his title a new level of authenticity. The picture, a densely and opaquely worked watercolour, was executed in Cairo – the only major work certainly completed there before Lewis's return to Britain in 1851 – where the artist had resided for fully ten years, allowing it would seem virtually all his connections at home to lapse (he was very nearly voted out of the Society of Painters in Water Colours, where the picture was shown in 1850, on account of not having submitted anything to their exhibitions since arriving in Egypt). *The Hhareem* marked his return to the London exhibiting stage, and must rank as one of the great artistic homecomings of history.

Lewis gave a full account of the action when the picture was shown again in Edinburgh in 1853. Crucially, we are being shown a scene that could scarcely be imagined as taking place in modern Cairo: the picture may well represent the nearest thing British Orientalist painting can provide (outside biblical illustration) to a scene from history. The master of the harem is a wealthy, polygamous Bey, 'habited in the old Mameluke dress of Egypt, now not often worn', that is, he belongs to the elite military caste that had taxed Egypt on behalf of the Ottomans before their leadership were wiped out by Muhammad 'Ali in a massacre in 1811.[14] The man sits on the left with his three wives, all of whom we must imagine he had originally bought as concubines. Lewis designates them as, from left to right, Georgian, Circassian and Greek respectively. The Georgian

is the 'Sit el Gebir, or ruling lady of the Hhareem' by virtue of being mother to the master's son who nestles against her. The black women are Abyssinians (Ethiopians), the laughing woman a longstanding 'inmate' of the harem, the woman being unveiled the latest arrival (the slave-trader's veiled wife, awaiting approval or payment, can be seen in the background). We are thus presented with a thoroughgoing racial taxonomy of the harem along the lines of those described by the Romantic poets including Byron and Tom Moore.[15] The new Abyssinian plays her conventional role as a kind of erotic natural anomaly, the woman who achieves a beauty of form and feature on a level with her Caucasian competitors 'despite' her African skin. If we imagine the man asking himself whether or not this new woman's degree of racial difference precludes his making her his fourth wife, then the central drama of the picture comes to turn on race as much as gender.[16] In addition to this ethnic cornucopia, there are beautiful animals, magnificent architecture and a virtual museum of decorative arts. It is impossible to take it all in, and indeed the master of the harem himself seems unable to focus his gaze very easily. This character's posture and expression give the cue for the viewer's reaction (the image's original spectators may have been assumed to be male, but today perhaps it is more fascinating to the female gaze). Far from being the complaisant European whom nothing can impress, as Viscount Castlereagh appears in Lewis's *A Frank Encampment in the Desert of Mount Sinai* (fig.101), we – like the Bey – cannot quite believe our eyes, and we have the feeling the artist does not expect us to. Lewis's initial invitation into his Oriental world thus assures us simultaneously of its accuracy (through the precise form of its title) and its fantasy (through its sheer impossibility). These are the terms on which he and his public would have to get along in future, as Lewis settled down (in London, and then in Walton-on-

Thames within the emerging Surrey commuter-belt) to a twenty-five year career as an Orientalist painter.

As was noted above, the house or houses in which Lewis lived while in Cairo have never been identified (not that we should expect them to have survived).[17] There exists a tantalising 'Ground Plan of Mr Lewis House Cairo' by the architect James William Wild (in the Victoria and Albert Museum), but this is frustratingly hard to follow, the rooms being labelled with letters to which there is no surviving key. A drawing, now untraced, in Lewis's 1877 studio sale was catalogued as 'Interior of upper room in a house, Esbekieh, Cairo, occupied by J.F. Lewis', suggesting the artist may have resided in the Azbakiya quarter, towards the north-west of the historic centre of Cairo, where a European-style landscaped garden had been laid out and which became the centre of tourist life in Cairo. This was where, for example, the artists Frederick Goodall and Carl Haag shared a studio during the winter of 1858–9 (see Haag's *Our Studio in Cairo*, fig.129). But more than one of Lewis's visitors explicitly stated that he lived away from the tourist areas, in a more 'native' part of town.[18] Despite this uncertainty, it is nevertheless clear that Lewis rented a grand old upper-class house and that he used its interior as a model for some of his pictures. The drawing inscribed 'Mandarah in my house at Cairo' (fig.127), for example, was evidently used for the setting of *A Lady Receiving Visitors* (fig.128). It also seems likely that when Lewis painted scenes set in the courtyards of Cairo houses, such as *The Mid-day Meal* (fig.83), his own residence was again the model (fig.133).

The architecture of *The Mid-day Meal* reappears, in re-ordered perspective, in Lewis's *The Courtyard of the Coptic Patriarch's House in Cairo*, an oil painting shown at the Royal Academy in 1864 (the version shown here is a smaller repetition, fig.134). In this picture, the leader of Egypt's ancient Christian denomination (the word 'Copt' ultimately derives from the same Greek root as 'Egyptian'), wearing a distinctive broad, round turban, is shown in the background dictating a letter to be taken to one of the Coptic monasteries in the desert. This incident is however just one of many taking place within a composition busy enough, as one critic observed, to supply twenty pictures.[19] Several of the details, especially the wildlife, parallel the description of Lewis's domestic life given by the novelist William Makepeace Thackeray following his visit to Cairo in 1844:

> First we came to a broad open court with a covered gallery running along one side of it [the *maq'ad*]. A camel was reclining on the grass there; near him there was a gazelle … On the opposite side of the covered gallery rose up the walls of his [Lewis's] long, queer, many-windowed, many-galleried house. There were wooden lattices to those arched windows through the diamonds of which I saw two of the most beautiful, enormous ogling black eyes in the world, looking down upon the interested strangers. Pigeons were flapping and hopping and fluttering, and cooing about. Happy pigeons you are, no doubt, fed with crumbs from the henna-tipped fingers of Zuleikah![20]

'Zuleikah', named by Thackeray after the Egyptian lady who took a fancy to Joseph in the Book of Genesis, and to whom the beautiful eyes belonged, was Lewis's cook, and perhaps, hints Thackeray lasciviously, concubine.[21] It is tempting to imagine the female figure who leans out of the first-floor window in Lewis's *The Courtyard of the Coptic Patriarch's House in Cairo* to be this same young woman. But whereas Thackeray describes the servant or slave remaining appropriately hidden from himself by the

mashrabiyya screens of the artist's house, the woman in Lewis's painting peers out unveiled, her face clearly visible to the men in the courtyard. (There is also an unveiled girl shown feeding the pigeons in the foreground although she is perhaps too young to need to be veiled?) Coptic women, Lane claims, adopted the same principles of veiling as their Muslim countrywomen, and so with this tiny detail Lewis appears to contradict all we thought we knew about how the modern harem operated.[22] As in his *Hhareem*, evidence of unprecedented first-hand knowledge of Egypt seems to go hand-in-hand with an impossible scenario, a paradox again visible in Lewis's *A Lady Receiving Visitors* (fig.128), in which the harem seems to have taken over the supposedly male-only space of the *mandarah* (see Emily Weeks's essay in this book). Thus Lewis ultimately deconstructs Lane's authority, as had Hunt in his *Lantern-Maker's Courtship* (see Introduction, p.16–17), refusing to become simply an illustrator of his famous book, or of the 'facts' of Middle Eastern domestic life as recounted there. Lewis's harem pictures weave between European models, and presumed Oriental models, of domestic life to create a kind of visual hybrid that is finally irreducible to any 'position' or opinion other than an apparent delight in showing us so much but refusing, in the end, to tell us anything for certain. As we have noted, Lewis was not a person comfortable with words. His currency was the craft of picture-making, and with his harem scenes, perhaps in his Oriental work altogether, Lewis presents us with a kind of pictorial stalemate that seems to trace the limits of what might be done by a Western artist confronting the Orient, with a commitment to retaining the independence of painting from the certainties of textual scholarship, perhaps more generally from the certainties of East/West antitheses. Lewis's continuing fascination for

us is based on this self-awareness of the boundaries defining the visual culture of Orientalism.

One regular feature of Lewis's harem scenes at which commentators have often raised an eyebrow is the decidedly un-Oriental appearance of the women in them. He must have used British models to sit for these figures after his return home in 1851, and among these was his wife Marian (fig.114) whom a fellow artist specifically noted as appearing in Lewis's *In the Bey's Garden, Asia Minor* 1865.[23] But we have seen that Caucasian women were especially prized as wives and concubines within the Ottoman Empire: women from this region became the sultans' preferred companions in Constantinople and stood at the top of the social order in Cairo. In using white European women as models, then, Lewis was able not only to make life convenient for himself, but also to suggest the peculiarly Oriental erotic cachet of the Caucasian.

Marian's features can also clearly be seen in Lewis's 1857 watercolour of *Hhareem Life, Constantinople* (figs.115, 121), possibly the most enigmatic of all his harem subjects. Here Marian is shown standing, sharing a gentle joke with a seated woman: perhaps they are enjoying the cat's game of shredding the second woman's peacock-feather fan. Marian's rather less elegant fan, and more attentive stance, seem to mark her as her companion's servant, and this was indeed how the critics read the situation.[24] Their costumes are however scarcely explicit in dictating these roles, and Lewis again seems to be playing with our assumptions: are the women perhaps equals, both wives of the same man, and their harem therefore a setting for the old vice of polygamy? Their precise social positions did not seem to matter, at least to the reviewer in the *Art Journal*, who referred to the seated woman as a 'khanum [*hanim*, a lady of status], odalisque [concubine], or what you will': this writer had learned not to look to Lewis

for precise lectures on the state of Oriental customs.[25] The women's husband or master is in fact minimally present in the picture: a pair of slippers, apparently a man's, are visible in the mirror. Slippers had a crucial role in the iconography of the harem, standing for all that was best about the institution in Western eyes, for a pair of lady's indoor yellow slippers placed at the entrance to the harem marked the presence of a female guest and thus absolutely forbade even the husband's entrance. Slippers might then mark the boundary of male authority and suggest the harem's potential as a site of female independence (and so the harem visit might mean more than the empty politeness lamented by Martineau).[26] But what are we to make of the man, if that is what these slippers signify, who is imagined standing before the two women in Lewis's *Hhareem Life, Constantinople*, regarding them much as we the viewers do? (Rather as in Edouard Manet's *Bar at the Folies-Bergère* of 1882, the man in the mirror and the spectator are elided.) The impression given is that they are scarcely aware of his presence, and certainly not intimidated by it. As with the case of 'Zuleikah' in the *Hosh*, these women's harem lives seem free of fear or constraint.

Lewis never painted a nude. The iconography of the odalisque (from the Turkish *odalik*, relating to *oda*, meaning room) – the Oriental sex slave whose image is offered up to the viewer as freely as she herself supposedly was to her master – is almost entirely French in origin. Above all we associate the odalisque with the great Classicist Ingres, the author of *La Grande odalisque* 1814 and *The Turkish Bath* 1862 (fig.27), among the defining images of French Orientalist painting.[27] From the 1860s, Ingres was to be a prime model for the revival of Classical nude painting in Britain. His *La Source* (completed 1856), a full-length standing nude (not Oriental but 'purely' Classical) pouring water from

an allegorical urn at her shoulder, in particular appeared to offer a chaste vision of what the nude might be. But even under this influence, the British artists did not import the nude into the harem. When Frederic Leighton, the greatest British Classical artist of his generation, painted an *Odalisque* in 1862 (fig.119), she was imagined clothed and dallying with a swan, suggesting the mythological figure of Leda, from whose union with Zeus in the form of a swan was born Helen of Troy, destined to be the trophy over which East and West collide in the Homeric legends.[28] In the following decade, Leighton returned to the harem with his charming *Music Lesson* (fig.135), in which the artist's favourite child model of the 1870s, Connie Gilchrist, is shown being taught the rudiments of the *saz* (long-necked lute) in an interior decorated in a style amalgamating the Islamic and the Classical.

Leighton's *Music Lesson* imagines the harem as a place of almost English domesticity, as do several of Lewis's pictures, although there the women take less interest in children. In both artists' work, women's fully clothed respectability suggests a moral healthiness to go with their natural good looks. For the Victorian art journalists this seemed one of many ways in which the British showed their superiority to the French, whose pictures always seemed to them to verge on pornography. They had the opportunity to confirm this impression when in 1870–1 the leading French Orientalist painter Jean-Léon Gérôme exhibited at the Royal Academy whilst avoiding the Franco-Prussian War and Paris Commune (Gérôme had already been elected one of the first batch of Honorary Foreign Academicians in 1869). At the 1871 Academy exhibition Gérôme showed his *For Sale: Slaves at Cairo*, depicting a Caucasian and an Abyssinian girl being offered for sale in Cairo (the painting shown here, fig.126, is a smaller version of the same date, with more figures).[29] The picture was widely found offensive, revelling in cruelties which – it was

objected – were no longer part of modern Egyptian life following the suppression of the slave trade there, and representing fleshliness only for its own sake. But one reason for the anger the picture provoked may well have been that its subject reminded the public precisely that the slave trade had in fact *not* yet been successfully suppressed in Egypt, despite frustratingly prolonged British diplomatic efforts to achieve this.[30] As for the surface of the painting itself, one attentive critic described its dangerously seductive qualities, observing that a high degree of detailing gave an impression of accuracy which was not really present, and that a garish tonality, 'instead of repelling, seems, like the intensity of the realisation, to attract us to penetrate its murky depth of meaning'.[31]

If Gérôme represented (as he has for some modern art historians) the equation of Orientalism with the nude in pornographic mode, then the Orient itself was also blamed, by champions of the chaste artistic nude, for the related crime of being the origin of unhealthy fears of the body. In 1878 the Chairman of Liverpool's Walker Art Gallery, Philip Rathbone, gave an extraordinary speech at the Social Science Congress in defence of the nude in art, in which he claimed that 'The Turk regarded and regards women as animals without souls, toys to be played with or broken at pleasure, and to be hidden, partly from shame, but chiefly for the purposes of stimulating exhausted passion'.[32] Ottoman occupation of Greece had, explained Rathbone, suppressed the purity of the Classical nude. According to this version of the European Classical tradition, the Orient needed to become more natural, to learn about the innocence of flesh. The principles of *hijab* (covering of the hair or face) and *harim* (separation of women from men) soon afterwards became central cultural symbols in the politics of the occupation, from 1882, of Egypt by Britain. Lord Cromer,

British Consul-General and virtual dictator of the country for many years, depicted Islam's supposed suppression of women as evidence of an entire culture's backwardness. Back in London, however, he was himself a leading figure within the Men's League for Opposing Women's Suffrage.[33]

In his Egyptian pictures of the 1850s, William Holman Hunt had already offered a rhetorical visual equivalent of these themes. His *Lantern-Maker's Courtship* (figs.73, 116) describes an urban society in which, as Rathbone claimed, lust seems to be increased through the frustration of the gaze. But Hunt's *The Afterglow in Egypt* (figs.117, 125) offers the timeless, rural antidote to what he perceived as the unnatural culture of urban Muslim society. A young *fellahah* (agricultural worker), the picture of strength and health, calmly confronts us. Unveiled as rural labourers typically were, allowing us to see the tattooing on her chin, she holds a jug at her shoulder, as if Ingres' *La Source* had been transported to the Nile. The picture's title, referring to the light still briefly illuminating the landscape after the disappearance of the Egyptian sun, suggests a distant modern echo of the grandeur of Ancient Egypt. But the figure's confidence and youth, seeming to allegorise labour, speak of the future. This picture, begun like the *Lantern-Maker's Courtship* in 1854, was only completed in 1863.[34] By the 1860s, voices were beginning to be raised by Ottoman reformers against the harem and against veiling. In 1867, Namık Kemal, later a leading figure among the 'Young Ottoman' intelligentsia, pointed to the unveiled female agricultural labourer as evidence that there was no natural law preventing women from taking their place in the world of work.[35] For the late nineteenth-century Ottoman intellectual, an awareness of Western beliefs concerning the position of women in their society was often a source of shame. Osman Hamdi Bey, one of the leading

Ottoman painters of the period, and the key figure in the birth of Turkish museology, has been praised for turning away from Western stereotypes of the harem in his pictures in an effort to represent the lives of Ottoman women in a more positive light.[36] Looking at his 1880 painting of *Two Musicians* (fig.136), however, we might feel he has simply replaced the model of Gérôme, with whom he may have studied in Paris in the 1860s, with that of Leighton, whose homely *Music Lesson* Hamdi's picture so closely resembles. By the end of the century, with the days of the Imperial harem itself clearly numbered, there was a keen awareness on the part of Middle Easterners of the West's appetite for ever more personalised tales and images of the harem. Several Ottoman women told of their experiences in English-language publications, in some case helped into print by British women.[37] In one of the founding works of modern Arabic fiction, Muhammad al-Muwaylihi's *Hadith ʿIsa ibn Hisham*, first published in serial form in Cairo at the turn of the twentieth century, the Minister of War under Muhammad ʿAli, Ahmad al-Manikali, returns as a ghost to modern Cairo to witness the cultural fallout of the development programmes initiated by his master. Attending a wedding, al-Manikali is taken aback to find among the guests a number of Europeans whose tour guides have sold them invitations. He is however pleasantly surprised to see the European women hurrying to the harem bearing what he assumes are presents in boxes, until he is disabused by another guest:

> They're cameras. They're taking them inside to get pictures of the harem and the women in all their finery … Often thousands of copies are made to be sold on the European market; they're distributed all over the place to be joked at and made the object of sarcastic remarks.[38]

How do we interpret this satire? Partly as a sardonic reflection upon the power that accrued to the West in the wake of Muhammad ʿAli's opening of Egypt to European technology. It also expresses Middle Eastern resentment at Western images of the harem, a resentment that evidently did not take into account the more flattering British visions of Turkish and Egyptian private life that we have considered. It was however by now rather late in the day to begin expecting clear objectivity in any aspect of the images and representations that surrounded the harem.

Fig.118
The Oriental Love Letter 1824
Henry William Pickersgill
Oil on canvas, 142.6 x 111.8
Royal Academy of Arts, London

Fig.119
Odalisque 1862
Frederic Leighton
Oil on canvas, 90.8 x 45.7
Private Collection

Fig.120
The Bouquet 1857
John Frederick Lewis
Oil on wood, 30 x 18
Dunedin Public Art Gallery

Fig.121
Hhareem Life, Constantinople 1857
John Frederick Lewis
Watercolour, 61.2 x 48.1
Laing Art Gallery, Newcastle-upon-
Tyne (Tyne and Wear Museums)

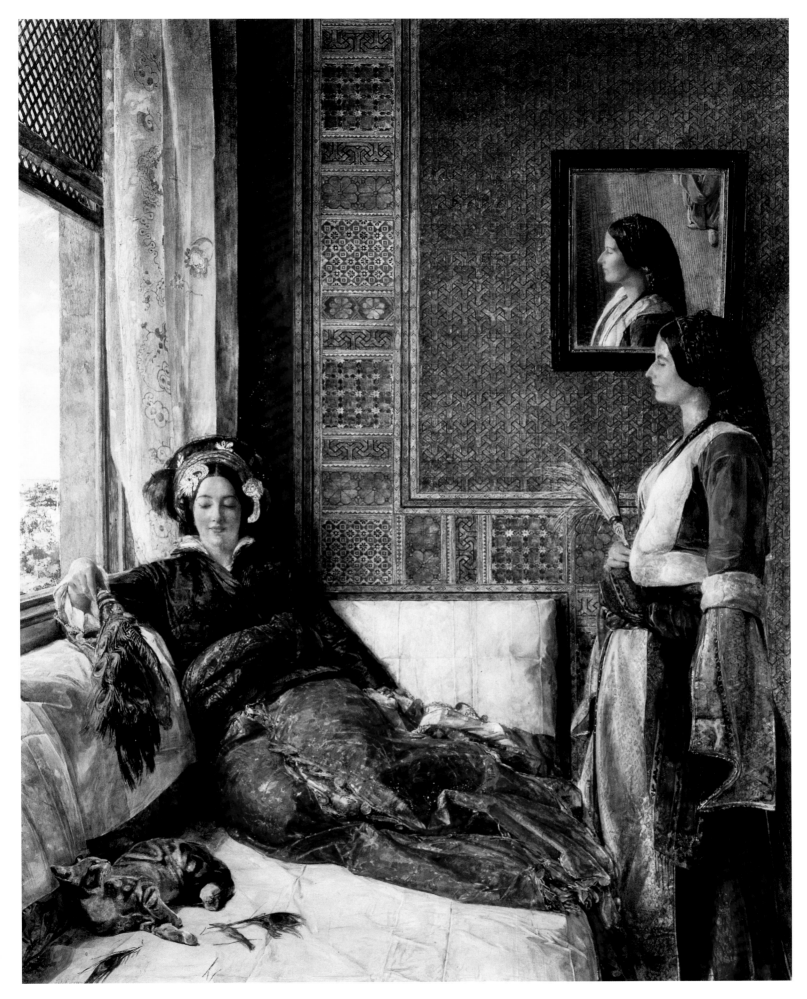

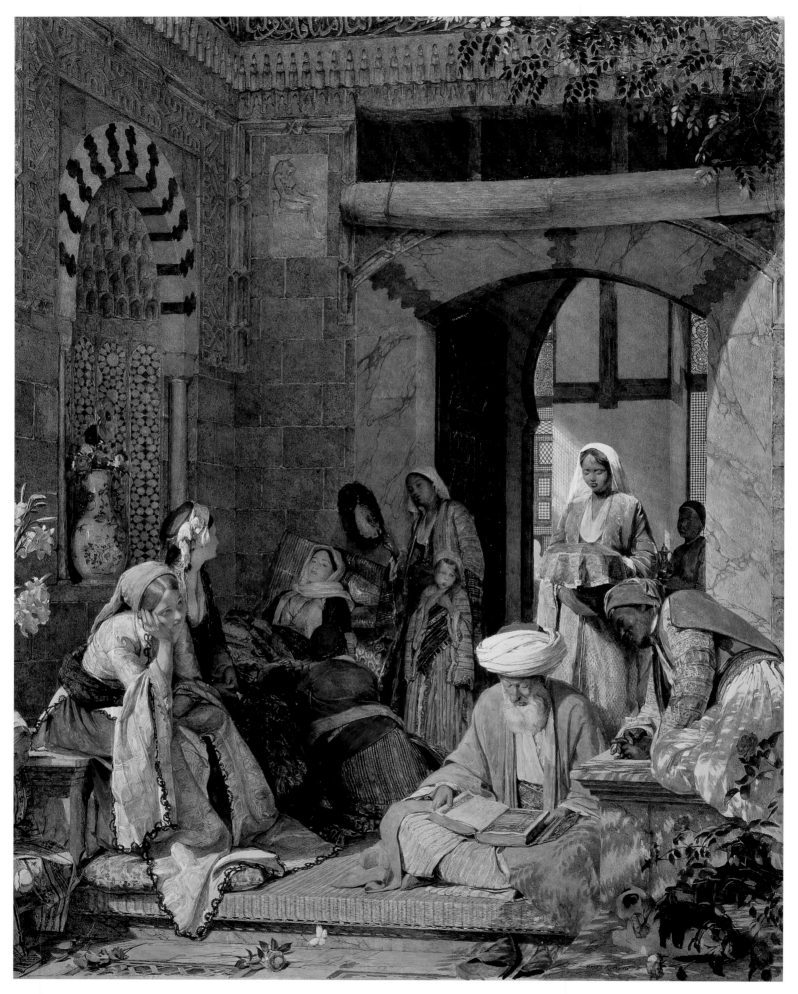

Fig.122
'And the Prayer of Faith Shall Save the Sick' 1872
John Frederick Lewis
Oil on wood, 90.8 x 70.8
Yale Center for British Art,
Paul Mellon Collection

Fig.123
Indoor Gossip 1873
John Frederick Lewis
Oil on panel, 30.5 x 20.3
The Whitworth Art Gallery,
University of Manchester

Fig.124
Outdoor Gossip 1873
John Frederick Lewis
Oil on panel, 30.5 x 20.3
The Whitworth Art Gallery,
University of Manchester (on loan
from a private lender)

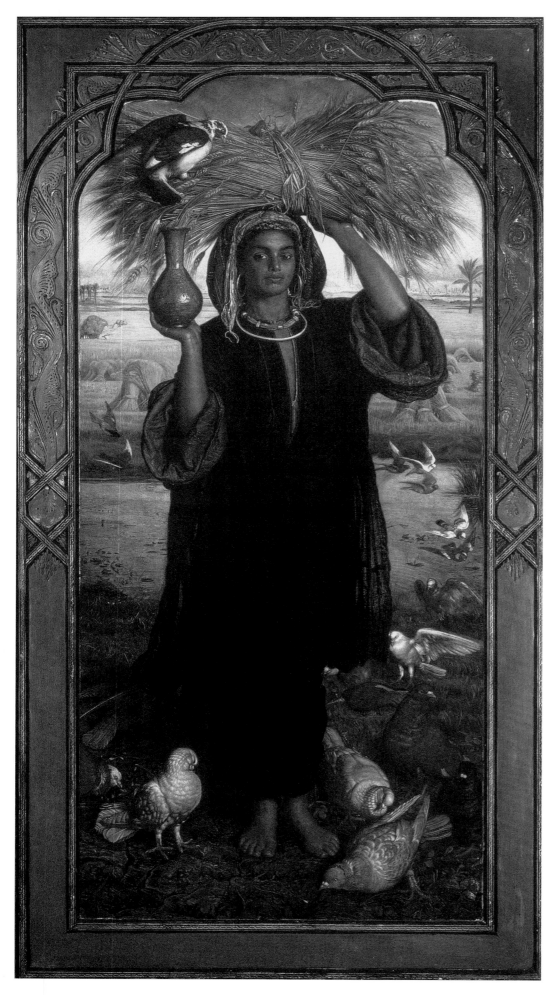

Fig.125
The Afterglow in Egypt 1854; 1860–3
William Holman Hunt
Oil on canvas, 185.4 x 86.3
Southampton City Art Gallery

Fig.126
For Sale: Slaves at Cairo *c*.1871
Jean-Léon Gérôme
Oil on canvas, 75 x 60
Cincinatti Art Museum

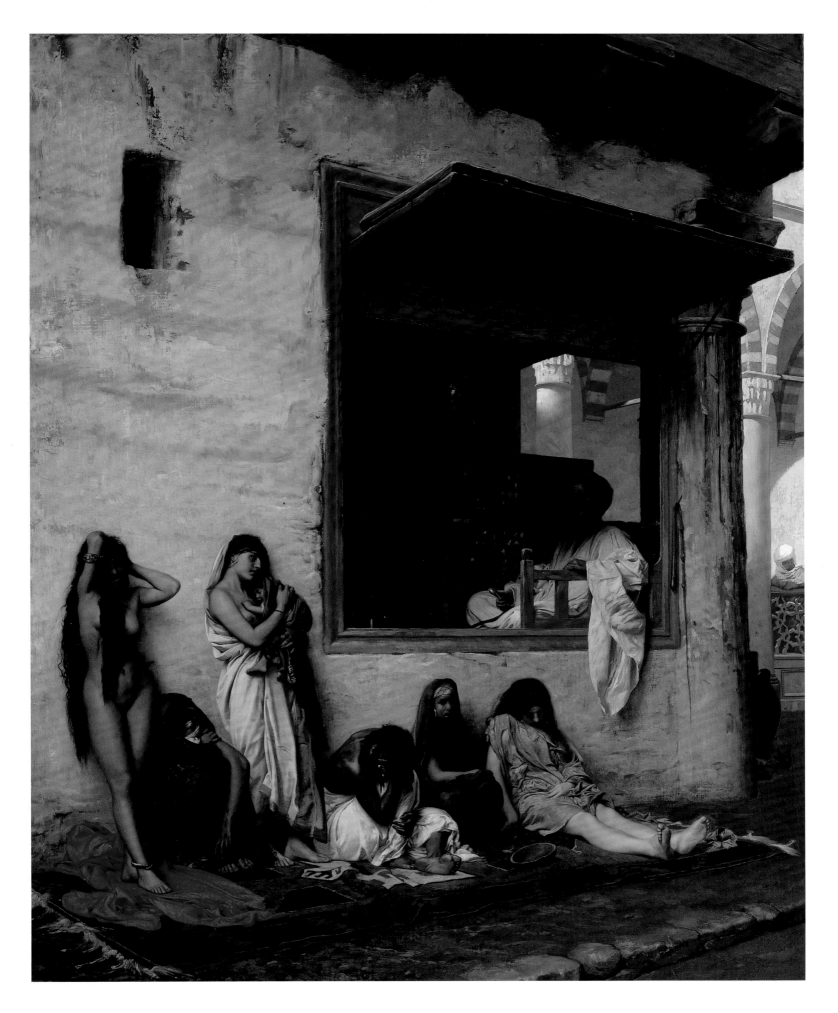

Fig.127
'Mandarah in my House at Cairo'
*c.*1841/51
John Frederick Lewis
Pencil, watercolour and gouache,
57.7 x 78.7
Victoria and Albert Museum

Fig.128
A Lady Receiving Visitors (The Reception) 1873
John Frederick Lewis
Oil on wood, 63.5 x 76.2
Yale Center for British Art,
Paul Mellon Collection
See overleaf for detail

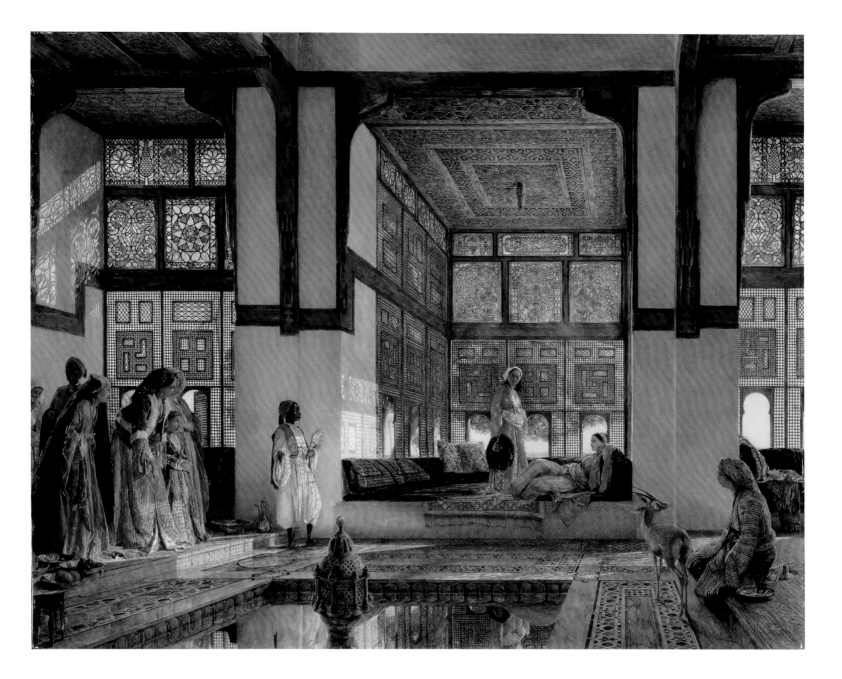

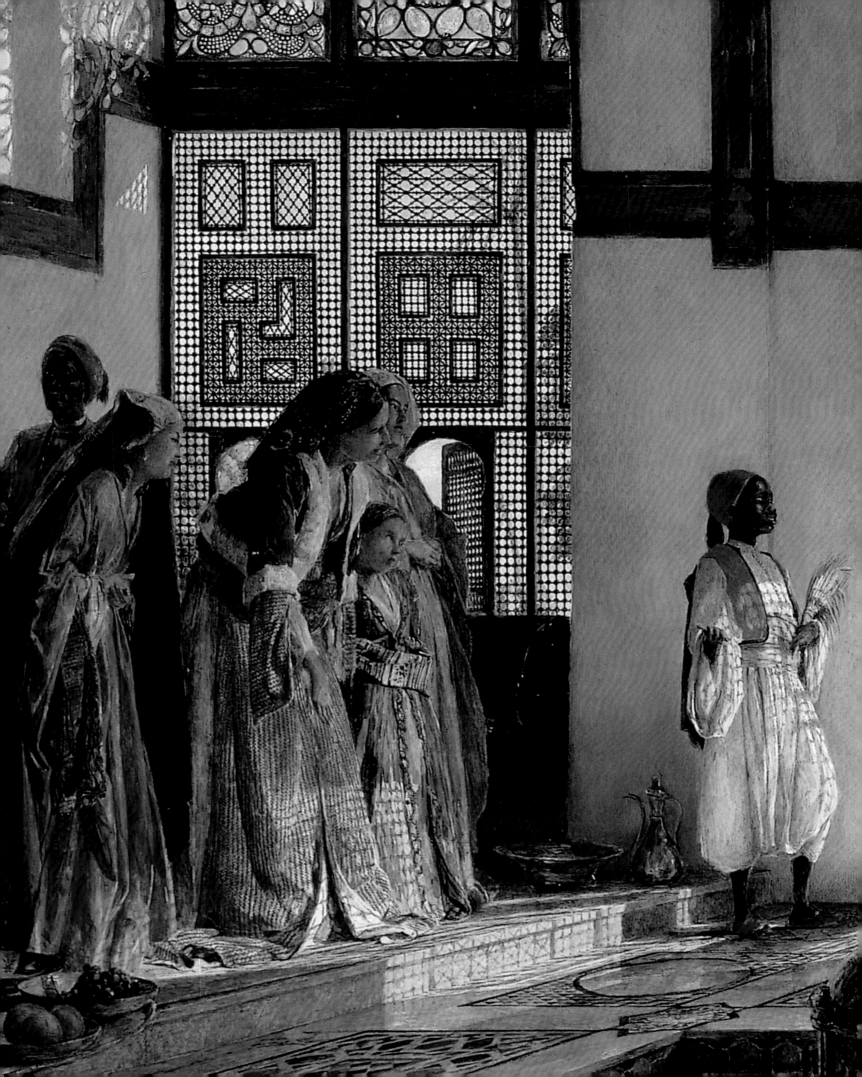

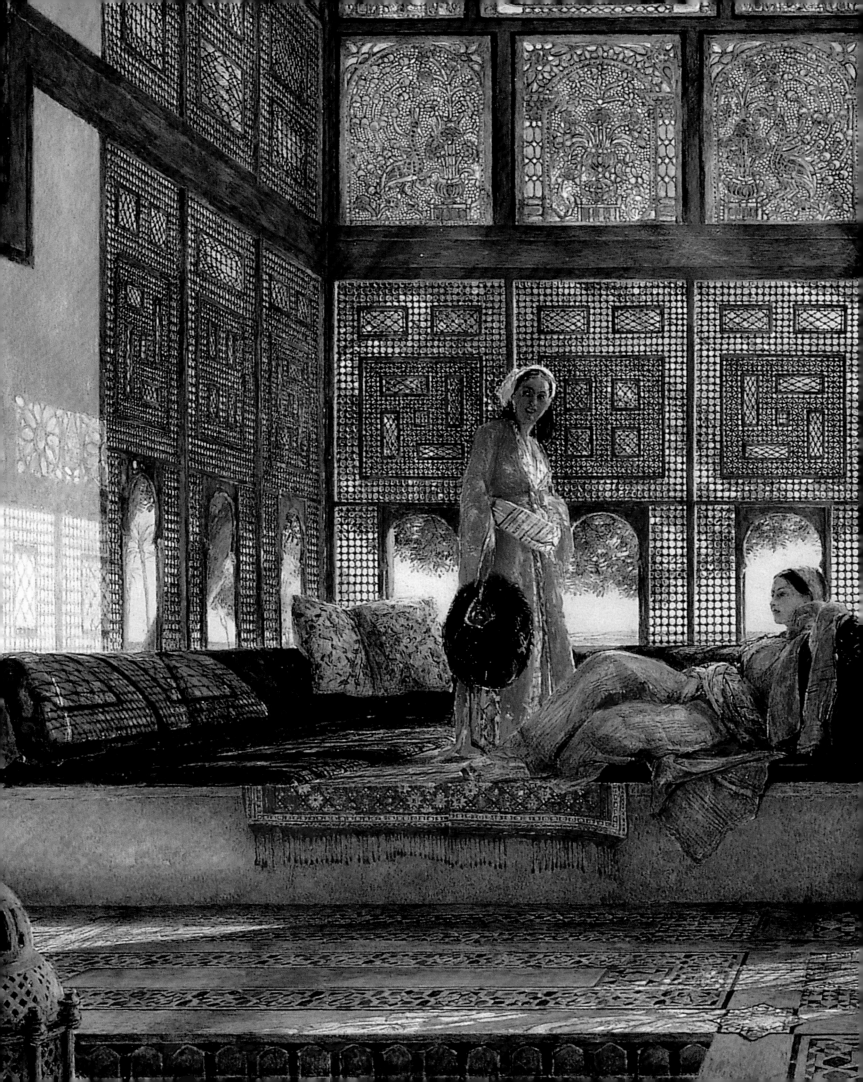

Fig.129
Our Studio in Cairo 1859
Carl Haag
Watercolour, 49.5 x 35
Private Collection

Fig.130
**Interior of William and Edith Holman
Hunt's House in the Street of the
Prophets, Jerusalem** *c.*1876/81
Edith Holman Hunt
Watercolour, 38 x 53.4 framed
Chris and Carolyn Lamb

Fig. 131
Interior of the House of the Mufti Sheikh al-Mahdi, Cairo *c.*1872
Frank Dillon
Watercolour, 30.5 x 47
Victoria and Albert Museum

Fig. 132
Interior of a room in the female quarters of the house of Sheikh al-Sadat, Cairo *c.*1875
Frank Dillon
Gouache, 74.5 x 58.5
Victoria and Albert Museum

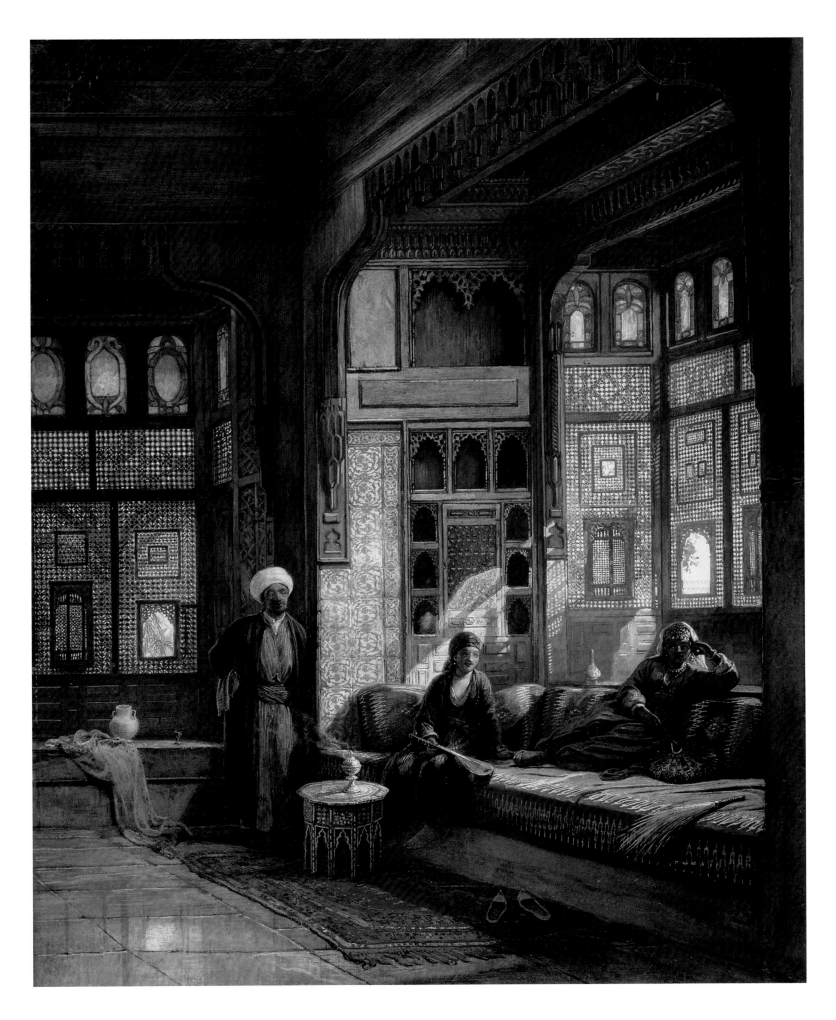

153

Fig.133
Courtyard of the Artist's House, Cairo *c*.1841/51
John Frederick Lewis
Watercolour, 78.7 x 57.7
Victoria and Albert Museum

Fig.134
The Courtyard of the Coptic Patriarch's House in Cairo *c*.1864
John Frederick Lewis
Oil on wood, 36.8 x 35.6
Tate

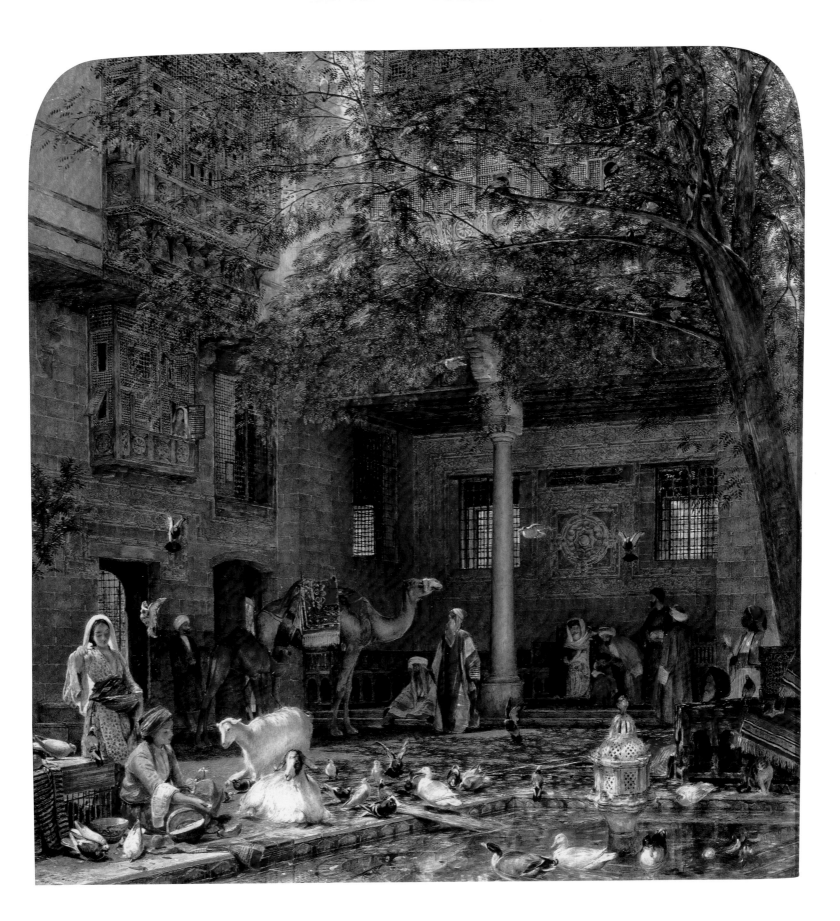

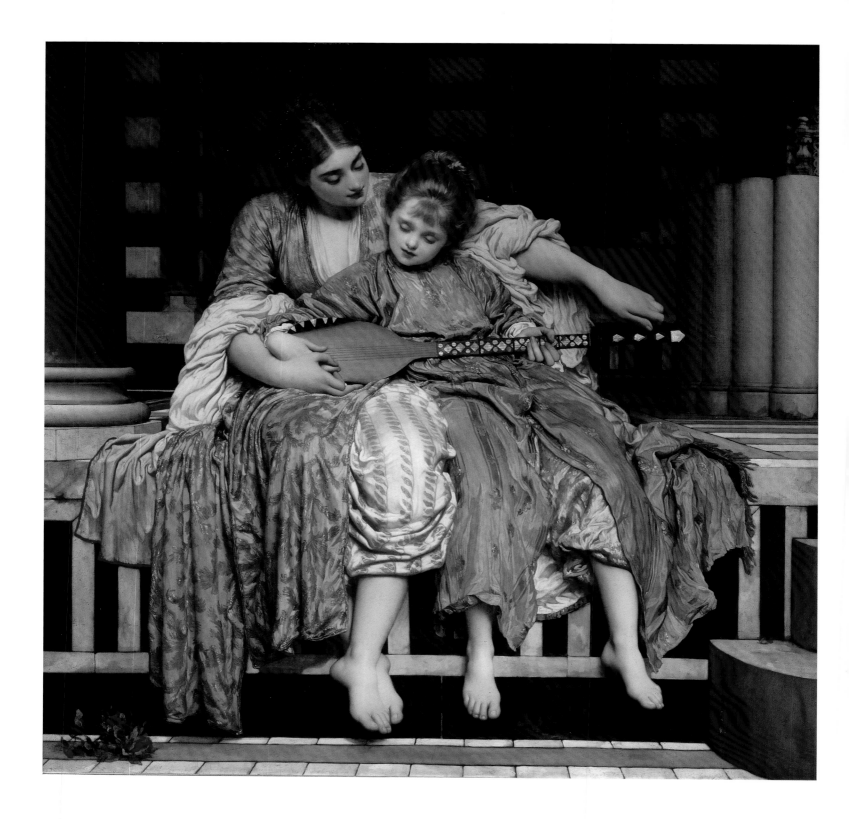

Fig.135
The Music Lesson 1877
Frederic Leighton
Oil on canvas, 92.7 x 95.2
Guildhall Art Gallery, City of London

Fig.136
Two Musicians 1880
Osman Hamdi Bey
Oil on canvas, 58 x 39
Suna and Kıraç Foundation
Orientalist Paintings Collection

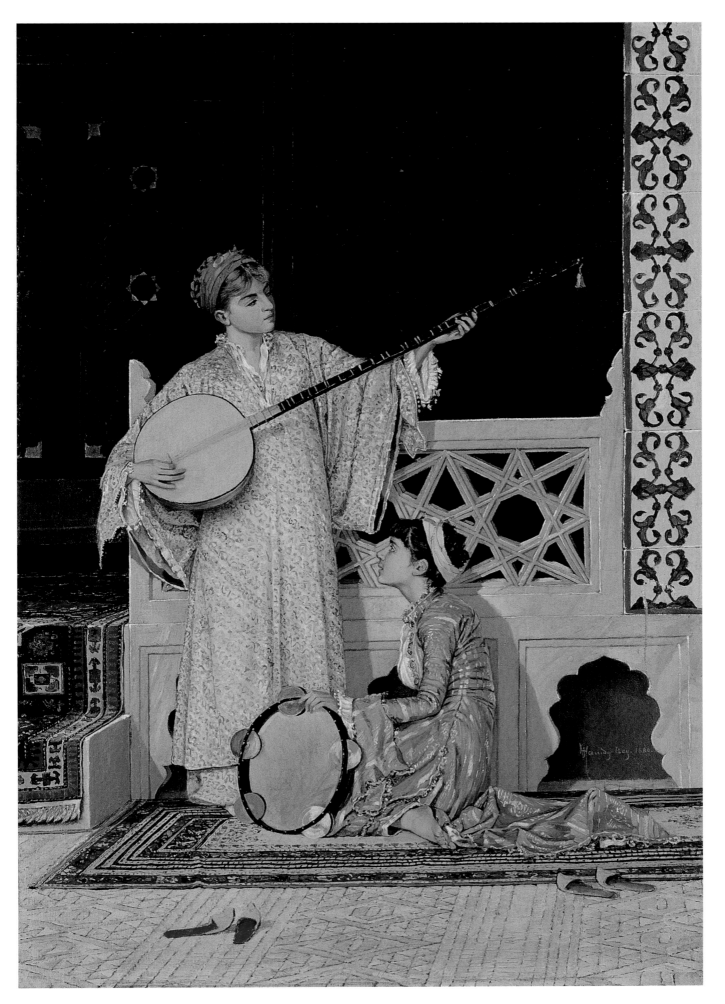

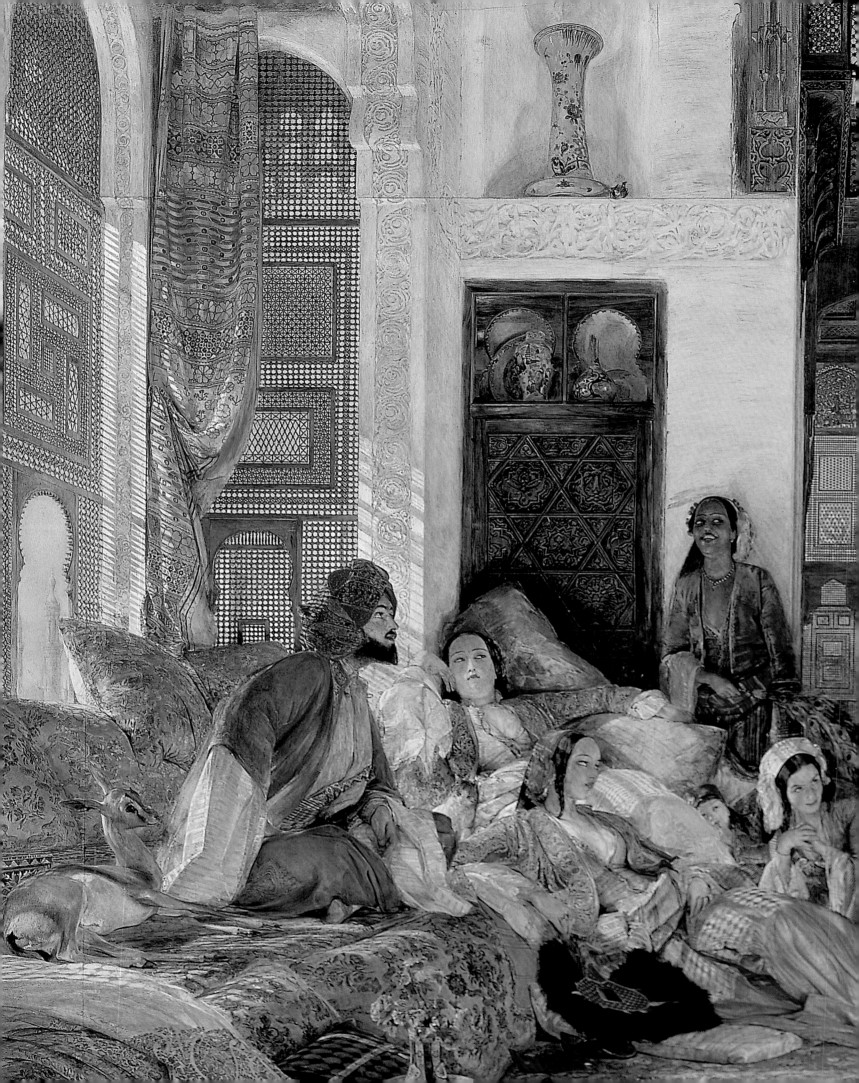

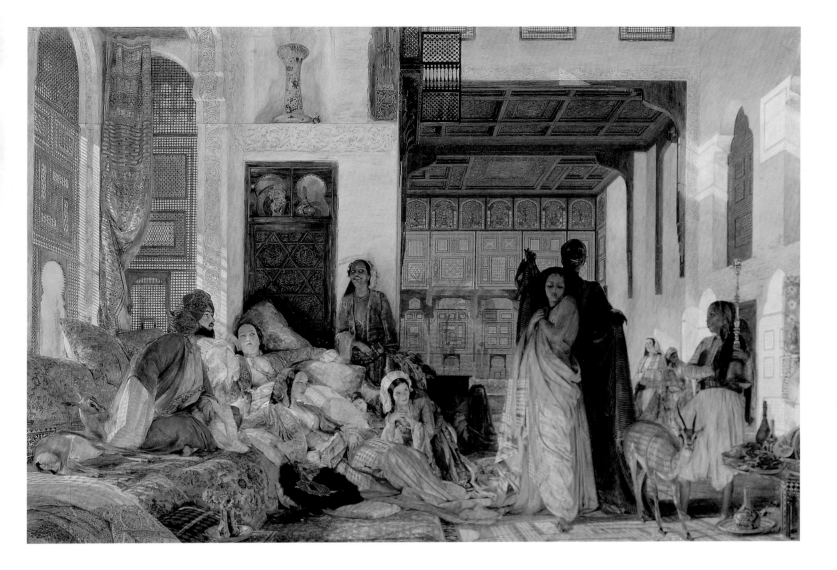

Fig.137
The Hhareem 1850
John Frederick Lewis
Watercolour, 88.6 x 133
Private Collection
See opposite for detail

RELIGION

THE HOLY CITY
NICHOLAS TROMANS

Fig.138
North Side of the Temple Platform
1864
Sergeant James Macdonald R.E.
From the Ordnance Survey of
Jerusalem, albumen photographic
print
Courtesy Palestine Exploration Fund

Fig.139
Godfrey Thomas Vigne
**Portrait of a Jewish Pilgrim from
Poland** 1843
Watercolour, 57.5 x 42.3
Victoria and Albert Museum

In 1922 the artist Stanley Spencer travelled to Bosnia and Montenegro, in what would soon be known as Yugoslavia, in the company of the Carline family, including Spencer's future wife Hilda Carline and her brother, the painter Richard (see his *Damascus and the Lebanon Mountains from 10,000 Feet*, fig.107). Spencer had particularly wanted to see more of the Islamic architecture in which he had become interested while serving in the Army Medical Corps in neighbouring Macedonia during the First World War. One modest picture resulting from this tour (fig.172) is a view of an elegant white minaret rising against the hills of Sarajevo, the capital of Bosnia, where in 1914 the Great War had been triggered by the assassination of the heir to the Austro-Hungarian Empire. Spencer's lonely minaret, the universal symbol of Islam, suggests the vulnerability of the Bosnian Muslim population (the largest such community in Europe outside Turkey) in the wake of the retreat from Eastern Europe of the Ottoman Empire, which was finally abolished in the year of Spencer's visit. That population was to suffer the worst of the violence in the war that followed the eventual break-up of Yugoslavia in the 1990s.

The long withdrawal from Europe of the Ottoman Empire, and its defeat in 1918, left cultural and ethnic fault lines exposed across its former territories. Most dramatically there was Palestine, invaded by the British Army under General Allenby in late 1917 and from 1920 administered by Britain under mandate from the League of Nations. As Allenby made his way to Jerusalem, in London the British government formally stated – in the Balfour Declaration – its support for the creation of a Jewish national home in Palestine, an undertaking which, after the War, Britain sought to balance against the opposition of Palestine's majority Arab population. The state of Israel came into being in 1948 upon the expiry of Britain's mandate,

declaring Jerusalem to be its capital although the post-armistice border with Jordan sliced straight through the centre of the segregated city. In 1967, following renewed war with its neighbours, Israel occupied all of Jerusalem. The defining photographs, at least in the West, of the Six Day War were those showing Israeli soldiers mesmerised by the sight of the Old City, especially the Temple Mount crowned by the Dome of the Rock. Many of these soldiers would have had earlier images of these holy places in their minds, as for example did this intelligence officer:

> with shots still filling the air, … suddenly you enter this wide open space that everyone has seen before in pictures, and though I'm not religious, I don't think there was a man who wasn't overwhelmed with emotion. Something special had happened.[1]

The Temple Mount, or Haram al-Sharif (Noble Enclosure), is the defining structure of ancient Jerusalem, the site of the Jewish King Solomon's tenth-century BCE Temple and its successor, the Second Temple, begun by King Herod in the second decade BCE and destroyed, along with most of the rest of Jerusalem, by the Romans in 70 CE almost immediately after its completion. The Jewish nation lost its centre and by the end of a second Jewish-Roman War in 132–5 its diaspora had begun. The city had meanwhile witnessed the dramatic end to the career of the healer and prophet Jesus from Nazareth who was executed by the Romans, placed in a tomb but, so his followers claimed, resurrected and carried into Heaven. After the Roman Empire was itself converted to Christianity in the fourth century, Christ's tomb was supposedly discovered just to the west of the Temple Mount, a location ever since marked by a sequence of buildings,

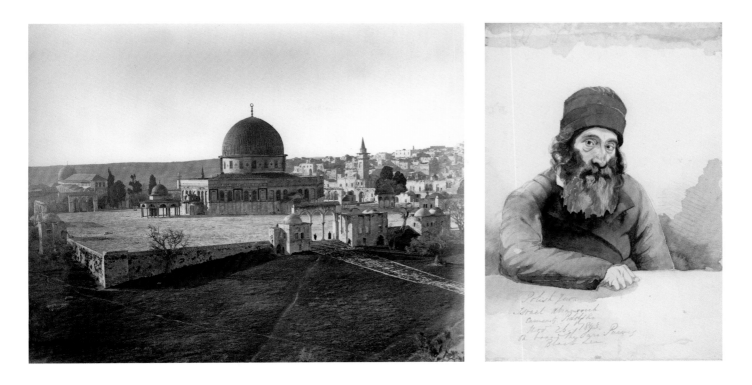

since Crusader times known as the Church of the Holy Sepulchre. Jerusalem fell to the Muslim forces of the Caliph 'Umar in 638, after which a mosque was built upon the Temple Mount, later known as the further or remote mosque (*al-Masjid al-Aqsa*). Over the site of the Jewish Temple itself, the beautiful Dome of the Rock (*al-Qubbat al-Sakhra*) was begun in 688 (fig.138). Not a mosque but an architectural symbol of Islam's succession to the monotheistic tradition of Judaism, the Dome's interior is decorated with Quranic inscriptions describing the Christian doctrine of the Trinity as a blasphemous deviation from that tradition. (Most Europeans, however, referred erroneously to the structure as the Mosque of Umar or Omar.) For Muslims, Christ was one of the mortal prophets who preceded Muhammad, himself the last prophet, and after the conquest of Jerusalem the tradition evolved that it had been from the Haram that the Prophet had made the 'Night Journey' referred to in the Qur'an, during which he ascended to Heaven to commune with his forebears, including Abraham, Moses and Jesus. To Muslims, Jerusalem was the third most sacred city after Mecca and Medina. It was *al-Quds*, the holy, and had been the place to which the direction of prayer (*qibla*) had been orientated until this was changed to Mecca. At Jerusalem the three great monotheistic religions were therefore literally and theologically built on top of one another.

From the point of view of the visiting British artist or tourist, who typically had a notion of religion, race and territory as all being naturally coterminous, it was an impossible situation. As British travellers began coming to the Middle East in substantial numbers from the 1840s, the sites of the life and passion of Christ were frequently on their itinerary, but Jerusalem very often disappointed them or worse. The city was by this time a backwater of no more than 15,000 inhabitants. Other

than the Dome of the Rock and perhaps the Church of the Holy Sepulchre there were precious few monuments of any magnificence, nor was there anything in the way of entertainment, while the surrounding country was potentially hazardous on account of Beduin tribesmen who had little reason to fear the local Ottoman authorities. The curtain wall built around the town by the Ottomans in the sixteenth century, within which Jerusalem remained enclosed until the 1850s, gave it the look of a citadel to those approaching, but not necessarily one of any grandeur: both David Wilkie in 1841 and William Holman Hunt in 1854 were reminded of Windsor Castle. These two painters were each making a pilgrimage of sorts to the Holy Land, not in order to attend certain chapels, shrines or relics, but to observe something more general: the peoples and places of the Bible, as the preliminary to painting subjects from the life of Christ.

The Protestant Reformation of the sixteenth century had established a form of religion in Britain that rejected the adoration of things or places – all the paraphernalia of saints and the traces of the Holy Family that the British associated with the older Christian denominations, especially the Catholic and Orthodox Churches. Among the other casualties of the Reformation had been the pilgrimage, the ritualised journey to visit Christian shrines. While many Jews went to see Jerusalem or to die there (see Godfrey Thomas Vigne, *Portrait of a Jewish Pilgrim from Poland*, fig.139), while all Muslims who were able were expected to visit Mecca, birthplace of the Prophet, and while Catholic and Orthodox Christians still had their great pilgrimage centres, the modern Protestant had nowhere special to go. The Protestant artists' vision of the Holy Land thus went entirely against the grain of the place. Instinctively unable to join in the veneration of specific locations, they sought to see through,

Fig.140
**The Miracle of the Sacred Fire,
Church of the Holy Sepulchre** 1892–9
William Holman Hunt
Mixture of oil and resin on canvas,
92 x 125.7
Harvard University Art Museums,
Fogg Art Museum

Fig.141
**View of the Ecce Homo Arch,
Jerusalem** 1857
James Roberston and Felix Beato
Photographic print
Courtesy Palestine Exploration Fund

Fig.142
Christ Before Pilate 1841
David Wilkie
Oil on board, 49.5 x 36.8
Private Collection

or see against, Jerusalem to the 'real' Christian history of the place that seemed to lie somewhere beyond the city's modern façade. This meant studying the Jewish population as a kind of window on to the culture of Christ, the assumption being that this community had not changed much in two thousand years (see Wilkie's *Jews at the Wailing Wall, Jerusalem*, fig.145).[2] It also meant studying the natural landscapes around Jerusalem, as these too were assumed to be essentially unchanged (Edward Lear, *Jerusalem*, fig.144; Thomas Seddon, *Jerusalem and the Valley of Jehoshaphat from the Hill of Evil Counsel*, fig.162).

The actual fabric of modern Jerusalem could however hardly be ignored altogether by artists, and David Roberts, the pioneer Orientalist among British professional painters, had a duty to include the city in his visual report on the architecture of the Middle East compiled during his journey of 1838–9. But even Roberts is unable to make very much of Jerusalem. Non-Muslims were traditionally still excluded from the Haram, although under the control of the Egyptian army in the 1830s more exceptions were made for visiting Europeans. The architectural draughtsman Frederick Catherwood, for example, managed to obtain permission to survey the Dome of the Rock in the early 1830s.[3] Roberts was given leave by the Governor of Jerusalem to make drawings of the Islamic structures of the city, as he had been at Cairo, but now only on condition he could protect himself while so doing. In the event, it seems he did not feel able to enter the Dome of the Rock, and relied instead upon the verbal description of its interior supplied by his Egyptian guide, Ismael.[4]

Roberts and his successors were able to access the Church of the Holy Sepulchre easily enough, but were generally appalled at the infighting between the different Christian denominations that shared custodianship of the place. (In an effort to control this

sectarian bickering, a Muslim was encharged with the keys to the church; Jews were however violently excluded from its precincts.) In Roberts's drawing of the Greek Orthodox chapel or Katholikon within the church (fig.152), we see the dense conglomeration of architecture, decoration and icons that captured the eye of the artist, despite his condemning it in his journal as the 'most monstrous jumble'.[5] Hunt visited the Church at Easter in 1855 and saw there the 'Miracle of the Sacred Fire', the annual ceremony during which the lamp over Christ's tomb was apparently miraculously rekindled. Many years later Hunt made this the subject of his last major original work (fig.140), an image of deliberately claustrophobic chaos.[6] As with Roberts, in Hunt's picture there is a sense of the visual imagination being pulled into uncanny, disturbing places from which the self-consciously rational mind recoils. These qualities can also be seen in some of John Frederick Lewis's interiors of Catholic and Orthodox Christian sites, such as his study of the Chapel of the Burning Bush in St Catherine's Monastery at Mount Sinai (fig.153), while a sheer sense of cultural overload pervades Richard Dadd's impenetrable *The Flight Out of Egypt* (fig.155), a painting executed in 1849–50 at Bethlem Hospital where Dadd had been interned after murdering his father on his return from the Middle East. Here we feel the legends, myths and histories of the different cultures of Egypt and the Holy Land have been resurrected and crowded into the same place and time to create, as in Hunt's *The Miracle of the Sacred Fire*, a polyglot dystopia.

How then did the British go about putting some order into what they perceived as chaos? One method, for Roberts, was to re-imagine the Christian churches of Palestine along the lines of a more British architecture. In Roberts's interior of the Greek Orthodox Church of the Nativity at Bethlehem (fig.154), a grander perspective dispels any claustrophobia, while the

looming crucifix and sombre tonality align the image with the Gothic mode. Only the turbaned figures definitely assure the viewer that we are in the Orient: Roberts represents the church at Easter with Christian pilgrims from across the Middle East. The Church of the Nativity at Bethlehem was, like the Holy Sepulchre some five miles north at Jerusalem, first established in the fourth century over the traditional location of a defining moment in the Christian narrative (it appears in Hunt's late view of Bethlehem, made to illustrate an epic poem by Edwin Arnold on the theme of Christ representing the consummation of all previous religions: fig. 156). But the claims of these locations to authenticity were widely doubted among British visitors, and a second method for evading the confusion of such places was to turn archaeologist and seek to reform the false sacred geographies of the Holy Land. Wilkie, seeking out authentic remnants of the Jerusalem that Christ would have known, got this process off to a bad start by trusting in the so-called Ecce Homo Arch on the Via Dolorosa. This structure, supposed to be the remains of the palace of Pontius Pilate and the location of Christ's condemnation, was in fact set up as part of the Romans' rebuilding of Jerusalem as Aelia Capitolina under the Emperor Hadrian in the second century CE. But Wilkie anachronistically based his attempt to paint a modernised *Ecce Homo* upon this setting (figs. 141, 142).[7]

Wilkie was in Jerusalem in 1841, and it was in that same year that the discipline of biblical archaeology was firmly established in its modern mode with the appearance of *Biblical Researches* by the American Edward Robinson. Robinson's ambition was to cut across the various interest groups that maintained the dubious modern holy places and to rediscover the actual sites of the Bible stories through modern surveying techniques. Modern, typically Protestant, historians thus aligned themselves with the universal principles of truth and precision, although the long subsequent history of biblical archaeology, with its tendency to reduce all history to biblical illustration, has itself been accused of becoming a conventionalised and compromised body of academic expertise from which more objective methodologies have been excluded.[8]

Other historians were soon following in Robinson's footsteps, and some bitter controversies raged around the new theories being put forward. An early candidate for demotion from authenticity was the Holy Sepulchre, and in 1847 the architectural historian James Fergusson published his conclusion that the chapel erected in the fourth century over the burial place of Christ by the first Christian Roman Emperor, Constantine, was not the original Church of the Holy Sepulchre but in fact none other than the existing Dome of the Rock on the Temple Mount.[9] This theory had the great attraction for evangelical Christians, keen on prophecy and global historical patterns, of relocating the Resurrection to the site of the Jewish Temple, thus tidily signifying Christ's fulfilment of the Old Testament. Hunt took a special interest in the Dome of the Rock after forming part of the first group of Europeans in centuries to be formally guided around it in 1855.[10] From this time Hunt embraced Fergusson's theory and thus in his images of the Dome (which he with his contemporaries persisted in calling a mosque) he believed himself to be representing, not the sign of Islamic ascendancy at Jerusalem, but the scarcely recognised authentic place of Christ's tomb, which was just the sort of oblique symbolism to appeal to the artist (see fig. 159).

Hunt's conviction in Fergusson's theory was undermined by new archaeological work carried out in Jerusalem between 1867 and 1870 by Charles Warren of the Royal Engineers.[11] Warren had been commissioned by the Palestine Exploration

Fig.143
The Mosque of Omar, showing the site of the Temple
L. Haghe after David Roberts
Lithograph, London 1842
Victoria and Albert Museum

Fig.144
Jerusalem 1865
Edward Lear
Oil on canvas, 81 x 161.6
Ashmolean Museum, Oxford

Fund (PEF) to investigate Fergusson's theories regarding the Temple Mount and also to make a preliminary survey of Palestine for potential future military usage.[12] The PEF, set up in 1865, thus represented the most extraordinary conflation of Victorian practicality and ideology. Although the Royal Engineers were to be the Fund's partners in their work, evangelical Christianity was equally a driving force. Ostensibly the key motive of the Engineers' own Ordnance Survey of Jerusalem of 1864–5 (fig.138), and a central concern of Warren's slightly later work, was to map the holy city's wells, cisterns and other water supplies, a focus that relates to the practical problem of sanitising an ancient but now rapidly expanding town, but which also surely has echoes of baptismal aspiration. Equally, digging underground was the most explicit possible reflection of a faith in a Judaeo-Christian truth underlying the apparent Muslim surface of Jerusalem.[13] The reporter-artist William Simpson was sent out to cover Warren's campaign by the *Illustrated London News*, and accompanied Warren down the shafts he had excavated in order to burrow under the Temple Mount (local officials prevented him repeating Catherwood's work on the platform itself). Simpson's watercolours of this alternative, underground Jerusalem, showing these secret spaces lit by magnesium wires, have a distinctly religious drama about them (fig.164).[14]

This drive to see into Jerusalem's layers of history, and into the natural landscape beneath them all, is also apparent in the work of the first professional British painters to visit Palestine. When Roberts gives the view over Jerusalem to the Dome of the Rock on the site of the former Jewish Temple (fig.143) he does so across the so-called Pool of Bethesda (also known as the *Birket Isra'il*), just to the north of the Haram, with the result that the Muslim building looks almost vulnerable, perched atop complex

strata of crumbling masonry (the praying figures are Orthodox Christians, facing west towards the Holy Sepulchre). Roberts's successor, Wilkie, even became an amateur surveyor, taking barometer readings during his time in Palestine in order to measure the altitude of different locations: he believed himself to be the first person scientifically to demonstrate the extent of the depression of the Dead Sea below sea level. His findings were immediately communicated to William Buckland, the leading geologist and a canon of Christ Church, Oxford, who combined Anglican orthodoxy with acceptance of the new geology which, with the vast time-spans it described, appeared to contradict traditional religious narratives of the history of the world.[15] In Hunt's *The Scapegoat* (fig.151), the background to the artist's image of sacrifice and redemption is a landscape apparently laying bare the ancient geological history of the Dead Sea. But Hunt, like Wilkie, began his work as an artist in the Holy Land on the premise that modern Protestant Christianity had nothing to fear from any sort of scientific truth.

The Oriental masterpiece of Hunt's companion Thomas Seddon, *Jerusalem and the Valley of Jehoshaphat from the Hill of Evil Counsel* (fig.162), joins in this effort to combine quasi-scientific objectivity of vision with Christian allegory. Seddon took his view from a hill to the south of the Temple Mount, so that the picture is framed by the Aqsa mosque on the left and the Mount of Olives, where Jesus retired to pray after the Last Supper, on the right, with the Church of the Ascension at its top. Just over the central point of the composition we find the curving conical upper part of a memorial pillar, dating from the Herodian period but traditionally known as the Tomb of Absalom, forming part of the ancient Jewish cemetery that stretched along the valley (the local Muslim villagers of Silwan were paid a tax by the Jews of Jerusalem not to allow damage

to the tombs).[16] Thus the three faiths of Jerusalem are included in this description of the place where, as all three agreed, the general resurrection and Last Judgement would take place. Hence the foreground motif of the shepherd with his sheep and goats, referring surely to Christ's own description of the last things:

> When the Son of man shall come in glory … before him shall be gathered all nations: and he shall separate them one from another, as a shepherd divideth his sheep from the goats.[17]

But this was a hint for the viewer to enjoy picking up themselves. What the artist forces upon us is first and foremost a painstaking survey. The swells and clefts of the landscape are so explicitly monitored that we feel we can almost make out the contour lines of a map such as that of the Ordnance Survey, which Seddon's picture however predates by a decade: this is landscape painting as model-making.

Seddon's painting thus captures the problematic image of Jerusalem essentially by turning away from it, at least so far as to suggest the city as only one element in a larger story. Roberts painted a whole series of views of the city from different approaches, often with excited pilgrims in the foreground to prompt the viewer's identification with the Christian outsider in a foreign Holy Land (see for example the 1841 picture at Royal Holloway College, Egham, Surrey).[18] Edward Lear also executed a sequence of vistas of Jerusalem, the most accomplished being completed in 1865, the year of the foundation of the PEF, giving a view on to the city from the north-east (fig.144). In general the most popular viewpoint for painters was from the Mount of Olives, looking west over the Haram. This perspective

had of course the fundamental interest of being that of Christ himself as he contemplated the end of his ministry and the onset of his suffering. Here was one way for the Protestant painter to evade all the disappointments of today's Holy Land, to reverse the emphasis from that being looked at to the eyes doing the looking. Many a British visitor recorded being moved by the thought that their saviour's eyes had seen something not very different to what they were now looking at. By painting from the Mount of Olives, or from around Nazareth in Galilee where Jesus grew up (see fig.157), an artist might evoke that personal link that was ultimately more important than the details of topography which mediated it across time, more important indeed than any question of the merely physical world. The Protestant urge to deny the veneration of place could thus be satisfied in the midst of the Holy Land itself.

From about 1840 the idea that Jerusalem should become again a Jewish city became established among British travellers, religious leaders and policy-makers. As with the work of the PEF, evangelical and practical considerations reinforced one another. The long-established notion that the restoration of the Jews to the Holy Land and their conversion to Christianity would mark the return of the messiah was reinvigorated by well-placed evangelicals from the turn of the nineteenth century, while the fact of continuing Jewish immigration to Palestine meant that British diplomacy sought to promote itself through identification with this expanding group. The British consulate at Jerusalem had been established (in 1838) in part through pressure from the Anglican Church's missionary London Society for the Promotion of Christianity Among the Jews, to which both of the first two consuls, William Young and James Finn, belonged. Young, whose wife Wilkie depicted in an elegant Syrian costume (fig.52),

observed to the sympathetic Foreign Secretary Palmerston that the future of Jerusalem lay in the hands of the Protestants and the Jews.[19] For many of the British 'restorationists', the colonisation of Palestine by the British and by Jews of the diaspora would go hand in hand. Charles Warren, for example, saw things in these terms, and so it seems did Hunt, who himself became a tentative pioneer settler, establishing a family home in Jerusalem between 1876 and 1878 (represented in his wife's watercolour, fig.130).[20] During the second half of the nineteenth century Christian evangelical restorationism and Jewish settlement were subsumed within the more urgent and more secular project of political Zionism (the word was coined in 1890), which saw the establishment of a Jewish homeland as the only practical solution to the dramatic rise of violent anti-Semitism in Europe, especially Russia.

What has this got to do with pictures? From the beginning of British professional Orientalist painting in around 1840, the Jews of Jerusalem held a special fascination for the artists. Wilkie had met the great Anglo-Jewish philanthropist and early Zionist Sir Moses Montefiore ('the Jewish world's symbolic hero and knight errant' in the words of a recent historian) at Constantinople in 1840, and had been enormously impressed both by the man and by what he stood for – the arrival in international politics of emancipated European Jewry.[21] At Jerusalem Wilkie painted a couple of deeply romantic oil sketches of Jewish religious life, including a group of mixed gender praying at the Western Wall (fig.145). The only surviving fragment of Herod's Temple, and a focus of Jewish piety since around 1500 (after taking possession of the city in 1516 the Ottomans cleared a niche along the wall to provide a setting for prayer), the 'Wailing Wall' as the British often referred to it, took on increasing importance from the 1840s as the one place

in Jerusalem where the city's divided Jewish communities might forget their differences.

In the decade after Wilkie's visit, the work of Hunt and Seddon seems informed by the efforts of the British to develop Jewish Jerusalem in the 1850s, that is, during the 'stirring times' that Consul Finn referred to in the title of his memoirs.[22] Seddon's *Jerusalem and the Valley of Jehoshaphat* was executed immediately prior to the first developments beyond the city walls and its composition seems to be poised, as it were, in anticipation of them. In the 1850s Finn and Montefiore both sponsored Jewish settlements outside the city walls, intended to provide more salubrious conditions than existed in the run-down Jewish quarter of the old city. They also hoped, through encouraging agriculture and handicrafts, to make more independent those immigrants dependent upon *halukka* (charitable pensions) from Europe. During their early years, however, some of the residents of these new settlements felt sufficiently uncomfortable among the surrounding Arab population as to retreat back within the city walls at night.[23] Perhaps this tension is what Hunt means to indicate in his watercolour of *The Plain of Rephaim from Mount Zion* 1855 (fig.160), in which a man and his small children are apparently chased back towards Jerusalem by a couple of youths.[24] Seddon's great landscape shows an Arab shepherd sleeping (recalling the delinquent *Hireling Shepherd* painted by his friend Hunt a few years earlier) and also emphasises 'the white skeletons of the old system of terracing still visible on the bare hill-sides' of Jerusalem, which Charles Warren later suggested had long been abandoned by the Palestinian Arabs.[25] Those British travellers who wished to see a Palestine with a Jewish future often represented agriculture and industry in the region as being in a decrepit state, blaming this partly on stifling Ottoman

Fig.145
Jews at the Wailing Wall, Jerusalem
1841
David Wilkie
Oil and pencil on board, 43 x 53
University of Dundee Museum
Services

Fig.146
Scene in a Synagogue 1854
William Holman Hunt
Pen and ink, 25.4 x 35.6
John Constable, England

taxes and partly on inherent Oriental laziness. John Singer
Sargent's 1905 landscape of *The Plains of Esdraelon*, however,
tells a different story (fig.157). The painting clearly describes the
well-developed field systems of this flourishing agricultural part
of northern Palestine, where the first *kibbutzim* (Jewish collective
farming settlements) were to be established from around 1910.

Seddon was to die young in Egypt in 1856, but Hunt
lived on into the twentieth century, long enough to witness the
campaigns led by Theodor Herzl to make Zionism a reality.
Hunt's commitment to the cause of a Jewish return to the
Holy Land never faltered, and indeed he became one of
the most prominent British Gentile supporters of Zionism.
He met with Herzl in 1896 to discuss the latter's plans,
championed the plight of Jewish refugees and was even made
an honorary member of the Maccabeans, the association
of Anglo-Jewish professionals and philanthropists who hosted
Herzl's London appearances.[26] In Jerusalem in 1855 Hunt visited
the synagogues each Sabbath to study Jewish culture (see fig.146),
as Wilkie had done and ultimately for the same reason, to revive
Christian art. With *The Scapegoat* (fig.151), Hunt aspired to a new
Christian visual culture based on prophecy and allegory derived
from Jewish tradition, that is, from the pre-Christian Bible
and from the Talmud (Jewish civil and ceremonial law).[27]
The scapegoat, driven out into the wilderness carrying the
community's sins, was an effort to illustrate a Jewish theme new
to Western painting, and to re-invent that theme as a Christian
allegory. If this accords with the evangelical vision of Judaism's
role as the agent of Christian fulfilment, then subsequently
Hunt's view of Jewish destiny took on a more practical
and secular tone in keeping with the evolution of Zionism.
Meeting Horatio (Lord) Kitchener, then attached to the Survey
of Palestine, in Jerusalem in 1876, Hunt agreed with the future

War Minister that a Jewish homeland was necessary for political
stability in the region.[28] As the Ottoman Empire retreated,
its former territories needed to be handed over to proper local
national leaderships, which to a British administrator with a
romantically tidy sense of ethnic nationalism might meant the
Zionists in Palestine, with the Arabs belonging most comfortably
in new nation states headed by monarchs of the Hashemite
dynasty, the longstanding guardians of the holy cities of Mecca
and Medina. Thus, beyond his Zionist hopes, Kitchener later also
looked forward to a time when the Sharifs of Mecca would have
their own kingdom, while the Hashemite cause also inspired such
famous early twentieth-century British Orientalists as T.E.
Lawrence ('of Arabia') and Gertrude Bell, Oriental Secretary
to the British administration in Baghdad from 1917.[29]

Soon before the outbreak of the First World War, the
leading Modernist painter David Bomberg declared: 'I hate
the colours of the East'. His interest was in 'the *construction
of Pure Form*', in Cubism and its British offshoot, Vorticism.[30]
But by the 1920s, short of work, Bomberg was ready to accept
the suggestion of a friend that he go out to Palestine to depict the
Zionist development projects being undertaken by the Palestine
Foundation Fund (*Keren Hayesod* – not to be confused with the
PEF). Bomberg was himself the son of Jewish immigrants from
Poland but had apparently little personal commitment to the
Zionist cause, and found a more comfortable source of patronage
among the leading figures of the British authorities then in charge
of Palestine, up to and including the Governor, Ronald Storrs.
Bomberg's painting of *Jerusalem, Looking to Mount Scopus* 1925
(fig.171) shows a view north out over the city, framed on the left
by the minaret of the Mosque of Umar next to the Holy
Sepulchre (a different building to the Dome of the Rock which,
as we have noted, confusingly often went under the same name)

Fig.147
Great Door of the Mosque of al-Ghuri, Cairo
c.1841/51
John Frederick Lewis
Watercolour, 52.7 x 38.1
Private Collection

Fig.148
**Exterior of the Mosque of Sultan Hasan,
Cairo** *c*.1841/51
John Frederick Lewis
Watercolour, 84.5 x 56.5 framed
National Gallery of Scotland, Edinburgh

Fig.149
Interior of Hagia Sophia 1840/1
John Frederick Lewis
Watercolour, 32.2 x 46.7
Margot Walker

Fig.150
Mausoleum of Sultan Mehmet, Bursa 1840/1
John Frederick Lewis
Watercolour, 57.7 x 48.7
Victoria and Albert Museum

and apparently taken from the tower of the Lutheran Church of the Redeemer, built by the Germans in the 1890s. Like Seddon's picture, it seems to be about the relationship of the Old City to Jerusalem's imminent expansion. The art critic Richard Cork has described the picture as representing a

> strangely pristine city, free not only from people but from any sign of the dirt, decay and architectural impurity Storrs was trying so hard to combat. Bomberg's pictures of 1925 show the environment in its ideal, untainted state.[31]

The painting was acquired by the British Attorney-General of Mandatory Palestine, Norman Bentwich, who was much attached to Jerusalem's Hebrew University, opened on Mount Scopus in the year of Bomberg's picture. Possibly the painting was intended to commemorate this central event in the history of modern Jewish Palestine.[32]

For the 'Bible Christian', the literal believer in the New and Old Testaments, Jewish tradition was full of messianic hope. Islam on the other hand seemed to offer them little. Representing the conclusion of the prophetic tradition, Muhammad relegated Judaism and Christianity to a past from which there would be no messianic return. When the British felt compelled to choose between Jews and Muslims, as they often did at Jerusalem, then in the nineteenth century there rarely seemed to them any question where allegiance was due. Elsewhere things could however be different. In places where Islamic culture was perceived by the British to be naturally at home, such as Cairo, then theological controversy did not intrude so directly and British travellers were more likely to interpret on its own terms the society they found there.

Generally, when Muslim ritual was represented for its own sake by British artists, it was shown as a healthy, communal expression of a shared culture, as in the picture of pilgrims en route to Mecca by Richard Beavis, who travelled to the Middle East in 1875. Arthur Melville's 1882 watercolour of Muslim pilgrims huddled together on board a boat (*Pilgrims on the Way to Mecca*, fig.169) is much less romantic but just as impressive in its depiction of stoic determination. Among the mosques visited by British artists, it seems to have been in the largest ones that there was least objection to visitors sketching, or perhaps where there was least chance of such activity being detected. At the beginning of the tradition of British Orientalist painting, in the late 1830s, Roberts had managed to obtain a *firman* (permit) from the authorities allowing him access to the mosques of Cairo, but William James Müller had no such success and did not get to see them. In the 1840s Lewis made many dramatic studies of the exteriors of some of the great mosques of Cairo, delighting in the challenge they presented through not offering any straightforwardly visible façade. The magnificent mosque and facing mausoleum of the early sixteenth-century Sultan al-Ghuri were especially attractive to him, compacted as they were into an impossibly cramped space surrounded by markets on the city's main north–south street (*The Bazaar of the Ghureyah from the Steps of the Mosque of al-Ghuri, Cairo*, fig.76; *Great Door of the Mosque of al-Ghuri, Cairo*, fig.147).[33] Increasingly ambitious development projects in Cairo did however have the effect of isolating some important old buildings, allowing them to stand out clearly as focal points. The vast fourteenth-century funerary complex of Sultan Hasan, located near the Citadel of Cairo and considered the greatest monument of early Mamluk architecture in the city, was studied by Lewis in the 1840s from an awkward perspective (*Exterior of the Mosque of Sultan Hasan, Cairo*, fig.148).

Subsequently the complex was shorn of its neighbouring structures and from 1873 formed the southern terminus of the grand new avenue named after Muhammad 'Ali, which sliced a new axis across the city up to Azbakiya.[34] In 1888 the Scottish painter Joseph Farquharson made this the setting of his *The Hour of Prayer: Interior of the Mosque of Sultan Hasan, Cairo* (fig. 167). We are shown the great *sahn* (courtyard) of the *madrasa* from each side of which radiate *iwans*, recessed spaces for teaching and prayer. In the centre of the courtyard – to the right in the painting – is a fountain for the ablutions required before prayer: Farquharson shows it in the poor state of repair into which it had fallen by the mid-nineteenth century. The largest *iwan*, into which we look, is a congregational mosque with magnificent decoration around its *mihrab* niche indicating the *qibla*. Farquharson also represents some of what had been hundreds of glass oil-lamps, hanging from chains from great heights from the arch of the *iwan*.

When Frederic Leighton visited Damascus in 1873 he was still very unusual among British painters in making such a journey, and his beautiful description of the interior of the prayer hall of the great eighth-century Umayyad mosque there (fig. 166) is both unique in Victorian painting and a valuable record of the appearance of the structure before the terrible fire of 1893. Leighton had little time to study the building and its use, and mentions having photographs made of the mosque from which to work once back in London.[35] This may explain the fact that Leighton shows a man praying at ninety degrees to the *mihrab* (indicating the direction of Mecca and hence the principal focus of prayer), while the *minbar* (pulpit) is conceived as of central importance, as if we were in a Protestant church. Presumably Leighton invented the figures when completing the picture for exhibition, and perhaps did not grasp the function of the

architecture he was painting.[36] Such confusion regarding Islamic architecture was common enough among British travellers: they certainly admired its beauty, and perhaps the focus on its aesthetic appeal encouraged vagueness as to its actual social usage. We have already noted the general assumption that the Dome of the Rock was a mosque. Visiting the old Ottoman capital of Bursa south of Constantinople in 1867, Leighton painted the courtyard and classroom of the *medrese* (school) forming part of the fifteenth-century Muradiye Complex of Sultan Murat II, but this also was assumed to be a mosque.[37] Lewis, meanwhile, had been in Turkey in 1840–1 and made studies of religious foundations there, including the vast Hagia Sophia, the great Byzantine church of Constantinople, which had become a mosque after the Ottoman conquest in 1453 (fig. 149), and the royal mausoleum (*Yesil Turbe*) of Sultan Mehmet I at Bursa (fig. 150).

The abstract pleasure that the British took in Islamic architecture related to the attraction that Islam itself held for a minority of them. Some British travellers, admiring Islam's theological simplicity, its emphasis upon the word of God and the relative unimportance of its clergy in mediating that word, saw Islam as a kind of early form of iconoclastic Protestantism.[38] Hunt implied this connection when writing in his diary of the austere good order of the Temple Mount at Jerusalem. If handed over to the city's Orthodox Christians, suggests Hunt, they would soon clutter the sacred space up with 'vulgar candlesticks, lamps and mean pictures ... and even the English would injure the place in having £50,000 of brand new gothic work erected'. The Haram was better off as it was, in Muslim control; 'in no other hand would the place have been preserved from the pollution of idols'.[39] Islam's most outspoken British admirer in this regard was Leighton's friend Richard Burton, the famous

diplomat, explorer and Orientalist. Burton had completed the hajj in 1853 disguised as an Afghan physician, and was often perceived as excessively zealous in his advocacy of Islam (see Seddon's portrait of Burton, fig.36). In 1864 he had gone so far as to describe Islam as 'the first and greatest reformation of the corrupted faith called Christianity.'[40] Potentially just as contentious as these words, if not more so, is the small painting by John Frederick Lewis in which he appears to represent himself praying in a Cairo mosque (fig.168). Lewis titled the picture *The 'Asr*, the afternoon prayer, the third in the daily sequence of five, to be performed when the sun's position is such that an object casts a shadow as long as its height. Lewis left little record of his personal life, and so he is the last artist whose religious opinions we are ever likely to be certain of. He is not known ever to have been accused of apostasy, as was Burton, but it seems clear at least that the artist had limited interest in Christianity: he managed after all to live in the Middle East for a decade without troubling to visit Jerusalem. But whether Lewis's interest in Islam really went beyond that of the professional Orientalist painter is impossible to say. What we can stress, however, is how in some of his pictures, in the *'Asr*, for example, and in the *Commentator on the Koran* (set in Mehmet's mausoleum at Bursa, fig.170), Lewis left an account of the Muslim's religious life as solitary and contemplative, which contrasts with the more communal ritual focused upon by most other British artists. This was an interpretation that suggested an understanding of Islam as being centred upon the direct relationship between the individual and God. In turn this hinted at affinities with modern Protestantism. As in his male genre subjects and harem scenes, Lewis appears to set multiple reflections working between East and West so that we end unsure of where the division lies.

Fig. 151
The Scapegoat 1854–5; 1858
William Holman Hunt
Oil on canvas, 33.7 x 45.9
Manchester Art Gallery

Fig.152
Church of the Holy Sepulchre, Jerusalem 1839
David Roberts
Watercolour, 22.3 x 33.3
Harris Museum and Art Gallery, Preston

Fig.153
Chapel of the Burning Bush, St Catherine's Monastery, Mount Sinai 1843
John Frederick Lewis
Pencil and watercolour, 36.8 x 49.5
Tate

Fig.154
Church of the Nativity, Bethlehem 1840
David Roberts
Oil on canvas, 142.2 x 111.8
Paisley Museum and Art Gallery

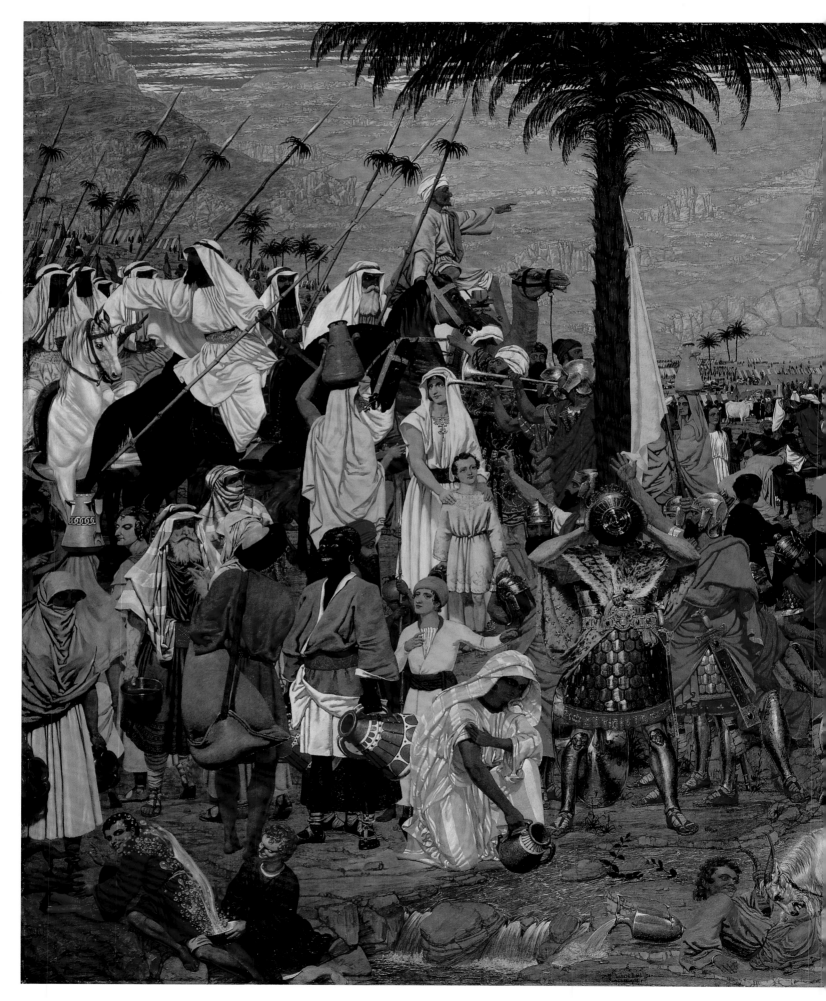

Fig.155
The Flight Out of Egypt 1849–50
Richard Dadd
Oil on canvas, 101 x 126.4
Tate

Fig. 156
Bethlehem from the North 1892/3
William Holman Hunt
Watercolour, 25.8 x 35.9
Private Collection

Fig. 157
The Plains of Esdraelon 1905
John Singer Sargent
Oil on canvas, 71.1 x 110.5
Tate

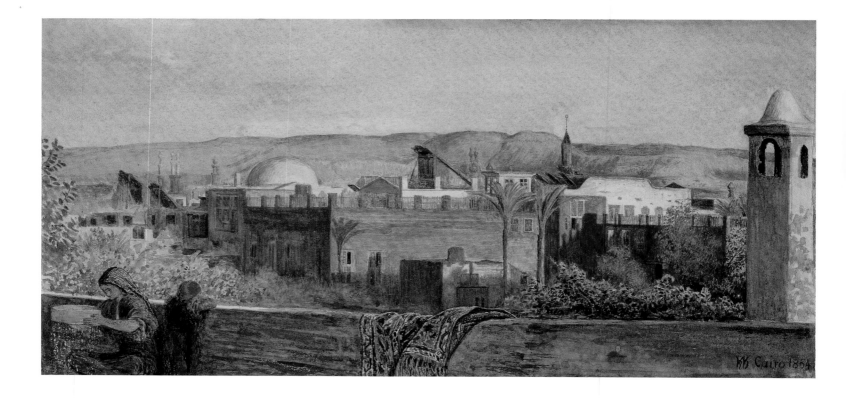

Fig.158
Cairo: Sunset on the Gebel Mokattum
1854; 1860–1
William Holman Hunt
Watercolour, 35.3 x 49.8
The Whitworth Art Gallery, The
University of Manchester

Fig.159
**The Dome of the Rock, Jerusalem,
during Ramadan** 1854–5; 1860–1
William Holman Hunt
Watercolour, 22.3 x 35.6
The Whitworth Art Gallery, The
University of Manchester

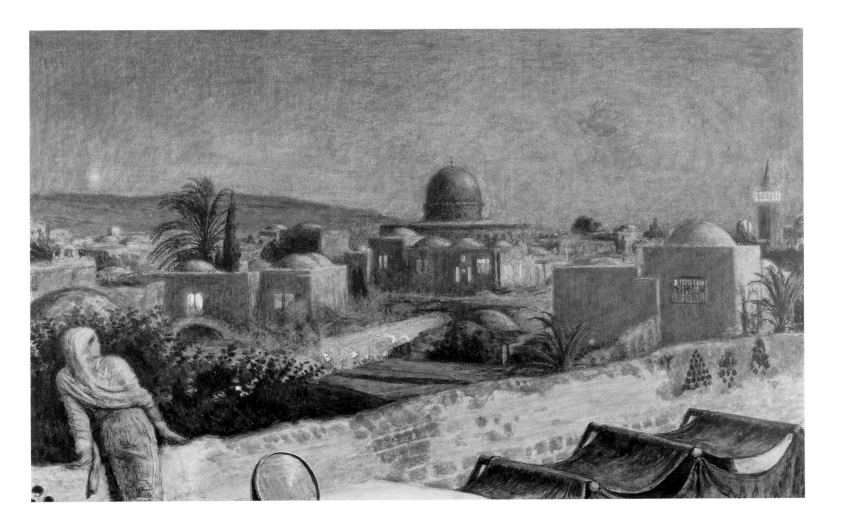

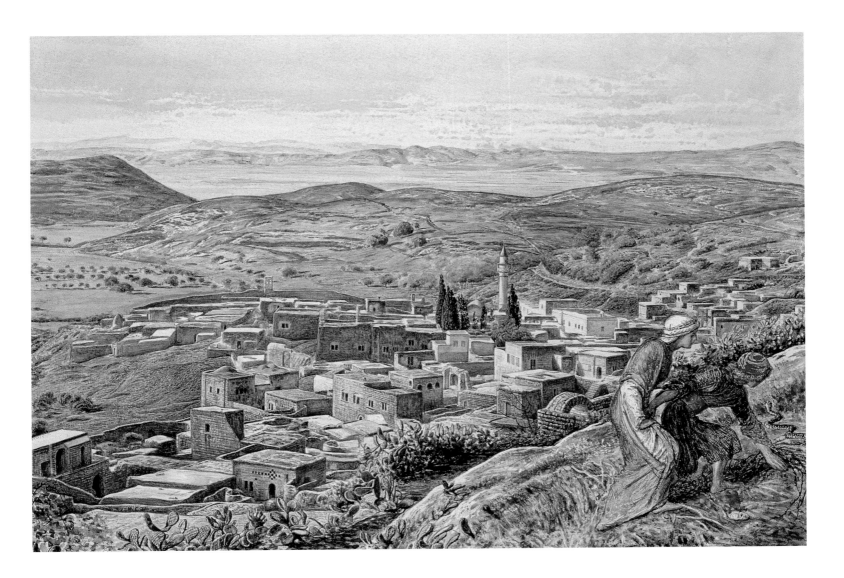

Fig.160
The Plain of Rephaim from Mount Zion, Jerusalem 1855; 1860–1
William Holman Hunt
Watercolour, 35.5 x 50.8
The Whitworth Art Gallery, The University of Manchester

Fig.161
Nazareth 1855; 1860–1
William Holman Hunt
Watercolour, 35.3 x 49.8
The Whitworth Art Gallery, The University of Manchester

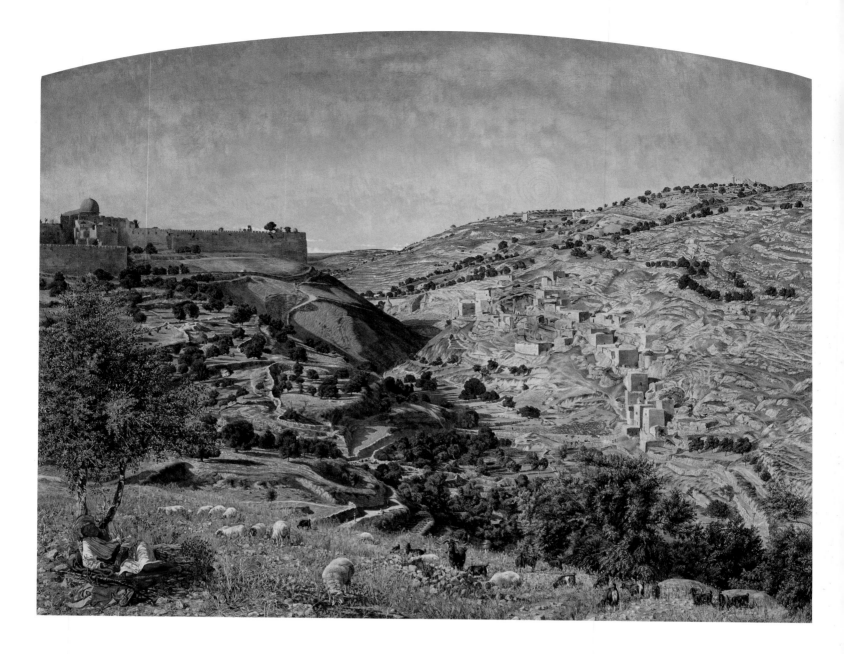

Fig. 162
Jerusalem and the Valley of Jehoshaphat from the Hill of Evil Counsel 1854–5
Thomas Seddon
Oil on canvas, 67.3 x 83.2
Tate
See opposite for detail

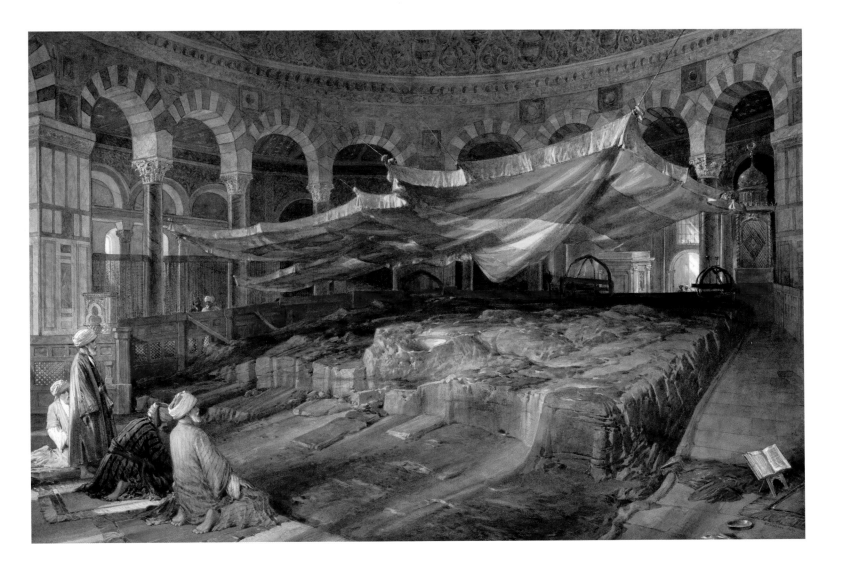

Fig.163
The Dome of the Rock 1869
William Holman Hunt
Watercolour, 25.4 x 35.6
Private Collection

Fig.164
Bahr al-Kabir or the Great Sea.
Rock-cut cistern under the site of
Solomon's Temple 1870
William Simpson
Watercolour, 57 x 38.6
Courtesy Palestine Exploration Fund

Fig.165
The Sacred Rock, Jerusalem: Interior
of the Dome of the Rock 1887
William Simpson
Watercolour, 55.3 x 78.1
Private Collection

Fig. 166
Interior of the Grand Mosque of Damascus 1873/5
Frederic Leighton
Oil on canvas, 158.1 x 122
Harris Museum and Art Gallery, Preston

Fig. 167
The Hour of Prayer: Interior of the Mosque of Sultan Hasan, Cairo 1888
Joseph Farquharson
Oil on canvas, 173.5 x 154.4
Aberdeen Art Gallery
See overleaf for detail

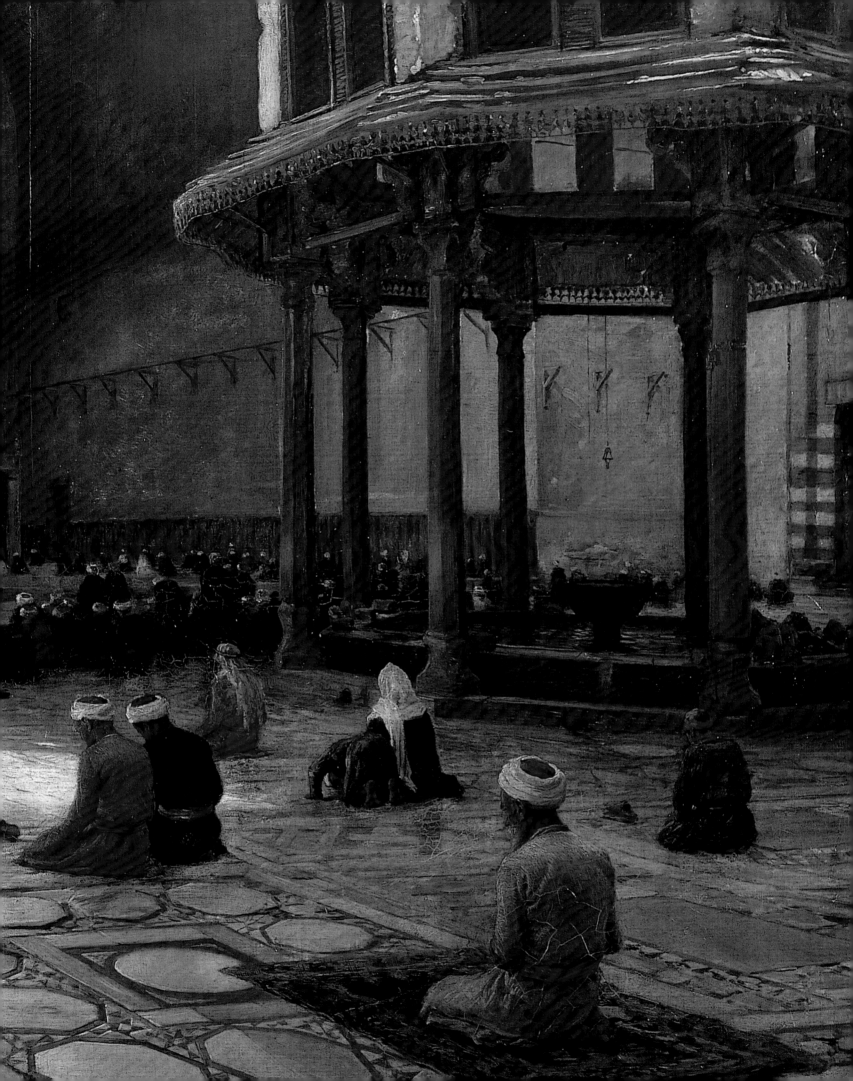

Fig. 168
Interior of a Mosque, Afternoon Prayer (The 'Asr) 1857
John Frederick Lewis
Oil on wood, 31 x 21
Private Collection

Fig. 169
Pilgrims on the Way to Mecca 1882
Arthur Melville
Watercolour, 35.6 x 50.8
Chazen Museum of Art, University of
Wisconsin-Madison

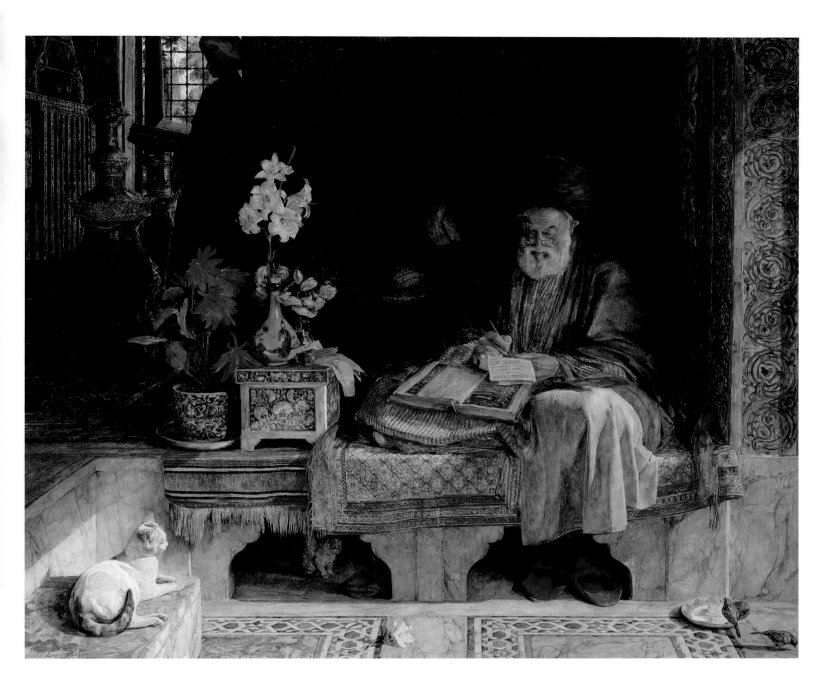

Fig.170
The Commentator on the Koran:
Interior of a Royal Tomb, Bursa, Asia
Minor 1869
John Frederick Lewis
Oil on wood, 62.5 x 75.5
Elton Hall Collection
See opposite for detail

Fig. 171
Jerusalem, Looking to Mount Scopus
1925
David Bomberg
Oil on canvas, 56.5 x 75.2
Tate

Fig. 172
Sarajevo 1922
Stanley Spencer
Oil on paper, 35.6 x 25.4
Southwark Art Collection

NOTES

Introduction: British Orientalist Painting

1. On the term 'Middle East', which is used in this book, see P. Mansfield, *A History of the Middle East*, 2nd ed., London 2003, p.1.

2. Until the British occupation of Egypt in 1882, the only area of these territories directly administered (as opposed to 'protected') by Britain was the Yemeni port of Aden, occupied in 1839 and developed as a coaling station for ships making the journey down the Gulf to India.

3. W.J.T. Mitchell, *What do Pictures Want? The Lives and Loves of Images*, Chicago 2005.

4. E. Said, *Orientalism* [1978], London 1985, p.163; cf. E.W. Lane, *An Account of the Manners and Customs of the Modern Egyptians* [1836], London 1860, pp.1–20. For an exasperated reply to Said on behalf of Lane, see J. Rodenbeck's paper in *Travellers in Egypt*, ed. P. Starkey and J. Starkey, London 2001, pp.233–43.

5. See C. Prendergast, 'Representing Other Cultures: Edward Said', in his *The Triangle of Representation*, New York 2000, pp.83–100, and Said's memoir *Out of Place*, London 2000, p.55.

6. J.P. Seddon, *Memoir and Letters of the Late Thomas Seddon, Artist*, London 1858, p.111.

7. Wilkie to William Collins, Jerusalem, 2 April 1841: W.W. Collins, *Memoirs of the Life of William Collins, Esq., RA*, London 1848, vol.ii, p.184.

8. Billie Melman observes how women travellers in the Middle East, because of a 'mistrust of textuality',

tended to speak of their own literary efforts in pictorial terms ('sketches', 'glimpses', etc.) in order to suggest modesty of ambition, but also to appeal to the more immediate realism of the image; *Women's Orients: English Women and the Middle East 1718–1918*, Basingstoke, Hants, 1992, pp.214, 217.

9. E. Bar-Yosef, *The Holy Land in English Culture 1799–1917: Palestine and the Question of Orientalism*, Oxford 2005, p.130; A. Cunningham, *Life of Sir David Wilkie*, London 1843, vol.iii, p.334. Wilkie, no admirer of Owen, seems to have been thinking of the New Lanark experiment in Scotland where the workforce formed a closed society dominated by Owen's diktat.

10. *The Exhibition … of the Royal Academy …with critical and descriptive remarks*, London 1842, p.13.

11. By the 1880s there were reckoned to be some one million residents of the Levant entitled to British rather than Turkish justice. S. Searight, *The British in the Middle East*, London 1979, p.115.

12. D. Holman-Hunt, *My Grandfather, His Wives and Loves*, London 1969, pp.121–2. Hunt's painting companion in Palestine, Seddon, adopted Arab costume 'To avoid annoyance from the boys', that is, from stone-throwing youths; Seddon 1858, p.39.

13. Quoted in Starkey and Starkey 2001, p.100.

14. The characters are Blue in *Snow* and Assef in *The Kite Runner*.

15. See J. Bronkhurst, *William Holman Hunt: A Catalogue Raisonné*, New Haven and London 2006, vol.i, no.83; cf.

Lane 1860, p.158 (only Hunt's second sentence is a direct quotation from Lane); on the burqa see Lane 1860, pp.45–7; Holman-Hunt 1969, p.130.

16. *Athenaeum*, 1861, p.600.

17. A. Behdad, *Belated Travellers: Orientalism in the Age of Colonial Dissolution*, Cork, Ireland, 1994, p.58.

18. *Egypt and Nubia*, vol.i, London 1846, p.3. The most important exception to this generalisation was the history of the Moors of Granada, whose conquest by the Spanish monarchy in the fifteenth century was a popular theme in European art and literature. In the section on the harem (see pp.126–59) it is suggested that John Frederick Lewis set at least one of his major works, *The Hhareem* (fig.137), in the recent past, or at the very least in a nostalgic mode.

19. R. Irwin, *For Lust of Knowing: The Orientalists and Their Enemies*, London 2006, p.166. Irwin's book, a defence of the European tradition of academic Oriental studies and an attack upon Edward Said, takes the leading part of its title from a once-famous poem by James Elroy Flecker of the Levant Consular Service, 'The Golden Journey to Samarkand' (1913). Given the aura of healthy, disinterested scholarship that the phrase conjures, it is only fair to point to the irony that in the same year as the poem, Flecker confessed of his life in Beirut that 'I loathe the East and the Easterns and spent all my time there dreaming of Oxford' (quoted by Searight 1979, pp.265–6). For a suggestion that Wilkie may have imagined a relationship between Christianity and the Shi'a identity of

the Persian prince whose features he used as the basis of his portrayal of Christ, see N. Tromans, *David Wilkie: The People's Painter*, Edinburgh 2007, p.203.

20. Quoted by A. Hourani, *Islam in European Thought*, Cambridge, UK, 1991, p.27.

21. Hourani 1991, p.65.

22. *The Reminiscences of Solomon Alexander Hart, R.A.*, ed. Alexander Brodie, London 1882, p.70.

23. Cunningham 1843, vol.iii, pp.433–4.

24. *The Reminiscences of Frederick Goodall, R.A.*, London 1902, pp.229–31; Roberts was a friend of Dadd's father.

25. S. Fenwick and G. Smith, *The Business of Watercolour: A Guide to the Archives of the Royal Watercolour Society*, Aldershot, Hants, 1997, p.43.

26. During Lewis's absence the Pre-Raphaelite style had appeared in London. Some critics took to reviewing Lewis as if he were an older associate of these artists (even 'the father of them all'; *The Times*, 12 May 1856, p.12).

27. See for example the *The Times*, 1 May 1869, p.12, on *The Seraff* (fig.27).

28. Salon review of 1864 quoted by R. Benjamin, *Orientalist Aesthetics: Art, Colonialism and French North Africa 1880–1930*, Berkeley, CA, 2003, p.25. As Benjamin's book describes, Orientalist painting in France was to become a far more organised affair than ever it was in Britain, complete with a dedicated exhibiting society and Oriental teaching outpost, the Villa Abd-el-Tif in Algiers.

29. *The Diaries of George Price Boyce*, ed.

V. Surtees, Norwich 1980, p.34.

30. *Athenaeum*, 1860, p.688; *Art Journal*, 1860, p.168. The paradigmatic example of this tendency of Orientalism to be credited as the last stand of true representation is John Ruskin's praise of Hunt and Seddon: 'I do not know an entirely faithful drawing of any historical site, except one or two studies made by enthusiastic young painters in Palestine and Egypt: for which, thanks to them always'; 'The Relation of Art to Use', 1870; *The Works of John Ruskin*, London 1903–12, vol.xx, pp.105–6. Only Ruskin's faith in the images could have assured him of their veracity, as he himself had never been to the Holy Land.

31. Some comment on Orientalist photography, a topic omitted from this book, is called for, but beyond referring the reader to D.R. Nickel, *Francis Frith in Egypt and Palestine: A Victorian Photographer Abroad*, Princeton, NJ, 2004, and K. Jacobson, *Odalisques and Arabesques*, London 2007, all I can do here is emphasise the shame that, for the Orientalist painter, attached to photography; A. Staley and C. Newall, *Pre-Raphaelite Vision: Truth to Nature*, exh. cat., Tate Britain, London, 2004, p.99. For the painters, such as Hunt and Frederic Leighton, photography was a time-saving device, able to provide aide-memoires for use back in the studio. The fact that some of the qualities of photography closely echoed the attributes of Orientalist painting emphasised here helps explain why painters so rarely felt able to record their use of it.

32. Wyndham Lewis titled his 1919 broadside against the meekness of modern architecture *The Caliph's Design: Architects! Where is your Vortex?* Here Lewis fantasises about the Caliph of Baghdad compelling his engineer and architect, on pain of death, to create a street on the model of cutting-edge Vorticist designs. When in 1931 Lewis visited Morocco, however, the country seems temporarily to have mellowed him. P. Edwards, *Wyndham Lewis: Painter and Writer*, New Haven and London 2000, pp.392–4.

33. See Z. Çelik, 'Speaking Back to Orientalist Discourse', in J. Beaulieu and M. Roberts (eds), *Orientalism's Interlocutors: Painting, Architecture, Photography*, Durham, NC, 2002, pp.19–41, and A. Wright, 'The Work of Translation: Turkish Modernism and the "Generation of 1914"', in J. Hackforth-Jones and M. Roberts (eds), *Edges of Empire: Orientalism and Visual Culture*, Oxford 2005, pp.139–61. Crucial here is the notion of Ottoman Orientalism, the phenomenon of Imperial Turkish culture adopting patterns of representing the alien East comparable to those of Europeans: see U. Makdisi, 'Ottoman Orientalism', *American Historical Review*, cvii, no.3, 2002. In painting we can point to the work of the Ottoman court artist Stanisław Chlebowski (1834–84), among whose subjects was *Sultan Bayazid in the Captivity of Tamerlane in 1403* (1878), in which the theme of Oriental cruelty is replicated and simply shunted further East; see B. Biedrońska-Słotowa (ed.), *The Orient in Polish Art*, exh. cat., National Museum, Cracow, 1992, no.III/18.

34. The classic treatment of this topic in English is T.W. Arnold, *Painting in Islam*, Oxford 1928, chapter 1.

35. G. Renda *et al.*, *A History of Turkish Painting*, Geneva 1988, pp.120–1. The Shah's love of sketching modern London life was the basis of a cartoon in *Punch*, 13 July 1889.

36. Arnold 1928, pp.38–9; G. Renda in *The Sultan's Portrait: Picturing the House of Osman*, exh. cat., Topkapı Palace Museum, Istanbul 2000, pp.442–3; J. Young, *A Series of Portraits of the Emperors of Turkey*, London 1815, pp.1–4. Even Young felt that 'foreign artists were treated by Selim with more munificence and regard than was consistent with the prejudices, and perhaps with the real interests, of his subjects'; p.126.

37. For a detailed discussion of one of these portraits (by Wilkie, fig.44), see E. Weeks, 'About Face: Sir David Wilkie's portrait of Mehemet Ali, Pasha of Egypt', in J.F. Codell and D.S. Macleod (eds), *Orientalism Transposed: The Impact of the Colonies on British Culture*, Aldershot, Hants, 1998, pp.46–62.

38. R. Kapuściński, *Shah of Shahs*, London 2006, p.23.

39. Hunt, *Pre-Raphaelitism and the Pre-Raphaelite Brotherhood*, London 1913, vol.i, p.312.

40. *G.F. Watts: A Nineteenth Century Phenomenon*, exh. cat., Whitechapel Art Gallery, London, 1974, no.66; W. Blunt, 'England's Michelangelo': A Biography of George Frederick Watts, O.M., R.A.*, London 1975, p.212.

41. Banksy, *Wall and Piece*, London 2005, p.116.

Cultures Crossed: John Frederick Lewis and the Art of Orientalist Painting

1. While in the possession of its first recorded owner, Sir Thomas Devitt, the (nearly identical) oil version of Lewis's painting acquired the supplemental title *The Carpet Seller*, by which it was known when it was sold at auction, 16 May 1924 (no.119). This appellation has carried over to the watercolour version as well.

2. See fig.72 in this book for William James Müller's painting of the same bazaar.

3. Reviews of the oil version, exhibited at the Royal Academy in 1861 (no.266), typically reported Lewis's picture as being yet another example of the artist's technical and ethnographic brilliance, e.g. *Athenaeum*, 11 May 1861, p.636.

4. The reviewer in the *Athenaeum* believed this accessory to be a pipe, a misidentification driven perhaps by his impression of the merchant as 'in a state of delicious do-nothingness'; ibid.

5. Under the rule of the new Pasha, Muhammad 'Ali, several architectural reforms had been called for in Egypt by the time of this picture's execution, the whitewashing of older buildings among them.

6. The turban was common headgear in Egypt, and had developed around it an elaborate terminology to designate colour, wrapping style, and shifting meanings.

7. For more on Lewis's calculated manipulation of biographical data and painted subject matter, and the meanings of both practices, see Emily M. Weeks, 'The "Reality Effect": The Orientalist Paintings of John Frederick Lewis (1805–1876)', Ph.D. diss., Yale University, 2004.

8. In the five-year period following the publication of *Orientalism*, at least sixty reviews appeared in Britain and America, demonstrating the sensation that Said's text had caused throughout various disciplines. It should be noted, however, that the foundations of Said's incendiary argument were laid earlier, in the largely neglected works of Anouar Abdel-Malek and A.L. Tibawi: see the texts gathered in A.L. Macfie (ed.), *Orientalism: A Reader*, New York 2000.

9. For the history of Orientalism in the original sense of the word, see D. Kopf, 'The Historiography of British Orientalism, 1772–1992', in *Objects of Enquiry: The Life, Contributions and Influence of Sir William Jones (1746–1794)*, ed. G.H. Cannon and K. Brine, New York 1995, pp.141–60.

10. Here, as throughout his text, Said refers specifically to the 'Middle East'.

11. Said, *Orientalism*, New York 1978, pp.2–3. The nuances of the term are taken up later in the text as well, pp.205–9.

12. D.A. Rosenthal, *Orientalism: The Near East in French Painting, 1800–1880*, exh. cat., University of Rochester Art Gallery, 1982, p.9.

13. L. Nochlin, 'The Imaginary Orient', *Art in America*, May 1983, pp.118–31, 187–91.

14. See Macfie 2000. It should be noted that after the publication of *Orientalism*, Said wrote much that nuanced, qualified and more precisely defined the theory he had created. See for example his 'Orientalism Reconsidered', in *Uses of History: Marxism, Postmodernism and the Renaissance (Literature, Politics, Theory)*, ed. F. Barker, P. Hulme and M. Iversen, Manchester 1991, pp.210–29.

15. When discussing earlier historical periods, art historians have been more willing to acknowledge that cross-cultural encounters were more complex than Said's *Orientalism* might suggest. For a particularly insightful example, see L. Jardine and J. Brotton, *Global Interests: Renaissance Art Between East and West*, London 2000. It should be noted, too, that recent scholarship in the field has begun to redress the situation: see especially Weeks 2004; Jill Beaulieu and Mary Roberts, *Orientalism's Interlocutors: Painting, Architecture, Photography*, Durham, NC, 2002; and Roger Benjamin, *Orientalist Aesthetics: Art, Colonialism, and French North Africa 1880–1930*, Berkeley, CA, 2003.

16. The picture was purchased directly by Charles P. Matthews, a wealthy brewer who already owned several works by Lewis including *An Intercepted Correspondence* (fig.110). Typical of Lewis's tendency to produce works in various media, a watercolour version of *The Reception* has recently come to light in a private collection. Both pictures seem to be based on a sketch entitled *Mandarah in my House at Cairo* (fig.127).

17. John Sweetman has proposed that Lewis's predilection for vivid colour contained within a rigorous overall design owes itself to his early (and lifelong) appreciation of fourteenth-century Florentine and fifteenth-century Renaissance art; Sweetman, 'John Frederick Lewis and the Royal Scottish Academy II: Italy, the Netherlands and France', *The Burlington Magazine*, March 2006, pp.195–6. Though most often associated with the Italian Renaissance and the religious works of Jan van Eyck – an artist whom Lewis admired – the connection between light and divine truth would not have been missed by Lewis's contemporaries. Indeed, the renowned Victorian art critic John Ruskin had recently commented on the ability of colour and light to represent faith; see *The Works of John Ruskin*, London 1903–12, vol.vii, p.419.

18. Lewis's suggestion of morality through technique can be compared with his treatment of another controversial harem subject, *The Hhareem* (fig.137). See further the

Harem section, pp.126–59.

19. Principles of etiquette among Egyptian women in the nineteenth century are described in fascinating detail in Sophia Lane Poole's account, *The Englishwoman in Egypt: … Letters from Cairo, Written … With E.W. Lane … by his Sister* [1844], 2 vols., London 1851–3.

20. As is true with each detail of Lewis's composition, the veracity here must be questioned. It seems that Lewis's model for this gazelle and others in his works was not to be found in Egypt, but rather at London's Zoological Society; letter from Philip Sclater to John Frederick Lewis, 20 January 1859, Private Collection.

21. For references to gazelles in their symbolic capacity, see Lady Mary Wortley Montagu, *Letters* [1763], New York 1971, vol.i, p.335.

22. W.M. Thackeray, *Notes of a Journey from Cornhill to Grand Cairo*, London 1846, pp.282–91.

23. Edward Lear to Mrs Lewis, 22 June 1875, Private Collection.

24. The reasons for Lewis's shift in medium were largely financial. I will discuss Lewis's watercolours versus his oil paintings, both in formal and more broadly contextual terms, in a forthcoming article.

25. Thomas Woolner to John Frederick Lewis, 18 July 1875, Yale Center for British Art, Department of Rare Books and Manuscripts. For more on Lewis's accounts to capitalise on Thackeray's account, see E. Weeks, 'John Frederick Lewis: Mythology as Biography, or Dis-orienting the "Languid Lotus-eater"', in S. Searight and M. Wagstaff (eds.), *Travellers in the Levant: Voyagers and Visionaries*, Durham, UK, 2001, pp.177–96.

26. Jean-Baptiste Vanmour, *Reception in a Turkish Harem*, oil on canvas, 58 x 89.2; private collection. See Lynne Thornton, *Women as Portrayed in Orientalist Paintings*, Paris 1994, pp.102–3. For Montagu's vivid description of ladies of the harem receiving visitors, see Montagu 1971, vol.i, p.406. Her text, it should be added, remained highly influential even centuries after its publication, and may have been an influence on Lewis's own work. See R.B. Yeazell, *Harems of the Mind: Passages of Western Art and Literature*, New Haven and London 2000.

27. E.W. Lane, *An Account of the Manners and Customs of the Modern Egyptians* [1836], London 1860, p.11. The 1860 edition is considered definitive, and I therefore refer to it throughout.

28. Ibid. pp.17–18.

29. Even so renowned a painter as Gérôme habitually used the illustrations in Lane's text, especially in his scenes of prayer.

30. For more on Lane's biographical details see L. Ahmed, *Edward W. Lane*, London 1978. For a thorough description of Lane's experience in Egypt, see Jason Thompson's introduction to *An Account of the Manners and Customs of the Modern Egyptians*, Cairo 2003.

31. I refer here to several letters in a Private Collection of manuscripts relating to Joseph Bonomi (1796–1878).

32. *Exhibition of the Royal Scottish Academy of Painting, Sculpture and Architecture*, no. 494, p.23.

33. Egypt's complicated political situation and its struggle for independence against the Ottoman Empire are summarised in M.S. Anderson, *The Eastern Question 1774–1923: A Study in International Relations*, London 1974.

34. For first-hand accounts of the most conspicuous of these changes in the mid-nineteenth century, see Poole, 1851–3, vol.ii, p.49; and John Gardner Wilkinson, *Handbook for Travellers in Egypt*, London 1847, p.115.

35. A.H. Hassan, *In the House of Muhammad Ali: A Family Album 1805–1952*, Cairo 2000, p.10.

36. See E. Weeks, 'About Face: Sir David Wilkie's Portrait of Mehemet Ali, Pasha of Egypt', in J.F. Codell and D.S. Macleod (eds.), *Orientalism Transposed: The Impact of the Colonies on British Culture*, Aldershot, Hants, 1998, pp.46–62.

37. The sartorial and social practices of Lewis, Lane and their colleagues in Cairo, and their broader implications, are extremely complex, and cannot be fully articulated here. For more on this matter, see Weeks 2004 and the Portraits section of this book, pp.46–75.

38. Mernissi, *Beyond the Veil: Mail–Female Dynamics in Modern Muslim Society* [1985], Bloomington, IN, 1987, pp.30–1.

39. Ibid. p.31.

40. Ibid. p.144. In her recent work, Mernissi has investigated the deconstruction of gender barriers brought about by new communications technologies, especially satellite television, in the Arab world.

41. See J. DelPlato, *Multiple Wives, Multiple Pleasures: Representing the Harem 1800–75*, Madison, NJ, 2002, chapter 2.

42. E. Toledano, *The Ottoman Slave Trade and its Suppression, 1840–1890*, Princeton, NJ, 1982, pp.168–71. The Turkish authorities resented the intervention of European diplomats in this matter, and no significant policy changes resulted from Elliot's initiative.

43. See I. Grewal, *Home and Harem: Nation, Gender, Empire and the Cultures of Travel*, Durham, NC, 1996; M. Hatem, 'Through Each Other's Eyes: Egyptian, Levantine-Egyptian and European Women's Images of Themselves and of Each Other (1862–1920)', *Women's Studies International Forum*, vol.xii, no.2, 1989, pp.183–98.

44. 'Women in the East', *Bentley's Miscellany*, vol.xxvii, 1850, p.384.

45. It is worth noting that, with the exception of Lewis, the subject of the harem remained a rare one among British artists. Audiences' familiarity with the subject derived largely from French examples.

46. See F. El Guindi, *Veil: Modesty, Privacy and Resistance*, Oxford 1999. With regard to the arts specifically, see *Veil: Veiling, Representation and Contemporary Art*, ed. David A. Bailey and Gilane Tawadros, Cambridge, MA, 2003.

47. N. Schor, *Reading in Detail: Aesthetics and the Feminine*, New York 1987.

48. In his dissertation 'Eugène Delacroix and the Pictorial Invention of Orientalism', Madison, WI, 1998, p.90, Thomas J. O'Brien has argued that the achievement of Orientalist pictures, in fact, lies precisely in their sanctioning of a shift in attention from the central subject matter to the marginal, pictorial accessories. The argument becomes even more interesting with regard to Lewis's watercolour version of *The Reception*, as this medium has long had a feminine (or 'marginal') connotation. I will be discussing this version in detail in a forthcoming article.

49. Joanna De Groot has also argued for the manipulative role of detail in Lewis's visual images, although her conclusions are different from my own. De Groot claims that Lewis's 'fetishistic' attention to the marginal elements of each composition allowed viewers to enjoy the picture in sexual terms, despite and in proportion to the 'gentrification' of his provocative subject matter; '"Sex" and "Race": The Construction of Language and Image in the Nineteenth Century', in *Sexuality and Subordination: Interdisciplinary Studies in Gender in the Nineteenth Century*, ed. S. Mendus and J. Rendall, London 1989, p.115. Without discounting this compelling suggestion, I believe that the artist could also, as in *The Reception*, use detail deliberately to exacerbate and draw attention to the problematic nature of the picture's subject.

Seduced by 'Samar', or: How British Orientalist Painters Learned to Stop Worrying and Love the Darkness

The themes of this essay, particularly 'lunar Islam' and universality, will be further developed and given fuller contexts in my forthcoming book, *Why Islam Scares the West: The Universal Community Dream Becomes a Digital Reality*.

1. Philip Slater, *The Glory of Hera: Greek Mythology and the Greek Family*, Boston 1968, p.104.

2. Alfred Crosby, *The Measure of Reality: Quantification in Western Society, 1250–1600*, New York 1997, p.93.

3. Ibid. p.182.

4. Bouhdiba is the author of the pioneering books *La Sexualité en Islam* (1975) and *L'Imaginaire Maghrébin* (1995), in which he highlights the link between the mother's power and the glorification of the moon and the night in the Muslim world view. A short introduction to his thesis is his article 'Au royaume des mères' in the collection *Dialoguer avec l'Islam: La psyché entre radicalisme et laïcité*, ed. Lidia Tarentini, Milan 2004.

5. Ibn Faris, *Mu'jam maqayis al lugha*, Beirut 1999, vol.iii, p.100.

6. Ibn Manzur, *Lisan al 'Arab* [the tongue of the Arabs], Cairo [n.d.], vol.iii, p.2024.

7. W. Montgomery Watt, *What Is Islam?* [1968], Beirut 1990, p.35.

8. Qur'an 78:8–11, trans. N.J. Dawood, *The Koran* [1956], London 1974, p.52.

9. Said, *Orientalism*, New York 1978, p.204.

10. 'Couleur de deuil en Occident, le noir est à l'origine le symbole de la fécondité, comme dans l'Egypte ancienne ou en Afrique du Nord: la couleur de la terre fertile et des nuages gonflés de pluie' ('The colour of mourning in the West, black is originally the symbol of fecundity, as in Ancient Egypt or North Africa: the colour of the fertile earth and of clouds swollen with rain'): Jean Servier, *L'homme et l'Invisible*, Paris 1964, p.96.

11. Matisse, *Ecrits et propos sur l'art*, Paris 1972, pp.83, 117.

12. I am very grateful to Judith Nesbitt, Head of Exhibitions at Tate Britain, for sending me Glaxton's 2005 book after her visit to Casablanca of April 2006.

13. Glaxton 2005, p.11.

14. Ibid. p.181.

15. Ibid. p.17.

16. Ibid. p.17.

17. Ibn Khaldun's quotes and Arabic original are from his *Muqaddimah* (Beirut 2003), p.447. The English translation is by Franz Rosenthal, *The Muqaddimah: An Introduction to History*, Princeton 1967, p.355 .

18. Glaxton 2005, p.21.
19. For example, the group of European and Arab psychoanalysts who started meeting after the IAAP (International Association of Applied Psychology) organised a conference in Tunis in October 2002: they are behind the publication of *Dialoguer avec l'Islam* (see note 4 above).
20. Marshall G.S. Hodgson, *The Venture of Islam*, vol.ii, Chicago 1959, p.509.
21. Erich Neumann, *The Great Mother: An Analysis of the Archetype*, Princeton, NJ, 1963, pp.55–6.
22. Barakat Mohamed Murad, 'Sina'at as-Sujjad wa Tajaliyat al Fan al Islami', in the Kuwaiti art magazine *Jaridat Al-Fonoon*, December 2005, p.52.
23. Nasr Hamid Abu Zaid, *Dawair al Khawf: qira'a fi khitab al mar'a* (Circles of Fear: Decoding the Women's Discourse, Casablanca 1999), p.264. For the political theory of *'asabiyya* (tribalism), see Ibn Khaldun's *Muqaddimah*, with commentary by Darwish al-Juwaydi, Beirut 2003, p.122; English trans. by Rosenthal 1967, p.98.
24. Abu Zaid 1999, p.277.
25. Qur'an 5:104, in Dawood 1956, p.386.
26. Hourani, *A History of the Arab Peoples* [1991], London 2005, p.38.
27. Diamond, *Guns, Germs and Steel: The Fates of Human Societies*, New York 1999, p.266.
28. The first quote is from Carl Jung, 'Psychological Types' (1921), *Collected Works*, vol.vi, Princeton, NJ, 1971, chapter 11; the second quote is from Seyyed Hossein Nasr, *Science and Civilization in Islam*, New York 1968, p.24.
29. Thomas W. Arnold, *Painting in Islam* [1928], New York 1965, p.4.
30. *Rasa'il Ikhwan al-Safa*, Beirut 2006, vol.iii, p.420; trans. Mernissi.
31. Muhammad ibn Ismail al-Bukhari, *Sahih: Hadith Authentiques*, Arabic text with French translation by Ahmed Harakat, Beirut 1998, vol.viii, p.337. The original Arabic text of Bukhari's chapter heading appears below.
32. An introduction in English to the dream manuals is Dwight F. Reynolds's section on 'Dreams, Visions, and Unseen Voices' in his edited collection *Interpreting the Self: Autobiography in the Arabic Literary Tradition*, California 2001, p.88.
33. Ibn Khaldun, *Muqaddimah* (Arabic text), 459; English trans. by Rosenthal, p.367.
34. You can still get today, in any mosque entrance, copies of Ibn Sirin's manual *Tafsir al Ahlam* (interpretation of dreams). Ibn Sirin was born 653/4 and died 728/9 CE.
35. Gamal Nkrumah in his article 'Dream On' in the Egyptian *Al Ahram Weekly*, 22–8 June 2006.
36. Jung, *Man and His Symbols*, New York 1964, p.20.
37. Ibid. p.23.
38. 'A longueur de jour et de nuit, dans son langage, ses gestes ou ses rêves, qu'il s'en aperçoive ou non, chacun de nous utilise les symboles. Ils donnent un visage aux désirs': Chevalier and Gheerbrant, *Dictionnaire des Symboles: mythes, rêves, coutumes, gestes, formes, figures, couleurs, nombres*, Paris 1969, p.i.
39. Lewis is far from being the only British artist in this exhibition under the spell of the dark and the symbolic: just look at Arthur Melville's *An Arab Interior* (fig.82), Frank Dillon's *Interior of a room in the female quarters of the house of Sheikh al-Sadat, Cairo* (fig.132) or Walter Horsley's *A Captive*.
40. Emily M. Weeks, 'The "Reality Effect": The Orientalist Paintings of John Frederick Lewis (1805–1876)', Ph.D. diss., Yale University, 2004, chapter 2: 'Life of a Lotus Eater'. I am very grateful to Emily M. Weeks for sending me her perceptive dissertation as a manuscript, just when I needed to penetrate the world of Lewis.
41. Adam Hochschild shows in his book *Bury the Chains: Prophets and Rebels in the Fight to Free an Empire's Slaves*, New York 2005, how extraordinarily quickly the founding of the Anti-Slavery Committee in 1787 led to a mass movement of popular protest.

Regarding Orientalist Painting Today

1. Rana Kabbani, *Europe's Myths of Orient: Devise and Rule*, London 1986.
2. Moustapha Safouan, *Why are the Arabs Not Free? The Politics of Writing*, London 1987, p.1.
3. Edward Said, 'Imperial Pursuits: Orientalism – 25 years on', *Guardian*, 2 August 2003, Review Section, p.2.
4. Edward William Lane, *An Account of the Manners and Customs of the Modern Egyptians*, London 1836.
5. Linda Nochlin, 'The Imaginary Orient', *Art in America*, May 1983, pp.118–31, 187–91. Nochlin was the first to question the celebratory mode of Orientalist art exhibitions, and she remains one of the most perceptive critics on the subject.
6. Wilfrid Scawen Blunt, *Atrocities of Justice Under British Rule in Egypt*, London 1906.
7. Leila Sebbar, *Femmes D'Afrique du Nord: Cartes Postales (1885–1930)*, Paris 2002.
8. *Ingres 1780–1867*, Musée du Louvre, Paris, 2006.
9. Colette, *En Algérie (prisons et paradis)*, Geneva 1969–72, p.177.
10. Malek Alloula, *Le Harem Colonial: Images d'un sous-érotisme*, Geneva 1981.
11. W.M. Thackeray, *Notes of a Journey from Cornhill to Grand Cairo*, London 1846, p.207.
12. Richard Francis Burton, *Personal Narrative of a Pilgrimage to Al-Madinah and Meccah*, 2 vols., London 1855–6.
13. David Roberts, *The Holy Land, Syria, Idumea, Arabia, Egypt and Nubia*, 6 vols., London 1842–9.
14. T.E. Lawrence, *The Letters of T.E. Lawrence*, ed. David Garnett, London 1938, p.291.
15. MaryAnne Stevens, 'Western Art and its Encounter with the Islamic World 1798–1914', *The Orientalists: Delacroix to Matisse (European Painters in North Africa and the Near East)*, exh. cat., Royal Academy, London, 1984, p.21.
16. Badr el-Hage, 'Les Arméniens et la photographie au Proche Orient', *L'Orient des photographes Arméniens*, Paris 2007.
17. Thackeray 1846, pp.278–9.
18. Stevens in RA 1984, p.20.
19. Hector de Callias, 'Le salon de 1864, XVII: Les Italiens et les orientaux', *L'Artiste*, 1864, p.198.
20. Edward Lear, *Later Letters of Edward Lear*, ed. Lady Strachey, London 1911, p.91.
21. Bridget Keenan, *Damascus: Hidden Treasures of the Old City*, London 2000.

Travellers and Sitters: The Orientalist Portrait

1. The following passage, published by Colonel James Capper, who was in the service of the East India Company, in 1793, is typical of the advice contained in seventeenth- and eighteenth-century travel narratives: 'In all Arabian and Turkish Countries, especially in those near the city of Mecca, to avoid the insults of the lower class of people, an European should allow his beard and whiskers to grow, and always wear an Eastern dress; it is best to make up a coarse one in the Arabian fashion for travelling, and another rather elegant in the Turkish fashion to wear at Cairo, and Alexandria … it may be proper to remark that a Christian should not wear green clothes at any place in the Levant, for green is a colour deemed sacred to those who have made a pilgrimage to Mecca, and to the descendents of the Prophet.' Capper, *Observations on the Passage to India Through Egypt and Across the Great Desert*, London 1783, p.2.
2. Mary Roberts, 'Cultural Crossings: Sartorial Adventures, Satiric Narratives and the Question of Indigenous Agency in Nineteenth-Century Europe and the Near East', in Jocelyn Hackforth-Jones and Mary Roberts (eds.), *Edges of Empire: Orientalism and Visual Culture*, Oxford 2005, p.70.
3. Judith Bronkhurst, *William Holman Hunt: A Catalogue Raisonné*, New Haven and London 2006, vol.i, pp.212–14.
4. Personal communication with Tabitha Barber. See Barber, *Traders in the Levant: Andrea Soldi and the English Merchants in Aleppo*, forthcoming 2008, www.tateonline.org.uk.
5. See Nabil Matar (ed. and trans.), *In the Lands of the Christians: Arabic Travel Writing in the Seventeenth Century*, New York 2002.
6. Margaret Morris Cloake (trans. and ed.), *A Persian at the Court of King George, 1809–10: The Journal of Mirza Abul Hassan Khan*, London 1988, p.137.
7. R.A. Ingrams, 'Rubens and Persia', *The Burlington Magazine*, vol.cxvi, no.853, p.197. That Shirley was a showman is suggested by Thomas Fuller's *The History of the Worthies of England* (1662), in which he is described as 'much affected to appear in foreign vests; and, as if his clothes were his limbs, accounted himself never ready till he had something of the Persian habit about him.' Quoted in Richard Wendorf, *The Elements of Life: Biography and Portrait-painting in Stuart and Georgian England*, Oxford 1990, p.102.
8. Court ceremonials also presented opportunities for painters and patrons. At the Ottoman court, for example, honorific garments were presented to European officials, which, according to custom, were strictly hierarchical in quality, from the ambassador downwards, and worn at ambassadorial receptions before the sultan or grand vizier. During his residence in Constantinople from 1699 to his death in 1737, the Flemish-French artist Jean-Baptiste Vanmour, who had originally accompanied the French ambassador, made a specialty of painting audiences with Sultan Ahmed III for a variety of European diplomats. See Patricia L. Baker, 'A History of Islamic Court Dress in the Middle East', Ph.D. thesis, University of London, 1986, pp.1–8 and 219–231, and Patricia L. Baker, 'Islamic Honorific Garments', *Costume*, no.25, 1991, pp.25–32. Shirley's costume incorporates a cloak and tunic (worn shorter than in the Ottoman Empire) with floral and figurative motifs, the latter denoting its Persian origin (see Baker 1986, pp.307–15). The lace collar, cuffs, boots and spurs are of European origin. It was during the second embassy that van Dyck painted the two full-length portraits of Shirley and his wife in Rome in 1622.
9. Richard Pococke, *Description of the East, and Some Other Countries: Egypt, Palestine, Mesopotamia, Cyprus, Candia, Greece, Asia Minor*, London 1743–5, vol.ii, p.iv. For further discussion of

Pococke's tour of the Near and Middle East, see Anita Damiani, *Enlightened Observers: British Travellers to the Near East 1715–1850*, Beirut 1979, pp.70–104.

10. That the achievement of Wood in particular was viewed as of national importance is underlined by Horace Walpole's assertions that 'of all the works that distinguish this age, none perhaps excel those beautiful editions of Baalbec and Palmyra … undertaken by private curiosity and good sense, and trusted to the taste of a polished nation'. Walpole, *Anecdotes of Painting in England*, London 1762, vol.i, p.xiii.

11. Dawkins and Wood did not 'discover' Palmyra, as a number of expeditions had been made by British merchants from Aleppo in the seventeenth century. But *The Ruins of Palmyra, Otherwise Tedmor in the Desert*, London 1753, and *The Ruins of Baalbec, Otherwise Heliopolis in Coelosyria*, London 1757, set a new standard for accuracy and comprehensiveness. See Damiani 1979, pp.105–32.

12. See Claire Pace, 'Gavin Hamilton's Wood and Dawkins Discovering Palmyra: The Dilettante as Hero', *Art History*, vol.iv, no.3, September 1981, pp.271–90.

13. Lady Llandover (ed.), *The Autobiography and Correspondence of Mary Glanville, Mrs Delaney*, vol.i, London 1862, p.180. The bewildering range of masquerade costume worn during the eighteenth century can be gleaned from the comments of Elizabeth, Countess of Moira in a letter to her brother concerning a masked ball in 1768, where she observed gentlemen masquerading as 'Vandykes, Hussars, Croats, Pandours, Spaniards, ancient Frenchmen, Indians from the Lake Huron and River Senegal, Turks, Armenians, Moors and some ideal personages'. Quoted in Aileen Ribeiro, *The Art of Dress: Fashion in England and France, 1750–1820*, New Haven and London 1995, p.181. See also Aileen Ribeiro, 'The Influence of Oriental Dress on Masquerade Dress in England in the Eighteenth Century' in *The Dress Worn at Masquerades in England, 1730–1790, and its Relation to Fancy Dress in Portraiture*, New Haven and London 1984.

14. Mary Wortley Montagu, *The Complete Letters of Lady Mary Wortley Montagu*, ed. R. Halsband, vol.i, Oxford 1965, p.328. For an analysis of portraits of Montagu see Marcia Pointon, 'Going Turkish in Eighteenth-Century London: Lady Mary Wortley Montagu and her Portraits' in *Hanging the Head: Portraiture and Social Formation in Eighteenth-Century England*, New Haven and London 1993, pp.141–57.

15. André du Ryer, *The Alcoran of Mahomet, Translated out of the Arabique into French … And Newly Englished for the Satisfaction of All That Desire to Look into the Turkish Vanities*, trans. Alexander Ross, London 1649, n.p.

16. As Ros Ballaster has observed, 'The two founding and most familiar voices of the Oriental tale-teller in the eighteenth century were those of Scheherazade, the newly married vizier's daughter who tells her sultan husband the *Arabian Nights Entertainment* (1704–17) and Mahmut, the Arabian fictional spy', in Giovanni Paolo Marana's *Letters Writ by a Turkish Spy at Paris* (first English ed. 1707). Ros Ballaster (ed.), *Fables of the East: Selected Tales, 1662–1785*, Oxford 2005, p.5. See also Ros Ballaster, 'Shape-Shifting: Oriental Tales' and 'Tales of the Seraglio: Turkey and Persia' in *Fabulous Orients: Fictions of the East in England, 1662–1785*, Oxford 2005, pp.25–58, 59–192.

17. In 1718, for example, Lady Mary Wortley Montagu wrote to her sister from Constantinople, that *Les Mille et un Jours* was 'excepting the Enchantments … a real representation of the manners here'. Montagu 1965, p.385. For further discussion on the critical reception of the *Arabian Nights Entertainment* see Muhsin Jassim Ali, *Scheherazade in England: A Study of Nineteenth-century English Criticism of the Arabian Nights*, Washington D.C. 1981.

18. Geoffrey Ashe, *The Hell-Fire Clubs: A History of Anti-Morality*, revised ed., Stroud, Glos., 2000, p.103. For a comprehensive discussion of the Divan Club and its members see Rachel Finnegan, 'The Divan Club, 1744–46', *EJOS*, vol.ix, no.9, 2006, pp.1–86.

19. *Memoirs of the Late Edw. Wortley Montague, Esq. with Remarks on the Manners and Customs of the Oriental World*, vol.i, London 1778, pp.22–9. See also Alex Kidson, *George Romney*, exh. cat., National Portrait Gallery, London, 2002, p.100.

20. Ibid. p.101.

21. J.P. Seddon, *Memoir and Letters of the Late of the Late Thomas Seddon, Artist*, London 1851, p.32.

22. As an example, Burton writes: 'Then I performed the seven circuits round the Ka'abah, called the Tawaf. I then managed to have a way pushed for me through the immense crowd to kiss it. While kissing it, and rubbing hands and forehead upon it, I narrowly observed it, and came away persuaded that it is an aerolite.' Quoted in Isabel Burton, *The Life of Captain Sir Richard F. Burton*, vol.i, London 1893, pp.175–6.

23. Mark Hallett, 'Reynolds, Celebrity and the Exhibition Space' in Martin Postle (ed.), *Joshua Reynolds: The Creation of Celebrity*, exh. cat., Tate Britain, London, 2005, p.35.

24. Tate 2005, p.220. Baldwin's high-rolled hairstyle, over which the turban cloth is wrapped, would have been highly fashionable amongst London's social elite, thus neatly underlining that this is above all a society portrait.

25. Ribeiro 1995, p.228.

26. As quoted in David Blayney Brown, *Romanticism*, London 2001, p.283.

27. 'The Giaour', line 615. *Lord Byron: The Major Works*, Oxford 2000, p.223.

28. Fiona MacCarthy, *Byron: Life and Legend*, London 2002, p.216.

29. The First Afghan War was one of the first major conflicts of what has been described as 'The Great Game', a term used in Britain to refer to the rivalry and strategic conflict between the British and Russian empires for supremacy in Central Asia.

30. Florentian Sale, *Journal*, London 1843, p.87.

31. Bronkhurst 2006, vol.i, pp.212–14.

32. Quoted in Briony Llewellyn, 'A "Masquerade" Unmasked: An Aspect of John Frederick Lewis's Encounter with Egypt', *Cairo Papers in Social Science*, vol.xxiii, no.3, 2000, p.133.

33. Ibid. p.142.

34. E.M. Weeks, 'The "Reality Effect": The Orientalist Paintings of John Frederick Lewis (1805–1876)', Ph.D. diss., Yale University, 2004, p.55.

35. Billie Melman, *Women's Orients, English Women and the Middle East, 1718–1918* [1992], 2nd ed., Hampshire and London 1995, p.16.

36. Quoted in Reina Lewis, *Gendering Orientalism: Race, Femininity and Representation*, London and New York 1996, p.136.

37. Montagu 1965, vol.i, pp.310–11, 328–9.

38. Angela Rosenthal, 'The Inner Orient' in *Angelica Kauffmann: The Art of Sensibility*, New Haven and London 2006, pp.123–53.

39. Ibid. p.127.

40. Patricia A. Cunningham, *Reforming Women's Fashion, 1850–1920: Politics, Health and Art*, Kent, OH, 2002, pp.33–8.

41. Quoted in Gayle V. Fischer, '"Pantalets" and "Turkish Trowsers": Designing Freedom in the Mid-Nineteenth-Century United States', *Feminist Studies*, 1997, p.123.

42. Terry Castle, *Masquerade and Civilization*, London 1986, p.40.

43. Dane Kennedy, *The Highly Civilized Man: Richard Burton and the Victorian World*, Cambridge, MA, 2005, p.90.

44. T.E. Lawrence, 'The Changing East', *The Round Table*, September 1920.

45. Rasheed El-Enany, *Arab Representations of the Occident: East-West Encounters in Arabic Fiction*, London and New York 2006, p.3.

46. See Sandra Naddaf, *Mirrored Images: Rifa'ah al-Tahtawi and the West*, Cairo, 1986.

47. The fez was part of earlier attempts at dress reform in 1796 by Sultan Selim III (1789–1807) and was formally adopted in 1827. In 1925, the government of the newly established Republic of Turkey made the wearing of the fez a criminal act. Thus, as Patricia L. Baker has noted, 'in the space of one hundred years, the fez had changed from being a proclamation of national identity and of support for modernization programmes, to being regarded as the symbol of Islamic orthodoxy, conservatism and allegiance to the old order, the Ottoman Sultanate'; Baker, 'The Fez in Turkey: A Symbol of Modernization', *Costume*, no.20, 1986, p.72.

48. Emily M. Weeks, 'About Face: Sir David Wilkie's Portrait of Mehemet Ali' in Julie F. Codell and D.S. Macleod (eds.), *Orientalism Transposed: The Impact of the Colonies on British Culture*, Aldershot, Hants, 1998, p.54.

49. See Michelle L. Woodward, 'Between Orientalist Clichés and Images of Modernization: Photographic Practice in the Late Ottoman Era', *History of Photography*, vol.xxvii, no.4, winter 2003, pp.366, 373. See also Zeynep Çelik, 'Speaking Back to Orientalist Discourse' in Jill Beaulieu and Mary Roberts (eds.), *Orientalism's Interlocutors: Painting, Architecture, Photography*, Durham, NC, and London 2002, pp.19–41.

50. Stanley Lane-Poole, Editor's Preface in Edward William Lane, *The Thousand and One Nights, Commonly Called in England, The Arabian Nights' Entertainment*, London 1859, vol.i, pp.x–xi.

51. Elaine Kilmurray and Richard Ormond (eds.), *John Singer Sargent*, exh. cat.,Tate Gallery, London 1998, pp.222–3.

52. In his '27 Articles', published in August 1917, Lawrence advised British intelligence officers that 'Disguise is not advisable. Except in special areas let it be known that you are a British officer and a Christian'. However, due to the cultural significance attached to clothing, when amongst the Beduin, 'Arab kit' worn by tribal leaders was appropriate: as Lawrence states, 'you will acquire their trust and intimacy to a degree impossible in uniform'. In *Seven Pillars of Wisdom*, a personal account of the Arab Revolt, Lawrence records that he was requested to wear Arab dress by both Sharif Ali and Emir Feisal as a show

of respect; Lawrence, *Seven Pillars of Wisdom: A Triumph* [1926], Garden City, 1935, p.126.

53. Steven C. Caton, 'The Sheik: Instabilities of Race and Gender in Transatlantic Popular Culture of the Early 1920s' in Holly Edwards (ed.), *Noble Dreams, Wicked Pleasures Orientalism in America, 1870–1930*, Princeton 2000, p.100.

54. Quoted in Ibid. p.103.

55. Mary Roberts; see note 2.

Genre and Gender in Cairo and Constantinople

1. See N. Tromans, *David Wilkie: The People's Painter*, Edinburgh 2007; and D. Solkin, *Painting Out of the Ordinary*, forthcoming, New Haven and London 2008.

2. A. Cunningham, *Life of Sir David Wilkie*, London 1843, vol.iii, p.220.

3. F. Mernissi, 'The Satellite, the Prince and Sheherazade: The Rise of Women as Communicators in Digital Islam', *Transnational Broadcasting Studies*, vol.xii, 2004.

4. Cunningham 1843, vol.iii, p.442.

5. Fromentin, *Un été dans le Sahara*, 1857, quoted by R. Benjamin, *Orientalist Aesthetics*, Berkeley, CA, 2003, p.19.

6. E. Barrington, *The Life and Work of Frederic Leighton*, London 1906, vol.i, p.301.

7. W.J. Müller, 'An Artist's Tour in Egypt', *Art-Union*, i, 1839, p.131.

8. See F. Greenacre and S. Stoddard, *W.J. Müller 1812–45*, exh. cat., Bristol City Art Gallery, 1991, p.108, fig.10, no.115.

9. E.W. Lane, *An Account of the Manners and Customs of the Modern Egyptians* [1836], London 1860, pp.76–7.

10. Among the pictures of Lewis to borrow from Lane was the *Della'l* (auctioneer) of 1875: cf. Lane 1860, p.317.

11. Lewis knew that he would be able to rely on models back in Britain, got up in the clothing that he brought back with him from Egypt (for the latter, see the catalogue of his studio sale, Christie's, London, 4 & 7 May 1877). Frederick Goodall names one male model whom Lewis apparently used regularly after his return home; *The Reminiscences of Frederick Goodall, R.A.*, London 1902, pp.272–3.

12. Lane 1860, p.144 (compare also the illustration of a courtyard of a private house in Cairo, p.10). Lane notes that most families generally dined together and that it was characteristic only of upper-class men to dine alone with friends, p.141.

13. W.M. Thackeray, *Notes of a Journey from Cornhill to Grand Cairo*, London 1846, pp.288–90.

14. *Illustrated London News*, 4 May 1850, pp.299–300.

15. See letter from Edward Stanley

Poole (Lane's nephew) to the Egyptologist Joseph Bonomi, n.d. [1847]; Private Collection; quoted in Emily M. Weeks, 'The "Reality Effect": The Orientalist Paintings of John Frederick Lewis (1805–1876)', Ph.D. diss., Yale University, 2004, p.283. Ironically, Lewis became the most conventionally settled married man of the leading early British Orientalist painters (although he and Marian had no children): Wilkie, Dadd, Leighton and Lear never married, Roberts was separated from his wife, and Hunt's second marriage to the sister of his first wife was not recognised by English law.

16. Lane 1860, pp.555–6. On ambiguities over coinage in Egypt see F. Stewart (Viscount Castlereagh), *A Journey to Damascus*, London 1847, vol.i, pp.39–40. The *seraff*'s white turban may indicate that he is Jewish: see T. Parfitt, *The Jews in Palestine 1800–1882*, Woodbridge, Suffolk, 1987, p.173.

17. Linda Nochlin's 1983 paper 'The Imaginary Orient' (reprinted in *The Politics of Vision: Essays on Nineteenth-Century Art and Society*, London 1991, pp.33–59) made this into an academic orthodoxy.

18. On the exclusion of Europeans from the Ottoman slave markets at the turn of the nineteenth century see G.A. Olivier, *Voyage dans l'empire Othoman, l'Égypte et la Perse*, vol.i, Paris 1801, p.178.

19. J. Howard *et al.*, *William Allan, Artist Adventurer*, exh. cat., City Art Centre, Edinburgh, 2001, p.53.

20. E. Toledano, *The Ottoman Slave Trade and its Suppression: 1840–1890*, Princeton, NJ, 1982, p.53.

21. [J.G. Lockhart] Revd P. Morris [pseud.], *Peter's Letters to his Kinsfolk*, Edinburgh 1819, vol.ii, pp.250ff, gives a detailed description of the picture.

22. J. DelPlato, *Multiple Wives, Multiple Pleasures: Representing the Harem, 1800–1875*, Cranbury, NJ, 2002, pp.74–9, fig.3.10.

23. L. Thornton, *Eastern Encounters: Orientalist Painters of the Nineteenth Century*, exh. cat., Fine Art Society, London, 1978, no.108; *Art Journal*, 1871, p.238.

24. *Art Journal*, 1861, p.265.

25. Virtually the only regularly referenced sartorial symbol was the green turban (as seen in Wilkie's *The Turkish Letter Writer*, fig.62, Hunt's *Lantern-Maker's Courtship*, fig.73, and the bearded figure on the right of Lewis's *Courtyard of the Coptic Patriarch's House*, fig.134), but even here there was confusion among British travellers: did this denote a *sharif* (or *sayyid* – descendant of the Prophet), or one who had completed the hajj (pilgrimage to Mecca), or neither or both? But see note 16 above for a

possible use by Lewis of a coloured turban as a symbol of identity.

Landscape: The Orient in Perspective

1. R. Hyde, *Panoramania! The Art and Entertainment of the 'All-Embracing' View*, exh. cat., Barbican Art Gallery, London, 1988, p.60; on the recent history of the military panorama in the Middle East see p.272 (Iraq) and p.275 (Egypt). On the Orientalist panorama see further E. Ziter, *The Orient on the Victorian Stage*, Cambridge, UK, 2003, chapter 1.

2. Letter of 8 December 1838: J. Ballantine, *The Life of David Roberts, R.A.*, Edinburgh 1866, p.99.

3. B. Llewellyn, 'A Master of the Topographical: David Roberts at Baalbek', *Archaeology and History in Lebanon*, vol.xii, 2000, p.42.

4. It was precisely as Roberts was completing his final picture of Baalbek that the Ottoman authorities, in the wake of the Lebanese civil war of 1860, began to take a serious archaeological interest in the ruins, in part to signal their responsible stewardship of the region.

5. *Egypt and Nubia*, vol.i , London 1846, p.4.

6. Ibid. vol.ii, 1849, unpaginated. Most important of all Belzoni's finds was the tomb of Pharaoh Sethos I, which included the magnificent alabaster sarcophagus that ended up in Sir John Soane's museum in London.

7. An interesting tension arose between William Holman Hunt's wish to sketch from his rooftop in Jerusalem and his neighbour's assertion of his rights to privacy; *Pre-Raphaelitism and the Pre-Raphaelite Brotherhood*, London 1913, vol.i, pp.296–7. Other European travellers reported similar cases, for example objections to their ascending tall buildings to gain views over cities, on the grounds that this might enable them to spy upon harem women in gardens. Seen in this light, bird's-eye panoramas of Muslim cities were extremely intrusive images.

8. In fact European engravings of cityscapes, if not city plans, were later a popular source of images used in Middle Eastern domestic decorative painting: see J. Carswell in T. Naff and R. Owen (eds.), *Studies in Eighteenth-Century Islamic History*, Carbondale, IL, 1977, pp.328ff.

9. The great mosque clearly visible in Carline's picture is the one painted by Leighton back in the 1870s (fig.166). Examples of the RAF's photography being put to use in architectural history can be found in the plates volume of Louis Hautecoeur and Gaston Wiet's *Les Mosquées du Caire* (1932).

10. J.F. Jones, *Memoirs of Baghdad, Kurdistan and Turkish Arabia* [1857], facsimile with introduction by R.M. Burrell, London 1998, p.xxix. This volume contains lithographs after what must have been the earliest British photographs of Arabia, taken by the East India Company's resident Civil Surgeon in Baghdad, Dr Hyslop.

11. Ballantine 1866, p.89; Hunt 1913, vol.ii, p.26.

12. C.L. Woolley and T.E. Lawrence, *The Wilderness of Zin*, published by the Palestine Exploration Fund in 1915.

13. For Roberts's own comment along these lines see Ballantine 1866, p.105.

14. W.J.T. Mitchell, in *Landscape and Power*, ed. Mitchell, 2nd ed., Chicago 2002, pp.265–6.

15. See J. Bronkhurst, *William Holman Hunt: A Catalogue Raisonné*, New Haven and London 2006, no.D79; for the Roberts see H. Guiterman and B. Llewellyn, *David Roberts*, exh. cat., Barbican Art Gallery, London 1986, no.134.

16. A. Staley, *The Pre-Raphaelite Landscape*, New Haven and London 2001, p.139; Hunt 1913, vol.ii, p.220.

17. Quoted by B. Llewellyn, 'The Real and the Ideal: Petra in the Minds and Eyes of Nineteenth-Century British and American Artist-Travelers', in G. Markoe (ed.), *Petra Rediscovered: The Lost City of the Nabataeans*, New York 2003, p.127. Petra declined rapidly in the third century CE, its role as the commercial hub of the region being taken over by Palmyra (see fig.51). Lear's other large painting of Petra appeared on the London art market in 2007.

18. See *Victorian Landscape Watercolours*, exh. cat., Yale Center for British Art, New Haven, 1992, no.36. We might compare Lear's care in orientating himself in this biblical terrain with Dadd's insouciance in Cairo: writing to his friend W.P. Frith, Dadd referred to 'The bazaars, especially one near – … I don't know where, nor do I care, nor do you care'; Frith, *My Autobiography and Reminiscences*, London 1888, vol.iii, p.189.

19. From a 1984 article quoted by I. Rogoff, *Terra Infirma: Geography's Visual Culture*, London 2000, p.99.

20. In his *Academy Notes* for 1856 Ruskin had written that he did not believe that 'since the death of Paul Veronese, anything has been painted comparable to it in its own way'. Back in 1840 at Constantinople, David Wilkie had suggested Lewis do something along the lines of Veronese, the great sixteenth-century Venetian painter of colourful luxury; A. Cunningham, *Life of Wilkie*, London 1843, vol.iii, p.339.

21. *The Times*, 28 April 1856, p.12: the writer compares Castlereagh's

complacency to that of Alexander Kinglake's *Eothen* (1840), on which see the Introduction, p.10.
22. Exodus 15:22–7; *The Reminiscences of Frederick Goodall, R.A.*, London 1902, pp.76ff.
23. S. Reynolds, *William Blake Richmond: An Artist's Life 1842–1921*, Norwich 1995, p.226.
24. *Athenaeum*, 24 May 1856, p.655.
25. Bronkhurst 2006, no.D112, App.D3.
26. Ibid. under no.D77.
27. Frith 1888, vol.iii, p.192: thanks to Patricia Allderidge for further information.
28. D. Cherry, *Beyond the Frame: Feminism and Visual Culture, Britain 1850–1900*, London 2000, chapters 2, 3. Leigh Smith Bodichon compiled a guidebook, *Algeria Considered as a Winter Residence for the English*, published by the *English Woman's Journal* in 1858.
29. Cherry 2000, p.83.
30. K. McConkey, *Sir John Lavery*, Edinburgh 1993, chapter 6, and the same author's 'A Thousand Miles Towards the Sun: British Artist-travellers to Spain and Morocco at the Turn of the Twentieth Century', *Journal of Visual Culture in Britain*, vol.iv, no.1, 2003, pp.25–43. On Tangier in the twentieth century see I. Finlayson, *Tangier: City of the Dream*, London 1992.

Harem and Home
1. L.M. Peirce, *The Imperial Harem: Women and Sovereignty in the Ottoman Empire*, Oxford 1993, p.29: this arrangement dispensed with troublesome dynastic alliances and rivalries in favour of absolute centralisation of power. The fact that later Ottoman emperors were thus descended from slaves was an important factor in their reluctance to see anything shameful in slavery. 'Circassians' is a loose term for the Muslim inhabitants of the region along the north-eastern shores of the Black Sea who were largely dispersed following the Russian conquests of the Caucasus in 1864.
2. Not being able to access the harem himself, when Lane returned again to Egypt in 1842, he invited with him his sister, Sophia Lane Poole, so that she might compile her own account of Egypt to remedy this omission. This was published, half-anonymously, as *The Englishwoman in Egypt … Letters from Cairo, written … with E.W. Lane … by his Sister*, 2 vols., London 1844. Poole observes that in the grandest Cairo establishments, the harem comprised a separate building with the reception room on the ground floor; vol.i, p.209; vol.ii, pp.55–6. For summaries of modern opinion on the division of space in Cairene houses,

which suggest Lane was too rigid in his account, see G.S.P. Freeman-Grenville, *The Beauty of Cairo*, London 1981, pp.76–8 and J. Scarce, *Domestic Culture in the Middle East*, Edinburgh 1996, pp.31–3.
3. See B. Llewellyn, 'Frank Dillon and Victorian Pictures of Old Cairo Houses', *Ur*, vol.iii, 1984, pp.3–10. For the history and present state of these structures see N. Warner, *The Monuments of Historic Cairo: A Map and Descriptive Catalogue*, Cairo 2005, no.463 (al-Sadat), no.208 (Radwan Bey); the house of Sheikh al-'Abbasi (location uncertain) was his official residence: see Warner 2005, pp.38, 76. On an earlier trip to Cairo in 1861–2, Dillon shared a studio with G.B. Boyce (see fig.105).
4. I. Grundy, *Lady Mary Wortley Montagu*, Oxford 1999, chapters 9, 10, 12; R.B. Yeazell, *Harems of the Mind: Passages of Western Art and Literature*, New Haven and London 2000, chapter 8. Montagu's account of the baths was later to be one of the sources for Jean-Auguste-Dominique Ingres' *The Turkish Bath*, fig.27.
5. Insofar as flower-messages were really part of harem life, they seem to have been sent principally between women (Yeazell 2000, 120).
6. Maria Pickersgill's poem, 'The Oriental Love-Letter', appeared in the illustrated annual the *Bijou*, 1828, p.242, along with an engraving after her husband's painting.
7. E.W. Lane, *An Account of the Manners and Customs of the Modern Egyptians* [1836], London 1860, pp.175, 178, 182, 302.
8. See B. Melman, *Women's Orients: English Women and the Middle East 1718–1918*, Basingstoke, Hants, 1992, chapter 5.
9. The idea that old travellers' tales of the harem were not to be trusted now in turn became an immovable certainty, to the extent, so a historian of disability has claimed, of unnecessarily preventing the use of Western texts in research into the important development of a pioneering signing language among deaf-mutes in the Imperial harem (who were employed so as not be party to gossip): see M. Miles, 'Signing in the Seraglio: Mutes, Dwarfs and Jestures at the Ottoman Court 1500–1700', *Disability and Society*, vol.xv, no.1, 2000, pp.115–34.
10. Melman 1992, p.137.
11. R. Lewis, *Gendering Orientalism: Race, Femininity and Representation*, London 1996, chapters 3, 4. The pictures may reflect Browne's visit to the Bosphorus summer palace of an aristocratic lady known as Zeïneb Sultana; M. Roberts, 'Contested Terrains: Women Orientalists and the Colonial Harem', in J. Beaulieu and

M. Roberts (eds), *Orientalism's Interlocutors: Painting, Architecture, Photography*, Durham, NC, 2002, p.196.
12. Because smoking was not considered ladylike in Britain, it became a sign of the female Oriental and in turn of the lady Orientalist; among the latter, notorious smokers included Lucie Duff Gordon and Lady Hester Stanhope.
13. See Melman 1992, pp.149–53, for some British women's admiration of the sparseness of harem decoration, which offered such a contrast to the cluttered Victorian interior.
14. Before the Ottoman conquest of Egypt in 1517 the Mamluks had ruled the country, and much Middle Eastern territory besides, in their own right.
15. Yeazell 2000, pp.104–5; on Abyssinian slaves see Lane 1860, p.184.
16. On the possibility of Ethiopian slaves becoming the wives of their owners, see E. Toledano, *Slavery and Abolition in the Ottoman Middle East*, Seattle 1998, p.13.
17. At the end of 1849 or early in 1850, the Cairo house in which Lewis was living was badly damaged by fire: this may have been a factor in his decision to return to Britain in 1851; Emily M. Weeks, 'The "Reality Effect": The Orientalist Paintings of John Frederick Lewis (1805–1876)', Ph.D. diss., Yale University, 2004, pp.130–1.
18. Christie's, London, 4 May 1877 (lot 176). William Makepeace Thackeray, visiting Lewis in 1844, wrote in his romanticised travelogue that the artist lived 'far away from the haunts of European civilization, in the Arab quarter'; *Notes of a Journey from Cornhill to Grand Cairo*, London 1846, p.282. One possible further clue is the inscription 'Archway near Mr Lewis's house in Cairo' on a drawing in the Victoria and Albert Museum (D.1182-1908), which relates to Lewis's painting *Street Scene in Cairo near the Babel Luk*. The Bab al-Luq district of Cairo was a little to the south-west of Azbakiya and so perhaps Lewis lived somewhere between the two: if so, the artist's life in-between two cultures extended even to his address.
19. *The Times*, 30 April 1864, p.14.
20. Thackeray 1846, pp.284–5: here Thackeray, who had trained as a painter before turning to literature, adds a little vignette of a woman's face behind a lattice-screened window.
21. Lewis may have been one of the several European residents of Cairo to come under social pressure from neighbours to take a wife or concubine.

22. Lane 1860, p.531.
23. Thomas Woolner to Lewis, 31 January 1875; Yale Center for British Art, New Haven.
24. For example *The Critic*, 1 May 1857, pp.208–9.
25. *Art Journal*, 1 June 1857, p.178.
26. Yeazell 2000, p.89; Melman 1992, pp.7, 110.
27. *Le Bain turc* entered the collection of Halil Bey, Ottoman Ambassador to Paris in the 1860s.
28. See Stephen Jones's catalogue entry in Jones *et al.*, *Frederic Leighton*, exh. cat., Royal Academy, London, 1996, no.24. *The Times*, 3 May 1862, p.14, suggested the figure in the painting may have been intended as Armida, the Saracen sorceress who in Torquato Tasso's sixteenth-century Crusader epic, *Jerusalem Delivered*, lures Christian knights away to her enchanted garden.
29. For the version shown in London in 1871 (now at Roubaix, northern France), see A. Smith, *The Victorian Nude: Sexuality, Morality and Art*, Manchester 1996, pp.168–72, and E. Morris, *French Art in Nineteenth-Century Britain*, New Haven and London 2005, p.156.
30. Toledano 1998, p.11. Despite agreements, conventions and laws drawn up throughout the nineteenth century, the Egyptian slave trade persisted into the period of British occupation (from 1882).
31. *Illustrated London News*, 6 May 1871, p.447.
32. Smith 1996, p.207.
33. L. Ahmed, *Women and Gender in Islam*, New Haven and London 1992, chapter 8; for the meanings of the veil generally, see F. El Guindi, *Veil: Modesty, Privacy and Resistance*, Oxford 1999.
34. J. Bronkhurst, *William Holman Hunt: A Catalogue Raisonné*, New Haven and London 2006, nos.85, App.A20, A21.
35. B. Lewis, *A Middle East Mosaic: Fragments of Life, Letters and History*, New York 2000, p.192.
36. Z. Çelik, 'Speaking back to Orientalist Discourse', in Beaulieu and Roberts 2002, pp.21–6.
37. On the plethora of contradictory identities generated in such texts, see R. Lewis, *Rethinking Orientalism: Women, Travel and the Ottoman Harem*, London 2004.
38. Translated by R. Allen as *A Period of Time*, Reading, Hants, 1992, pp.281–2.

Religion: The Holy City

1. Arik Akhmon quoted by M.B. Oren, *Six Days of War: June 1967 and the Making of the Modern Middle East*, London 2003, p.245.
2. Through this strategy Wilkie sought to improve upon the work of those French painters, such as Horace Vernet, who used Arab models for biblical subjects: see *Art-Union*, vol.vi, 1844, p.10, and generally on the theme of costume in European recreations of Jewish history: I.D. Kalmar, 'Jesus Did Not Wear a Turban: Orientalism, the Jews, and Christian Art', in Kalmar and D.J. Penslar (eds), *Orientalism and the Jews*, Waltham, MA, 2005, pp.3–31.
3. In 1835 Catherwood published an important map of Jerusalem, and a panorama of the city based on his drawings went on show in Leicester Square.
4. *Eastern Journal*, National Library of Scotland, Acc.7723/2, entries for March and April 1839: thanks to Briony Llewellyn and Iain Gordon Brown for transcriptions of the relevant passages.
5. *Eastern Journal*, April 1839.
6. J. Bronkhurst, *William Holman Hunt: A Catalogue Raisonné*, New Haven and London 2006, no.151.
7. Wilkie's oil sketch of the *Supper at Emmaus* (see N. Tromans, *David Wilkie*, Edinburgh 2007, fig.4.12) contains another architectural anachronism in its use of Islamic decoration in a scene set in the first century.
8. See K. Whitelam, *The Invention of Ancient Israel*, London 1996.
9. The arguments set out in Fergusson's *Essay on the Ancient Topography of Jerusalem* were based upon his reading of Catherwood's plans. Roberts, when exhibiting his *Jerusalem from the South East* in 1845, mistakenly claimed in his catalogue text that the Mosque al-Aqsa had originally been a church, thus extending the fantasy of early Christian occupation across the Haram (the Aqsa had however temporarily been appropriated by the Crusaders).
10. Hunt, *Pre-Raphaelitism and the Pre-Raphaelite Brotherhood*, London 1913, vol.ii, pp.5–7.
11. See Hunt's letter from Jerusalem partly printed in the *Athenaeum*, 26 February 1870, p.300. British efforts to re-site the holy sepulchre continued, most notably in the 1880s when General Charles Gordon ('of Khartoum') believed he had identified the authentic location of the tomb to the north of the city walls, on the basis of anthropomorphic shapes he perceived in the contour lines of the Ordnance Survey map; K. Armstrong, *A History of Jerusalem*, London 2005, p.365.
12. J.J. Moscrop, *Measuring Jerusalem: The Palestine Exploration Fund and British Interests in the Holy Land*, London 2000, pp.76–7. The Fund's maps and other publications were indeed closely studied by General Allenby prior to the 1917 Palestine campaign.
13. E. Bar-Yosef, *The Holy Land in English Culture, 1799–1917: Palestine and the Question of Orientalism*, Oxford 2005, pp.178–9.
14. Warren's account of his work, along with his prescriptions for the future of Palestine, were published as *Underground Jerusalem*, London 1876. For the *Bahr al-Kabir*, or Great Sea, see S. Gibson and D.M. Jacobson, *Below the Temple Mount: A Sourcebook on the Cisterns, Subterranean Chambers and Conduits of the Haram al-sharif*, Oxford 1996, pp.33–41.
15. A. Cunningham, *The Life of Sir David Wilkie*, London 1843, vol.iii, pp.405, 435–6.
16. T. Parfitt, *The Jews in Palestine 1800–1882*, Woodbridge 1987, p.167.
17. Matthew 25:31–2.
18. Roberts's most ambitious picture of Jerusalem showed its destruction by the Romans. Exhibited in London in 1849 and then sent on tour, this huge painting was accompanied by a description by George Croly, who had earlier written the text for Roberts's prints of the Holy Land and whose novel *Salathiel* (1828) had been on the theme of the Wandering Jew and the destruction of the Temple.
19. A. Schölch, *Palestine in Transformation 1856–1882*, Washington D.C. 1993, p.52. The historical demography of Palestine is controversial, but see the summary of evidence in Y. Ben-Arieh, *Jerusalem in the Nineteenth Century: The Old City*, Jerusalem 1984, pp.126–31, 190–4, 267–79, and Parfitt 1987, pp.33–8. What seems clear is that, during the 1850s, the combined Jewish communities of Jerusalem came to form the largest religious grouping in the city, and that during the following decade they came to form an overall majority of the population. For the modern development of a special relationship between Protestant and Zionist fundamentalisms see G. Gorenberg, *The End of Days: Fundamentalism and the Struggle for the Temple Mount*, Oxford 2002.
20. See Edith Holman Hunt's semi-autobiographical chidren's story *Children at Jerusalem*, London 1881. For the portrait of Edith by her husband that appears in her watercolour see Bronkhurst 2006, no.D313.
21. L.P. Gartner, *History of the Jews in Modern Times*, Oxford 2001, p.148.
22. *Stirring Times, Or, Records From Jerusalem Consular Chronicles of 1853 to 1856*, 1878.
23. Armstrong 2005, p.356.
24. Bronkhurst 2006, no.D125.
25. Warren 1876, 456; J. Seddon, *Memoir and Letters of the Late Thomas Seddon, Artist*, London 1858, pp.101–2.
26. See *Jewish Chronicle*, 10 July 1896, pp.9–11.
27. See A. Boime, 'William Holman Hunt's *The Scapegoat*: Rite of Forgiveness/Transference of Blame', *Art Bulletin*, vol.lxxxiv, no.1, 2002, pp.94–114. Boime sticks to the image of Hunt as an affiliate of essentially anti-Semitic Christian restorationism, for which the abolition of Judaism was envisaged as a precondition of the messiah's return. Strangely, he does not mention Hunt's later Zionism. The question begged by Hunt's case is surely how far the anti-Semitism inherent in Christian restorationism was erased through its translation into political Zionism.
28. Hunt 1913, vol.ii, p.255. A kind of link between messianic restorationism and practical Zionism was represented by the Canadian visionary Henry Wentworth Monk, whom Hunt met in Jerusalem and with whom he maintained an arm's-length correspondence. Hunt's extraordinary portrait of Monk is no.92 in Bronkhurst's catalogue.
29. A. Palmer, *Decline and Fall of the Ottoman Empire*, London 1992, p.235.
30. *Works by David Bomberg*, exh cat., Chenil Gallery, London 1914, Foreword.
31. In S. Rachum (ed.), *David Bomberg in Palestine 1923–1927*, exh. cat., Israel Museum, Jerusalem, 1983, p.15. When Herzl visited Jerusalem in 1898, he also had desired to see it cleaned up, the key old monuments scrubbed white and the interspersed structures removed.
32. Bentwich, the nephew of the Anglo-Jewish painter and long-time President of the Maccabeans, Solomon J. Solomon, became a professor at the University in 1932. On the reaction of the city's Arab population to the opening of the university, and to what this symbolised, see Armstrong 2005, p.376.
33. N. Warner, *The Monuments of Historic Cairo: A Map and Descriptive Catalogue*, Cairo 2005, nos.66, 67, 189.
34. Warner 2005, p.60, no.133.
35. E. Barrington, *Life, Letters and Work of Frederic Leighton*, London 1906, vol.ii, 208; the artist did however complete an oil sketch on the spot.
36. The 'wrongly' orientated man may however be praying towards the shrine of John the Baptist within the prayer hall: venerated in Islam as the Prophet Yahya, the shrine is supposed to contain the Baptist's head. Conceivably Leighton wished precisely to consider this overlap between Christian and Muslim tradition.
37. L. Ormond in *Frederic Leighton*, exh. cat., Royal Academy, London, 1996, no.39.
38. The classic statement of this association is in Thomas Carlyle's *On Heroes, Hero-Worship, and the Heroic in History*, 1841.
39. Diary, 7 April 1855, John Rylands Library, Manchester: MS.1211, fol.31v: thanks to Shalini Le Gall for pointing me to this reference. The *mihrab* niches in mosques must have reminded British travellers of the empty niches from which statues had been removed in many a reformed North European church.
40. D. Kennedy, *The Highly Civilized Man: Richard Burton and the Victorian World*, Cambridge, MA, 2005, p.80.

SOME KEY POLITICAL EVENTS 1792–1923

1792
Sultan Selim III resolves to establish permanent diplomatic representation in Europe as part of his reform programme.

1793
First permanent Ottoman embassy is established in London.

1798
French army led by Napoleon Bonaparte invades Egypt. Mamluk forces are defeated at the Battle of the Pyramids.

1801
French army expelled from Egypt by combined Ottoman/British forces.

1805
Muhammad 'Ali (1769–1849) appointed Viceroy of Egypt.

1830
French invasion of Algeria.

1831
Muhammad 'Ali invades Palestine and Syria.

1838
First Afghan War (1838–42) signals the beginning of British attempts to secure Afghanistan, and by extension India, from Russian expansionism.

1839
Tanzimat (Reorganisation) reform programme instigated by Mahmud II (1785–1839) and developed by his son Abdul Mejid I (1823–61).

1840
Muhammad 'Ali granted hereditary rule of Egypt by Ottoman Empire, following his expulsion from Palestine and Syria with British assistance.

1847
The principal Constantinople slave market, the *Esir Pazari*, is closed down.

1849
Muhammad 'Ali dies and is succeeded by his grandson 'Abbas (1813–54).

1854
Crimean War (1854–6) begins, fought by an alliance of the Ottoman Empire, France, Britain and the Kingdom of Sardinia, against Russia.

1860
Civil war in Lebanon.

1861
Sultan Abdul Mejid dies and is succeeded by his brother Abdul Aziz (1830–76).

1869
Suez Canal opens.

1882
British occupation of Egypt begins.

1888
Convention of Constantinople. Suez Canal is declared a neutral zone under British protection.

1889
Completion of a direct rail line to Istanbul, servicing the Orient Express.

1908
Oil discovered in the Middle East (in Persia).

1909
Deposition of Sultan Abdul Hamid II; the Imperial Harem is closed.

1912
First Balkan War begins: Albania declares independence from the Ottoman Empire. Morocco partitioned between France and Spain.

1914
First World War (1914–18) begins. The Ottoman Empire is in alliance with Germany.

1916
The Arab Revolt (1916–18) aims to achieve Arab independence from Ottoman Empire.

1917
General Allenby enters the old city of Jerusalem. Balfour Declaration in favour of a Jewish national home in Palestine.

1919
Peace Treaty of Versailles marks the end of the First World War. Turkish War of Independence.

1920
League of Nations grants British mandates over Iraq and Palestine.

1922
Ottoman Sultanate abolished.

1923
Declaration of Turkish Republic: the capital is moved from Istanbul to Ankara.

FURTHER READING

E. Bar-Yosef, *The Holy Land in English Culture 1799–1917: Palestine and the Question of Orientalism*, Oxford 2005

J. Beaulieu and M. Roberts (eds.), *Orientalism's Interlocutors: Painting, Architecture, Photography*, Durham, NC, 2002

A. Behdad, *Belated Travellers: Orientalism in the Age of Colonial Dissolution*, Cork 1994

Y. Ben-Arieh, *Jerusalem in the Nineteenth Century: Emergence of the New City*, Jerusalem 1986

R. Benjamin (ed.), *Orientalism: Delacroix to Klee*, exh. cat., Art Gallery of New South Wales, Sydney 1997

R. Benjamin, *Orientalist Aesthetics: Art, Colonialism and French North Africa 1880–1930*, Berkeley 2003

I.E. Boer, *Disorienting Vision: Rereading Stereotypes in French Orientalist Texts and Images*, Amsterdam and New York 2004

F.N. Bohrer, *Orientalism and Visual Culture: Imagining Mesopotamia in Nineteenth-Century Europe*, Cambridge, UK, 2003

A. Boime, 'William Holman Hunt's *The Scapegoat*: Rite of Forgiveness/Transference of Blame', *Art Bulletin*, vol.lxxxiv, 2002, pp.94–114

Z. Celik, 'Colonialism, Orientalism and the Canon', *Art Bulletin*, vol.lxxviii, 1996, pp.202–5

J.F. Codell and D.S. Macleod (eds.), *Orientalism Transposed: The Impact of the Colonies on British Culture*, Aldershot, Hants, 1998

J. DelPlato, *Multiple Wives, Multiple Pleasures: Representing the Harem 1800–75*, Cranbury, NJ, 2002

F. El Guindi, *Veil: Modesty, Privacy and Resistance*, Oxford and New York 1999

I. Grewal, *Home and Harem: Nation, Gender, Empire and the Cultures of Travel*, Durham, NC, and London 1996

I. Grundy, *Lady Mary Wortley Montagu*, Oxford 1999

J. Hackforth-Jones and M. Roberts (eds.), *Edges of Empire: Orientalism and Visual Culture*, Oxford 2005

R. Irwin, *For Lust of Knowing: The Orientalists and their Enemies*, London 2006

R. Kabbani, *Imperial Fictions: Europe's Myths of Orient*, London 1994

I.D. Kalmar and D.J. Penslar (eds.), *Orientalism and the Jews*, Waltham, MA, 2005

D. Kennedy, *The Highly Civilized Man: Richard Burton and the Victorian World*, Cambridge, MA, 2005

R. Lewis, *Gendering Orientalism: Race, Femininity and Representation*, London 1996

R. Lewis, *Rethinking Orientalism: Women, Travel and the Ottoman Harem*, London 2004

B. Llewellyn, 'A Masquerade Unmasked: An Aspect of John Frederick Lewis's Encounter with Egypt', in J. Thompson (ed.), *Cairo Papers in Social Science*, vol.xxiii: *Egyptian Encounters*, 2000, pp.133–51

L. Lowe, *Critical Terrains: French and British Orientalisms*, Ithaca, NY, 1991

A.L. Macfie (ed.), *Orientalism: A Reader*, New York 2000

J.M. MacKenzie, *Orientalism: History, Theory and the Arts*, Manchester 1995

U. Makdisi, 'Ottoman Orientalism', *American Historical Review*, vol.cvii, no.3, 2002, pp.768–96

N. Matar, *Islam in Britain, 1558–1685*, Cambridge, UK, 1998

N. Matar, *Turks, Moors, and Englishmen in the Age of Discovery*, New York 1999

B. Melman, *Women's Orients: English Women and the Middle East 1718–1918*, Basingstoke 1992

F. Mernissi, *Scheherazade Goes West: Different Cultures, Different Harems*, New York 2001

T. Mitchell, *Colonising Egypt*, Cambridge, UK 1988

J.J. Moscrop, *Measuring Jerusalem: The Palestine Exploration Fund and British Interests in the Holy Land*, London 2000

D.R. Nickel, *Francis Frith in Egypt and Palestine: A Victorian Photographer Abroad*, Princeton 2004

C. Pace, 'Gavin Hamilton's *Wood and Dawkins Discovering Palmyra*: The Dilettante as Hero', *Art History*, vol.iv, 1981, pp.271–90

L.M. Peirce, *The Imperial Harem: Women and Sovereignty in the Ottoman Empire*, Oxford 1993

M. Roberts, *Intimate Outsiders: The Harem in Nineteenth-Century Ottoman and Orientalist Art and Travel Literature*, Durham, NC, 2007

E.W. Said, *Orientalism: Western Conceptions of the Orient*, London 1978

E.W. Said, *Culture and Imperialism*, New York 1993

P. Starkey and J. Starkey (eds.), *Travellers in Egypt*, London and New York 2001

E. Toledano, *Slavery and Abolition in the Ottoman Middle East*, Seattle 1998

S. Vernoit (ed.), *Discovering Islamic Art: Scholars, Collectors and Collections, 1850–1950*, London 2000

N. Warner, *The Monuments of Historic Cairo: A Map and Descriptive Catalogue*, Cairo 2005

K. Watt, 'Thomas Walker Arnold and the Re-Evaluation of Islam, 1864–1930', *Modern Asian Studies*, vol.xxxvi, no.1, 2002, pp.1–98

E.M. Weeks, 'The "Reality Effect": The Orientalist Paintings of John Frederick Lewis (1805–1876)', Ph.D. diss., Yale University, 2004

C. Williams, 'John Frederick Lewis: "Reflections of Reality"', *Muqarnas*, vol.xviii, 2001, pp.227–43

R.B. Yeazell, *Harems of the Mind: Passages of Western Art and Literature*, New Haven and London 2000

M. Yegenoglu, *Colonial Fantasies: Towards a Feminist Reading of Orientalism*, Cambridge, UK, 1998

E. Ziter, *The Orient on the Victorian Stage*, Cambridge, UK, 2003

ARTISTS' BIOGRAPHIES
HEATHER BIRCHALL

William Allan
Born Edinburgh, 4 October 1782; died Edinburgh, 23 February 1850

Allan painted coats of arms on carriage panels before entering the Trustees' Academy, Edinburgh, where he studied under John Graham and became close friends with David Wilkie. Allan's early exhibiting career coincided with extended trips to Russia, Circassia and Turkey. There he made many portraits of the local dignitaries, and assembled costumes, arms, utensils and other artefacts to use as studio props on his return to Edinburgh. Allan became a Scottish pioneer of Oriental pictures and produced large theatrical paintings, including *Circassian Captives*, which was purchased jointly by Walter Scott, John Lockhart, John Wilson and others, and *Tartar Robbers Dividing Spoil* 1817. Encouraged by Wilkie and Scott, Allan also produced scenes from Scottish history, continuing to maintain accuracy with the costumes and setting. He became an established graphic artist, illustrating Scott's Waverley novels. Allan visited Constantinople in 1829, and in 1834 he visited Spain, where he produced studies of the Alhambra, and Morocco. In 1838, the year he was appointed President of the Royal Scottish Academy, Allan exhibited *Slave Market, Constantinople* (fig.74) at the Royal Academy, one of the most ambitious of all British Orientalist narrative paintings. In 1841 Allan succeeded Wilkie as Limner to the Queen for Scotland and was knighted the following year.

David Bomberg
Born Birmingham, 5 December 1890; died London, 19 August 1957

At the age of twenty-two Bomberg secured a place at the Slade School of Art with the help of the Jewish Education Aid Society. His period at the Slade coincided with the first exhibitions in London of the French Post-Impressionists and Italian Futurists, and his early work, such as *Vision of Ezekiel* 1912, reflects the ideals of European Modernism and Bomberg's close association with the Vorticist group led by Wyndham Lewis in London. Following the war (during which he enlisted with the Royal Engineers), Bomberg continued to receive commissions and in 1923, assisted by the Palestine Foundation Fund, he was appointed its official artist. His work from this period includes topographical views of Jerusalem, Petra and the surrounding countryside; a selection was exhibited at the Leicester Galleries, London, in 1928. Bomberg subsequently visited Morocco (1930), Greece (1930), Russia (1933) and Spain (1934–5). His reputation faltered in the 1930s, and in 1945 he took up a teaching post at the Borough Polytechnic (now London South Bank University). He remained there until 1953, and greatly influenced the work of Frank Auerbach and Leon Kossoff. Bomberg executed his final landscapes at Ronda in Andalusia in 1954, the expressive brushwork in these works contrasting with his earlier more linear and Cubist-inspired style.

Henry Pierce Bone
Born Truro, 6 February 1755; died Somerstown, London, 1834

An important miniature and enamel painter, Bone developed his skills at a young age working at the Cookworthy Factory in Plymouth, where he was employed to produce designs on hard-paste china. Moving to London in 1779, he began to paint miniatures on ivory which, from 1781, he sent to the Royal Academy exhibitions. Bone also received numerous commissions for enamel copies of religious and mythological paintings, an arduous task that involved making accurate outlines of the work in pencil or ink, which were then traced through to the enamel plaque. This was subsequently fired to fix the outline. Often up to twelve firings were required, and the enamel could take up to three years to complete. This process is now referred to as the 'Bone technique'. Bone often worked on an ambitious scale, his enamel copy of Leonardo's *Madonna of the Rocks* taking two years to complete and measuring 41 by 25.4 cm. In 1800 he was appointed enamel painter to the Prince of Wales. Bone was elected Royal Academician in 1811 and had seven children, five of whom also became miniaturists.

George Price Boyce
Born London, 24 September 1826, died Chelsea, London, 9 February 1897

Initially working for the architectural firm of Wyatt and Brandon, Boyce resolved to become a painter after meeting David Cox in 1849, and the broad manner of his early watercolours reflects the influence of the landscape artist. From the late 1850s, influenced by John Ruskin's *Modern Painters* (1843–60) and by the work of the Pre-Raphaelites, he began to produce more closely observed watercolour studies of Venetian palazzos and picturesque mills on the River Thames. In 1861, following the death of his sister, Joanna, Boyce travelled to Egypt accompanied by the artists Frank Dillon and Egron Lundgren. He remained there until February 1862, living in an old house at Giza. Boyce remarked in his diary that Dante Gabriel Rossetti 'Did not like what I had done in the East. Said that all the things that artists brought from the East were always all alike and equally uninteresting'. Despite this comment, Boyce painted some of his most impressive watercolours in Egypt, including *The Great Sphinx at Gizeh* 1862, which he painted in tribute to his friend Thomas Seddon, who had died at Cairo in 1856. In 1858 Boyce was elected an associate of the Old Water-colour Society (he did not become a full member until 1878), and he exhibited with them until 1890, often showing tumbledown mills and farm buildings in the Thames Valley. Boyce's later works, in particular those of Venice and Verona, are characterised by a looser technique and more subdued colours and tones.

Henriette Browne
(born Sophie de Boutailler)
Born Paris, 1829; died 1901

Browne, whose real name was Sophie De Saux, studied with the Anglo-French artist Charles Chaplin in Paris. Chaplin had opened an atelier for female students in the late 1840s or early 1850s, and it was there that she studied the figure and developed her talents as a genre and still-life painter, making her debut at the Paris Salon in 1853. Married to a diplomat, Comte Jules De Saux, in France Browne became part of an intellectual milieu and often accompanied her husband on trips abroad, spending time in Constantinople (1860), Morocco (1865) and Egypt and Syria (1868–9). Inspired by her travels, Browne exhibited her first Orientalist subjects at the 1861 Salon, *A Visit: Harem Interior, Constantinople* (fig.112) and *A Flute Player* 1860. The paintings took the Paris art world by storm, in part due to their authenticity, as Browne had been able to experience the harem first hand. The poet and critic Théophile Gautier remarked on seeing her paintings that 'only women should travel to Turkey … *A Visit* indeed shows us the interior of a harem by someone who has seen it'. Browne continued to exhibit Orientalist work at the Paris Salon, often focusing on children and scenes of education such as *A Turkish Schoolroom* 1870. Her work was also shown in London, but received scant attention by comparison.

Richard Carline
Born Oxford, 9 February 1896; died Hampstead, London, 18 November 1980

Born into an artistic family, Carline started attending lectures at the age of sixteen under Percyval Tudor-Hart (who advocated the 'system of colour harmony equivalent to that of music'), first in Paris and from 1913 in Hampstead. In 1916 Carline became an officer in the Royal Flying Corps and two years later was appointed an Official War Artist, responsible for producing drawings of the Western Front from the air for training purposes. In 1919 he was posted to the Middle East with his brother, Sydney, and there produced some remarkable images of aerial warfare in the British zones in Palestine, Syria, Mesopotamia and Persia, some of which he later turned into large oil paintings. Carline also produced a large number of semi-abstract watercolours of the ancient sites he visited in Jerusalem and Babylon. Following the War, Carline studied at the Slade School of Art. Influenced by fellow artists, including John Nash and Stanley Spencer (Spencer married Carline's sister, Hilda, in 1925), he adopted a realist approach, using strong colours and paying attention to minute details. Carline was elected a member of the London Group in 1920. Although he exhibited with them until the 1970s, he devoted more and more energy to organising exhibitions. Determined to spread art appreciation through national and international organisations, Carline became involved with the Artists' International Association and the Britain-China Friendship Association.

Adrien Carpentiers
Born 1739; died London, 1778

Early biographical details about Carpentiers are scant, but it is thought that he grew up in Switzerland or Flanders, coming to England at an early age. There are records of Carpentiers' work being exhibited at the Society of Artists, the Free Society and the Royal Academy throughout the 1760s and early 1770s. Although he may have settled in London, it is likely that he became an itinerant painter, his polished style bearing comparison with his contemporary, Joseph Highmore. The Italian painter, Francesco Zuccarelli, and the French sculptor, Louis-François Roubiliac, were among his sitters.

Richard Dadd
Born Chatham, Kent, 1 August 1817; died Broadmoor, Berkshire, 8 January 1886

Dadd entered the Royal Academy Schools at the age of twenty and studied there alongside William Powell Frith and Augustus Egg. From 1839 he began exhibiting historical and literary subjects, and became a member of 'The Clique' sketching club. In 1842, following an introduction from David Roberts, Dadd was employed as a travelling artist to Sir Thomas Phillips, a wealthy barrister and former mayor of Newport, south Wales. Riding awkwardly on the back of a mule, Dadd sketched the landscape of Turkey, Syria, Palestine and Egypt, also visiting John Frederick Lewis in Cairo en route. Dadd wrote to Roberts that the steep valleys and coastal plains of Lycia in Asia Minor 'would wake all the artist in you, or indeed in anybody with the least love of nature', and he crammed sketchbooks with meticulously drawn figures and studies of architecture. Following his return in May 1843 Dadd began to show signs of mental illness, and that summer he murdered his father and fled to France where he was promptly captured. He was certified insane and spent his remaining forty-three years confined first to Bethlem Hospital, London, and,

from 1864, to Broadmoor Hospital outside London. Dadd maintained his fascination with the Near East however and, using his travel sketchbooks and vivid imagination, occupied his enclosed hours producing luminous drawings and paintings that allude to his Oriental expedition.

Frank Dillon
Born London, 24 February 1823; died London, 2 May 1909

Dillon began his studies at the Royal Academy Schools when he was twenty-six, shortly before he began to travel extensively. He visited Portugal and Madeira in 1848–9 and, in 1854, embarked on his first tour of Egypt (he visited the country at least four times). The praise Dillon received for his views of Egypt encouraged a second visit in 1861, this time accompanied by the artists George Price Boyce and Egron Lundgren. The group rented an Arab house near Giza and claimed to live there in true 'Oriental' style. Dillon remained entranced by the East and paid subsequent visits to Egypt in 1869–70 and 1873–4 (Dillon visited Japan in 1875–6, one of the few Victorian artists besides Christopher Dresser to do so). The work he produced during this period concentrates mainly on the domestic and civil architecture of Cairo. Dillon's topographical approach, and his attention to architectural decoration and interior decor, was influenced by John Frederick Lewis and by William James Müller, whose watercolours were collected by his father. In addition his pictures reflect his ambition to increase public awareness of Mamluk domestic architecture, which was threatened with neglect and destruction (Dillon later campaigned for its preservation). In 1860 Dillon moved to South Kensington, London, where he lived until his death, surrounded by the wealth of souvenirs from his trips to the Orient.

Joseph Farquharson
Born Edinburgh, 4 May 1846; died Finzean, Grampian, April 1935

Farquharson is known primarily for his paintings of flocks of sheep in snow-laden landscapes, which earned him the nickname 'frozen mutton Farquharson'. He inherited from his father, an amateur artist, the title of laird of Finzean in south Aberdeenshire, and many of his paintings were produced from his hut there, which was fitted with large windows and a stove to ease the effects of driving blizzards. Trained at the Trustees' Academy, Edinburgh, Farquharson received instruction in his early career from the Scottish landscape artist and family friend, Peter Graham. He exhibited his first painting at the Royal Scottish Academy at the age of thirteen and enjoyed early successes there. From 1880 Farquharson spent his winters in the Parisian studio of the French academic artist, Charles Carolus-Duran, who encouraged his students to study the works of the Spanish master, Diego Velázquez. His style was transformed into having what Walter Sickert later described as 'extraordinary virtuosity'. Between 1885 and 1893 Farquharson frequently visited Egypt and produced a number of paintings of mosques and street scenes, in addition to the ancient sites at Thebes. In 1915 Farquharson was elected to the Royal Academy and, over the course of his career, exhibited more than two hundred paintings there.

Andrew Geddes
Born Edinburgh, 5 April 1783; died London, 5 May 1844

Geddes studied at Edinburgh University and spent the first part of his career working for the Excise Office. Through his father's collection of prints he developed an interest in European painting and enrolled at the Royal Academy, London, studying with Benjamin Robert Haydon and David Wilkie. Following his studies, Geddes returned to Edinburgh and opened a studio in York Place, establishing himself there as a portrait painter. Anticipating his election to associate membership of the Royal Academy, Geddes moved his studio to the capital, where he continued to paint large-scale portraits, often in the manner of his contemporary, Thomas Lawrence. From the mid-1820s Geddes concentrated on printmaking, experimenting with intaglio processes, including etching and drypoint.

Jean-Léon Gérôme
Born Vesoul, Haute-Saône, 11 May 1824; died Paris, 10 January 1904

One of the most famous artists in the world during his lifetime, Gérôme was a leader of the Neo-Grec movement with Jean-Louis Hamon and Henri-Pierre Picou. He studied in the atelier of Charles Gleyre and later attended the Ecole des Beaux-Arts. In 1854, accompanied by the actor Edmond Got, Gérôme travelled down the River Danube through Greece to Constantinople. Shortly after, with 20,000 francs he had received from the French Government on completion of a commission for the Parisian church of St Séverin, Gérôme visited Egypt. His painting *Plain of Thebes, Upper Egypt* 1857 was highly acclaimed when it was submitted to the Salon on his return, and may have encouraged his continued fascination with the life and culture of the Near East.

He made at least six trips there, studying the streets, bazaars and mosques of Turkey and Algiers, in addition to the animals and landscape of North Africa, which provided the inspiration for many of his paintings that were shown in France, Italy, Germany and Britain. His paintings were described by contemporary critics as 'archaeological' owing to their high finish and extreme attention to detail. In 1869 Gérôme received honorary membership of the Royal Academy.

Frederick Goodall
Born London, 17 September 1822; died London, 28 July 1904

The son of Edward Goodall, a successful engraver, Frederick showed an early aptitude for painting, and his early peasant and genre scenes reveal his attention to the work of Wilkie. From his early twenties Goodall began to travel further afield in search of subject matter, and in 1854 visited the Crimea and, later, Morocco, Spain, Portugal and Italy. For nine months from September 1858 Goodall lived in the Azbakiya quarter of Cairo with the artist, Carl Haag. Their sketches of the Sphinx, the Pyramids, and the Wells of Moses in Sinai, reveal the length of their expeditions across the country. In 1860 Goodall exhibited the first of many Oriental subjects at the Royal Academy, *Early Morning in the Wilderness of Shur* (fig.90). The large painting, praised by both Edwin Landseer and David Roberts, established his reputation, and he sold his oil sketches from the tour to the dealer Ernest Gambart. Goodall decided to embark on a second tour in 1870. On this expedition, he pitched camp for many months amongst the pastoral Beduin on the border of the desert near Saqqara in Egypt. Goodall continued to exhibit at the Royal Academy until the age of eighty.

Carl Haag
Born Erlangen, Bavaria, 20 April 1820; died Oberwesel, Germany, 24 January 1915

Following his studies in Nuremberg, Haag began painting miniature portraits in Munich and Brussels. At the age of twenty-seven he travelled to London and there began to experiment with watercolour. In 1853 Haag was elected a full member of the New Water-colour Society, and that year made the first of several visits to Balmoral in Scotland to paint Queen Victoria with Prince Albert and their children. From 1858, when he first visited Egypt with Frederick Goodall, Haag developed an obsession with the East. The two artists shared a house in Cairo (fig.129), making sketching trips to Giza and Suez. The following year Haag visited Jerusalem and, at the request of Queen Victoria, painted the Dome of the Rock, working under armed guard. Haag remained abroad for another year producing studies of Beduin, camels and Arab life, which he would use as source material for his finished watercolours on his return. In 1867, seven years after he had settled in London and become naturalised, Haag built an Oriental studio at his house in Hampstead. He made his final visit to Egypt in 1873, but continued to produce detailed watercolours of Eastern subjects until the 1890s.

Osman Hamdi Bey
Born Constantinople, 30 December 1842; died Constantinople, 24 February 1910

Hamdi Bey combined a number of professions during his career, including that of painter, archaeologist and museum curator. He studied law initially in Constantinople, and later in Paris. He took a keen interest in the artistic life of the French capital and, over the following twelve years, was taught painting by the history painters Gustave Boulanger and Jean-Léon Gérôme. Hamdi Bey returned to Constantinople an accomplished artist and, following a period holding official appointments in the Ottoman bureaucracy, was appointed Director of the Imperial Museum. Two years later, in 1883, he founded the Academy of Fine Arts, and the next year he oversaw an important regulation prohibiting historical artefacts from being smuggled abroad. The Archaeological Museum at the Topkapı Palace, which officially opened in 1891, acquired the findings from archaeological digs instigated by Hamdi Bey, including the sarcophagus of Alexander the Great, which was found in excavations in Saïda, Lebanon. Towards the end of his life Hamdi Bey began to concentrate on painting; his immaculately executed works showing aspects of Ottoman life were exhibited to critical acclaim in Paris, Vienna, Berlin and London.

Gavin Hamilton
Born Murdieston, Lothian, 1723; died Rome, 4 Jaaury 1798

Recognised during his lifetime as the most successful British history painter in Rome, Hamilton was admitted to Glasgow University at the age of fifteen, where he became proficient in Classical literature and history. In 1744 he made

his first trip to the Italian capital, and was given instruction in portraiture by the President of the Accademia di San Luca, Agostino Masucci. Hamilton's fascination with the Antique inspired a trip to Naples and the ruins at Pompeii and Herculaneum. Returning to London in 1751, Hamilton became a successful portraitist. However, his creative energy was reserved for his large-scale history paintings inspired by subjects from Classical literature, many of which were reproduced in engravings and distributed internationally. In 1758 he completed his monumental canvas of the discovery of Palmyra by Robert Wood and James Dawkins, a painting that brought together the Classical past and the East (fig.51). He also established a reputation as a dealer of Old Master pictures and Antique sculptures. Many of the latter were excavated by Hamilton in Italy and subsequently sold to British clients and public collections.

Walter Charles Horsley
Born 1855; died 1934

Son of the leading Victorian academic painter, and notorious opponent of the nude in art, John Callcott Horsley. W.C. Horsley exhibited at the Royal Academy from 1875. In 1878 Horsley visited Egypt, and thereafter he specialised in Orientalist genre subjects. Although his painting technique was limited, and his professional success modest, Horsley was nevertheless a fascinating artist on account of the entirely novel imperial themes that he developed. His pictures characteristically represented, with a down-to-earth bluntness, everyday encounters between Indians, Egyptians and other colonised peoples on the one hand, and British soldiers and civilians on the other.

Edith Holman Hunt (née Waugh)
Born 1846; died 1931

During the time of her marriage to the Pre-Raphaelite painter William Holman Hunt, Edith was a loyal supporter of her husband, enduring with him two of his uncomfortable and often dangerous periods of residence in Jerusalem. The daughter of a Regent Street chemist, she married Hunt (who was nineteen years her elder) following the death of her sister Fanny, his first wife, on 8 November 1875 in Neuchâtel, Switzerland; under English Church law at the time it was illegal for a widower to marry the sister of his deceased wife. (None of Edith's family spoke to her again after the wedding.) Shortly after the wedding the couple sailed from Venice to Alexandria down the Adriatic coast, and soon after their arrival in Jerusalem, their first child, Gladys Millais Mulock Holman Hunt, was born. This was Hunt's third trip to Jerusalem, and they lived in a house outside the city walls at 64 Hanevi'im Street (the Street of the Prophets), which still exists today (fig.130). Edith modelled for several of the pictures he worked on there, including *The Triumph of the Innocents*. She was a competent artist, often recording sights on the journeys they made together. On their trip to Egypt in 1892 Edith produced many sketches of the spectacular scenes they encountered travelling up the Nile. In 1881 Edith's book, *Children at Jerusalem: A Sketch of Modern Life in Syria*, was published, with the watercolour she had made of the interior of the family home in Jerusalem reproduced as the frontispiece.

William Holman Hunt
Born London, 2 April 1827; died London, 7 September 1910

Hunt's enduring association with the East began in 1854, six years after he had formed the Pre-Raphaelite Brotherhood with John Everett Millais, Dante Gabriel Rossetti and four others. Spurred by his Christian faith and his desire to document the unique characteristics of the Holy Land, at the age of twenty-seven he embarked on the first of four visits there. Arriving in Cairo in February 1854, Hunt travelled to Jaffa and then to Jerusalem, which he used as a base for the next sixteen months to visit Constantinople, Nazareth, Damascus and Beirut. Shortly after his arrival he described Jerusalem to the sculptor John Lucas Tupper: 'There was more than a ruined city there, one could see the Kingdom of Heaven rising above it.' *The Scapegoat*, which he exhibited at the Royal Academy on his return to London in 1856, is remarkable for its minute precision and symbolic content. Conscious of the need to make a visual record of areas of the Holy Land that were under threat from modernisation, Hunt occasionally bought photographs of important sites, which he used as aide-memoires on his return to England. Revisiting Jerusalem in 1869, he stayed there until late 1872 to work on *The Shadow of Death* 1870–3. Returning three years later, in 1875, with his new wife, Edith, he began *The Triumph of the Innocents*, which represents the Holy Family surrounded by the spirits of the children slain by Herod. The family returned to London in 1878. Hunt's final visit to Jerusalem took place in 1892, at the age of sixty-five, when he conceived *The Miracle of the Sacred Fire in the Church of the Sepulchre, Jerusalem* (fig.140).

Augustus John
Born Tenby, Pembrokeshire, 4 January 1878; died Fordingbridge, Hampshire, 31 October 1961

Recognised as one of the most talented artists of his generation, in his lifetime John's reputation was also associated with wild love affairs and bohemianism, symbolised by his beard and heavy bouts of drinking. Both John and his sister, Gwen, studied at the Slade School of Art, and in 1903 John became a member of the New English Art Club, where he was a regular exhibitor. For a short period John adopted a nomadic lifestyle, living in a caravan and camping with gypsies. In 1902 he fell in love with a friend of his sister, Dorothy McNeill, to whom he gave the gypsy name, Dorelia. She became the subject of a large number of his paintings, and in 1907 became his wife. That year John went to Paris and met Pablo Picasso, the influence of the Spanish master soon becoming apparent in his paintings, for example *A French Fisherboy* c.1913, and *A Family Group I* 1909. After the First World War, John was employed by the Canadian government as a war artist in France, but was sent home after only two months in disgrace after becoming involved in a brawl. In 1919 he was requested to paint the delegates to the Versailles Peace Conference, and thereafter John dedicated his career to portraiture. Thomas Hardy, George Bernard Shaw and T.E. Lawrence were among his celebrity sitters. John produced many paintings and drawings of the latter until his death in 1935 in a motorcycle accident.

Robert Scott Lauder
Born Silvermills, Edinburgh, 23 June 1803; died Edinburgh, 21 April 1869

Lauder was encouraged in his early artistic career by David Roberts who lived nearby, and in 1822 he was accepted into the Trustees' Academy in Edinburgh. Following a further three years of study in London, Lauder made his debut at the Royal Academy. Returning to Edinburgh, he established a reputation as a portrait painter, many of his likenesses appearing in exhibitions at the Royal Institution and Royal Scottish Academy. His painting of Roberts in Arab dress (fig.39) was commissioned by Roberts's friend David Ramsay Hay and is amongst his most ostentatious works. From the early 1840s, inspired by the novels of Walter Scott, Lauder produced fewer portraits and turned to historical narrative subjects. In 1852 he took up a teaching position at the Trustees' Academy where he became an influential teacher, encouraging the talented young Scottish artists William Quiller Orchardson and John Pettie.

John Lavery
Born Belfast, 20 March 1856; died Kilkenny, 10 January 1941

Brought up an orphan in Ireland, at the age of seventeen Lavery became an apprentice to a Glasgow photographer and used his earnings to attend the Haldane Academy of Art in Glasgow. He spent a brief period at Heatherley's School of Art in London before moving to Paris in 1881, where he entered the Académie Julian. In Paris Lavery adopted the *plein-air* naturalist style of Jules Bastien-Lepage and, with other Glasgow artists, worked at the village of Grez-sur-Loing. Returning to Glasgow in 1885 he became a leader of the Glasgow Boys, establishing his reputation with modern life subjects such as *The Tennis Party* 1885. In the late 1880s Lavery became one of the city's leading portraitists. Through one of his sitters, R.B. Cunninghame Graham, he was introduced to Morocco (a country that had already attracted fellow artists Arthur Melville and Thomas Millie Dow), and Lavery settled there for a time, owning a studio in Tangier that he used during the summer months to work up his sketches of snake-charmers and mosques into finished paintings. Lavery's friend and biographer, Walter Shaw Sparrow, wrote that far from the 'winter gloom of London' Tangier had put a spell on Lavery: 'The light and warmth there made a deep impression on him … Such is the "call" of Africa and the East.' Lavery was appointed Official War Artist in 1917 and continued to travel widely. In 1935 he visited Hollywood with the aim of painting portraits of actors and actresses, but remained there for only a short spell before returning to Ireland.

Edward Lear
Born Holloway, London, 12 May 1812; died San Remo, Italy, 29 January 1888

Between 1841 and 1870 Lear published seven books illustrating his travels, this large body of work attesting to his often-quoted aim to 'topographize and typographize all the journeys of my life'. Although he was not recognised as a serious landscape painter during his lifetime (Lear did not have any formal training as an artist), he travelled extensively throughout Europe, Egypt, Palestine and Syria, sketching voraciously at each of the places he visited and often indicating on his drawings the precise date, time of day and location. In particular he was inspired by Egypt, travelling there on five separate occasions and producing studies of the pyramids at Giza and the Temple at Philae dedicated to the Egyptian goddess Isis. Unlike his nonsense writings,

which were a commercial success, the oil paintings Lear exhibited at the Royal Academy and the British Institution rarely found buyers, and he depended upon a small circle of patrons for commissions and sales. Despite fits of depression resulting from his epilepsy, Lear was encouraged throughout his working life by William Holman Hunt, who advised him on technique, composition and colour.

Frederic Leighton
Born Scarborough, North Yorkshire, 3 December 1830; died London, 25 January 1896

Nicknamed the 'Jupiter Olympus', Leighton was one of the most popular and successful artists in the Victorian art establishment. He trained in Germany and Italy, and absorbed current Academic practice. During the 1850s Leighton became closely associated with the Pre-Raphaelites. Between 1855 and 1858 he studied in Paris, meeting contemporary French artists, including Jean-Auguste-Dominique Ingres, Jean-Baptiste-Camille Corot and Eugène Delacroix, and producing Classical subjects. Leighton made five trips to North Africa and the Near East, visiting Algiers, Constantinople, Egypt and Damascus. On one trip the Khedive of Egypt, Isma'il Pasha, provided him with a steamer, a French chef and an Italian waiter to aid his journey up the Nile to Aswan. In Damascus Leighton produced studies of backgrounds and accessories, which later became props in the Orientalist scenes he completed in his London studio, including *Old Damascus* 1874 (fig.29). In addition these became the inspiration for the 'Arab Hall', which was added to his home in Holland Park, Kensington, between 1877 and 1879. Working with the architect George Aitchison, Leighton's Arab Hall was also inspired by the twelfth-century Moorish palace of La Zisa in Palermo, and included a fountain and Moorish tiles. Leighton was elected President of the Royal Academy (which he remained until his death) at the age of forty-eight and was raised to the peerage in 1896, the first artist in Britain to be so honoured.

John Frederick Lewis
Born London, 14 July 1805; died Walton-on-Thames, Surrey, 15 August 1876

Lewis is considered one of the most important Victorian artists to visit the Middle East. The son of Frederick Christian Lewis, a successful engraver, he gained early success as a painter of animals and sporting subjects. Following a two-year visit to Spain in 1832–4 he published a series of lithographs that both enhanced his status as an artist and increased his desire to travel. In 1840–1 Lewis travelled, via Italy, Greece and Turkey, to Cairo, where he remained for the next ten years. The only detailed source of information about his life there was compiled by the novelist William Makepeace Thackeray. Based on a short visit to Lewis in 1844, Thackeray portrayed him in *Notes of a Journey from Cornhill to Grand Cairo* (1846) dressed as a 'Turkified European' and living in an elegant Ottoman house complete with camel and gazelle in the courtyard. Lewis made nearly six hundred watercolours and drawings throughout the decade. These works, together with the Oriental costumes and artefacts he collected, became the foundation of his paintings of desert encampments, harem interiors and mosques that he made and exhibited after his return to London in 1851. Lewis worked in watercolour from the 1830s, but from the late 1850s returned to working in oils in the hope of making more money and on the advice of John Ruskin. His paintings, however, retained their minuteness of detail.

Jean-Etienne Liotard
Born Geneva, Switzerland, 22 December 1702; died Geneva, Switzerland, 12 June 1789

Liotard achieved success during his lifetime as a pastel painter, miniaturist and engraver. Initially trained as a miniaturist in Geneva and Paris, he travelled to Italy, where he painted Pope Clement XII and several cardinals, and in 1738 to Constantinople, accompanied by his patron, Lord Duncannon. Liotard remained in Turkey until 1742 and became accustomed to the habits and lifestyle of the people there, growing a beard and dressing in Oriental costume. In addition he produced pastel portraits of British aristocrats in Turkish attire, including the traveller and writer, Richard Pococke (fig.33), and Liotard's English patron, William Ponsonby, 2nd Earl of Bessborough. He continued to adopt Turkish manners abroad, and in Paris, London, Vienna and elsewhere acquired the nickname of the 'Turkish painter'. His sitters included the Empress Maria-Theresa, Augusta, Princess of Wales, Marie-Antoinette and Louis XVI. A number of his portraits, characterised by an incisive style and avoidance of flattery, were exhibited at the Royal Academy. In 1781, at the age of seventy-nine, Liotard published *Traité des principes et des règles de la peinture*, in which he promoted his own style of painting and criticised other artists for their sloppy manner.

Arthur Melville
Born Loanhead of Guthrie, Forfarshire, 10 April 1855; died Redlands, Surrey, 28 August 1904

The son of a coachman, Melville spent his childhood working as a grocer's apprentice. In 1875 he entered the Royal Scottish Academy Schools where he remained for the next three years, before moving to Paris to study at the bohemian atelier, the Académie Julian. In Paris he became aware of the importance of *plein-air* painting and the French Orientalist painters Delacroix and Gérôme. Inspired by their work Melville travelled to Egypt in 1880, visiting Cairo and Luxor. Despite succumbing to a fever and complaining of the 'absolutely suffocating' heat, he remained in Cairo for nearly six months before riding solo across Asia Minor from Baghdad to the Black Sea. Twice on this expedition he was attacked by bandits, his survival dependant on the local Arab gendarmes. Returning to London in August 1882, Melville worked up many of his sketches into watercolours, which were exhibited in London and Edinburgh. In order to capture the brilliant light he had experienced in the East, Melville developed an innovative technique of placing watercolour on wet paper impregnated with gouache. His work subsequently had an important influence on the Glasgow Boys, whose principal members included Joseph Crawhall and James Guthrie.

William James Müller
Born Bristol, 28 June 1812; died Bristol, 8 September 1845

The son of a Prussian émigré who settled in Bristol, Müller showed an early aptitude for drawing and at the age of fifteen was apprenticed to a local artist, James Baker Pyne. His early technique, which was heavily influenced by a collection of locally owned John Sell Cotman drawings, can be seen in the strong draughtsmanship of his sketches of the back streets of Bristol and the surrounding area. A keen traveller, from the early 1830s Müller toured Italy and Switzerland, producing oils that he sold on to his dealers and patrons. In 1838 he embarked on an expedition to the Near East, visiting Cairo and sailing up the Nile to Thebes and the Valley of the Kings. Impressed by the colourful bazaars and Ancient ruins of Egypt, Müller produced numerous oil paintings, which he exhibited on his return at the Royal Academy and the British Institution. In 1843 he accompanied the archaeologist Sir Charles Fellows on his Lycian expedition to Xanthus in south-west Turkey. Müller produced some of his most remarkable watercolours of the Turkish landscape and the nomadic people in pure watercolour. During his short lifetime Müller's work was sometimes received unfavourably, but in 1869 the *Daily Western Mail* reported that 'a Bristol gentleman without a Müller is without his credentials to critical status'.

Thomas Phillips
Born Dudley, Warwickshire, 18 October 1770; died London, 20 April 1845

Leaving school at thirteen, Phillips was apprenticed to a glass painter in Birmingham before moving to London to study at the Royal Academy. In the capital he met the American expatriate artist Benjamin West, whom he assisted on a series of paintings (never completed) for George III. Between 1794 and 1844 Phillips exhibited prolifically at the Royal Academy, and replaced Henry Fuseli there as Professor of Painting in 1825, seventeen years after his election as Royal Academician. His fame rested primarily on his portraits (he produced around eight hundred), in particular those depicting men of science, and also Romantic writers including William Blake and Samuel Taylor Coleridge. The latter was painted for 50 Albemarle Street, London, the home of the publisher John Murray. Phillips occasionally produced portraits of his sitters in fancy dress, including Lord Byron dressed as an Albanian (fig.59), and the Duke of Sussex in Elizabethan costume. The smoothness that characterises Phillips's work is perhaps a reflection of his early career painting on glass.

Henry William Pickersgill
Born London, 3 December 1782; died London, 21 April 1875

Pickersgill worked as an apprentice to a silk manufacturer in Spitalfields, east London, before the outbreak of the Napoleonic Wars (1799–1815). He then decided to become a painter, studying under the landscape and marine artist George Arnald, before entering the Royal Academy Schools. Although Pickersgill's early subjects were inspired by momentous episodes from history and mythology, he soon acquired a reputation for portraiture. Assisted by his wife Maria in managing his clients, Pickersgill produced likenesses of some of the most eminent men and women of the day, including William Godwin, Robert Peel and Michael Faraday. In 1827 Maria published *Tales of the Harem*, which provided the inspiration for a number of Pickersgill's studies of young women dressed in Greek and Near Eastern costume. In 1826 Pickersgill was elected Royal Academician and in the following years sent nearly four hundred

pictures to the Academy exhibitions. In 1856 he was appointed Librarian at the Royal Academy, a position he held until his death.

Joshua Reynolds
Born Plympton, Devon, 16 July 1723; died London, 23 February 1792

The most fashionable portrait painter of his time, at the age of seventeen Reynolds was apprenticed to the leading portraitist, Thomas Hudson. In 1749 he travelled to Italy and, working mainly in Rome, made a study of the Old Masters. In 1753 Reynolds settled in London and began to paint idealised portraits, the elegant poses of his sitters often echoing antique sculptures in an attempt to associate them with Classical values. Determined to raise the status of art and artists in Britain, Reynolds helped to found the Royal Academy in 1768, where he delivered his influential *Discourses on Art* between 1769 and 1790. His dramatic paintings, characterised by strong lighting and free handling of paint, influenced the next generation of portraitists, including Thomas Lawrence and Henry Raeburn. Reynolds depicted several female sitters in Oriental costume, and in 1782 painted the nineteen-year-old Mrs Baldwin in exotic costume (fig.53). Although she had no East European blood, Mrs Baldwin was born in Smyrna (now Izmir in Turkey) and nicknamed the 'pretty Greek'.

William Blake Richmond
Born London, 29 November 1842; died London, 11 February 1921

Richmond, born one day after the anniversary of Blake's birthday, was given the forenames of the visionary artist in his honour. Following in the direction of his father, an established portrait painter, at the age of sixteen Richmond entered the Royal Academy Schools, studying alongside Simeon Solomon and Frederick Walker. In 1860 and 1861 Richmond paid brief visits to Italy, where he studied works by the Venetian and Florentine masters, and on his return he began exhibiting portraits of children at the Royal Academy, often in a Pre-Raphaelite manner, for example *The Three Sisters of Dean Liddell* 1864. Following a visit to Rome his style shifted dramatically, and he began to paint large-scale Classical pictures in the manner of Leighton. Like his father, however, Richmond relied on portraiture for a secure income, and he produced numerous likenesses of glamorous society hostesses and the country's leading scientists and politicians. An enthusiastic traveller, in the mid-1850s Richmond travelled via Italy to Egypt, where he delighted in the light, colour and animals of the East. Despite being poisoned by mosquitoes he produced a number of small oil landscapes and sketches of the Sphinx and the Pyramids. In 1878 Richmond succeeded Ruskin as Slade Professor at Oxford, but resigned three years later. He was elected an associate of the Royal Academy in 1888 and a Royal Academician in 1895.

David Roberts
Born Stockbridge, near Edinburgh, 24 October 1796; died London, 25 November 1864

Roberts began his career as a theatrical scene painter working in Edinburgh and Glasgow, and later at the Drury Lane Theatre in London's Covent Garden, often assisted by the marine painter Frederick Clarkson Stanfield. From the 1830s Roberts became fascinated with picturesque topography, and began a series of trips abroad that resulted in architectural paintings and watercolours. Following a visit to Spain and Tangier in 1832–3, and the success of his series of lithographs, *Picturesque Sketches in Spain*, Roberts embarked on a tour of the Near East in 1838, focusing on Egypt and the Holy Land. During this visit Roberts explored the major biblical and Ancient monumental sites, and produced hundreds of detailed drawings and sketches of the mosques and bazaars. The result of his expedition was published as *Views in the Holy Land, Syria, Idumea, Arabia, Egypt and Nubia* (the 247 lithographs created by Louis Haghe), which appeared in six volumes between 1842 and 1849, and was long accepted as an invaluable source for topographical information about the Orient. Roberts continued to travel throughout his lifetime, and also regularly sent in pictures of Eastern subjects to the Royal Academy. His large, and often theatrical, compositions are reminiscent of his early work as a scene painter. By the time of his death Roberts had painted and sold nearly 280 large oil paintings, more than fifty of which were of Egypt and the Holy Land.

George Romney
Born Dalton-in-Furness, Lancashire, 15 December 1734; died Kendal, Cumbria, 15 November 1802

At the age of twenty Romney was apprenticed to the itinerant portrait painter, Christopher Steele, in Kendal. It was in this town that he first began to make a reputation for his full-length portraits and copies of Old Master prints.

Eventually leaving the North-West, where by the late 1750s he had become a local celebrity, Romney settled in London and, undercutting Joshua Reynolds, his large-scale portraits were in constant demand. In 1773 Romney travelled to Italy and, in-between studying the works of the Renaissance masters, made extensive studies of the buildings and people. While in Venice he was introduced to the Oriental traveller, Edward Wortley Montagu, through John Udney, the former British Consul in Venice. As well as narrating tales of his travels to Romney and teaching him how to make Turkish coffee, Montagu posed for Romney wearing a beard and turban (fig.35; Montagu unfortunately died from septicaemia before the portrait was completed). Romney had no shortage of commissions when he returned to London, and he adopted a more spontaneous technique to keep up with demand. Romney's later years were dominated by Emma Hamilton, the mistress of Viscount Nelson, whose striking face and figure became the subject of his imaginative allegorical and mythological paintings.

James Sant
Born Croydon, Surrey, 23 April 1820; died London, 12 July 1916

Known primarily for his fashionable society portraits and sentimental paintings of children, Sant studied under John Varley and Augustus Wall Callcott and later at the Royal Academy Schools. His work quickly gained popularity, with his idealised depictions of children and young girls appearing at the Academy exhibitions (Sant rarely missed an exhibition, showing around three hundred pictures there) before being disseminated widely through the medium of engraving. In 1872 Sant was appointed principal painter to Queen Victoria, though paradoxically she never sat for him. Throughout his career Sant made portraits for the embassies of Turkey and Spain. His early work is highly polished but, later, under the influence of John Singer Sargent, he adopted a more spontaneous style.

John Singer Sargent
Born Florence, Italy, 12 January 1856; died London, 25 April 1925

Described as the 'van Dyck of our times' by Auguste Rodin, Sargent was the most fashionable painter of his age working in England and the United States. He studied initially in the Paris studio of the champion of Velázquez, Carolus-Duran, his tuition interspersed with trips to the countryside where his keen sense of naturalism was inspired by the Barbizon School and the Impressionists. He increasingly turned to portraiture, and soon built up a large clientele, his portraits evoking movement and a sense of immediacy. After a negative response to his painting, *Madame X*, which he exhibited at the 1884 Paris Salon, Sargent settled in London. In 1888, two years after his move, he became a member of the New English Art Club. In 1890 Sargent received a commission to decorate the Boston Public Library with a series of murals illustrating the development of religious thought and, feeling compelled to gather a range of preparatory material, he travelled to Egypt in the winter of 1891. From his studio in Cairo he researched and painted Old Testament subjects. Continually seeking subjects for his mural cycle, in 1905–6 Sargent went on his first trip (though his fourth expedition to the Arab world) to the Holy Land, visiting Jerusalem, Nazareth and the Jordan Valley. There he became fascinated by the local Beduin and made a number of studies of them. In 1907 Sargent gave up his portraiture and spent his remaining years painting landscapes, primarily in watercolour, and working on the mural cycles in the Boston Public Library, which he completed just before his death.

Thomas Seddon
Born London, 28 August 1821; died Cairo, Egypt, 23 November 1856

Before his untimely death from dysentery in Cairo, Seddon produced what John Ruskin described as 'the first landscapes uniting perfect artistical skill with topographical accuracy'. The son of a successful cabinet-maker and brother of the architect J.P. Seddon, at sixteen Seddon entered his father's business, Seddon & Sons. He decided to become a painter after studying ornamental art in Paris for one year, and enrolled at a drawing school run by Charles Lucy, at the same time attending life classes at the Artists' Society in Clipstone Street, London. Seddon eventually set up his own art school in Camden Town for the instruction of working men, the North London School of Design. In 1853 Seddon went on the first of two expeditions to Cairo, where he met the Arabic scholar and explorer Richard Burton. The following year he was joined by Holman Hunt who, sharing his religious fervour, accompanied him to Jerusalem and the Holy Land. Camping outside the city for five months, Seddon painted *Jerusalem and the Valley of Jehoshaphat* (fig.162), one of his most topographically detailed works, and possibly completed with the aid of photographs. Before returning to Cairo in 1856, Seddon produced a number of Orientalist pictures while travelling in

Europe, including *Arabs Return to their Tents on the Border of the Egyptian Desert*, Seddon's last finished painting.

Stanley Spencer
Born Cookham, Berkshire, 30 June 1891; died Cliveden, Berkshire, 14 December 1959

One of the most important artists within the British figurative tradition, Spencer entered the Slade School of Art in 1908. There, nicknamed 'Cookham' by his fellow students because of his obsession with his native village on the River Thames, he developed his skills as a draughtsman and made a thorough study of the Old Masters. During the First World War Spencer served with the Royal Army Medical Corps and was later posted to Macedonia with the Field Ambulance divisions. Following demobilisation Spencer returned to Cookham. Described by the artist as 'a kind of earthly paradise', the village was used as the backdrop for his religious subjects, including *Resurrection, Cookham* 1924–6, in which he alludes to his experiences of military life. In 1922, while courting Hilda Carline (whom he married in 1925), Spencer joined her family on a painting trip to Yugoslavia where, following his Macedonian experience, he hoped to paint Muslim tombs and mosques. In Sarajevo he produced a remarkable painting of a minaret, the symbol of Islam (fig.172). In the 1930s Spencer painted many powerful figure paintings and a number of more marketable landscapes. In the Second World War he was appointed Official War Artist and recorded shipbuilding on the Firth of Clyde.

Godfrey Thomas Vigne
Born London, 1 September 1801; died Woodford, Essex, 12 July 1863

Vigne began his working life in the legal profession, although his interests lay in art and exploration. In the early 1830s he went on the first of many expeditions, visiting the United States and Canada and describing his trip in *Six Months in America* (1832). Shortly after this work was published Vigne went to India via eastern Turkey and Persia, and spent the next seven years travelling around the north-western region of the country, visiting Kashmir, Ladakh and Afghanistan. He frequently dressed as an English gentleman and claimed that the travelling benefited his health. During this period he produced vivid portraits of the Persians, Afghans and Indians he encountered, demonstrated by his watercolour of Abdul Samut Khan, whom he met in 1836 at the court of the ruler of Kabul, Dost Muhammad. In 1840 Vigne's account of his travels in the mountainous frontier region was told in *A Personal Narrative of a Visit to Ghuzni, Kabul, and Afghanistan*. Two years later he published *Travels in Kashmir*, both books giving an insight into the north-west frontiers of India. He continued to travel in the 1850s, recording the topographies of the West Indies, Mexico, Nicaragua and the United States.

David Wilkie
Born Cults, Fife, 18 November 1785; died at sea off Gibraltar, 1 June 1841

Wilkie spent five years at the Trustees' Academy in Edinburgh before leaving for London where, at the age of twenty, he entered the Royal Academy Schools. His talents quickly recognised, he attracted the attention of the Prince Regent and notable wealthy patrons. In 1806, five years before being elected Royal Academician, *Village Politicians*, echoing the seventeenth-century Dutch and Flemish tradition, was exhibited to huge acclaim. In 1825 Wilkie embarked on a grand tour. He extended his trip to visit Spain, and the portraits he painted on his return reveal the hallmark of the Spanish masters, Velázquez and Murillo. In 1830 George IV appointed him his Painter in Ordinary, a position he retained during the reigns of William IV and Queen Victoria. In 1840, partly inspired by David Roberts's drawings of Palestine, Wilkie travelled to the Holy Land to produce authentic studies of the lands described in the Bible. Finally reaching Jerusalem in 1841, he wrote to Robert Peel: 'It is remarkable that none of the great painters to whom the world has looked for the visible appearance of Scripture Scenes and feelings have ever visited the Holy Land.' Returning home from Jerusalem Wilkie died on board the SS *Oriental*. His burial at sea off Gibraltar was commemorated by his friend and colleague J.M.W. Turner in *Peace – Burial at Sea* 1842 (fig.1).

LIST OF EXHIBITED WORKS

Works will be exhibited at all venues unless otherwise stated. Further works may be added to supplement this list at the individual venues.

Dimensions are given in centimetres, height before width.

William Allan 1782–1850

The Slave Market, Constantinople 1838
Oil on canvas, 129 x 198
National Gallery of Scotland, Edinburgh
Figs.68, 74

Richard Beavis 1824–1896

Pilgrims en route to Mecca 1878
Oil on canvas, 112 x 178
Sharjah Art Museum

David Bomberg 1890–1957

Jerusalem, Looking to Mount Scopus 1925
Oil on canvas, 56.5 x 75.2
Tate. Purchased 1972
Fig.171

Henry Bone 1755–1834 (after William Beechey, 1753–1839)

A Portrait of Thomas Hope in Turkish Costume 1805
Enamel on copper, 29 x 21
Suna and Kıraç Foundation Orientalist Paintings Collection
Istanbul only

George Price Boyce 1826–1897

The Pyramids 1861
Watercolour, 18.5 x 26.5
The Robertson Collection, Orkney
Fig.105

Henriette Browne 1829–1901

A Visit: Harem Interior, Constantinople, 1860 1860/1
Oil on canvas, 89 x 114
Private Collection – Courtesy of Marco Frignati Art Advisory, London
Fig.112

Richard Carline 1896–1980

Damascus and the Lebanon Mountains from 10,000 Feet 1920
Oil on canvas, 143.5 x 105.4
Imperial War Museum, London
Fig.107

Adrien Carpentiers fl.1739–1775/6

Portrait of Sir Francis Dashwood c.1745
Oil on canvas, 78 x 64
Private Collection
London only
Fig.34

Richard Dadd 1817–1886

Pages from a sketchbook used in the Middle East 1842–3
Dimensions variable
Victoria and Albert Museum

Seated Man with Chibouk 1842/3
Watercolour, 25 x 19.7
Fine Arts Museums of San Francisco, Museum Purchase, Achenbach Foundation for Graphic Arts Endowment Fund.
Fig.81

Sir Thomas Phillips Reclining in Eastern Costume 1842/3
Watercolour, 17.8 x 25.4
Bethlem Hospital, Beckenham
London only
Fig.22

The Halt in the Desert c.1845
Watercolour, 36.8 x 70.7
The British Museum, London
New Haven and London only
Figs.4, 99

The Flight Out of Egypt 1849–50
Oil on canvas, 101 x 126.4
Tate. Purchased 1947
Fig.155

Fantasie Egyptienne 1865
Watercolour, 25.7 x 17.8
Bethlem Hospital, Beckenham
London only
Fig.63

Frank Dicksee 1853–1928

Leila 1892
Oil on canvas, 100 x 126
Private Collection
Fig.21

Frank Dillon 1823–1909

Exterior of the House of Radwan Bey, Cairo 1870
Gouache, 30.5 x 40.6
Victoria and Albert Museum
New Haven and London only
Fig.109

Interior of a room in the female quarters of the house of Sheikh al-Sadat, Cairo c.1875
Gouache, 74.5 x 58.5
Victoria and Albert Museum.
Purchased with the assistance of The Art Fund, the National Heritage Memorial Fund, Friends of the V&A and Shell International
New Haven and London only
Fig.132

Interior of the House of the Mufti Sheikh al-Mahdi, Cairo c.1872
Watercolour, 30.5 x 47
Victoria and Albert Museum
New Haven and London only
Fig.131

Joseph Farquharson 1846–1935

The Hour of Prayer: Interior of the Mosque of Sultan Hasan at Cairo 1888
Oil on canvas, 173.5 x 154.4
Aberdeen Art Gallery
Fig.167

Andrew Geddes 1783–1844

Sir William Allan in Circassian Costume 1815
Intaglio print, 21.6 x 14.6
Tate. Presented by Sir Charles Holmes 1924

Charles Lenox Cumming-Bruce in Turkish Dress 1817
Oil on wood, 64.1 x 53.3
Yale Center for British Art, Paul Mellon Collection

Jean-Léon Gérôme 1824–1904

Napoleon in Egypt c.1863
Oil on wood, 35.8 x 25
Princeton University Art Museum. Museum purchase, John Maclean Magie, Class of 1892, and Gertrude Magie Fund
New Haven and London only
Fig.43

For Sale: Slaves at Cairo c.1871
Oil on canvas, 75 x 60
Cincinnati Art Museum
New Haven and London only
Figs.28, 126

Frederick Goodall 1822–1904

Early Morning in the Wilderness of Shur 1860
Oil on canvas, 97 x 305
Guildhall Art Gallery, City of London
London only
Figs.9, 90

Carl Haag 1820–1915

Our Studio in Cairo 1859
Watercolour, 49.5 x 35
Private Collection
London only
Fig.129

Osman Hamdi Bey 1842–1910

Two Musicians 1880
Oil on canvas, 58 x 39
Suna and Kıraç Foundation Orientalist Paintings Collection
London and Istanbul only
Fig.136

Gavin Hamilton 1723–1798

James Dawkins and Robert Wood Discovering the Ruins of Palmyra 1758
Oil on canvas, 309.9 x 388.6
National Gallery of Scotland, Edinburgh. Purchased with support by The National Lottery through the Heritage Lottery Fund and with the assistance of The Art Fund
London only
Figs.10, 51

Walter Horsley 1855–1934

A Captive 1892
Oil on canvas, 106 x 94
Private Collection

E.R. Hughes after William Holman Hunt 1827–1910

Self portrait in Oriental Costume after 1875
Medium, 105 x 73
Private Collection
London only

Edith Holman Hunt 1846–1931

Interior of William and Edith Holman Hunt's House in the Street of the Prophets, Jerusalem c.1876/81
Watercolour, 38 x 53.4 framed
Chris and Carolyn Lamb
Fig.130

William Holman Hunt 1827–1910

A Street Scene in Cairo: The Lantern-Maker's Courtship 1854–7; 1860–1
Oil on canvas, 54.6 x 35
Birmingham Museums & Art Gallery
Figs.5, 73, 116

Cairo: Sunset on the Gebel Mokattum 1854; 1860–1
Watercolour, 16.5 x 35.6
The Whitworth Art Gallery, University of Manchester
London only
Fig.158

Scene in a Synagogue 1854
Pen and ink, 25.4 x 35.6
John Constable, England
Fig.146

The Afterglow in Egypt 1854; 1860–3
Oil on canvas, 185.4 x 86.3
Southampton City Art Gallery
New Haven and London only
Figs.117, 125

The Great Pyramid 1854
Watercolour, 17 x 24.7
Peter Nahum At The Leicester Galleries
Fig.106

Jerusalem by Moonlight 1854
Watercolour, 20 x 35.3
Gallery Oldham

The Sphinx, Giza, looking towards the Pyramids of Saqqara 1854
Watercolour, 25.4 x 35.5
Harris Museum and Art Gallery, Preston
London only
Fig.104

Nazareth 1855; 1860–1
Watercolour, 35.3 x 49.8
The Whitworth Art Gallery, University of Manchester
London only
Fig.161

The Plain of Rephaim from Mount Zion, Jerusalem 1855; 1860–1
Watercolour, 35.5 x 50.8
The Whitworth Art Gallery, University of Manchester
London only
Fig.160

The Dome of the Rock, Jerusalem, during Ramadan 1854–5; 1860–1
Watercolour, 22.3 x 35.6
The Whitworth Art Gallery, University of Manchester
London only
Fig.159

Self-Portrait in Oriental Costume 1867/75
Oil on canvas, 105.3 x 73
Uffizi Gallery, Florence
New Haven only
Fig.55

Bethlehem from the North 1892/3
Watercolour, 25.8 x 35.9
Private Collection
Fig.156

Augustus John 1878–1961

Colonel T.E. Lawrence 1919
Oil on canvas, 80 x 59.7
Tate. Presented by the Duke of Westminster 1920
Figs.48, 60

Robert Scott Lauder 1803–1869

David Roberts Esq. in the Dress he Wore in Palestine 1840
Oil on canvas, 133 x 101.3
Scottish National Portrait Gallery, Edinburgh
Fig.39

John Lavery 1856–1941

Tangier: The White City 1893
Oil on canvas, 61 x 81.4
Private Collection, Courtesy Karen Reihill Fine Art, Dublin
Fig.108

Edward Lear 1812–1888

Constantinople from Eyüp 1858
Oil on canvas, 38 x 24
Private Collection
New Haven and London only
Fig.89

The Dead Sea 1858
Pen and ink with watercolour, 36.8 x 55.2
Yale Center for British Art, Paul Mellon Collection
London only
Fig.100

Petra 1859
Oil on canvas, 69.7 x 115.5
Private Collection
Fig.102

Beirut c.1861
Oil on canvas, 45.9 x 69.3
Government Art Collection, UK
Fig.103

Jerusalem 1865
Oil on canvas, 81 x 161.6
The Ashmolean Museum, Oxford. Accepted by H. M. Government in lieu of Inheritance Tax on the estates of Captain and Mrs L.E.D. Walthall and allocated to the Ashmolean Museum, 2006
London only
Fig.144

Frederic Leighton 1830–1896

Courtyard at Bursa 1867
Oil on canvas, 36.3 x 26.4
Cecil Higgins Art Gallery, Bedford

Interior of the Grand Mosque of Damascus 1873/5
Oil on canvas, 158.1 x 122
Harris Museum and Art Gallery, Preston
Fig.166

The Music Lesson 1877
Oil on canvas, 92.7 x 95.2
Guildhall Art Gallery, City of London
Fig.135

John Frederick Lewis 1805–1876

Interior of Hagia Sophia 1840/1
Watercolour, 32.2 x 46.7
Margot Walker
London only
Fig.149

Courtyard of the Artist's House, Cairo c.1841/51
Watercolour, 78.7 x 57.7
Victoria and Albert Museum
Fig.133

Exterior of the Mosque of Sultan Hasan, Cairo c.1841/51
Watercolour, 84.5 x 56.5 framed
National Gallery of Scotland, Edinburgh
London and Istanbul only
Fig.148

'Mandarah in my House at Cairo' c.1841/51
Pencil, watercolour and gouache, 57.7 x 78.7
Victoria and Albert Museum
New Haven and London only
Fig.127

Mausoleum of Sultan Mehmet, Bursa 1840/1
Watercolour, 57.7 x 48.7
Victoria and Albert Museum
Istanbul and Sharjah only
Fig.150

The Circassian Girl 1841
Watercolour, gouache and chalk, 45.3 x 35.9
Private Collection

Great Door of the Mosque of al-Ghuri, Cairo c.1841/51
Watercolour, 52.7 x 38.1
Private Collection
Fig.147

The Bazaar of the Ghureyah from the Steps of the Mosque of al-Ghuri, Cairo c.1841/51
Watercolour, 54 x 37.9
Tate. Purchased as part of the Oppé Collection with assistance from the National Lottery through the Heritage Lottery Fund 1996
Fig.76

Chapel of the Burning Bush, St Catherine's Monastery, Mount Sinai 1843
Pencil and watercolour, 36.8 x 49.5
Tate. Presented by Lady Holroyd in accordance with the wishes of the late Sir Charles Holroyd 1919
Fig.153

Seller of Antiquities, Thebes 1850
Watercolour, 53.9 x 36.2
Lent by the Syndics of the Fitzwilliam Museum, Cambridge
Istanbul only

The Ramesseum at Thebes c.1850
Watercolour and gouache on paper, 33.3 x 50.2
Yale Center for British Art, Paul Mellon Collection

The Noonday Halt 1853
Pencil, watercolour and bodycolour on thin card, 40.9 x 57
Lent by the Syndics of the Fitzwilliam Museum, Cambridge
Istanbul only

A Halt in the Desert 1855
Watercolour, 60 x 72.5
Victoria and Albert Museum, Ellison Gift
Istanbul and Sharjah only
Fig.96

A Frank Encampment in the Desert of Mount Sinai, 1842 1856
Watercolour, 64.8 x 134.3
Yale Center for British Art, Paul Mellon Collection,
London only
Fig.101

Hhareem Life, Constantinople 1857
Watercolour, 61.2 x 48.1
Laing Art Gallery, Newcastle-upon-Tyne (Tyne and Wear Museums)
Figs.115, 121

The Bouquet 1857
Oil on wood, 30 x 18
Dunedin Public Art Gallery
Fig.120

Interior of a Mosque, Afternoon Prayer (The 'Asr) 1857
Oil on wood, 31 x 21
Private Collection
Figs.6, 168

Edfou, Upper Egypt 1860
Oil on wood, 29.8 x 77.5
Tate. Purchased 1894
Fig.95

In the Bezestein, El Khan Khalil, Cairo (The Carpet Seller) 1860
Watercolour, 33.5 x 26
Blackburn Museum & Art Gallery
Figs.11, 54

Caged Doves, Cairo 1864
Drawing, watercolour and bodycolour, 32.6 x 22.7
Lent by the Syndics of the Fitzwilliam Museum, Cambridge
Istanbul only

*The Courtyard of the Coptic Patriarch's House in Cairo c.*1864
Oil on wood, 36.8 x 35.6
Tate. Purchased 1900
Fig.134

Interior of a School, Cairo 1865
Watercolour, 47.1 x 60
Victoria and Albert Museum
New Haven and London only
Fig.78

The Commentator on the Koran: Interior of a Royal Tomb, Bursa, Asia Minor 1869
Oil on wood, 62.5 x 75.5
Elton Hall Collection
London only
Fig.170

The Seraff – A Doubtful Coin 1869
Oil on canvas, 74.9 x 87.3
Birmingham Museums & Art Gallery
Fig.75

'And the Prayer of Faith Shall Save the Sick' 1872
Oil on wood, 90.8 x 70.8
Yale Center for British Art, Paul Mellon Collection
New Haven only
Fig.122

The Bezestein Bazaar, El Khan Khalil, Cairo 1872
Oil on wood, 115.6 x 88.3
Private Collection
London only
Fig.123

Indoor Gossip 1873
Oil on panel, 30.5 x 20.3
The Whitworth Art Gallery, University of Manchester
New Haven and London only
Fig.123

Outdoor Gossip 1873
Oil on panel, 30.5 x 20.3
The Whitworth Art Gallery, University of Manchester (on loan from a private collector)
New Haven and London only
Fig.124

A Lady Receiving Visitors (The Reception) 1873
Oil on wood, 63.5 x 76.2
Yale Center for British Art, Paul Mellon Collection
New Haven only
Figs.15, 25, 128

The Siesta 1876
Oil on canvas, 88.6 x 111.1
Tate. Purchased 1921
Istanbul and Sharjah only

*The Siesta c.*1876
Pencil, watercolour and bodycolour, 46.5 x 59.1
Lent by the Syndics of the Fitzwilliam Museum, Cambridge
Istanbul only

Arthur Melville 1855–1904

An Arab Interior 1881
Oil on canvas, 95 x 72.8
National Gallery of Scotland, Edinburgh.
Fig.82

Pilgrims on the Way to Mecca 1882
Watercolour, 35.6 x 50.8
Chazen Museum of Art, University of Wisconsin-Madison. Carolyn T. Anderson, Elvehjem Museum of Art, General, Alice Drews Gladfelter Memorial, Walter J. and Cecille Hunt, and John H. Van Vleck Endowment Funds purchase, 1995.2
New Haven and London only
Fig.169

William James Müller 1812–1845

Sketchbook used in Egypt 1838
Graphite, wash and watercolour, open 12.6 x 46
The British Museum, London
New Haven and London only

Opium Seller, Egypt 1838/9
Watercolour, 33.7 x 25.2
The British Museum, London
Fig.80

Moonrise on the Nile 1839
Watercolour and graphite, 20.6 x 31.2
The British Museum, London
Fig.97

The Carpet Bazaar, Cairo 1843
Oil on panel, 62.2 x 74.9
Bristol Museum and Art Gallery
London only
Fig.72

Thomas Phillips 1770–1845

George Gordon, Lord Byron 1814
Oil on canvas, 127 x 102
Government Art Collection, UK
Figs.37, 59

Henry William Pickersgill 1782–1875

The Oriental Love Letter 1824
Oil on canvas, 142.6 x 111.8
Lent by the Royal Academy of Arts, London
Fig.118

James Silk Buckingham and his Wife Elizabeth in Arab Costume, Baghdad 1825
Oil on canvas, 145 x 115
Royal Geographical Society
Fig.41

Joshua Reynolds 1723–1792

Mrs Baldwin 1782
Oil on canvas, 141 x 110
Compton Verney
Fig.53

William Blake Richmond 1842–1921

The Libyan Desert, Sunset 1888
Oil on wood, 29.2 x 40
Tate. Bequeathed by Miss Maud Beddington 1940
Fig.92

David Roberts 1796–1864

Temple at Philae 1838
Watercolour 29.2 x 49.5
Private Collection
Fig.98

The Valley of the Kings: Entrance to the Tombs of the Kings 1838
Watercolour, 63 x 83
Frits Lugt Collection, Institut Néerlandais, Paris
London only
Fig.87

Church of the Holy Sepulchre, Jerusalem 1839
Watercolour, 22.3 x 33.3
Harris Museum and Art Gallery, Preston
Fig.152

Church of the Nativity, Bethlehem 1840
Oil on canvas, 142.2 x 111.8
Paisley Museum and Art Gallery
Fig.154

Ruins of the Great Temple of Karnak 1845
Oil on canvas, 144.8 x 237
Private Collection
Fig.94

The Ruins of the Temple of the Sun at Baalbec 1861
Oil on canvas, 158 x 251
Sharjah Art Museum
Fig.93

after David Roberts

The Mosque of Omar, showing the site of the Temple
L. Haghe, lithograph, vol.i, 1842, 20.3 x 90.5
Victoria and Albert Museum
Fig.143

George Romney 1734–1802

Edward Wortley Montagu in Oriental Costume 1775
Oil on canvas, 141 x 108
Sheffield Galleries & Museums Trust
London only
Fig.35

James Sant 1820–1916

*Captain Colin Mackenzie c.*1842/4
Oil on canvas, 237 x 145
National Army Museum, London
Fig.58

John Singer Sargent 1856–1925

The Plains of Esdraelon 1905
Oil on canvas, 71.1 x 110.5
Tate. Purchased 1957
Fig.157

Almina Wertheimer 1908
Oil on canvas, 134 x 101
Tate. Presented by the widow and family of Asher Wertheimer in accordance with his wishes 1922
Istanbul and Sharjah only

Thomas Seddon 1821–1856

Portrait of Richard Burton in Arab Dress 1853
Watercolour, 28.2 x 20
Private Collection
Fig.36

View on the Nile Near Cairo 1853/4
Watercolour, 19 x 35.5
Private Collection

Jerusalem and the Valley of Jehoshaphat from the Hill of Evil Counsel 1854–5
Oil on canvas, 67.3 x 83.2
Tate. Presented by subscribers 1857
Fig.162

The Mountains of Moab 1854
Watercolour, 25.1 x 35.2
Tate. Bequeathed by Miss E.K. Virtue Tebbs 1949
Fig.91

William Simpson 1823–1899

Bahr al-Kabir or the Great Sea. Rock-cut cistern under the site of Solomon's Temple 1870
Watercolour, 57 x 38.6
Courtesy Palestine Exploration Fund
Fig.164

Andrea Soldi c.1703–1771

*Portrait of Henry Lannoy Hunter in Oriental Dress, Resting from Hunting, with a Manservant Holding Game c.*1733–6
Oil on canvas, 118.5 x 146
Tate. Purchased with assistance from Tate Patrons and The Art Fund 2004
Fig.32

Stanley Spencer 1891–1959

Sarajevo 1922
Oil on paper, 35.6 x 25.4
Southwark Art Collection. Gift to the Contemporary Art Society, 1954, to the South London Gallery
Fig.172

Godfrey Thomas Vigne 1801–1863

Portrait of a Jewish Pilgrim from Poland 1843
Watercolour, 57.5 x 42.3
Victoria and Albert Museum. Purchased with the assistance of The Art Fund, the National Heritage Memorial Fund, Friends of the V&A and Shell International
New Haven and London only
Fig.139

David Wilkie 1785–1841

The Tartar Messenger Narrating the Fall of Acre 1840
Oil on board, 68.6 x 53.3
Private Collection
Fig.61

Sultan Abdul Mejid 1840
Oil on board, 80.7 x 58.4
The Royal Collection Trust
London only
Fig.45

The Turkish Letter Writer 1840
Oil on board, 71.7 x 54
Aberdeen Art Gallery & Museums
Fig.62

Abram Jacob Messir, the Armenian Dragoman of Mr Abbott of Smyrna 1841
Chalk and watercolour, 46.6 x 30.4
Wadsworth Athenaeum Museum of Art, Hartford, CT. Gift of James Junius Goodwin
New Haven and London only

An Arab Muleteer 1841
Watercolour and chalk, 54.6 x 38.3
National Gallery of Scotland, Edinburgh
London and Istanbul only
Fig.38

Muhammad 'Ali, Pasha of Egypt 1841
Oil on board, 61 x 50.8
Tate. Bequeathed by the Earl of Effingham 1927
Fig.44

Jews at the Wailing Wall, Jerusalem 1841
Oil and pencil on board, 43 x 53
University of Dundee Museum Services
Fig.145

Elizabeth Young in Eastern Costume 1841
Watercolour, 49.5 x 33.7
Tate. Bequeathed by Mrs Elizabeth Young 1900
Fig.52

Unknown Artist, British School

Sir Robert Shirley, Envoy of Shah 'Abbas of Persia to the Courts of Europe before 1628
Oil on canvas, 195 x 105
Trustees of the Berkeley Will Trust
London only
Fig.49

Lady Teresia Shirley before 1628
Oil on canvas, 214 x 124
Trustees of the Berkeley Will Trust
London only
Fig.50

Lenders to the Exhibition

Public Collections

Aberdeen Art Gallery
Achenbach Graphic Arts Council, San Francisco
Ashmolean Museum, Oxford
Bethlem Royal Hospital, Beckenham
Birmingham Museums & Art Gallery
Blackburn Museum & Art Gallery
Bristol City Museum & Art Gallery
The British Museum, London
Cecil Higgins Art Gallery, Bedford
Chazen Museum of Art, Madison WI
Cincinnati Art Museum
Compton Verney
Dunedin Public Art Gallery
The Syndics of the Fitzwilliam Museum, Cambridge
Frits Lugt Collection, Institut Néerlandais, Paris
Government Art Collection, London
Guildhall Art Gallery, London
Harris Museum and Art Gallery, Preston
Imperial War Museum, London
Laing Art Gallery, Newcastle-upon-Tyne
Manchester Art Gallery
National Army Museum, London
National Gallery of Scotland, Edinburgh
Oldham Art Gallery and Museums
Paisley Museum and Art Gallery
Palestine Exploration Fund, London
Suna and Inan Kıraç Foundation, Istanbul
Princeton University Art Museum
Royal Academy of Arts, London
Royal Collection Trust, London
Royal Geographical Society, London
Scottish National Portrait Gallery, Edinburgh
Sharjah Art Museum
Sheffield Galleries and Museums Trust
Southwark Art Collection, London
Southampton City Art Gallery
Tate, London
Trustees of the Berkeley Will Trust, Gloucestershire
Uffizi Gallery, Florence
University of Dundee
Victoria and Albert Museum, London
Wadsworth Athenaeum Museum of Art, Hartford
The Whitworth Art Gallery, Manchester
Yale Center for British Art, New Haven

Private Collections

John Constable, England
Elton Hall Collection
Chris and Carolyn Lamb
Peter Nahum At The Leicester Galleries
Private Collection, courtesy of Marco Frignati Art Advisory, London
Private Collection, Courtesy Karen Reihill Fine Art, Dublin
The Robertson Collection, Orkney

And other private lenders who wish to remain anonymous

Photographic Credits

Aberdeen Art Gallery & Museums Collections figs.62, 167
Ashmolean Museum, University of Oxford fig.144
Derek Barrett Photography, Isle of Wight fig.130
Berkeley Will Trust figs.49, 50
Photographs reproduced by kind permission of the Bethlem Art and History Collections Trust figs.22, 63
© Birmingham Museums & Art Gallery figs.5, 18, 73, 75, 111, 116
University of Birmingham fig.31
Blackburn Museum & Art Gallery figs.11, 54
© Fernando Botero, courtesy Marlborough Gallery, New York fig.26
The Bridgeman Art Library figs.15, 20, 21, 24, 27, 36, 61, 64, 78, 79, 88, 93, 100, 101, 104, 110, 117, 122, 125, 131, 135, 166
Bristol's Museums, Galleries and Archive fig.72
The British Library figs.17, 66
© Copyright the Trustees of The British Museum figs.4, 80, 97
Osman Hamdi Bey Museum fig.120
Chazen Museum of Art, University of Wisconsin-Madison fig.169
Christie's Images Limited figs.67, 83, 84, 94, 119, 129, 165
Photographic Survey, Courtauld Institute of Art fig.146
Terry R. Duffell fig.34
University of Dundee Museum Services fig.145
Collection of the Dunedin Public Art Gallery fig.120
Fine Arts Museums of San Francisco fig.81
The Fine Art Society, London fig.69
Courtesy of Marco Frignati Art Advisory, London fig.112
Collection Frits Lugt, Institut Néerlandais, Paris fig.87
© C.G. & S.A. Fry fig.12
© Gottfried Keller Foundation, Winterthur, all rights reserved fig.33
© Guildhall Art Gallery, City of London figs.9, 90
Harris Museum and Art Gallery fig.152
Katya Kallsen © President and Fellows of Harvard College fig.140
Trustees, Cecil Higgins Art Gallery, Bedford, England fig.77
Laing Art Gallery (Tyne and Wear Museums) figs.115, 121
© Manchester Art Gallery fig.151
Photo courtesy Mathaf Gallery, London figs.6, 168
Courtesy of the Council of the National Army Museum, London fig.58
The National Gallery, London fig.30
National Gallery of Scotland figs.10, 38, 51, 68, 70, 71, 74, 82
National Portrait Gallery, London figs.3, 42, 114
Paisley Museum and Art Galleries fig.154
Princeton University Art Museum fig.43
Photograph by Prudence Cuming Associates Ltd. fig.53
© Royal Academy of Arts, London. Photographer: John Hammond fig.118
The Royal Collection © 2005, Her Majesty Queen Elizabeth II fig.45
Trustees of the Royal Watercolour Society fig.13
Scottish National Portrait Gallery fig.39
Sheffield Galleries & Museums Trust fig.35
Courtesy of Sotheby's Picture Library, London figs.29, 70, 163
© Estate of Stanley Spencer / DACS 2007 fig.172
Sterling and Francine Clark Art Institute, Williamstown, Massachusetts fig.14
Tate Photography figs.1, 32, 44, 48, 52, 57, 60, 76, 91, 92, 95, 98, 134, 153, 155, 156, 157, 162, 170
© Queen's Printer and Controller of HMSO, 2007. UK Government Art Collection figs.37, 59, 103
V&A Images/Victoria and Albert Museum figs.86, 96, 109, 127, 132, 133, 139, 143, 150
Witt Library figs.71, 142
The Whitworth Art Gallery, The University of Manchester figs.123, 124, 158, 159, 160, 161
Yale Center for British Art, Paul Mellon Collection, USA / The Bridgeman Art Library figs.15, 25, 100, 101, 128

Copyright Credits

Work by Richard Carline © The Estate of Richard Carline 2008
Works by Augustus John © The Estate of Augustus John/The Bridgeman Art Library 2008
Work by John Lavery © The Estate of Sir John Lavery 2008
Work by Stanley Spencer © Estate of Stanley Spencer/DACS 2008

INDEX

SUPPORTING TATE

Tate relies on a large number of supporters – individuals, foundations, companies and public sector sources – to enable it to deliver its programme of activities, both on and off its gallery sites. This support is essential in order for Tate to acquire works of art for the Collection, run education, outreach and exhibition programmes, care for the Collection in storage and enable art to be displayed, both digitally and physically, inside and outside Tate. Your donation will make a real difference and enable others to enjoy Tate and its Collection both now and in the future. There are a variety of ways in which you can help support Tate and also benefit as a UK or US taxpayer. Please contact us at:

Development Office
Tate
Millbank
London SW1P 4RG
Tel: 020 7887 8945
Fax: 020 7887 8098

American Patrons of Tate
1285 6th Avenue (35th floor)
New York, NY 10019
USA
Tel: 001 212 713 8497
Fax: 001 212 713 8655

Donations
Donations, of whatever size, are gratefully received, either to support particular areas of interest, or to contribute to general activity costs.

Gifts of Shares
We can accept gifts of quoted shares and securities. All gifts of shares to Tate are exempt from capital gains tax, and higher rate taxpayers enjoy additional tax efficiencies. For further information please contact the Development Office.

Gift Aid
Through Gift Aid you can increase the value of your donation to Tate as we are able to reclaim the tax on your gift. Gift Aid applies to gifts of any size, whether regular or a one-off gift. Higher rate taxpayers are also able to claim additional personal tax relief. Contact us for further information and to make a Gift Aid Declaration.

Legacies
A legacy to Tate may take the form of a residual share of an estate, a specific cash sum or item of property such as a work of art. Legacies to Tate are free of inheritance tax, and help to secure a strong future for the Collection and galleries.

Offers in lieu of tax
Inheritance Tax can be satisfied by transferring to the Government a work of art of outstanding importance. In this case the amount of tax is reduced, and it can be made a condition of the offer that the work of art is allocated to Tate. Please contact us for details.

Membership Programmes
Tate Members enjoy unlimited free admission throughout the year to all exhibitions at Tate, as well as a number of other benefits such as exclusive use of our Members' Rooms and a free annual subscription to *Tate Etc*. Whilst enjoying the exclusive privileges of membership, you are also helping secure Tate's position at the very heart of British and modern art. Your support actively contributes to new purchases of important art, ensuring that the Tate's Collection continues to be relevant and comprehensive, as well as funding projects in London, Liverpool and St Ives that increase access and understanding for everyone.

Tate Patrons
Tate Patrons share a strong enthusiasm for art and are committed to giving significant financial support to Tate on an annual basis. The Patrons support the acquisition of works across Tate's broad collecting remit, as well as other areas of Tate activity such as conservation, education and research. The scheme provides a forum for Patrons to share their interest in art and to exchange knowledge and information in an enjoyable environment. United States taxpayers who wish to receive full tax exempt status from the IRS under Section 501 (c) (3) are able to support the Patrons through the American Patrons of Tate. For more information on the scheme please contact the Patrons office.

Corporate Membership
Corporate Membership at Tate Modern, Tate Liverpool and Tate Britain offers companies opportunities for corporate entertaining and the chance for a wide variety of employee benefits. These include special private views, special access to paying exhibitions, out-of-hours visits and tours, invitations to VIP events and talks at members' offices.

Corporate Investment
Tate has developed a range of imaginative partnerships with the corporate sector, ranging from international interpretation and exhibition programmes to local outreach and staff development programmes. We are particularly known for high-profile business to business marketing initiatives and employee benefit packages. Please contact the Corporate Fundraising team for further details.

Charity Details
The Tate Gallery is an exempt charity; the Museums & Galleries Act 1992 added the Tate Gallery to the list of exempt charities defined in the 1960 Charities Act. Tate Members is a registered charity (number 313021). Tate Foundation is a registered charity (number 1085314). American Patrons of Tate is an independent charity based in New York that supports the work of Tate in the United Kingdom. It receives full tax exempt status from the IRS under section 501(c)(3) allowing United States taxpayers to receive tax deductions on gifts towards annual membership programmes, exhibitions, scholarship and capital projects. For more information contact the American Patrons of Tate office.

Jim Bartos
Mr and Mrs Paul Bell
Alex and Angela Bernstein
Madeleine Bessborough
Janice Blackburn
Mr and Mrs Anthony Blee
Sir Alan Bowness, CBE
Mrs Lena Boyle
Mr and Mrs Floyd H. Bradley
Ivor Braka
Mr Simon Alexander Brandon
Viscountess Bridgeman
The Broere Charitable Foundation
Mr Dan Brooke
Ben and Louisa Brown
Michael Burrell
Mrs Marlene Burston
Mr Charles Butter
Elizabeth Capon
Peter Carew
Sir Richard Carew Pole
Lord and Lady Charles Cecil
John and Christina Chandris
Frank Cohen
Mr and Mrs Paul Collins
Terrence Collis
Mr and Mrs Oliver Colman
Carole and Neville Conrad
Giles and Sonia Coode-Adams
Mr and Mrs Paul Cooke
Cynthia Corbett
Mark and Cathy Corbett
Sidney and Elizabeth Corob
Ms Pilar Corrias
Mr and Mrs Bertrand Coste
James Curtis
Sir Howard Davies
Sir Simon Day
Nicole and John Deckoff
Chantal Defay Sheridan
The de Laszlo Foundation
Simon C. Dickinson Esq
Joanna Drew
Michelle D'Souza
Joan Edlis
Lord and Lady Egremont
Maryam Eisler
John Erle-Drax
Stuart and Margaret Evans
Gerard Faggionato
Tawna Farmer
Mrs Heather Farrar
Mrs Margy Fenwick
Mr Bryan Ferry
Joscelyn Fox
Eric and Louise Franck
Elizabeth Freeman
Stephen Friedman
Julia Fuller
Mr and Mrs Albert Fuss
Gapper Charitable Trust
Mrs Daniela Gareh
The Hon Mr William Gibson
Mr David Gill and Mr Francis
 Sultana
Mr Mark Glatman
Nicholas and Judith Goodison
Paul and Kay Goswell
Penelope Govett
Andrew Graham
Gavin Graham
Martyn Gregory

Sir Ronald Grierson
Mrs Kate Grimond
Richard and Odile Grogan
Miss Julie Grossman
Mr Haegy
Louise Hallett
Andrea Hamilton Photography
Mrs Sue Hammerson OBE
Samantha Hampshire
Richard Hazlewood
Michael and Morven Heller
Iain Henderson-Russell
Kim Hersov
Patsy Hickman
Robert Holden
Mr Jonathan Horwich
John Huntingford
Robin Hyman
Soren Jessen
Mr Michael Johnson
Mr and Mrs Peter Johnson
Mr Chester Jones
Jay Jopling
Tracey Josephs
Mrs Gabrielle Jungels-Winkler
Isabella Kairis
Andrew Kalman
Dr. Martin Kenig
Mr David Ker
Mr and Mrs Simon Keswick
Mr Ali Khadra
David Killick
Mr and Mrs Paolo Kind
Mr and Mrs James Kirkman
Brian and Lesley Knox
Ms Angeliki Koulakoglou
Kowitz Trust
Patricia Lankester
Simon Lee
Zachary R. Leonard
Mr Jeffrey Leung
Mr Gerald Levin
Leonard Lewis
Ina Lindemann
Miss Laura Lindsay
Anders and Ulla Ljungh
Barbara Lloyd and Dr Judith Collins
Mr Gilbert Lloyd
George Loudon
Mark and Liza Loveday
Thomas Loyd
Marillyn Maklouf
Mr and Mrs Eskander Maleki
Robert A. Mandell
Mr M.J. Margulies
Marsh Christian Trust
Janet Martin
Mr and Mrs Y Martini
Penny Mason
Barbara Meaker
Matthew Mellon
Dr Rob Melville
Michael Meynell
Mrs Michelle Michell
Mr Alfred Mignano
Victoria Miro
Jan Mol
David Moore-Gwyn
Houston Morris
Mrs William Morrison
Mr Stamatis Moskey
Mr and The Hon Mrs Guy Naggar

Richard Nagy, London
Annette Nygren
Michael Nyman
Julian Opie
Desmond Page
Maureen Paley
Dominic Palfreyman
Michael Palin
Stephen and Clare Pardy
Eve and Godfrey Pilkington
Lauren Papadopoulos Prakke
Oliver Prenn
Susan Prevezer QC
Valerie Rademacher
Will Ramsay
Mrs Phyllis Rapp
Mr and Mrs Philip Renaud
Sir Tim Rice
Lady Ritblat
Tim Ritchie
David Rocklin
Chris Rokos
Frankie Rossi
Mr James Roundell
Mr Alex Sainsbury and Ms Elinor
 Jansz
The Hon Michael Samuel
Bryan Sanderson
Cherrill and Ian Scheer
Sylvia Scheuer
Charles Schneer
Carol Sellars
Amir Shariat
Neville Shulman CBE
Andrew Silewicz
Simon and Rebecca Silver
Mr and Mrs David T Smith
Stella Smith
Louise Spence
Barbara Spring
Digby Squires Esq.
Mr and Mrs Nicholas Stanley
Mr Timothy and the Hon. Mrs Steel
Lady Stevenson
Robert Suss
The Swan Trust
Robert and Patricia Swannell
Mr James Swartz
The Lady Juliet Tadgell
Sir Anthony and Lady Tennant
Christopher and Sally Tennant
Soren S.K. Tholstrup
Mrs Lucy Thomlinson
Margaret Thornton
Britt-Marie Tidelius
Mrs George Titley
Emily Tsingou and Henry Bond
Maureen Turner
Melissa Ulfane
Mrs Cecilia Versteegh
Gisela von Sanden
Mr Christopher V. Walker
Audrey Wallrock
Offer Waterman
Mr and Mrs Mark Weiss
Mr Sean N. Welch
John W Wendler
Miss Cheyenne Westphal
Max Wigram
The Cecilia Wong Trust
Anna Zaoui
and those who wish to remain anonymous

Outset Frieze Acquisitions Fund for Tate

Ghazwa Abu Suud
Jennifer Moses and Ron Beller
Carrie and Steve Bellotti
Philippe and Bettina Bonnefoy
Silvia Bruttini
Lady Sharon and Sir Ronald Cohen
Alastair Cookson
Blake and Michael Daffey
Candida Gertler
Mark Glatman
Max and Jane Gottschalk
Rhian-Anwen and Michael Hamill
Maria and Stratis Hatzistefanis
Sam and Brian Heyworth
Johannes and Leili Huth
Tom and Karen Kalaris
Tarek and Diala Khlat
Donna M. Lancia and Jeffrey E.
 Brummette
Amalie and Guillaume Molhant
 Proost
Mary Moore
Yana Peel
Kirsten and Dwight Poler
Jenny Halpern Prince and Ryan
 Prince
Emmanuel and Barrie Roman
Michael and Melanie Sherwood
Carol and Rick Sopher
Ramez and Tiziana Sousou
Monica and Amir Weissfisch
Shirly and Yigal Zilkha
and those who wish to remain anonymous

American Acquisitions Committee

Alessandra and Jonas Almgren
Ron Beller and Jennifer Moses
William and Ronit Berkman
James Chanos
Cota Cohen Knobloch
David B. Ford
Glenn R. Fuhrman
Kathy Fuld
Andrew and Christine Hall
Susan and Richard Hayden
Monica Kalpakian
Daniel S. Loeb and Margaret Munzer
 Loeb
Stavros Merjos
Gregory Miller
Kelly Mitropoulos
Peter Norton
John and Amy Phelan
The Honorable Leon B and Mrs
 Cynthia Polsky
Kirk Radke and Liz Gerring
Robert Rennie and Carey Fouks
Michael Sacks
Pamela and Arthur Sanders
Anthony Scaramucci
Kimberly and Tord Stallvik
Steven and Lisa Tananbaum
B.J. Topol and Jon Blum
Tom and Diane Tuft
Andreas Waldburg
and those who wish to remain anonymous

Latin American Acquisitions Committee

Ghazwa Mayassi Abu-Suud
Robert and Monica Aguirre
Tiqui Atencio Demirdjian and Ago Demirdjian
Luis Benshimol
Patricia Beracasa
Estrellita and Daniel Brodsky
Carmen Buqueras
Carmen Busquets
Rita Rovelli Caltagirone
Cesar Cervantes
Paul and Trudy Cejas
Patricia Phelps de Cisneros
Gerard Cohen
Prince Pierre d'Arenberg
Tania Fares
Eva Firmenich
Anne-Marie and Geoffrey Isaac
Nicole Junkermann
Jack Kirkland
Eskander and Fatima Maleki
Becky Mayer
Solita and Steven Mishaan
Margarita Herdocia and Jaime Montealegre
Jorge G. Mora
Isaac and Victoria Oberfeld
Michel and Catherine Pastor
Mrs Sagrario Perez Soto
Catherine Petitgas
Isabella Prata and Idel Arcuschin
Luciana Redi
Frances Reynolds
Lilly Scarpetta and Roberto Pumarejo
Catherine Shriro
Norma Smith
Ricardo and Susana Steinbruch
Luis Augusto Teixeira de Freitas and Beatriz Quintella
Britt-Marie Tidelius
Paula Traboulsi
Juan Carlos Verme
Baroness Alin Ryan von Buch
Arnoldo and Tania Wald
Anita Zabludowicz

Asia Pacific Acquisitions Committee

Mrs Maryam Eisler
Eloisa and Chris Haudenschild
Becky and Jimmy Mayer
Young-Ju Park
The Red Mansion Foundation
Catherine Shriro
Mr David Tang OBE
UCCA Beijing
Yageo Foundation, Taiwan

International Council Members

Doris Ammann
Gabrielle Bacon
Anne H. Bass
Nicolas Berggruen
Mr and Mrs Pontus Bonnier
The Hon Mrs Janet Wolfson de Botton
Mrs John Bowes
Brian Boylan
Ivor Braka
The Broad Art Foundation

Donald L. Bryant Jr
Melva Bucksbaum and Raymond Learsy
Mrs Christina Chandris
Rajiv and Payal Chaudhri
Patricia Phelps de Cisneros
Mr and Mrs Borja Coca
David and Michelle Coe
Erika and Robin Congreve
Douglas Cramer
Gordon and Marilyn Darling
Mr Dimitris Daskalopoulos
Mr and Mrs Michel David-Weill
Julia W. Dayton
Mr Ago Demirdjian and Mrs Tiqui Atencio Demirdijian
Joseph and Marie Donnelly
Stefan Edlis and Ms Gael Neeson
Alan Faena
Doris and Donald Fisher
Dr Corinne M Flick
Fondation Cartier pour l'art contemporain
Candida and Zak Gertler
Alan Gibbs
Noam and Geraldine Gottesman
Mr Laurence Graff
Mr Pehr Gyllenhammar
Mimi and Peter Haas Fund
Mr Joseph Hackmey
Mr and Mrs Paul Hahnloser
Andy and Christine Hall
Mr Toshio Hara
Ms Ydessa Hendeles
André and Rosalie Hoffmann
Dakis and Lietta Joannou
Sir Elton John and Mr David Furnish
Mrs Lena Josefsson
Naomi Milgrom and John Kaldor
Ms Alicia Koplowitz
C. Richard and Pamela Kramlich, The Kramlich Gallery
Pierre and Catherine Lagrange
Baron and Baroness Lambert
The Hon Ronald and Mrs Lauder
Agnès and Edward Lee
Elena Bowes Marano
Mr and Mrs Donald B. Marron
Mr Ronald and The Hon Mrs McAulay
Angela Westwater and David Meitus
Solita and Steven Mishaan
Peter Norton
Mrs Kathrine Palmer
Sydney Picasso
Jean Pigozzi
Patrizia Sandretto Re Rebaudengo and Agostino Re Rebaudengo
Lady Ritblat
Barrie and Emmanuel Roman
Ronnie and Vidal Sassoon
Ms Dasha Shenkman
Dr Uli Sigg
Wendy Stark Morrissey
Norah and Norman Stone
David Teiger
Mr and Mrs Robert J. Tomei
His Excellency the Ambassador of the United States of America and Mrs Robert H. Tuttle
Mr and Mrs Guy Ullens
Mr Paulo A.W. Vieira

Ziba and Pierre de Weck
Diana Widmaier Picasso
Beth Rudin de Woody
Yageo Foundation, Taiwan
Anita and Poju Zabludowicz

Tate Britain Corporate Members 2007

Accenture
AIG
Apax Partners Worldwide LLP
Aviva plc
Barclays Wealth
BNP Paribas
City Inn Ltd
Clifford Chance
Credit Suisse
Deutsche Bank
Drivers Jonas
Ernst & Young
Fidelity Investments International
Freshfields Bruckhaus Deringer
Friends Provident PLC
GAM
GLG Partners
HSBC Holdings plc
Jones Day
Linklaters
Nomura
Pearson
Reuters
RBS
Shearman & Sterling LLP
Sotheby's
Tishman Speyer
UBS

Tate Britain Corporate Supporters

AIG
Constable: The Great Landscapes (2006)

AXA Art Insurance LTD
Conservation: Tate AXA Art Modern Paints Project

Barclays PLC
Turner and Venice (2003)

BP
Campaign for the creation of Tate Britain (1998–2000)
BP British Art Displays at Tate Britain
Tate Britain Launch (2000)

The British Land Company PLC
Joseph Wright of Derby (1990)
Ben Nicholson (1993)
Gainsborough (2002)
Degas, Sickert, Toulouse-Lautrec (2005)
Holbein in England (2006)

BT
Tate Online

Channel 4
Turner Prize (1991–2003)

The Daily Telegraph
Media Partner for:
American Sublime (2002)

Pre-Raphaelite Vision: Truth to Nature (2004)
In-A-Gadda-Da-Vida (2004)
Constable the Great Landscapes (2006)
Howard Hodgkin (2006)

Diesel
Late at Tate Britain (2004)
*Art Now (*2004, 2005)

Egg Plc
Tate & Egg Live (2003)

Ernst and Young
Picasso: Painter/ Sculpture (1994)
Cézanne (1996)
*Bonnard (*1998)
Art of the Garden (2004)
Turner Whistler Monet (2005)

GlaxoSmithKline plc
Turner on the Seine (1999)
William Blake (2000)
American Sublime: Landscape Painting in the United States, 1820–1880 (2002)

Gordon's gin
Turner Prize (2004, 2005, 2006)

The Guardian
Media Partner for:
Intelligence (2000)
Wolfgang Tillmans if one thing matters, everything matters (2003)
Bridget Riley (2003)
Tate & Egg Live Series (2003)
20 years of the Turner Prize (2003)
Turner Prize (2004, 2005, 2006, 2007)
How We Are: Photographing Britain (2007)
The Turner Prize: A Retrospective (2007)

The Independent
Media Partner for:
Hogarth (2007)

Sotheby's
Tate Britain Duveens Commission

Tate & Lyle PLC
*Tate Members (*1991–2000)
Ideas Factory, Tate Britain
Art Trolley, Tate Britain

Tate Members
Exposed: The Victorian Nude (2001)
Bridget Riley (2003)
A Century of Artists' Film in Britain (2003–2004)
In-A-Gadda-Da-Vida (2004)
Art Now: Nigel Cooke (2004)
Gwen John and Augustus John (2004)
Michael Landy – Semi Detached (2004)
Picture of Britain (2005)
Hogarth (2007)
Millais (2007)

The Times
Media partner for:
Art and the 60s: This Was Tomorrow (2004)